CONTENTS

P9-BZF-723

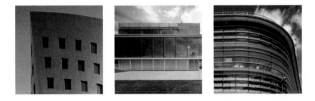

OFFICES DESIGNSOURCE

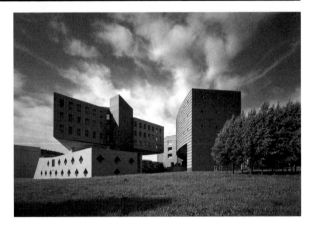

Introduction

Offices DesignSource presents a comprehensive selection of offices and corporate buildings that embody the current revolution in architecture and interior design with regard to professional working spaces. The innovative spaces displayed here are characterized by flexible and dynamic floor plans that can be adapted to multiple purposes and functions, where workers can carry out their duties in comfort and with efficiency. The spaces featured here range from large corporate buildings designed by architects as renowned as Frank O. Gehry and Richard Meier, to smaller projects headed by recognized firms like Claesson Koivisto Rune and Klein Dytham, all the way to offices integrated into domestic spaces by talented young designers.

The selected projects are a faithful reflection of the evolution and transformation taking place in the work space. In these designs one can see the most avant-garde ideas, as well as highly functional and effective solutions to common obstacles. Many different ways of planning spaces are presented, including open-plan offices with shared working areas; unconventional layouts and dividing techniques; and the adventurous use of color, which until recently has been an uncommon feature in the workplace.

Advances in technology and security have influenced the planning, distribution, and especially the interior design of modern work spaces. Even though the particular activity of each company dictates its needs, the idea of reserving large spaces for information storage is no longer a necessity. Now

that virtually everything can be saved in digital format, the bulky, heavy shelves and storage furniture of the past are giving way to stylized auxiliary elements. Dull colors are being abandoned in favor of bright and pleasing chromatic schemes, and materials, textures, and finishes such as glass, aluminum, plastic, and Plexiglas are now used more frequently.

Office buildings have experienced such a vast transformation that there are no longer any fixed rules to be applied. The new designs ingeniously combine a mixture of styles, dynamic architectural solutions, new resources, and an eclectic spirit that are all at the service of functionality. Many factors have contributed to this evolution. One of them is the notion of the highly aesthetic space—a break with formal convention—where technological advances are key to bringing about functional solutions. Different strategies are used in each office space to impart that identity, so that the design projects become laboratories of ideas for architects and designers. Other factors include the aim to provide professionals with a pleasant and comfortable working atmosphere, the development of construction and architectural methods, and, of course, technical advances that have played a major role in the transformation of offices. The result of this ongoing evolutionary process can be witnessed throughout the pages of this book, which displays the skill, imagination, and efficiency with which contemporary offices are crafted today.

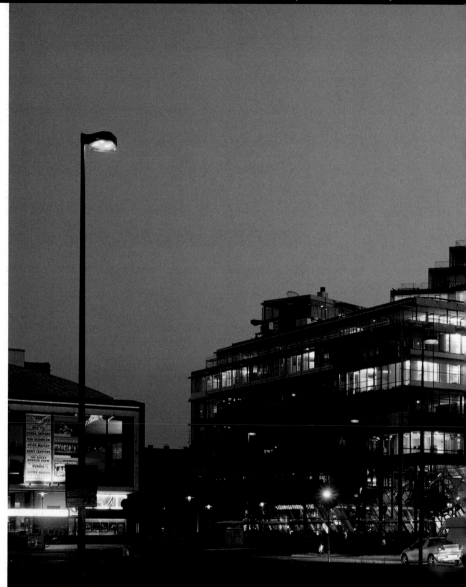

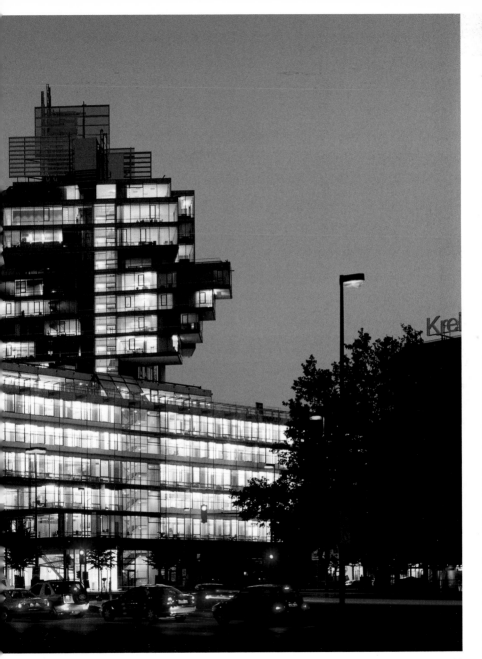

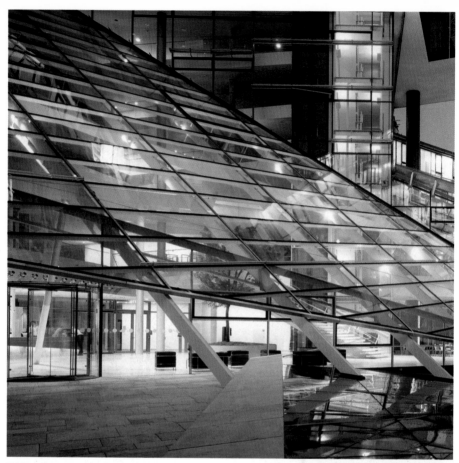

This building, which houses the offices of
NORD/LB, as well as commercial, cultural,
entertainment, and sports facilities, is a
self-contained complex that is open, accessible,
and well integrated into its surroundings.

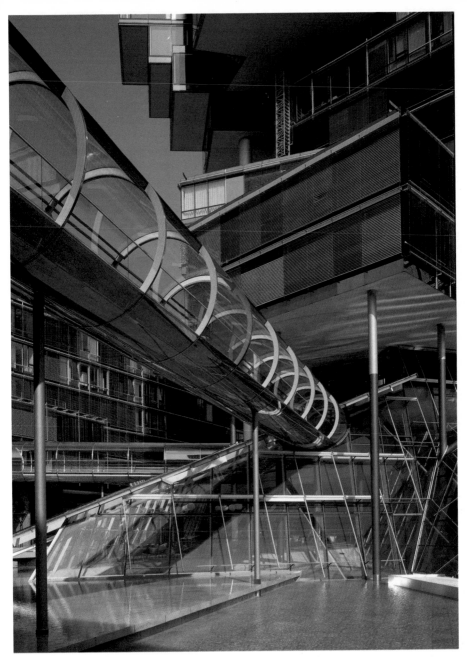

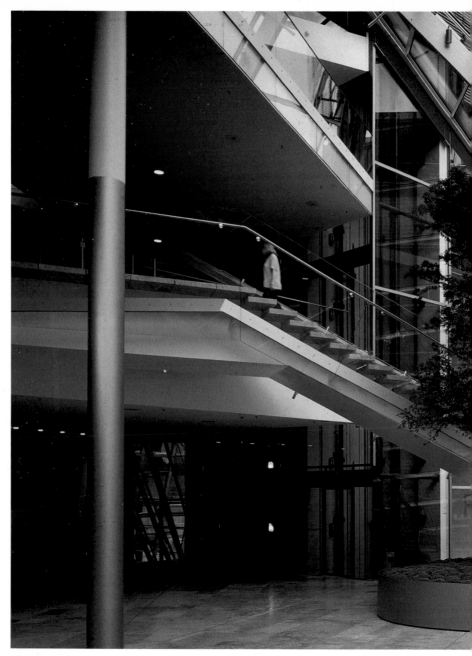

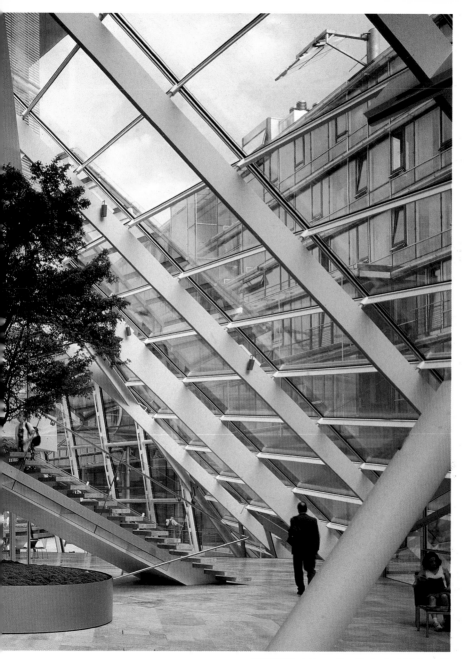

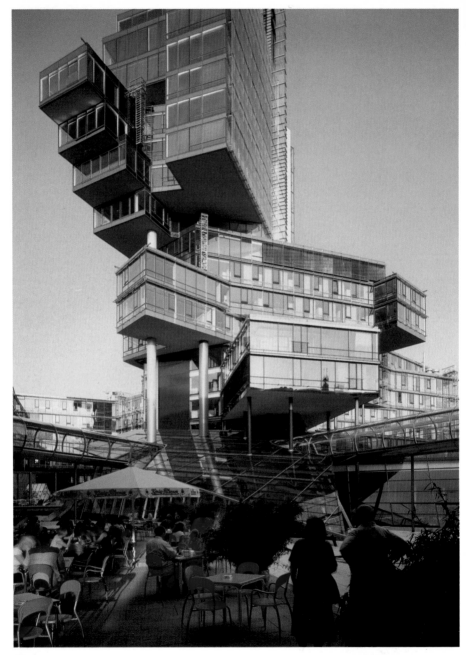

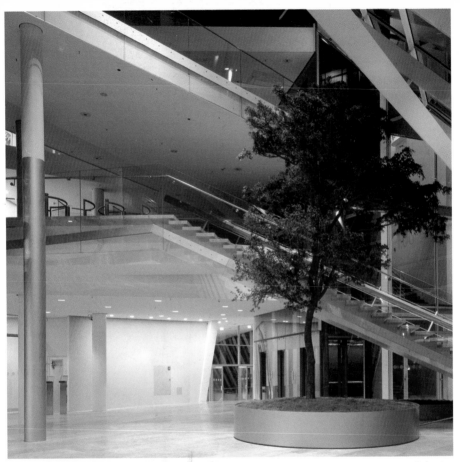

The enigmatic and unique multilevel tower, a spiral of provocative angles that can be seen from a distance, is the main feature of the building.

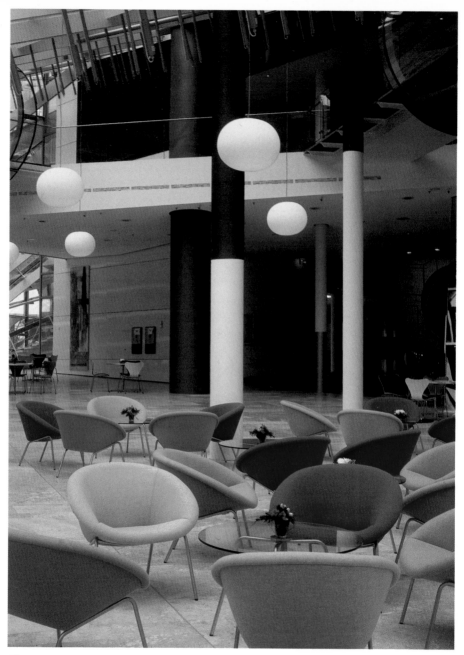

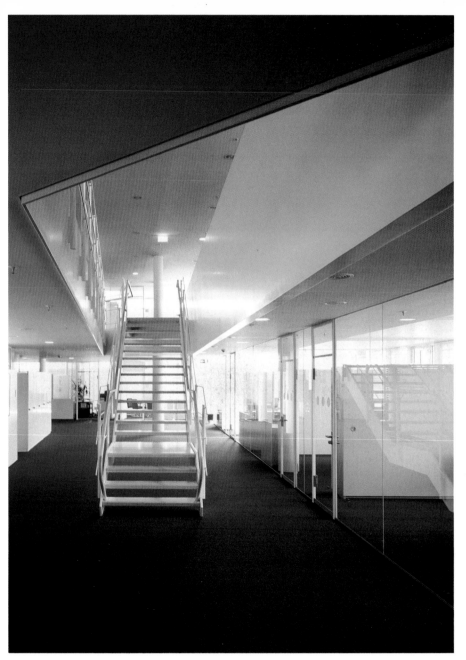

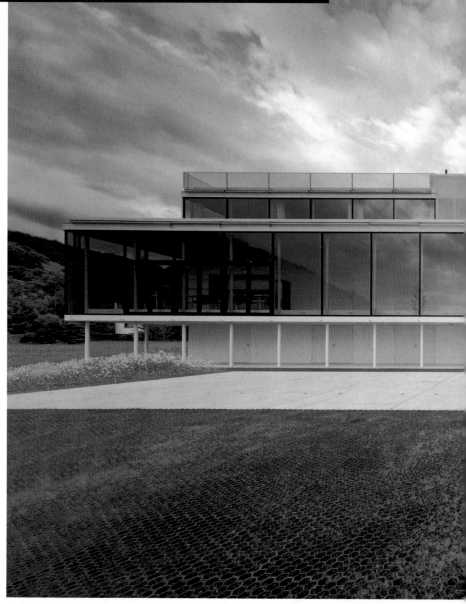

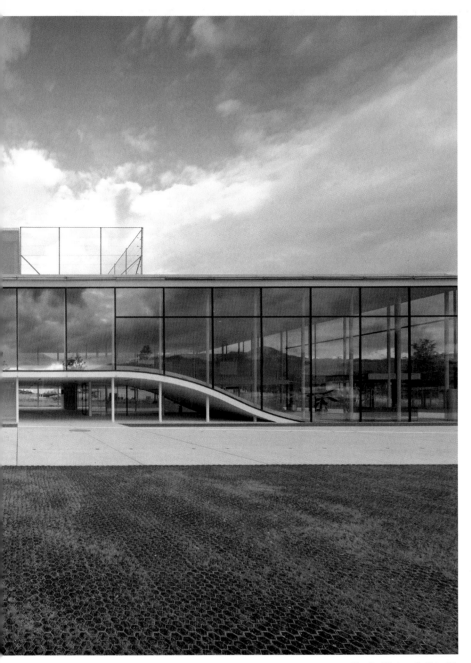

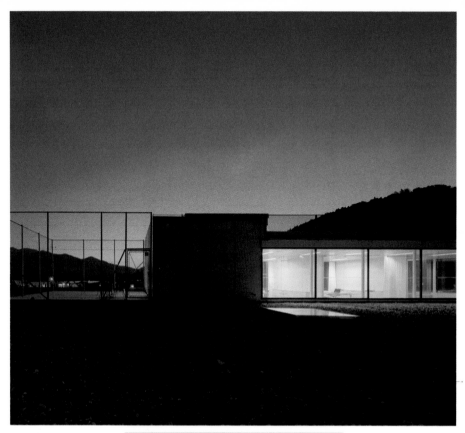

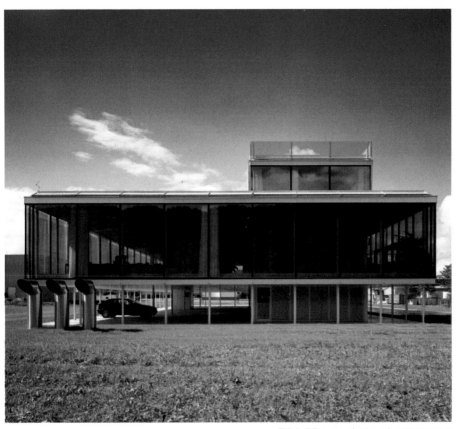

This building, conceived as a large transparent
rectangle, is an ingenious and rational design
composed of steel and glass.

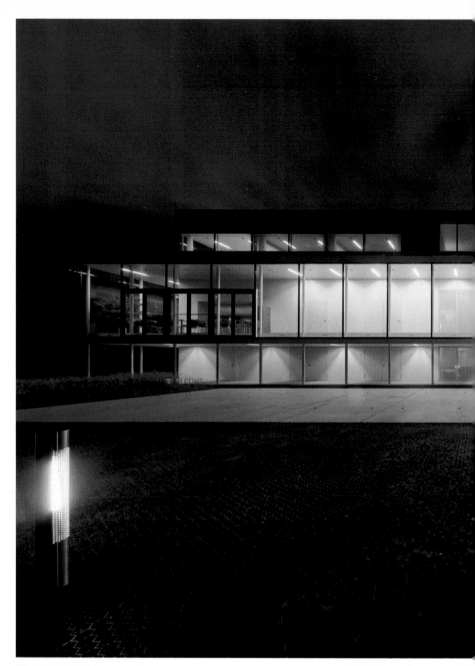

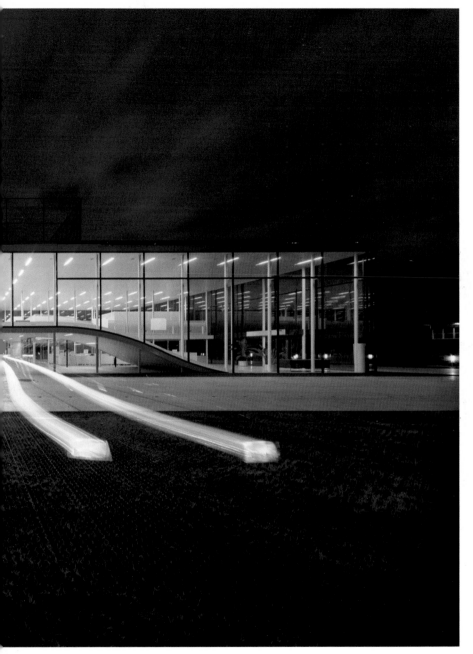

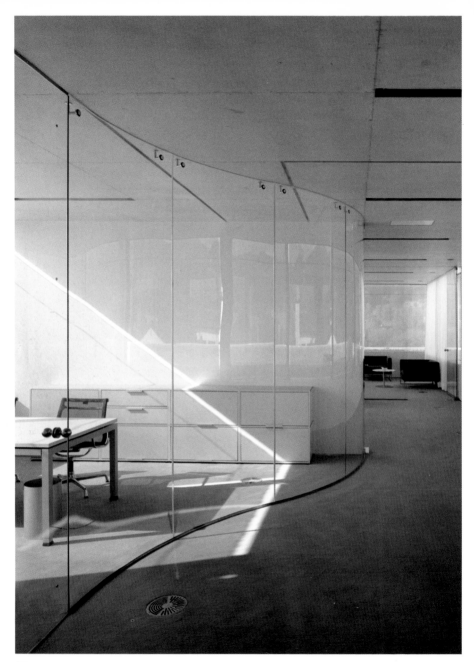

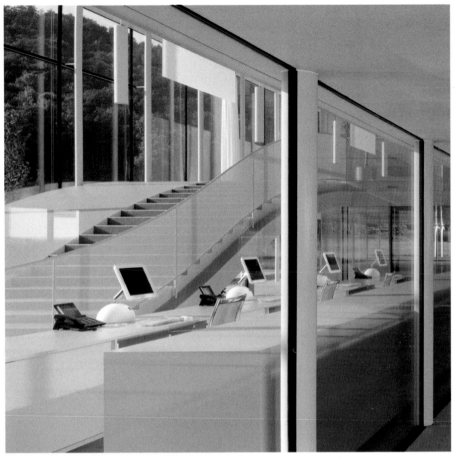

The work areas, placed on the upper floors, are connected to the lobby and reception area by carpeted stairs. Carpet is also used on the floor in the workspaces.

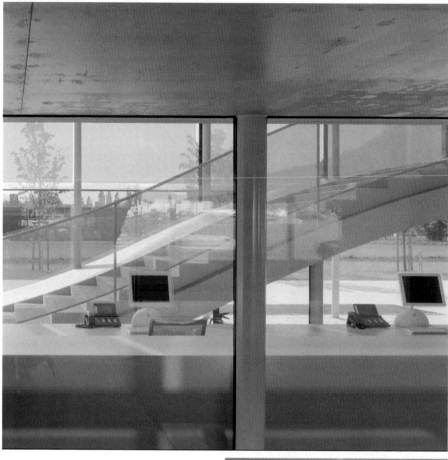

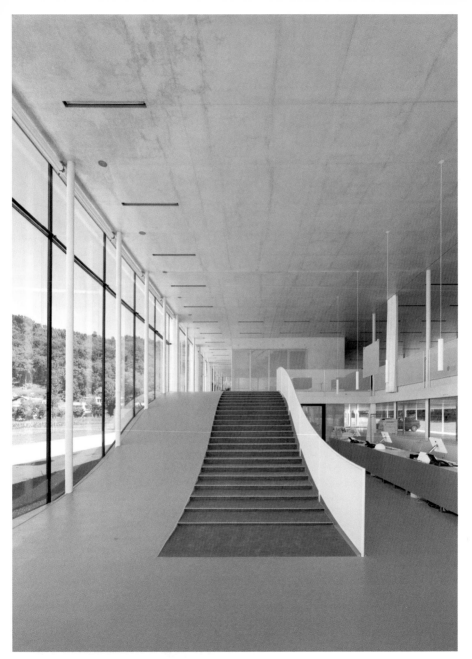

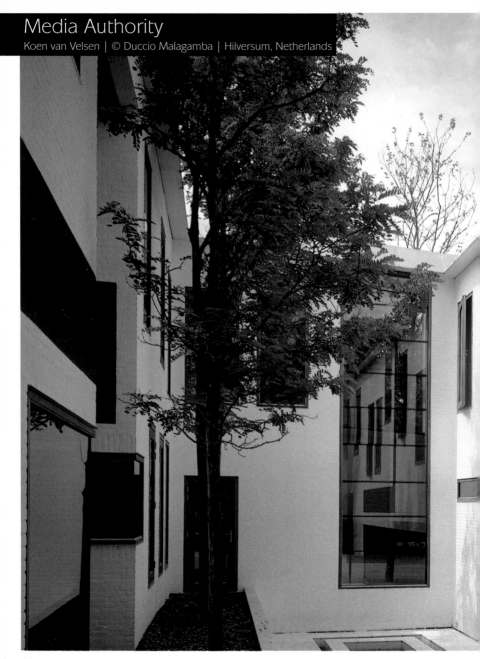

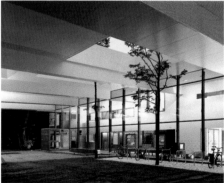

The verticality of the trees, which literally split open part of the roofs of the building, contrasts with the horizontal and rectilinear construction of the building. As a result, we are afforded volumes with great expressiveness, accentuated by the fragility of the glass and the well-chosen lighting.

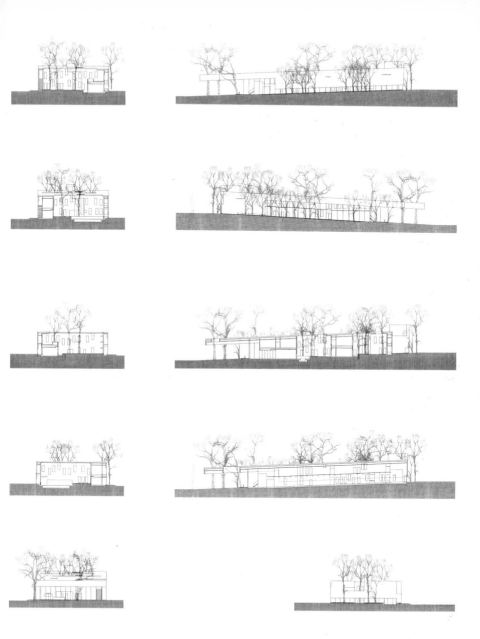

Elevations

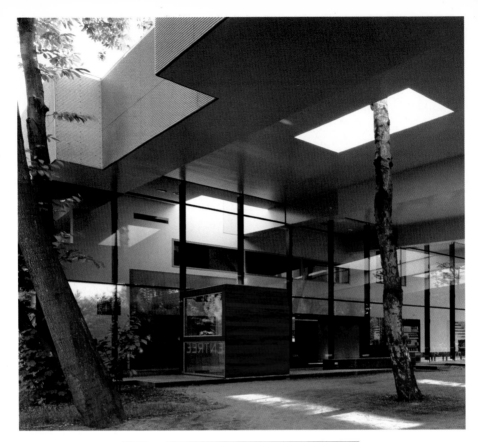

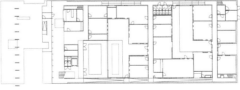

First floor

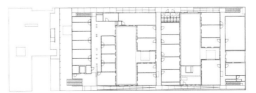

Second floor

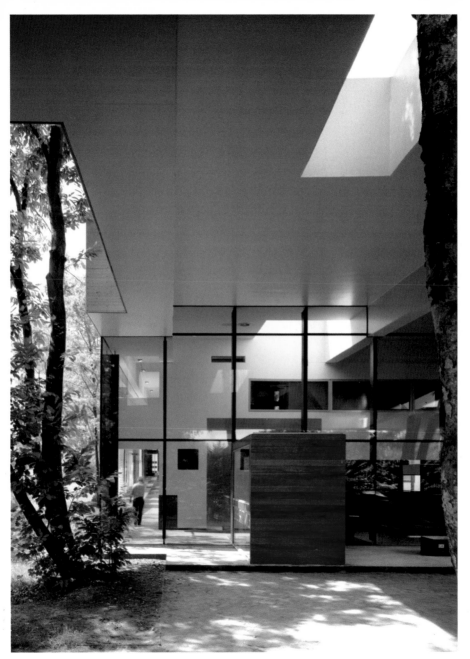

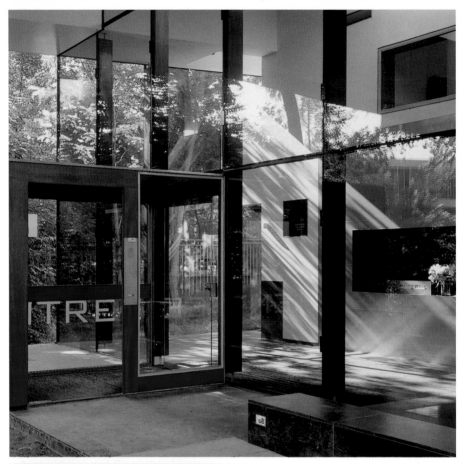

Transparent glass walls cover the façades, integrating the building with the surrounding landscape and permitting natural light to shine through the interior.

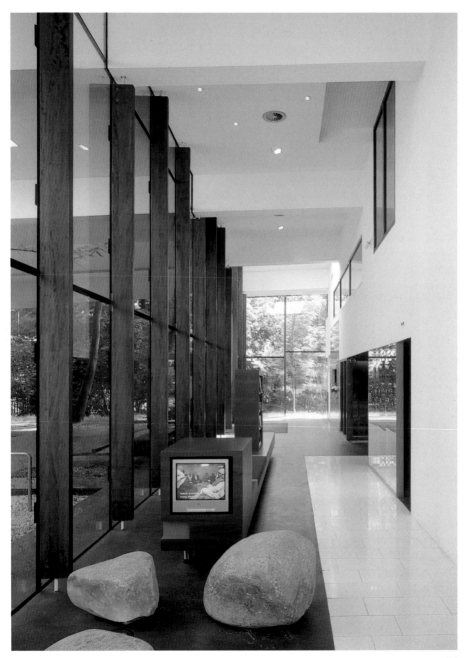

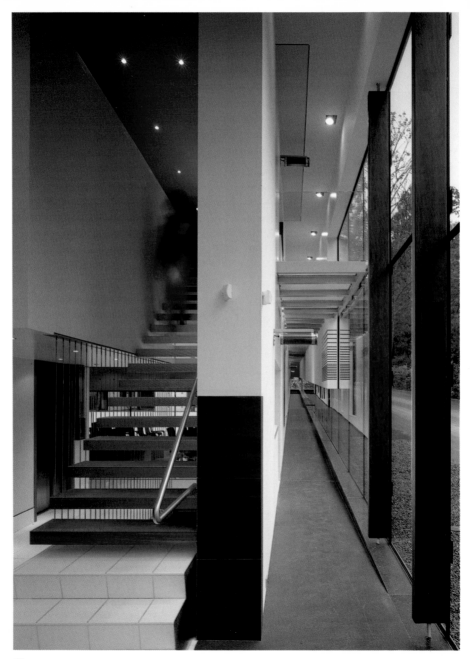

To counteract and subdue the rigid geometric
lines of the volumes, the architects made use of
the transparency and fragility of glass and the
combination of metal frames with natural wood.

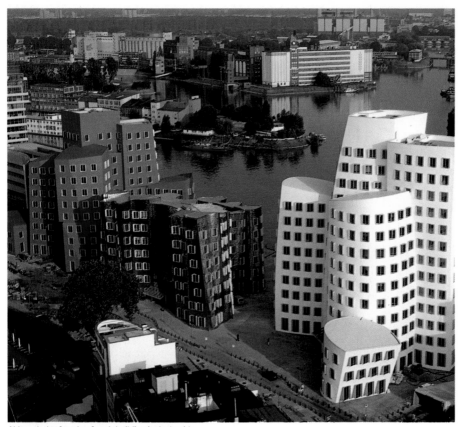

Although the façade of each building is dealt with in a different way, the ensemble is characterized by great homogeneity. Once again, Gehry has managed to design a structure of geometric and sinuous lines, teeming with personality.

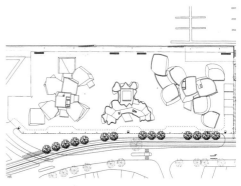

Site plan

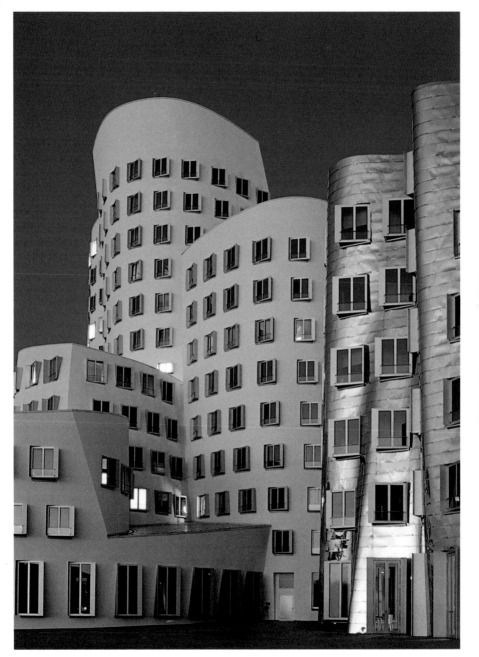

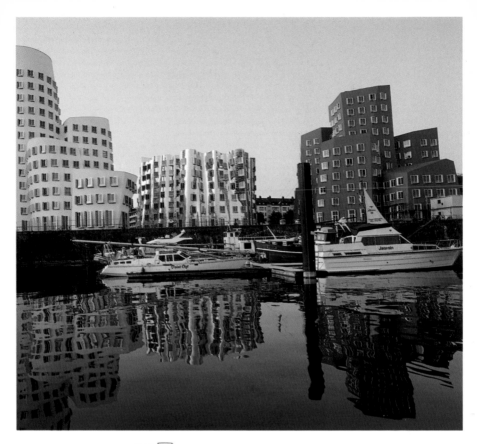

Axonometric perspectives

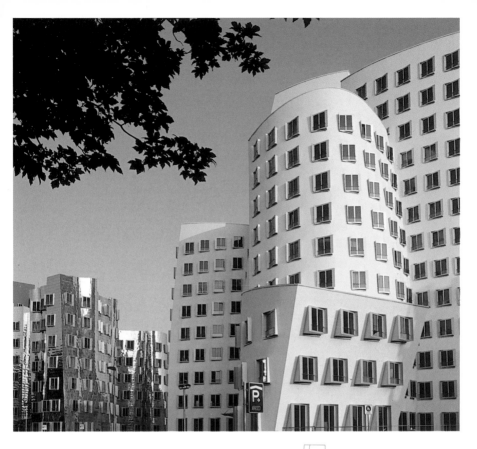

South elevation

North elevation

Der Neue Zollohof 45

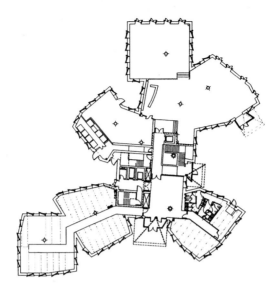

First floor

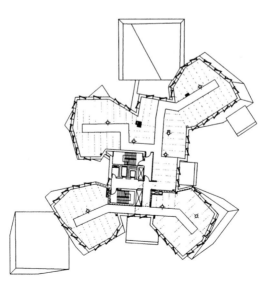

Sixth floor

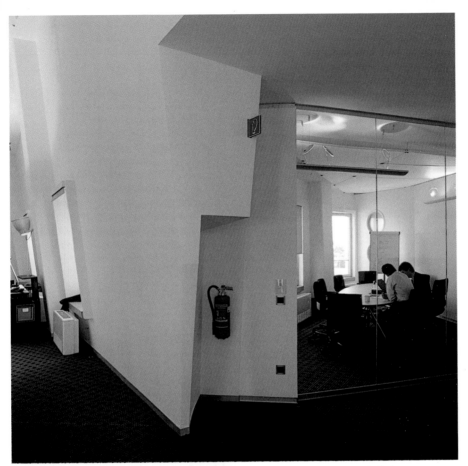

The design of the interior spaces is diaphanous, luminous, and well adapted to the forms imposed by the exterior volumes of the buildings.

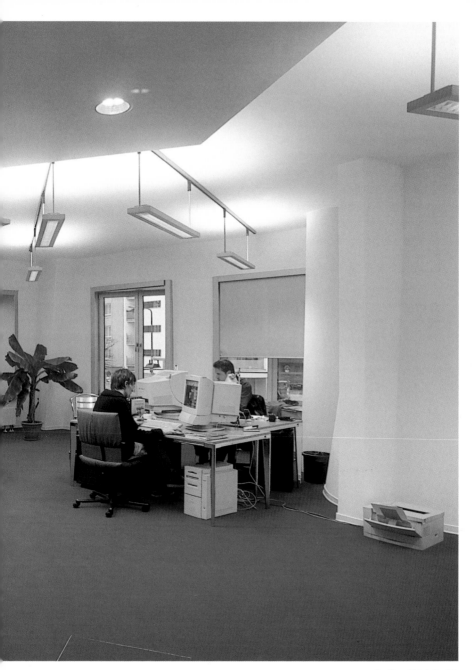

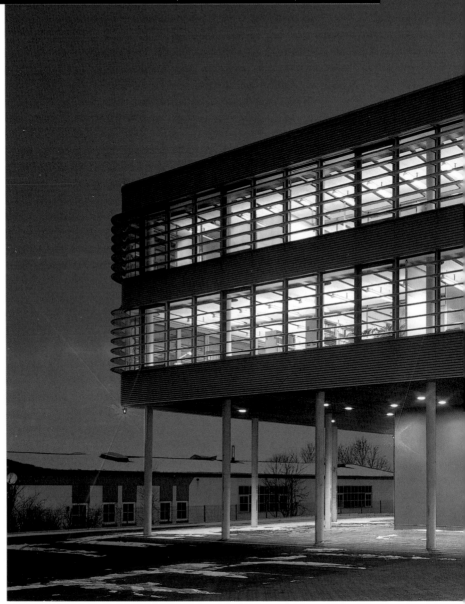

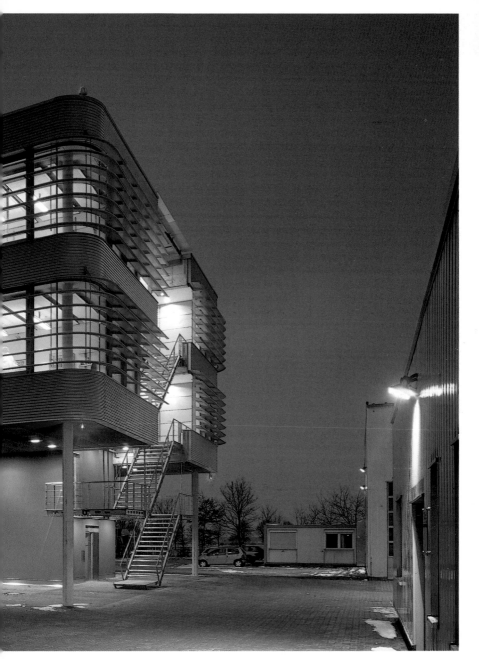

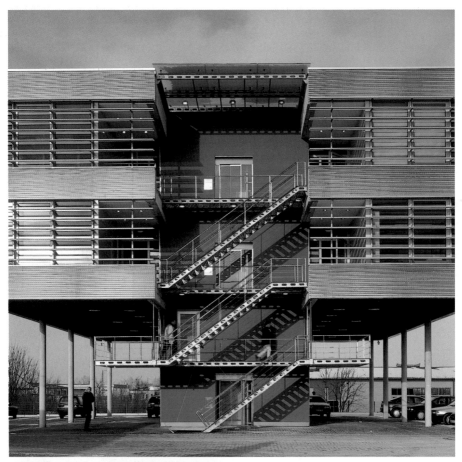

A spectacular staircase in the middle of one of the façades divides the building in half while connecting the different levels from the exterior.

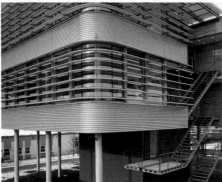

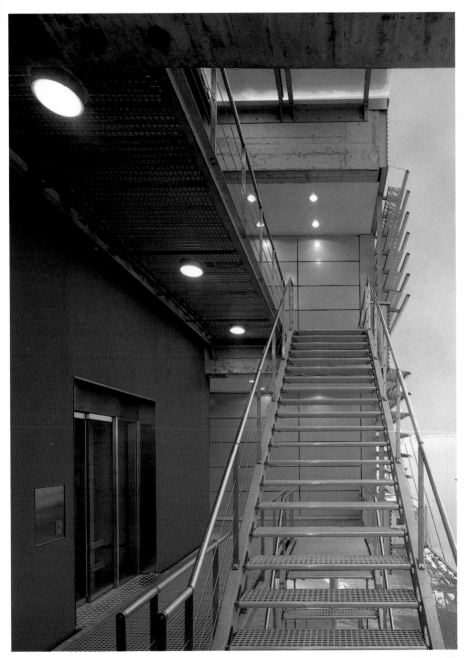

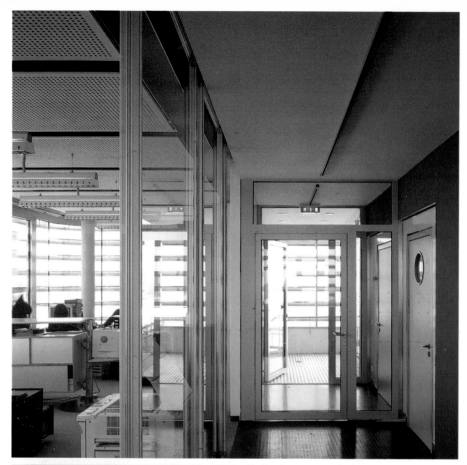

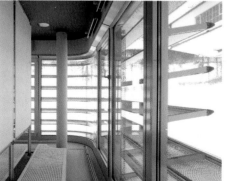

The interiors were conceived as open spaces where, thanks to the meticulous distribution, the communication would be free and flowing. The use of neutral and light tones, as well as an intelligent and ordered illumination, creates the sensation of a large, expansive interior.

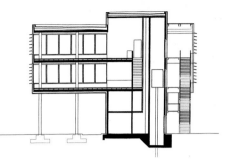

Sections

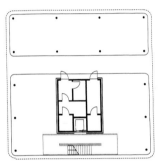

First floor

Second floor

Third floor

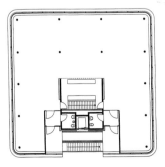

Fourth floor

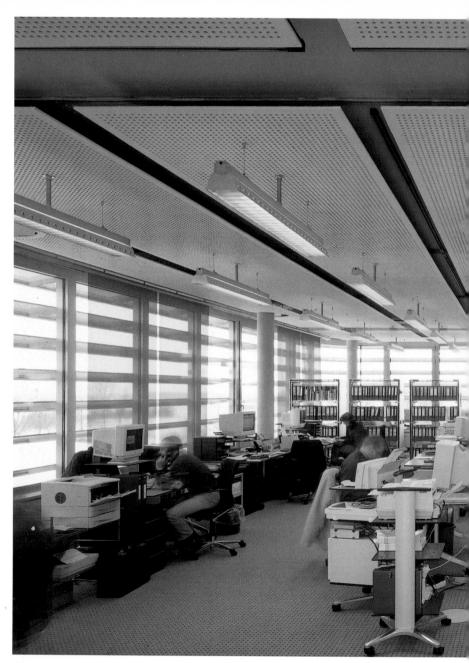

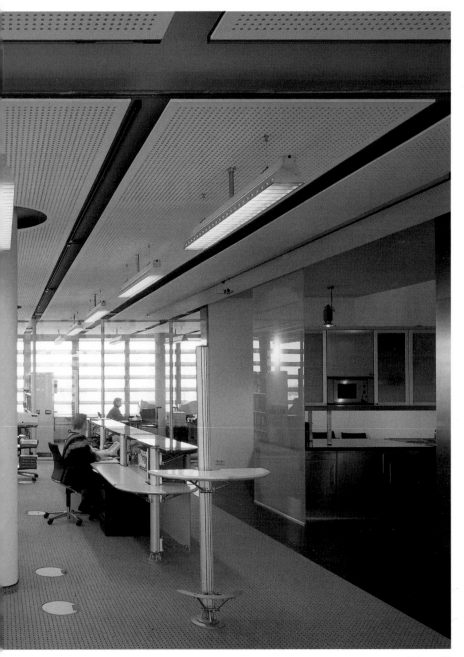

Sanitas Headquarters

Ortiz-León Arquitectos (Iñigo Ortiz Díez de Tortosa and Enrique León García)
| © Jordi Miralles | Madrid, Spain

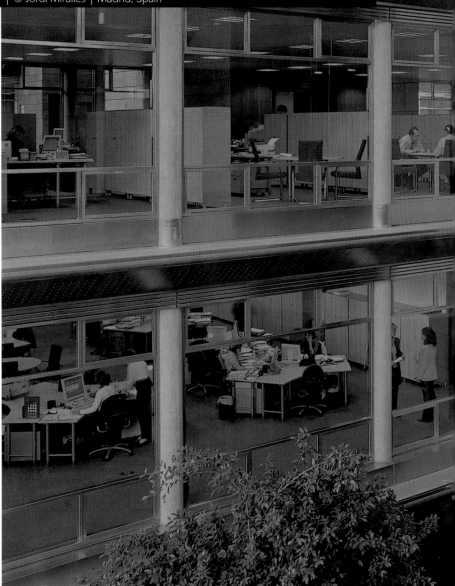

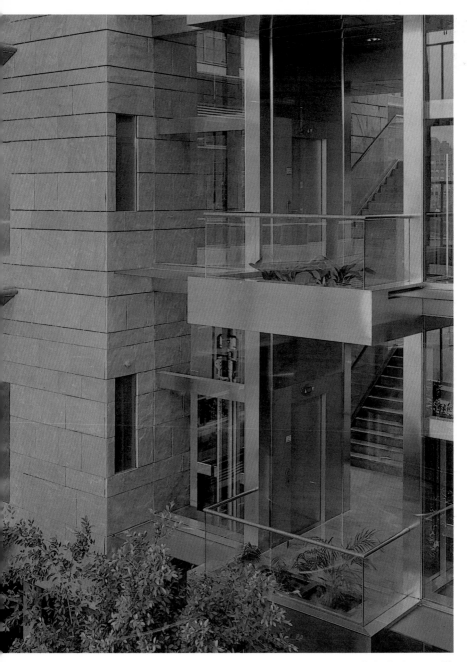

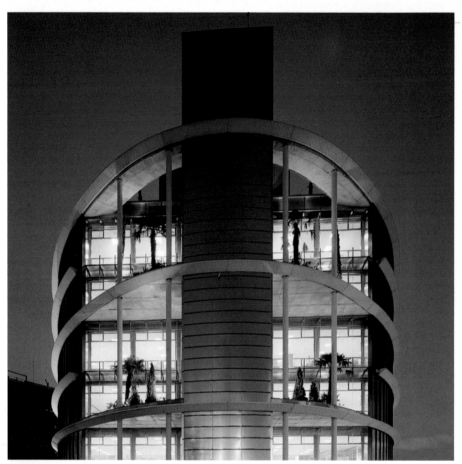

The various closed areas between the floors of the building are equipped with double-waterproofed, high-density, protected fiberglass. The glass-enclosed façade, supported by a minimal stainless steel structure, guarantees proper ventilation and well-lit interiors.

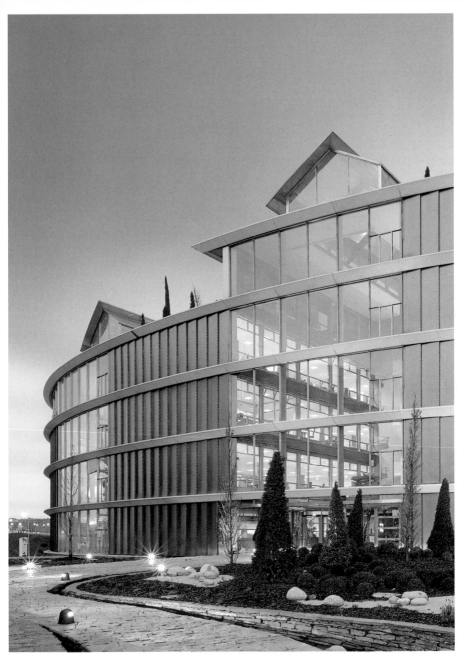

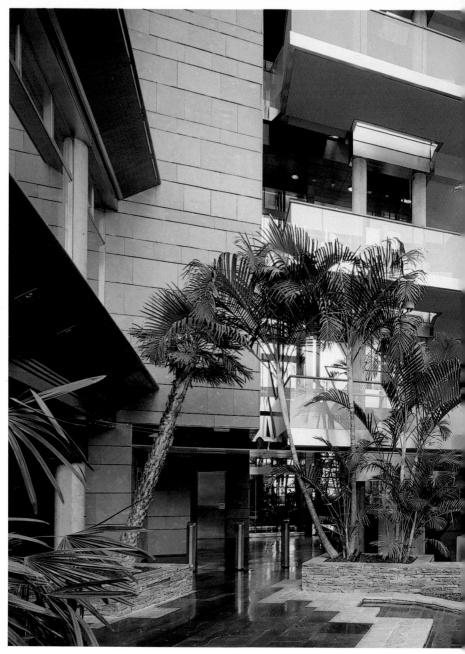

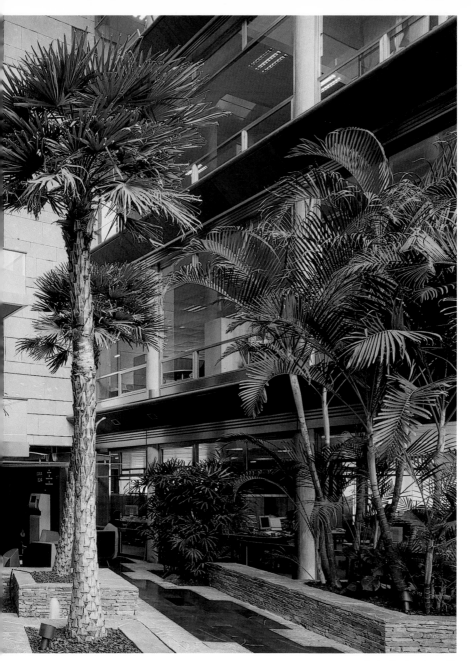

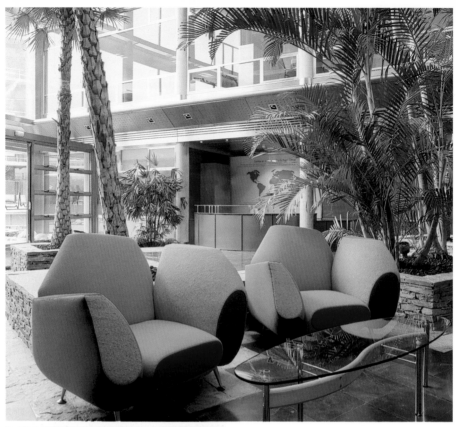

Divided by the block of vertical connecting structures, several courtyards have been designed, crossing the building from side to side. Plants and water have been included, which, in addition to aesthetically enriching the space, reduce the temperature of the air, increase the oxygen, and act as an acoustic buffer.

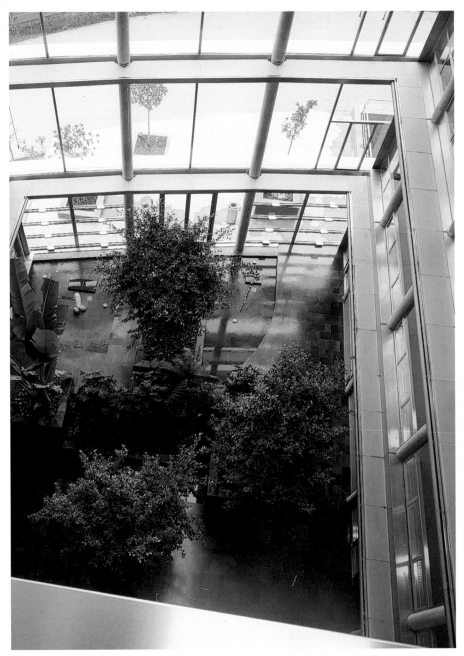

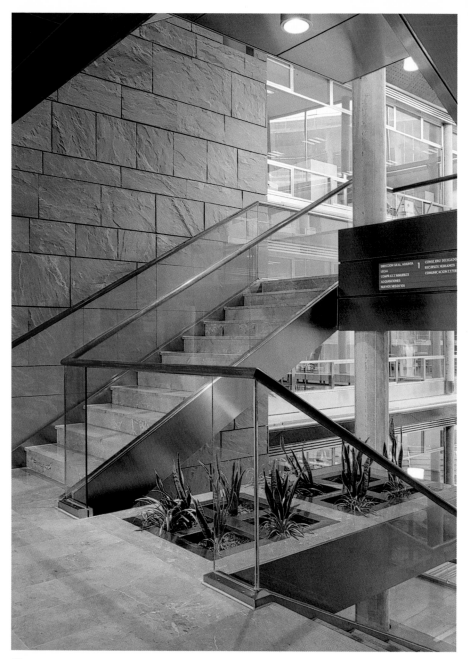

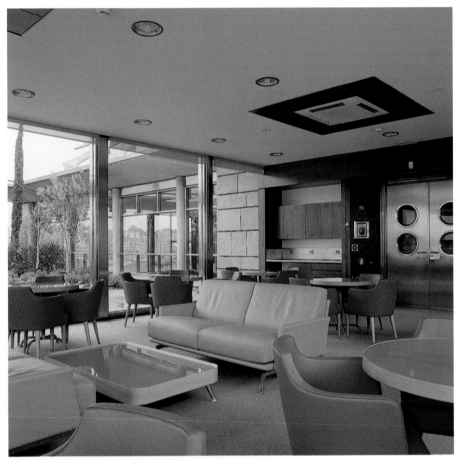

The indirect light is constant, but direct sunlight has been avoided not only due to the north-south orientation of the building, but also by using skylights and vertical windows with movable solar protection panels in the atriums of the building.

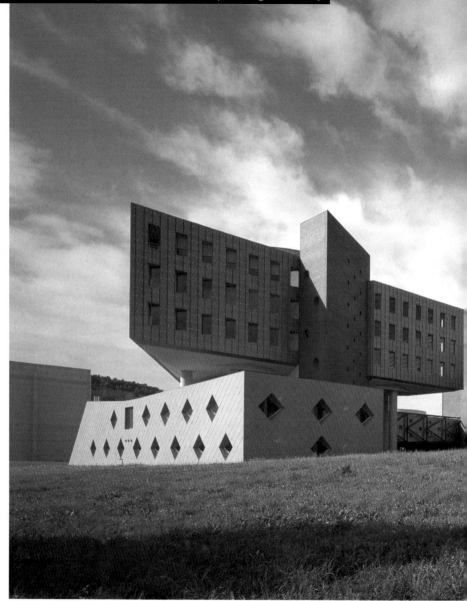

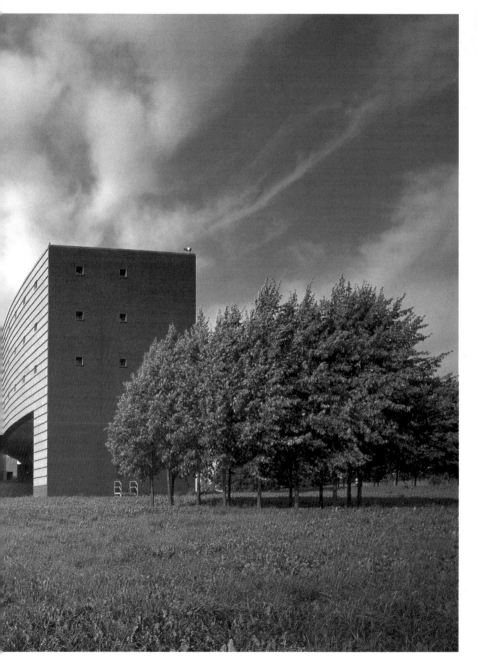

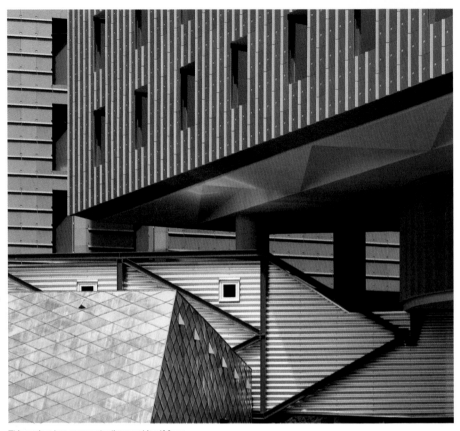

This project has purposely distanced itself from the formal and functional characteristics of traditional office buildings. The architects' goal was to create a modern space whose distribution would be based on a thoughtful and efficient internal structure. The architectural solution employed reaches its goal through a hybrid of open and closed spaces.

Site plan

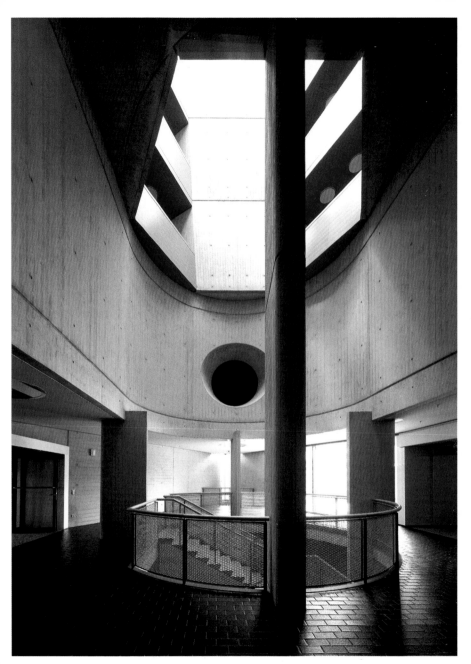

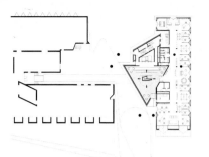

First floor

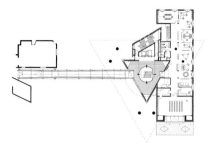

Second floor

Axonometric perspective

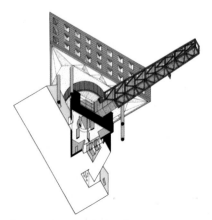

Axonometric perspective from below

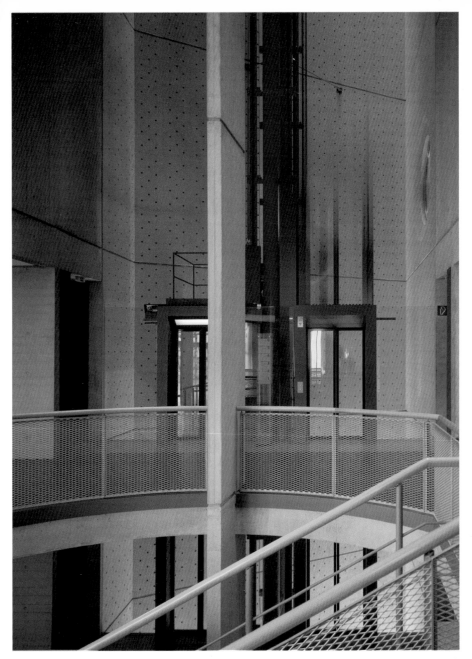

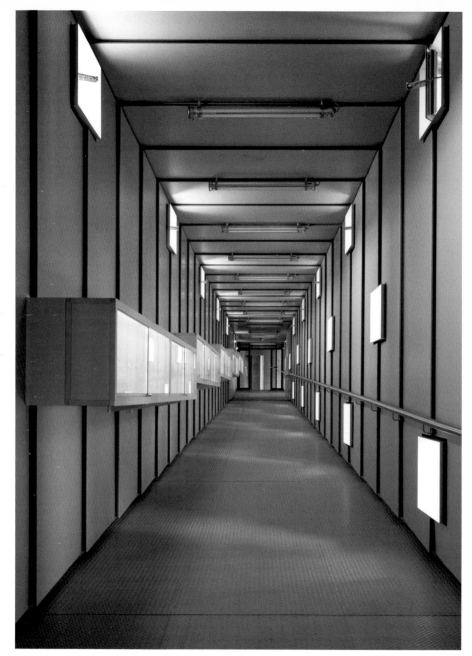

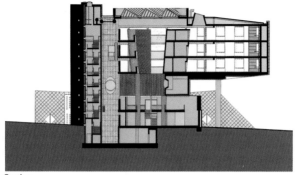

Section

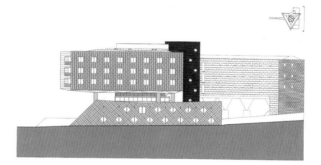

Elevations

Üstra Office Building

Frank O. Gehry | © Thomas Mayer | Hanover, Germany

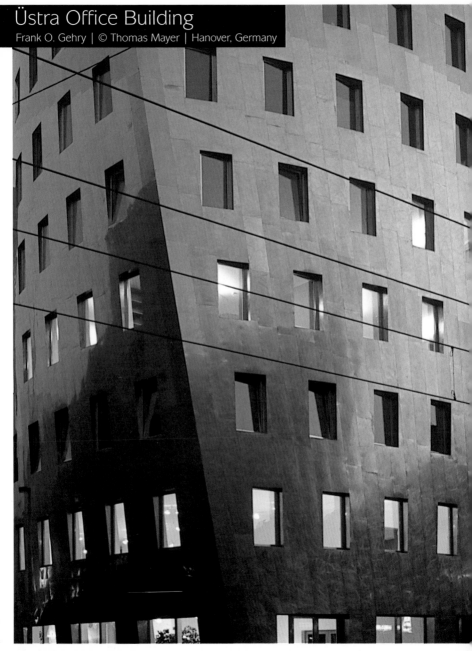

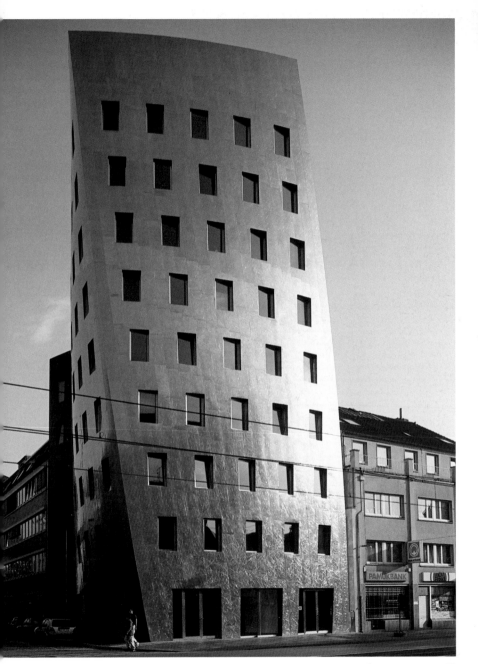

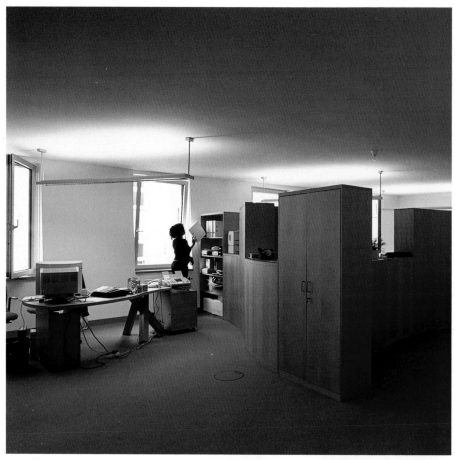

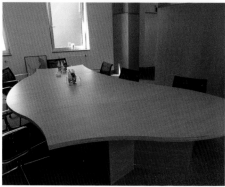

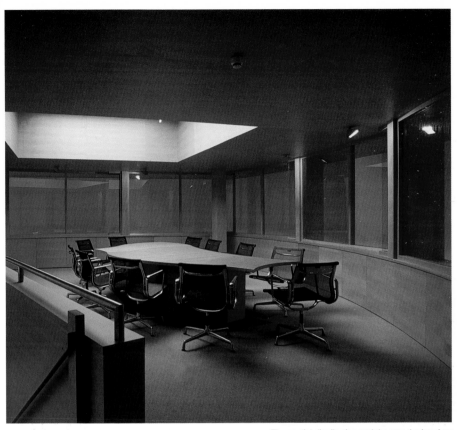

The spatial distribution and the way the interiors
were designed had to respond to the demands of
the various tasks that were to be carried out. The
results of all of these requirements translated
into an avant-garde and functional building that is
far from the typical forms that define the most
traditional of offices.

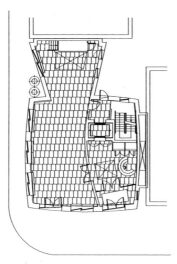

First floor

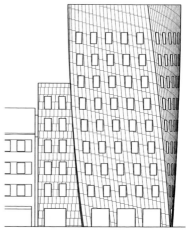

Second floor

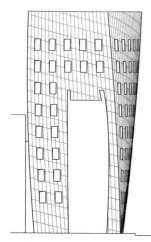

North elevation

East elevation

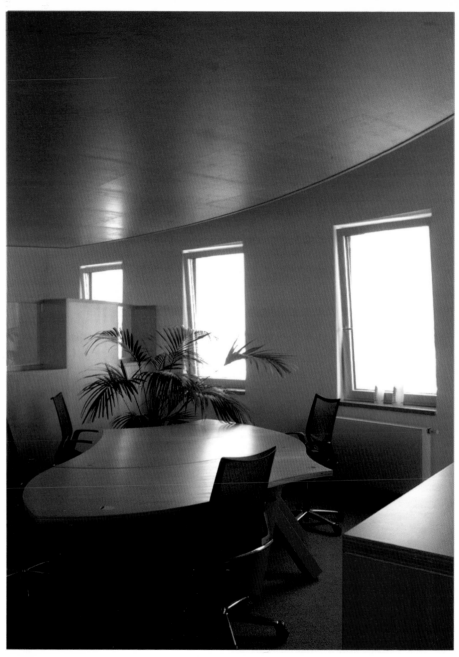

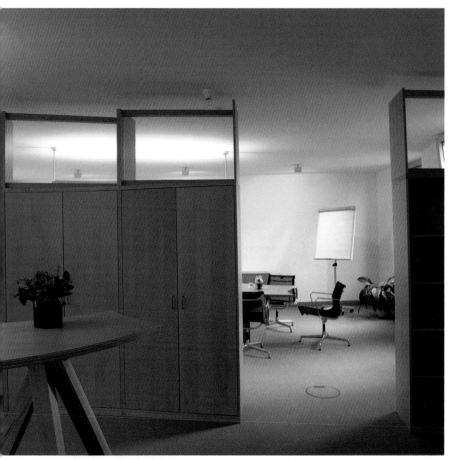

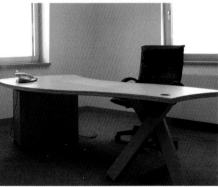

This building contains multipurpose and multifunctional spaces capable of accommodating different groups of employees according to their activities.

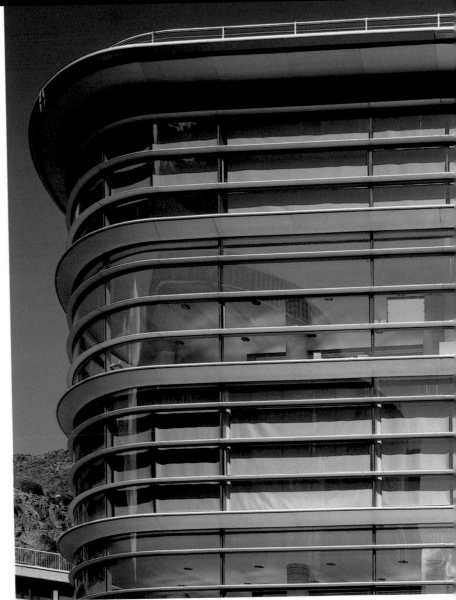

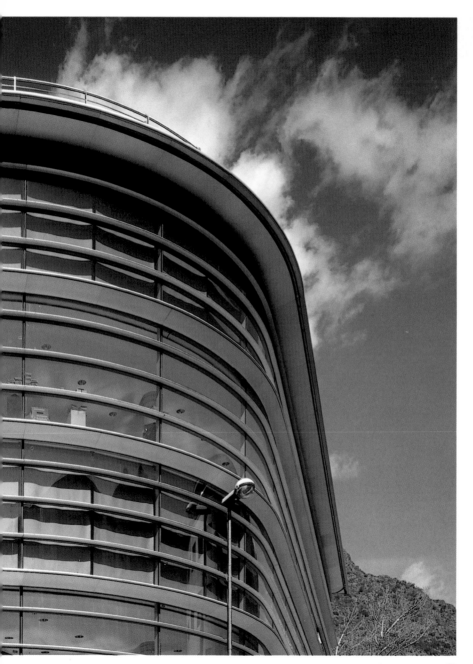

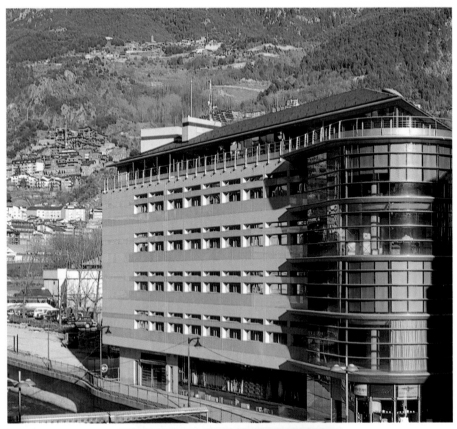

The glass walls—the true skin of the main façade—
let in the light that bathes the interior. The façade
extends along the structure and, together with
other materials, becomes a main feature. The
different designs of the façades help strengthen the
building's sense of contrast.

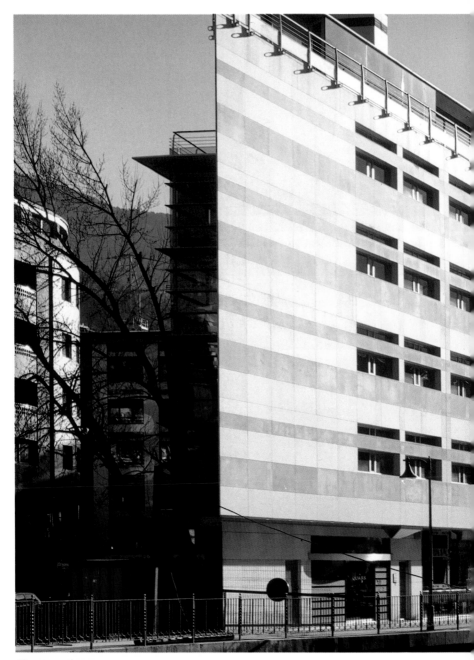

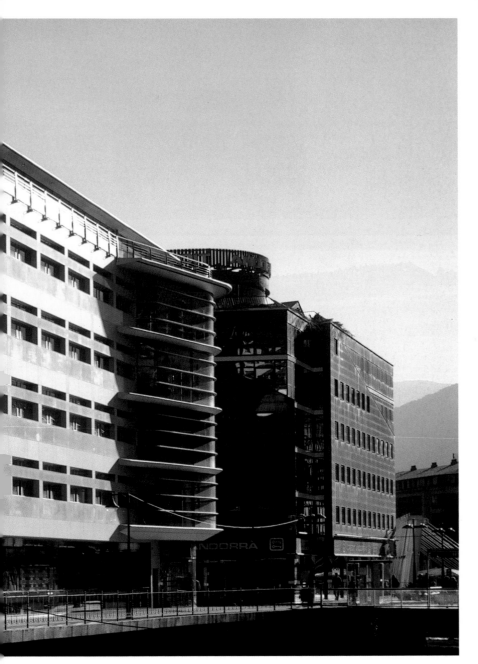

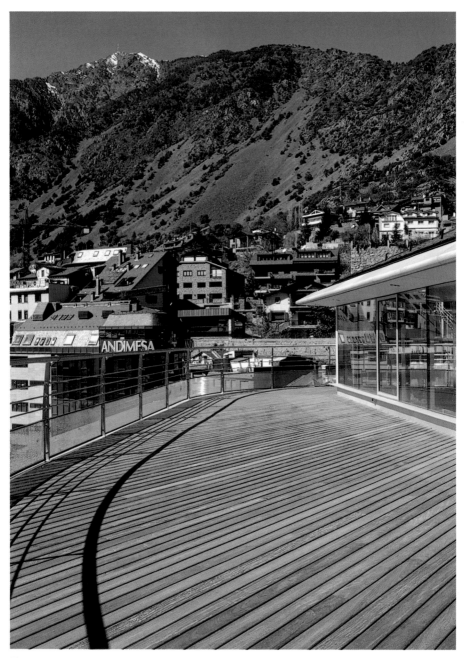

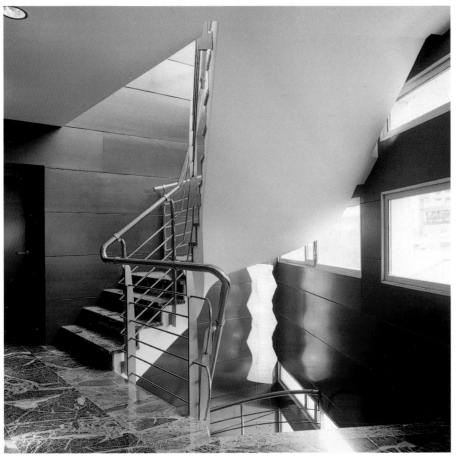

The transparency, dynamics, and coolness of the glass and steel façade contrast with the warmth of the interiors, which were redefined and organized to make them highly functional.

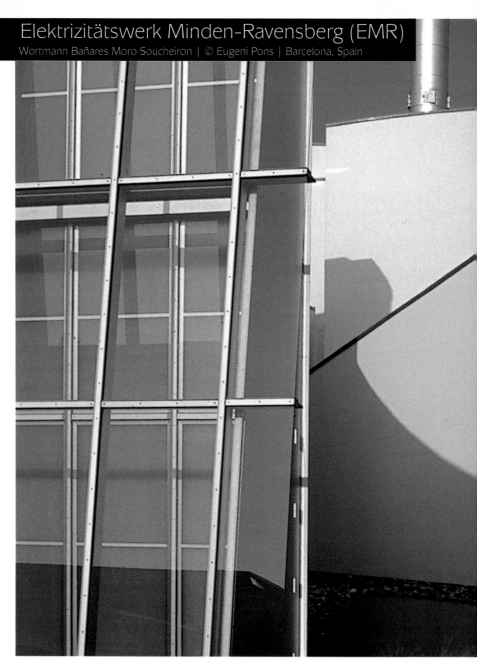

Elektrizitätswerk Minden-Ravensberg (EMR) 95

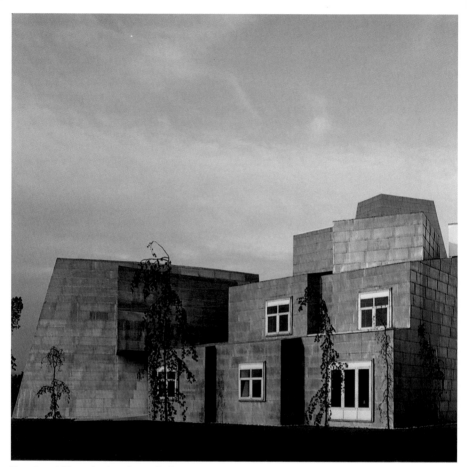

From the outside, each volume is perceived as an independent structure that forms part of a perfectly interconnected whole. This individuality has been emphasized with a different finish for each building.

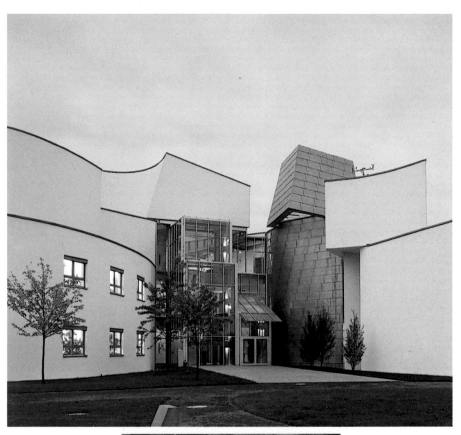

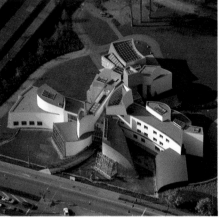

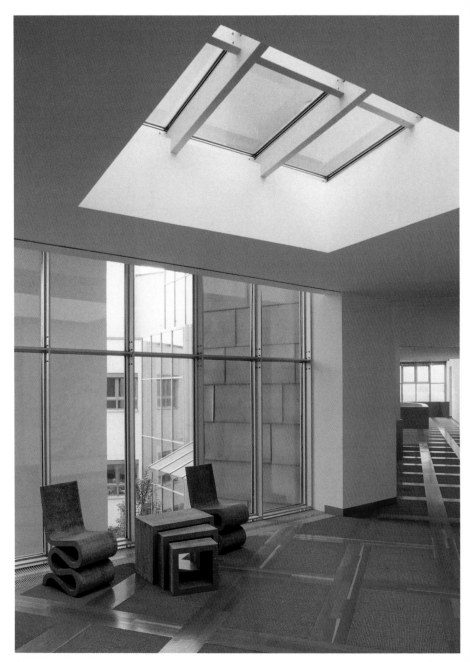

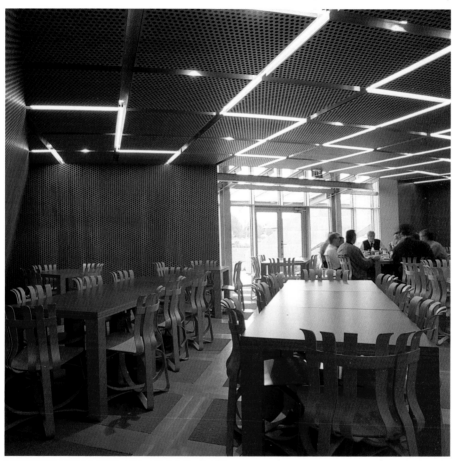

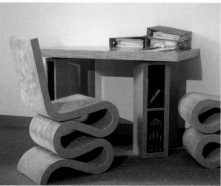

The spatial organization and the way the interiors were designed had to respond the various tasks that were to be carried out. An innovative, functional, and far-from-monotonous building is the result of those requirements.

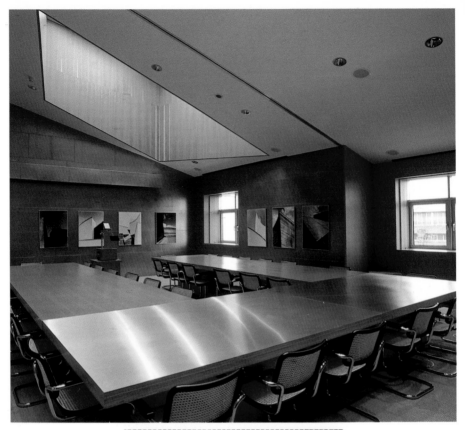

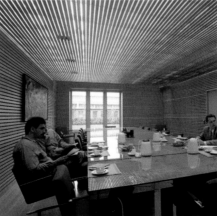

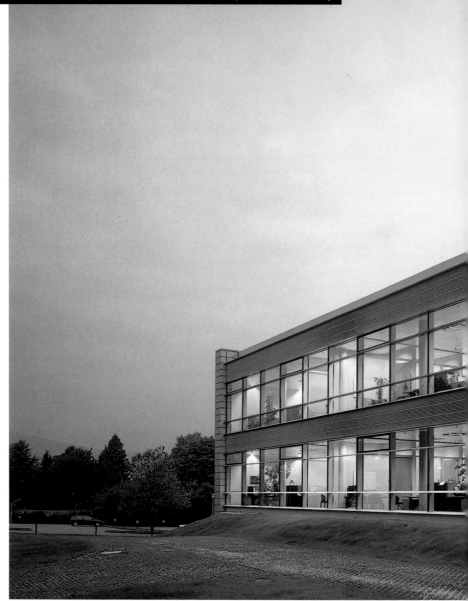

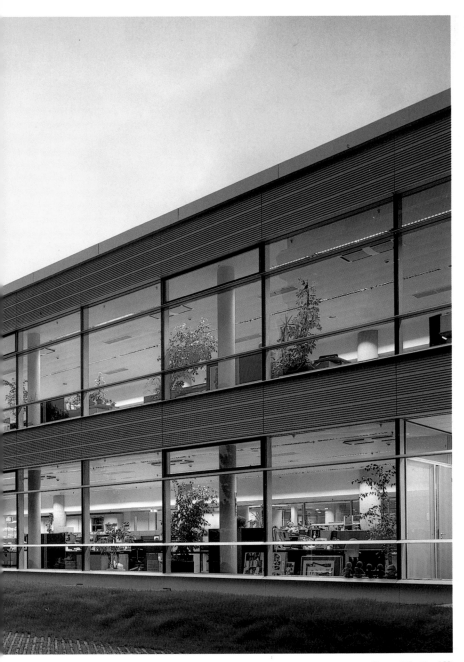

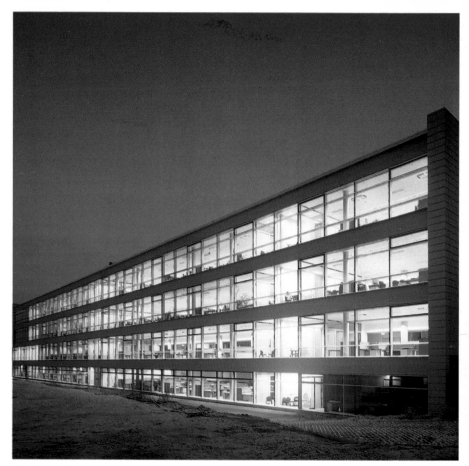

This rectangular building was divided into different levels that can be seen from the outside through the glass façades. This feature also provides excellent illumination to the interiors.

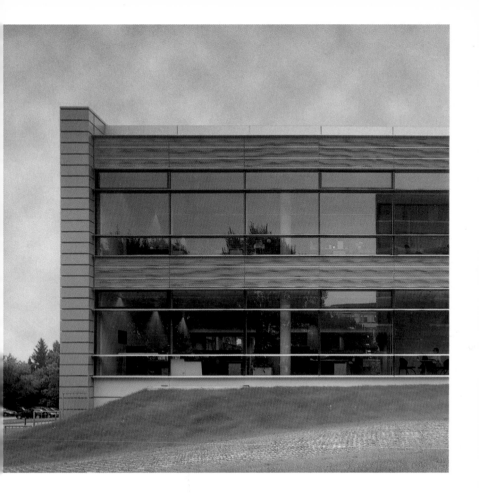

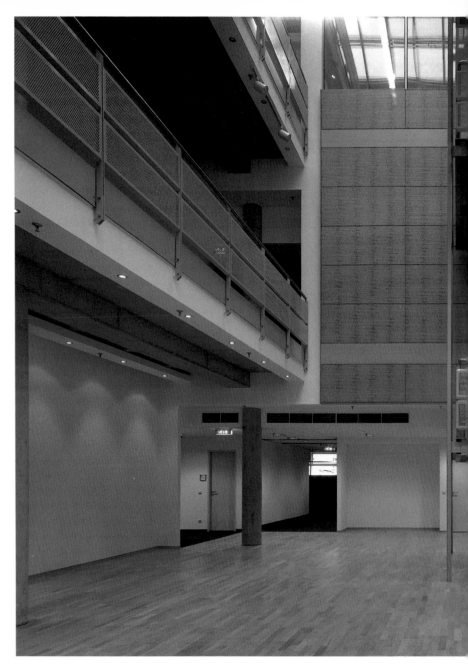

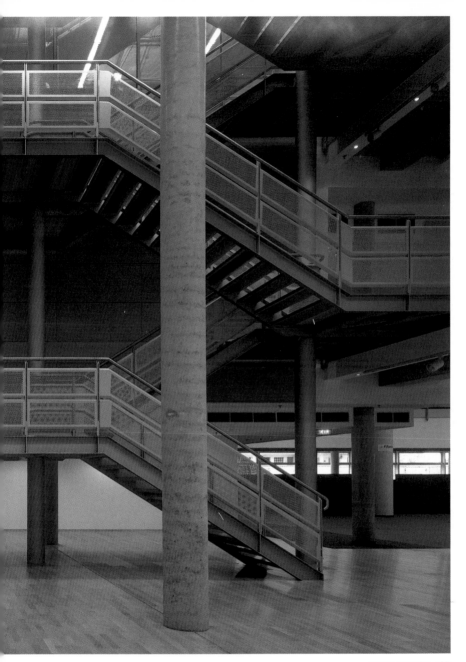

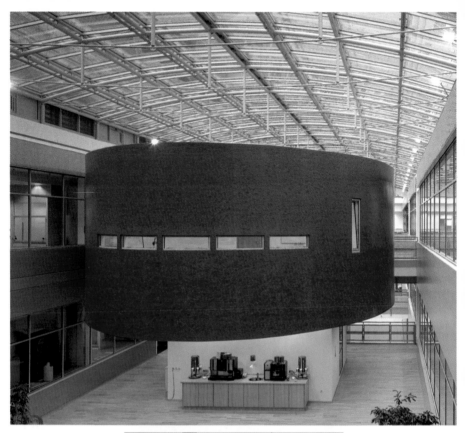

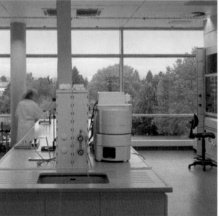

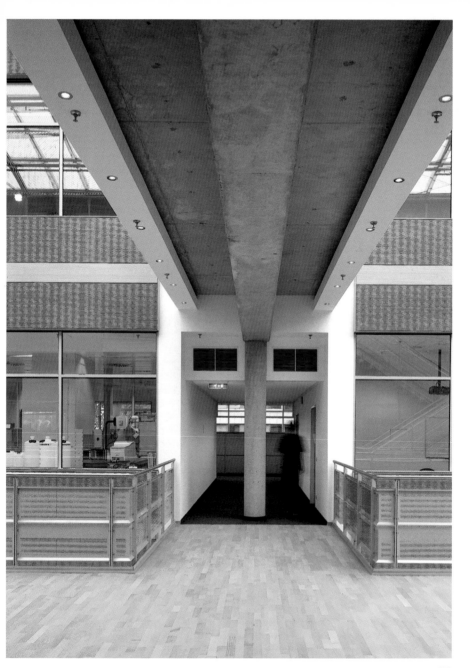

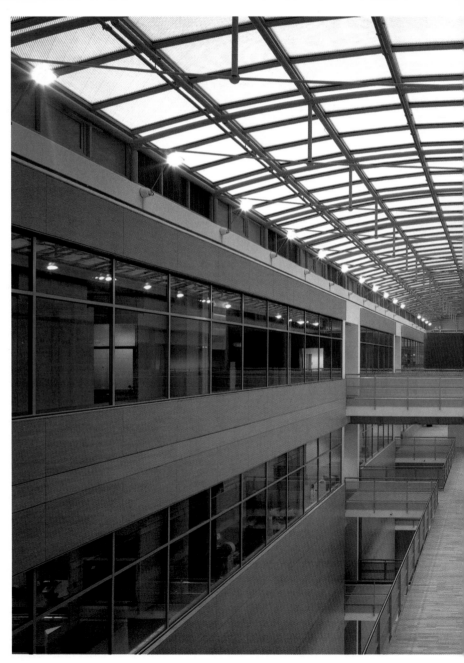

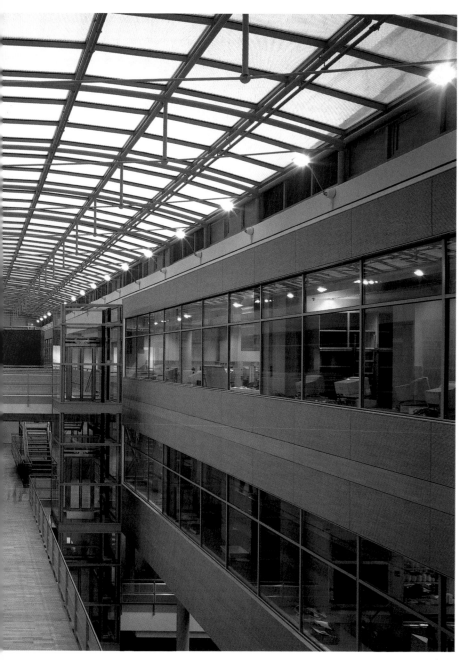

Morgan Stanley Dean Witter

Gabriel Allende and Ángel Serrano (Aguirre Newman Arquitectura) | © Jordi Miralles
| Madrid, Spain

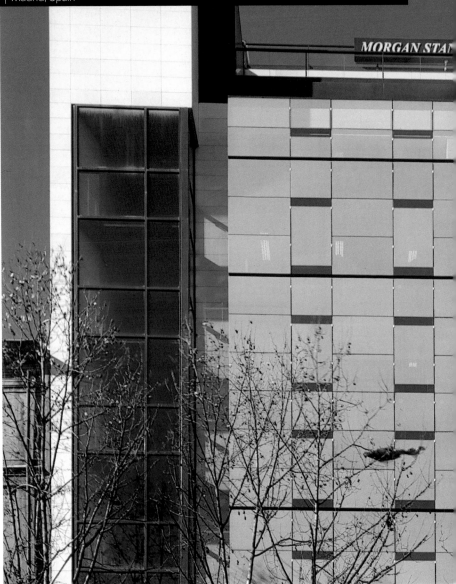

MORGAN STA

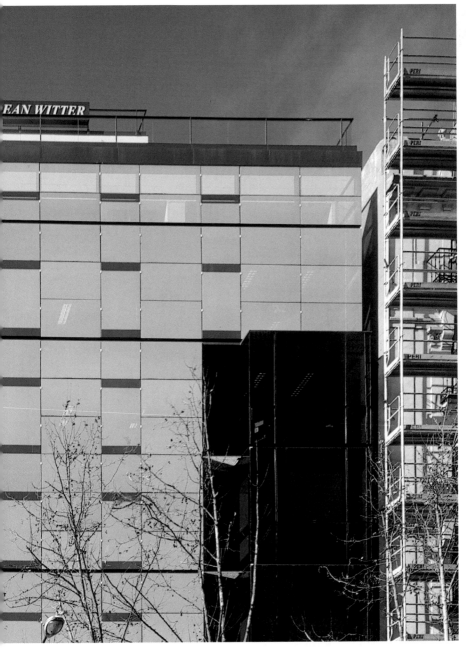

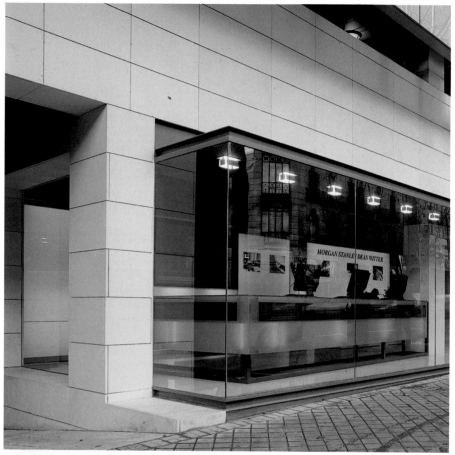

The lack of natural light, a main concern of those responsible for this project, was resolved with an interior courtyard located alongside the building. This provision allows light to enter through a skylight that extends the length of the space.

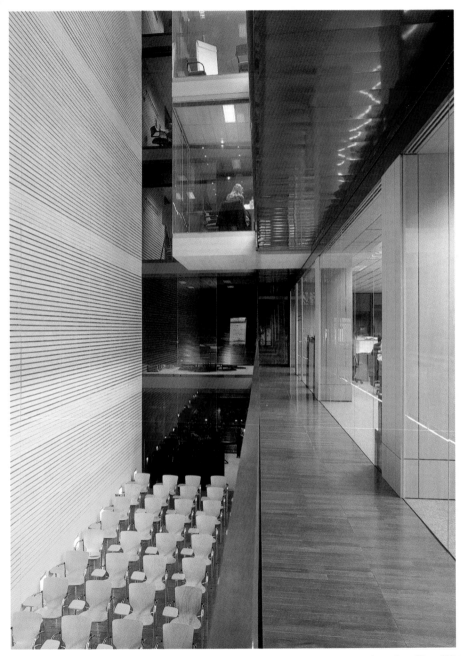

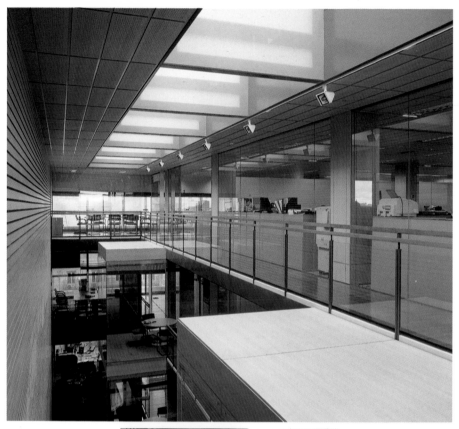

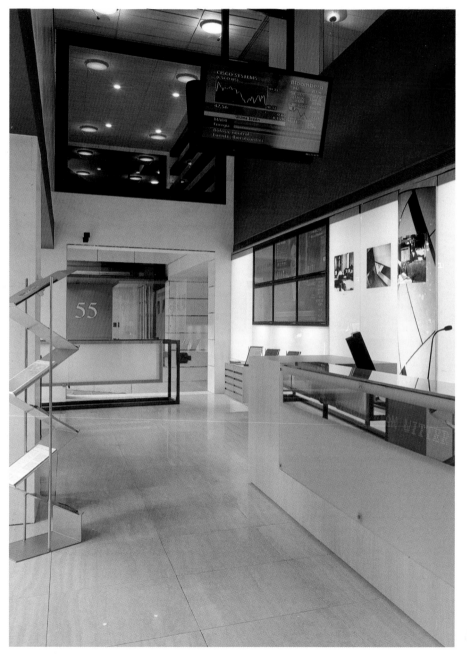

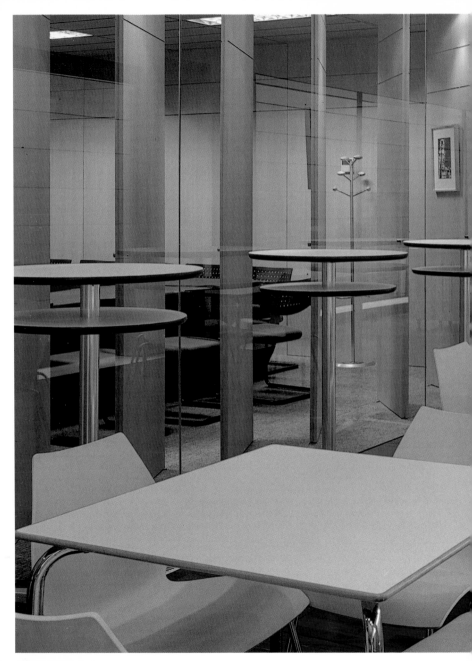

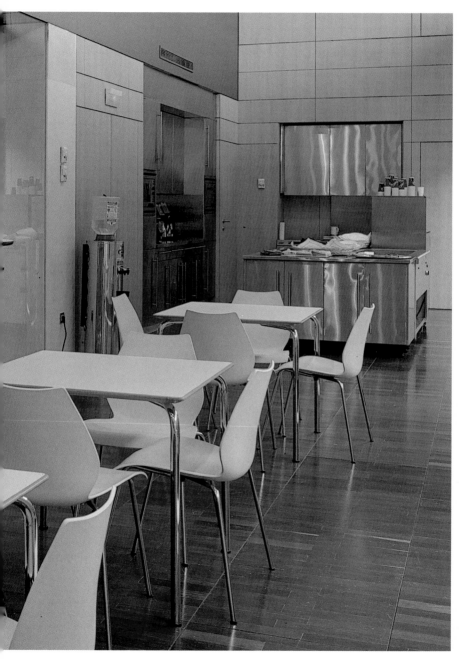

The decision to place the meeting rooms inside two capsules suspended in space, giving them a view of the skylight while taking maximum advantage of the natural light, is one of the building's many efficient construction solutions.

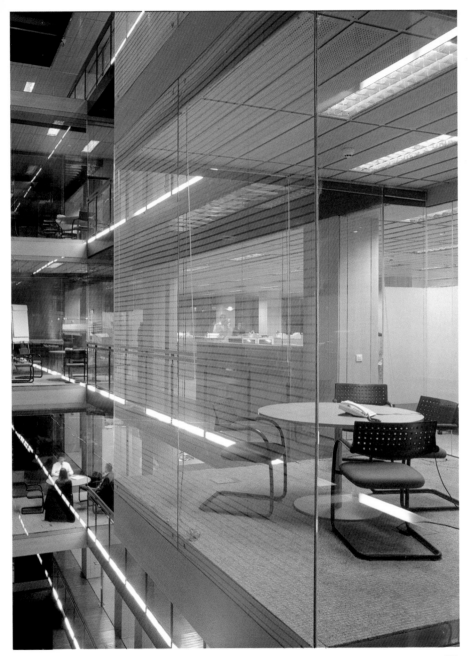

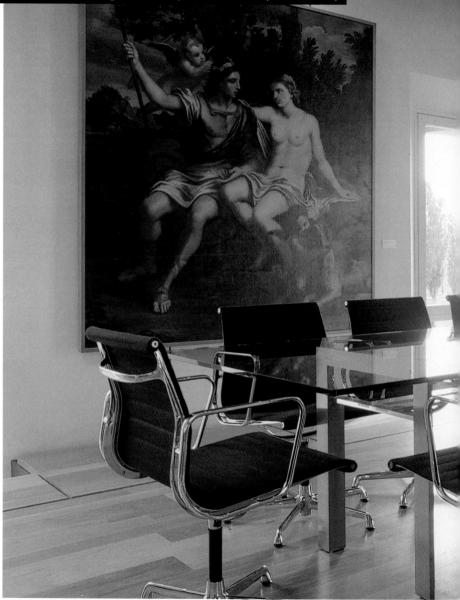

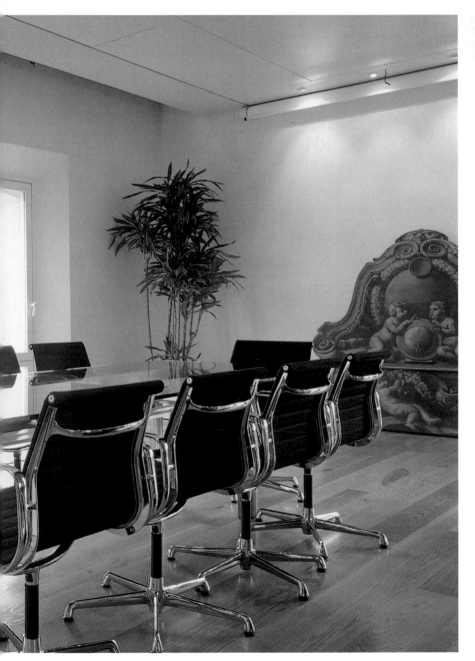

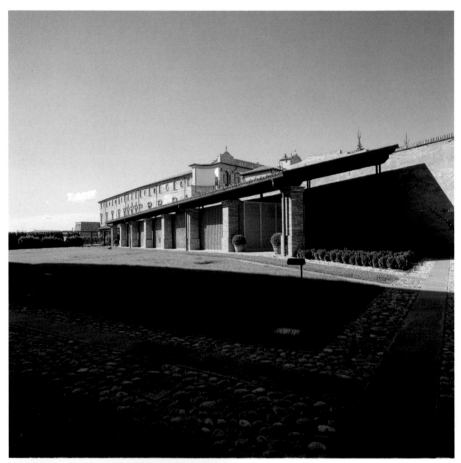

These offices are located in a duke's old stables—part of an impressive property, built in 1781, that belonged to the aristocratic family Estense de Sassuolo. The renovation allowed for the recovery of an emblematic building and the construction of modern and efficient installations in which past and present go hand in hand.

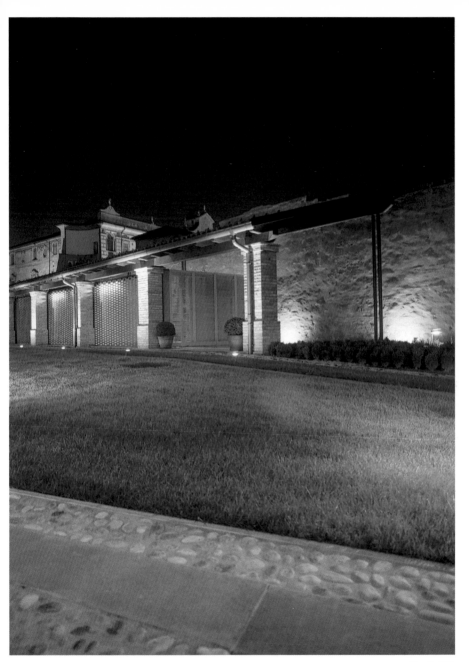

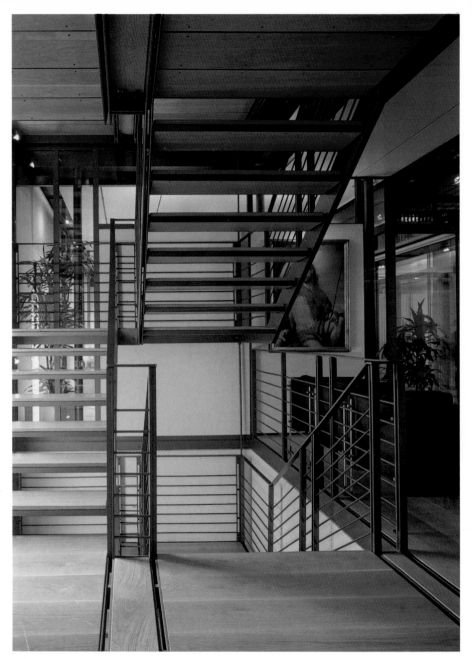

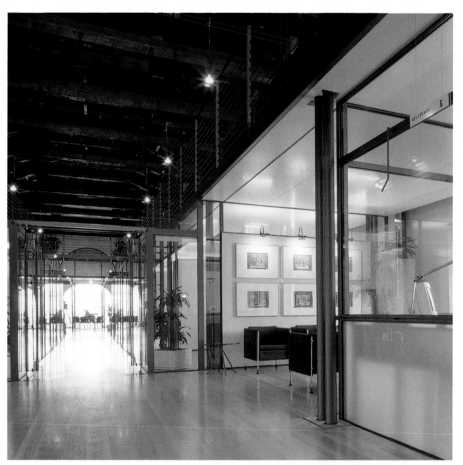

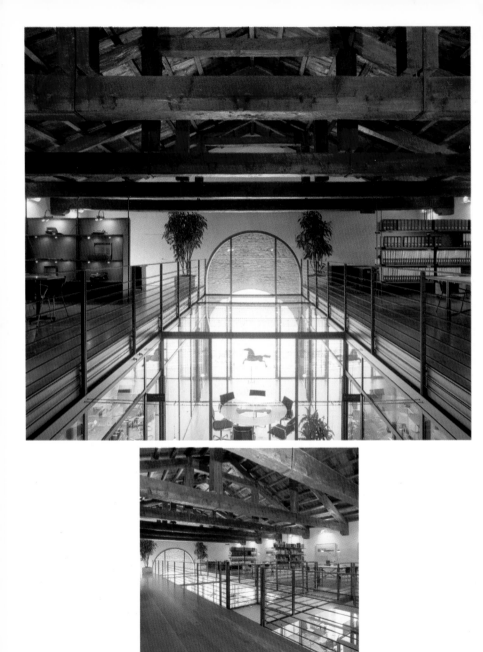

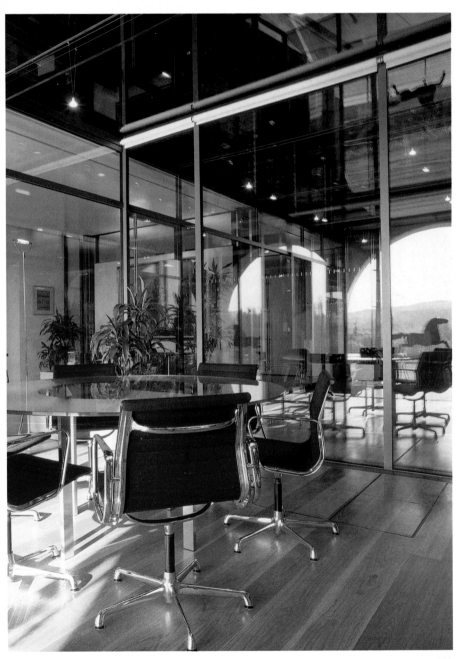

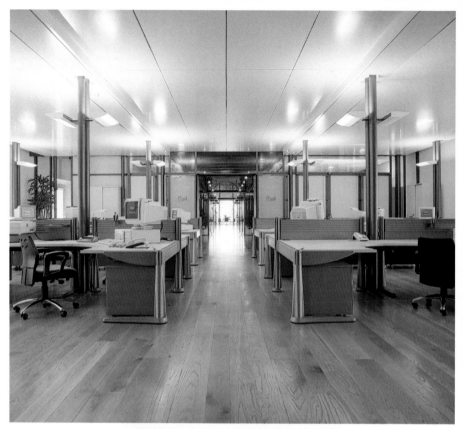

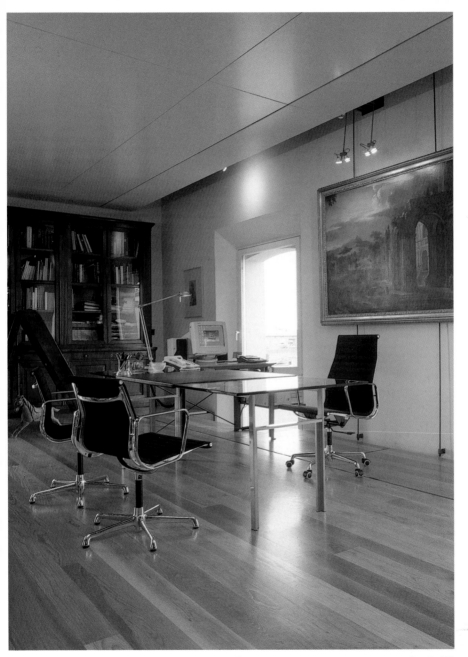

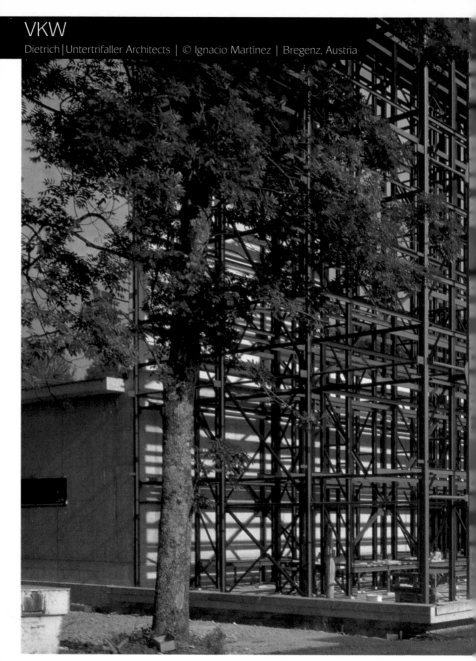

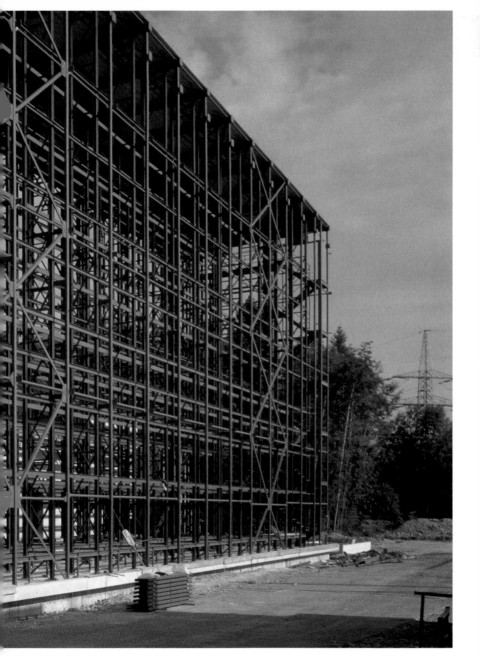

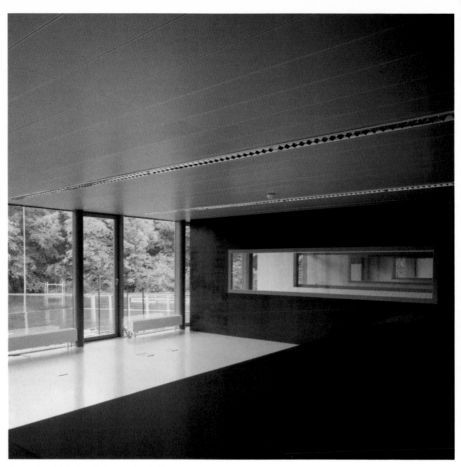

The architects' choice of glass and metal for
certain parts of the façade contributes to an
abundance of natural light and a permanent
visual relation with the exterior. The various
spaces created inside the building and their
relationship with the exterior can be seen from
the main lobby.

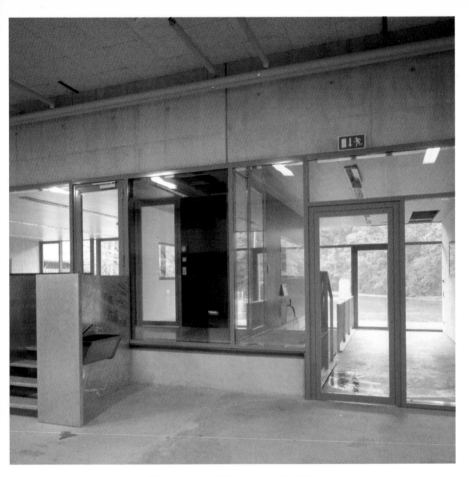

First floor

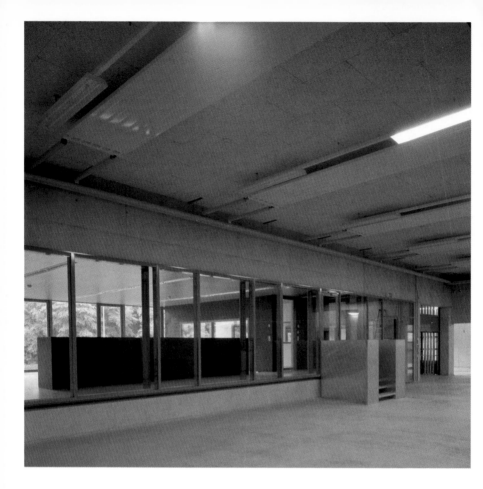

Sections

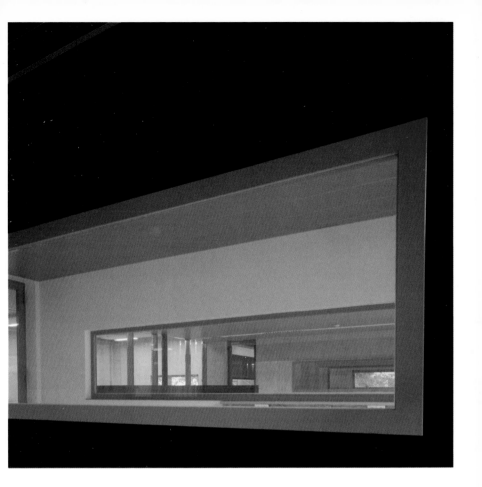

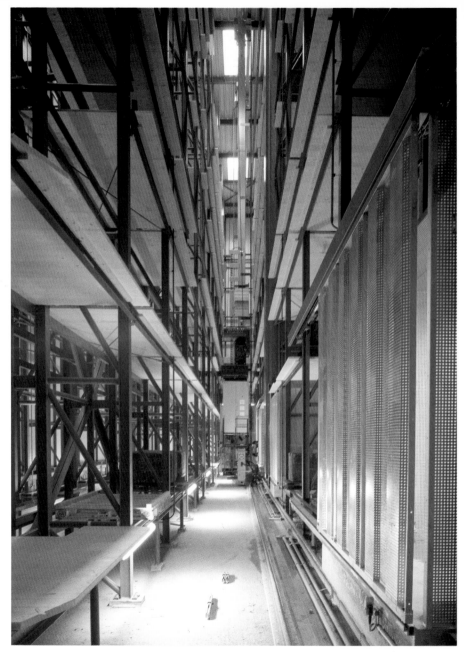

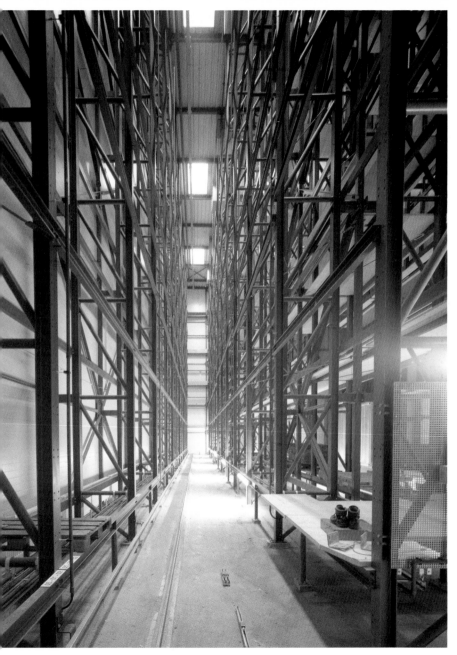

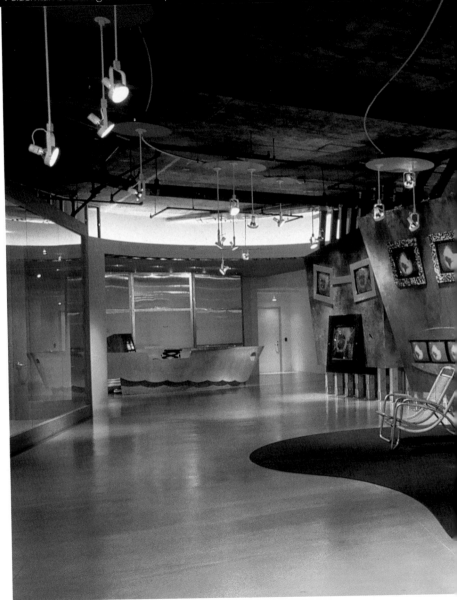

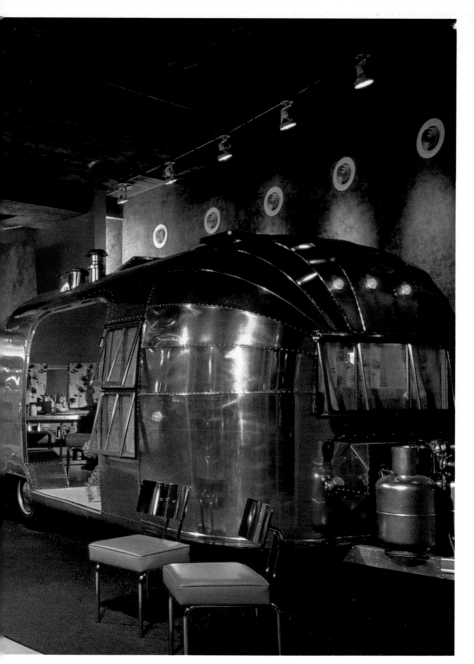

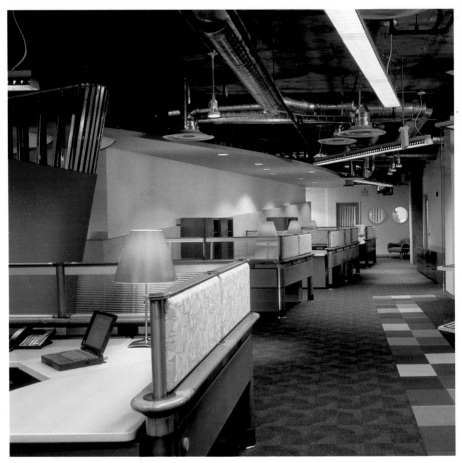

The fixtures and structures can be perceived among the decorative details of the actual office spaces. The interior combines a stark concrete framework with sophisticated coverings, finishes, and materials, such as painted wood, tweed wool fabrics, sheer drapery, and metal panels.

First floor

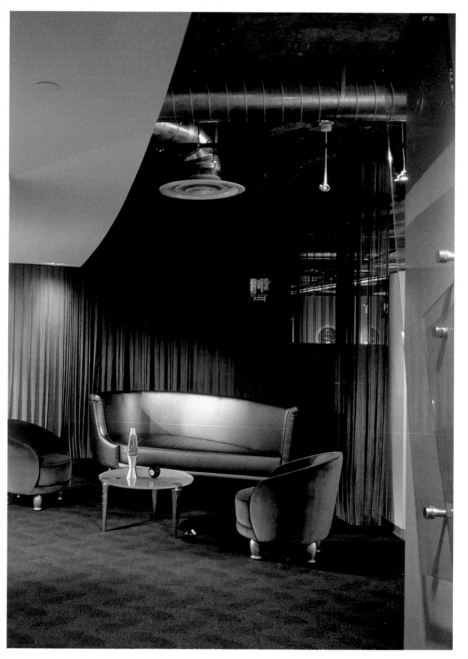

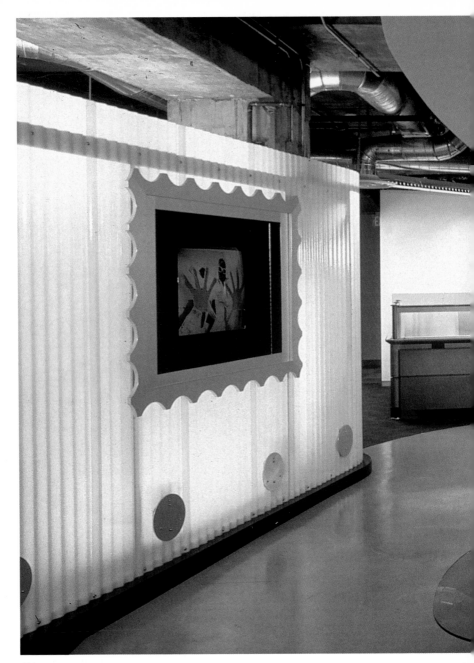

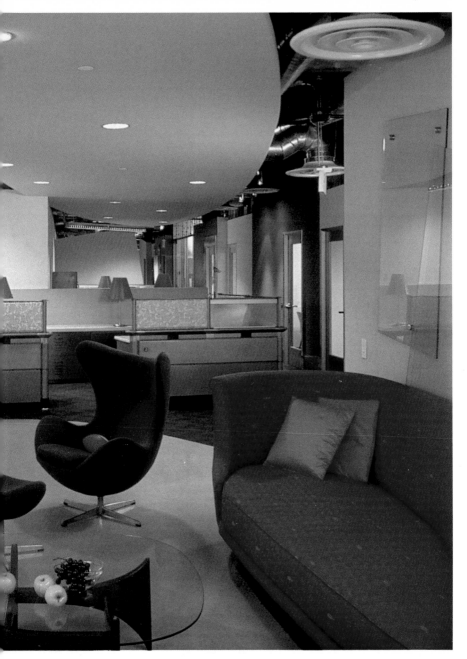

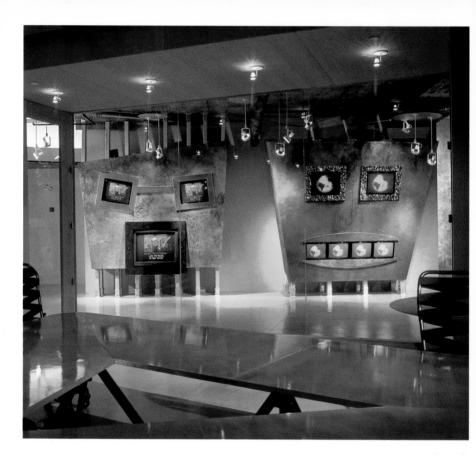

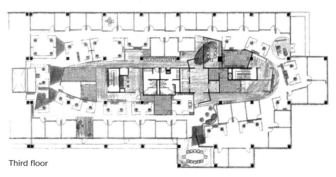

Third floor

146

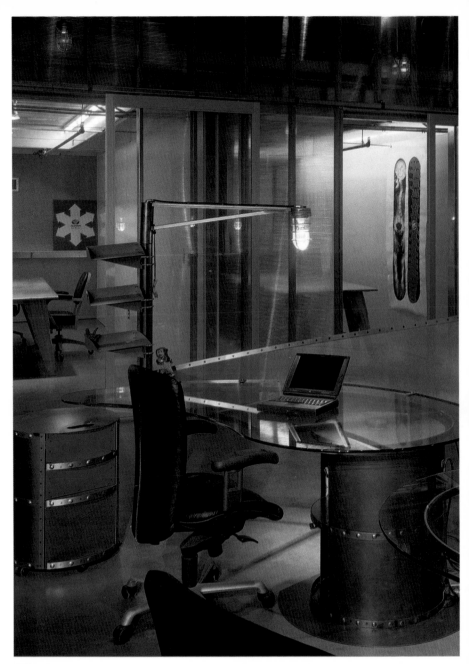

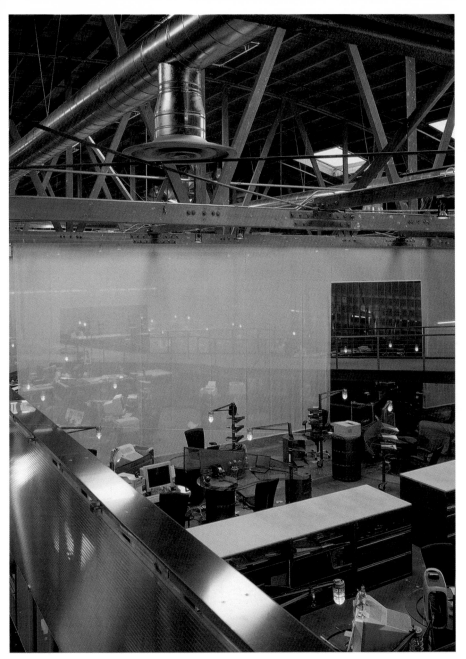

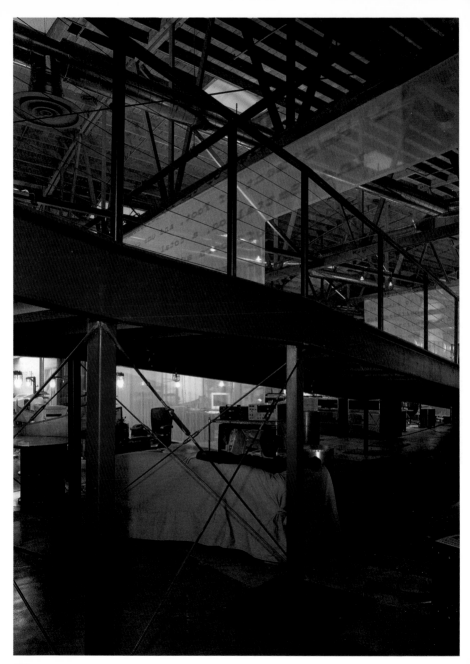

The reception area is accessed via a ramp that extends into the space and divides it into two levels. The attractive structural forms that can be seen from the entrance are a pleasant precursor to the design solutions and decoration of the interiors, where the combination of materials and textures results in a highly personal and futuristic aesthetic.

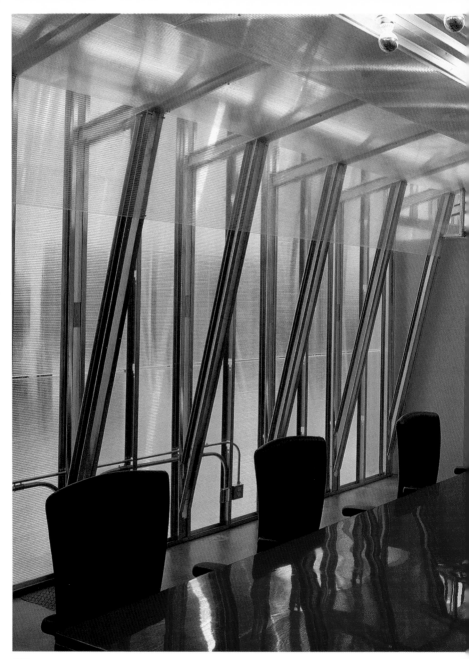

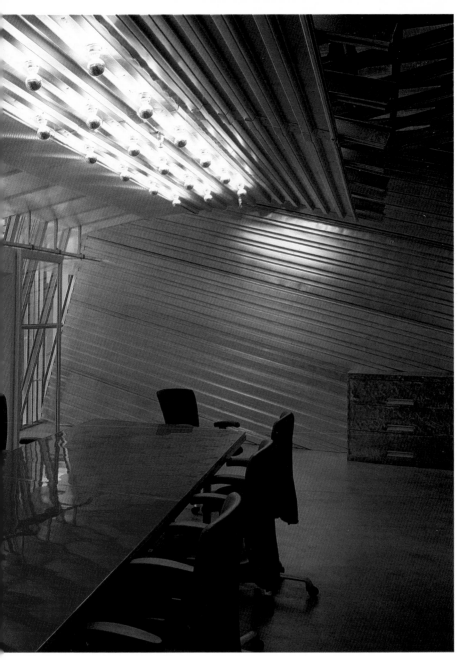

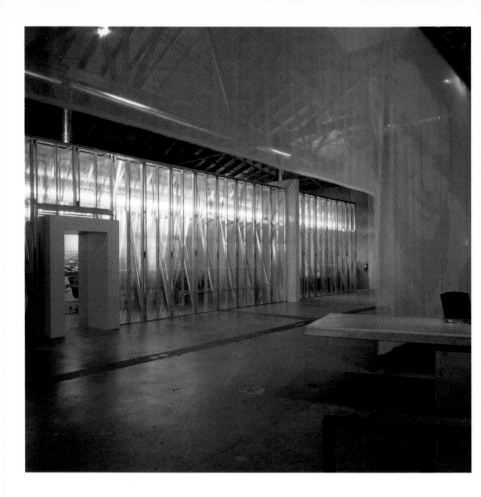

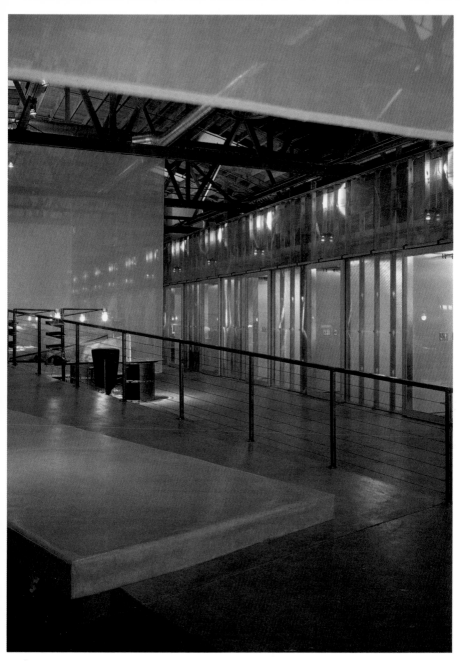

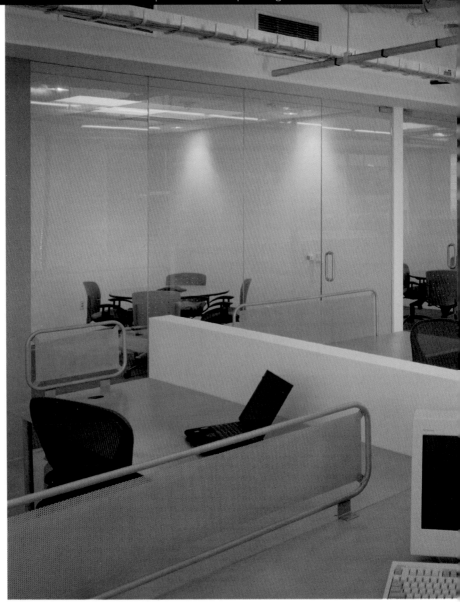

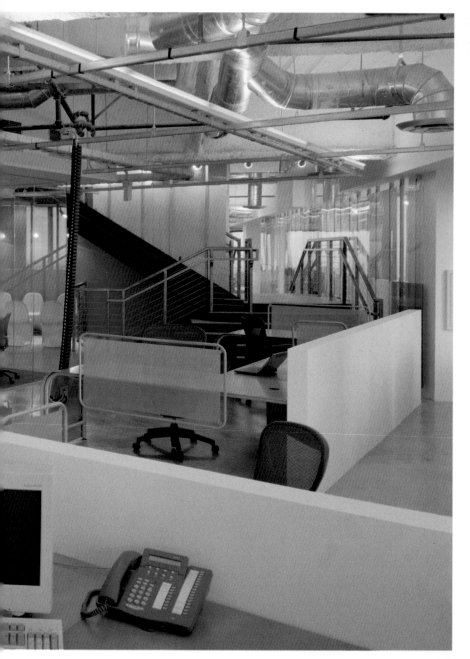

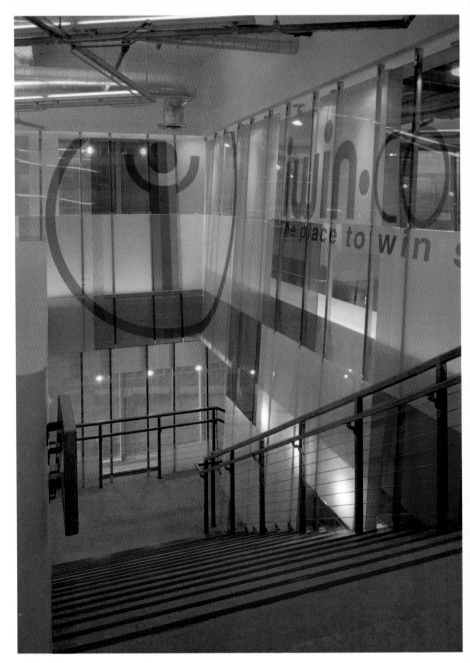

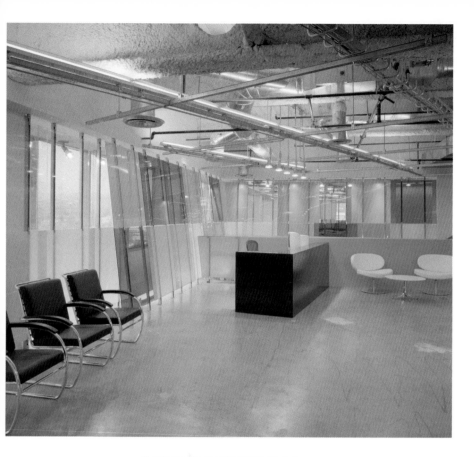

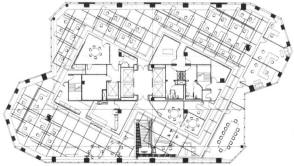

Floor plan

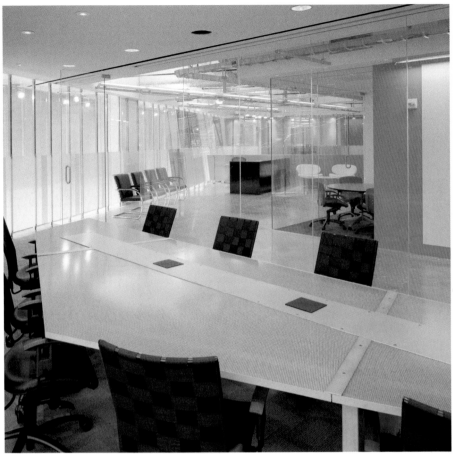

In accordance with the decision of the clients, a loft philosophy was adopted, resulting in continuous spaces that are vast, open, and diaphanous with an industrial feel.

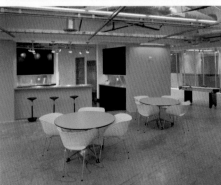

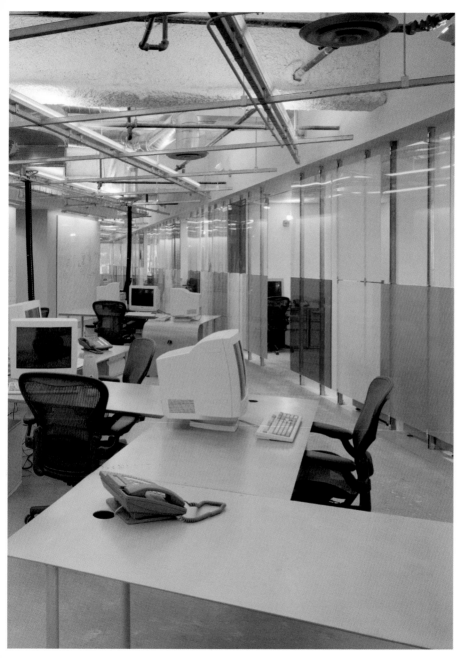

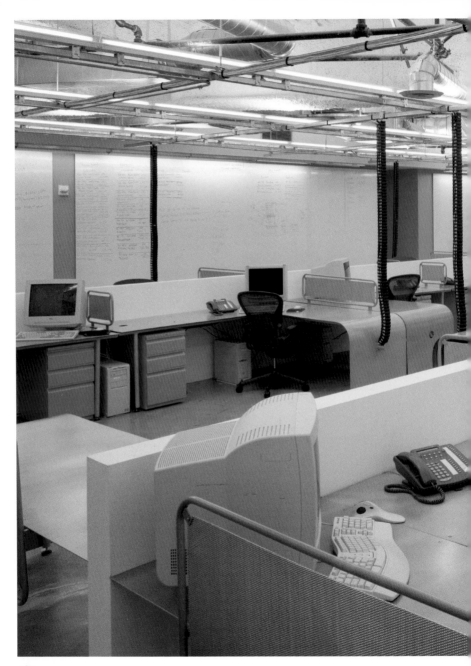

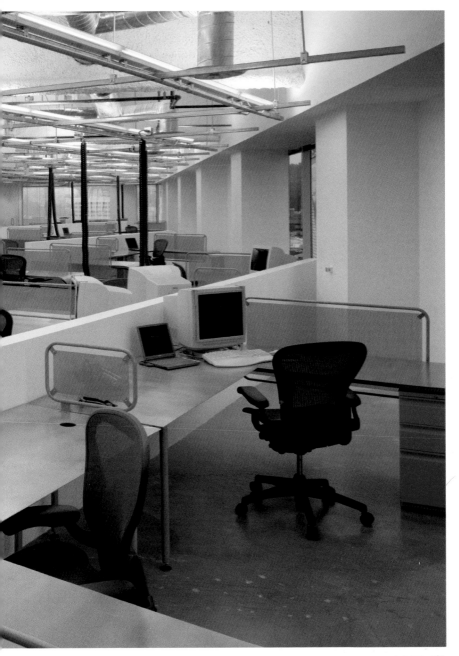

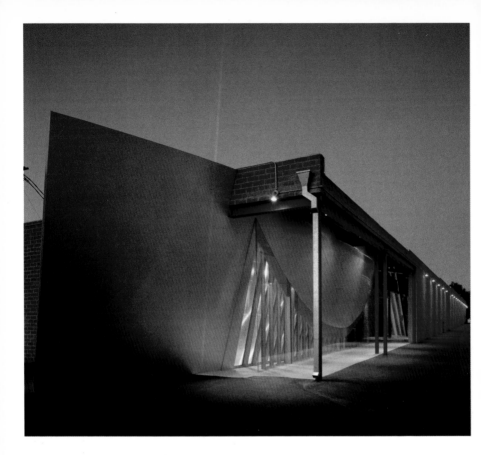

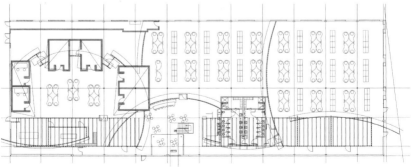

Floor plan

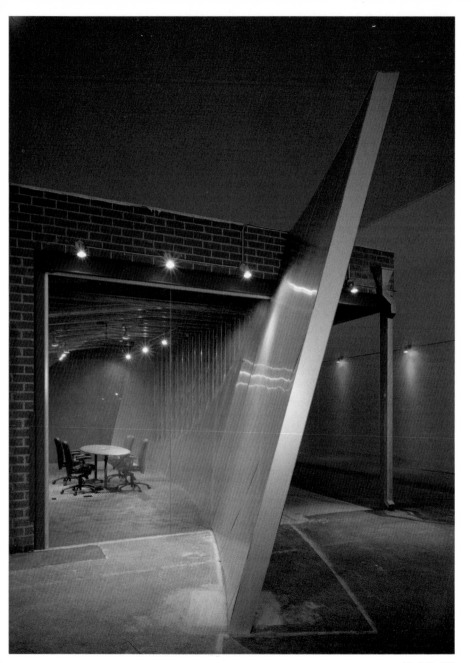

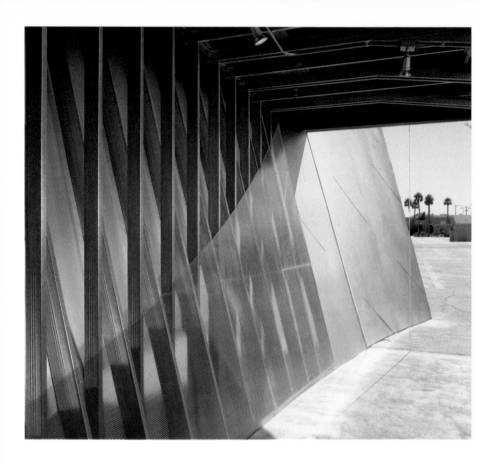

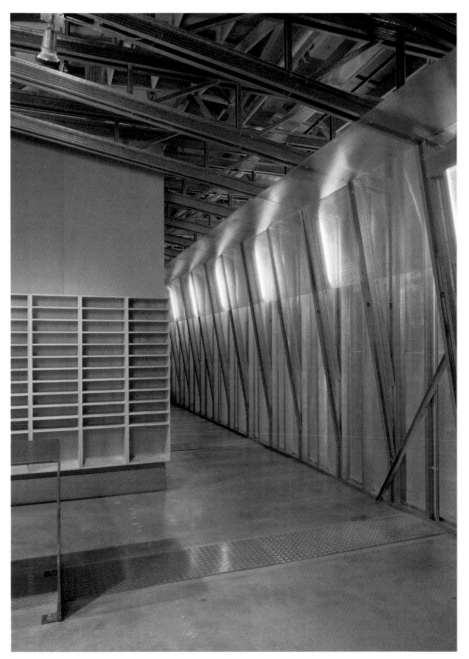

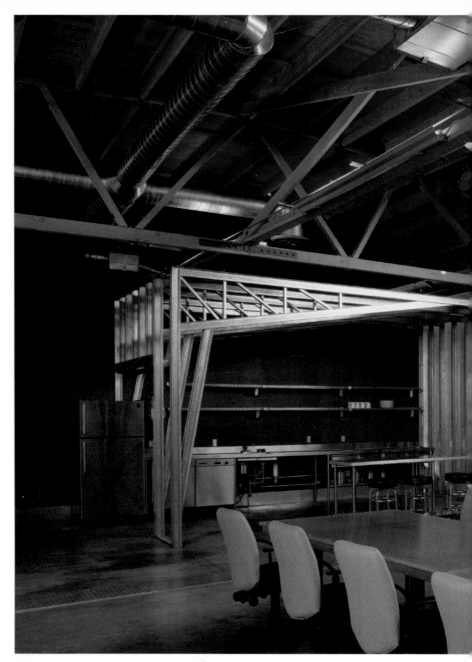

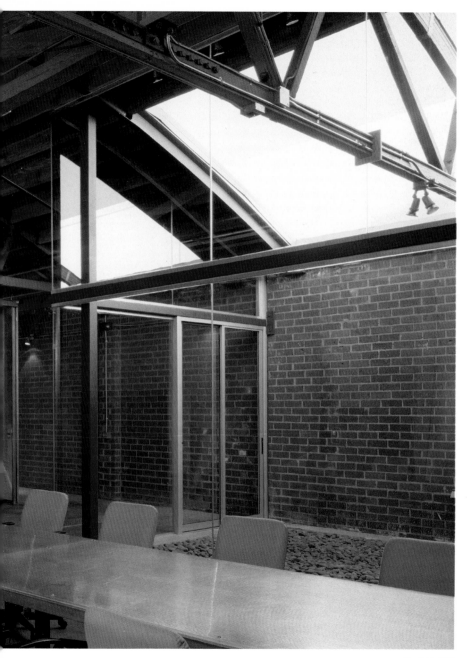

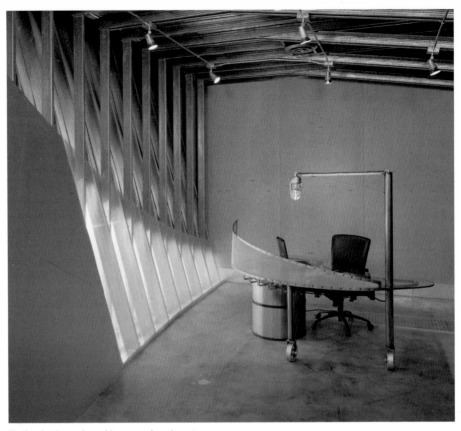

The interior decoration, with ergonomic and avant-garde furniture, exhibits an attractive visual interplay of eccentricity and futuristic imagination.

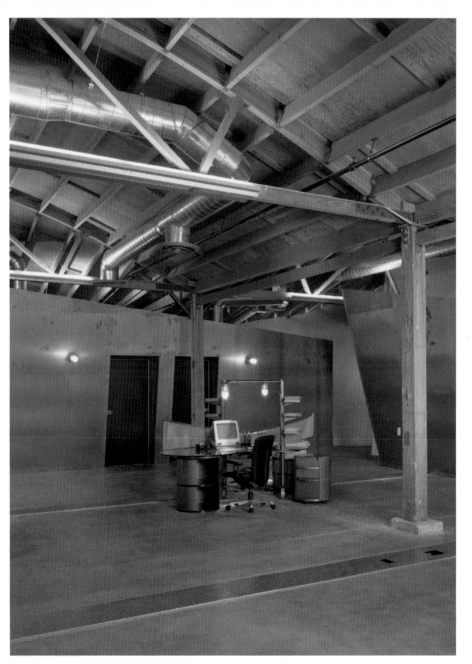

Located in the center of Stockholm, these
offices occupy a former church that has been
duly remodeled and rehabilitated. Whereas
the architectural compostion is complex, the
details turn out to be extraordinarily simple.
Unclad materials and visible glass supports are
just a few of the elements that help to create
this contrast.

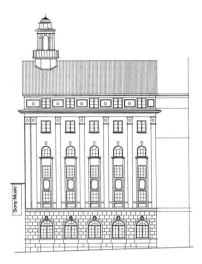

Elevation

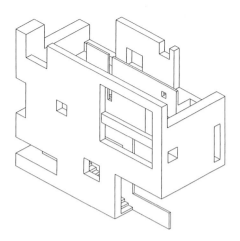

Axonometric perspective

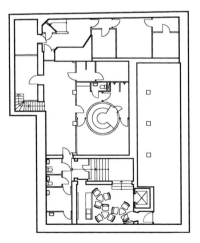

Ground floor

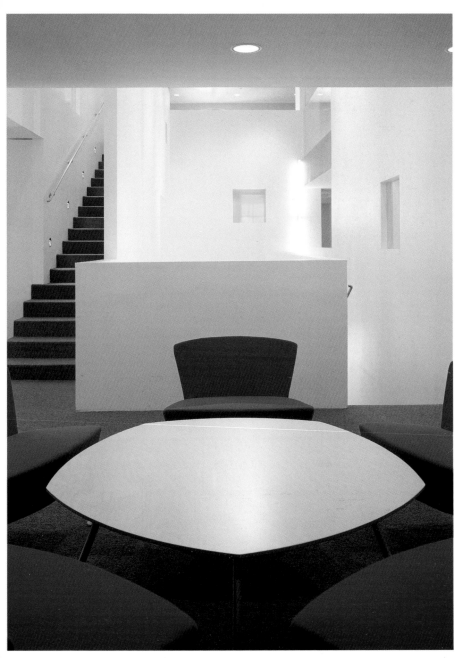

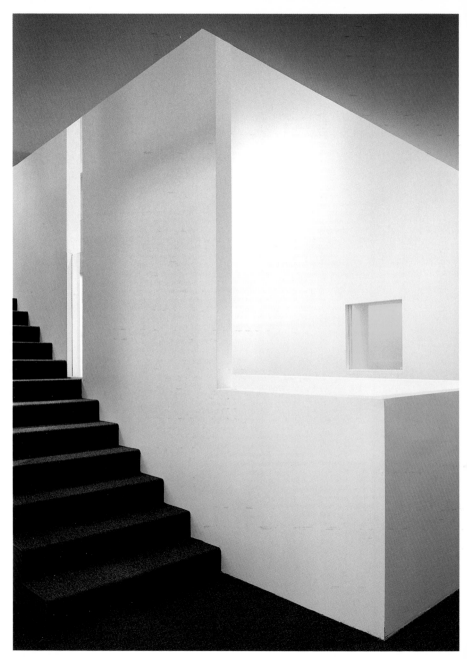

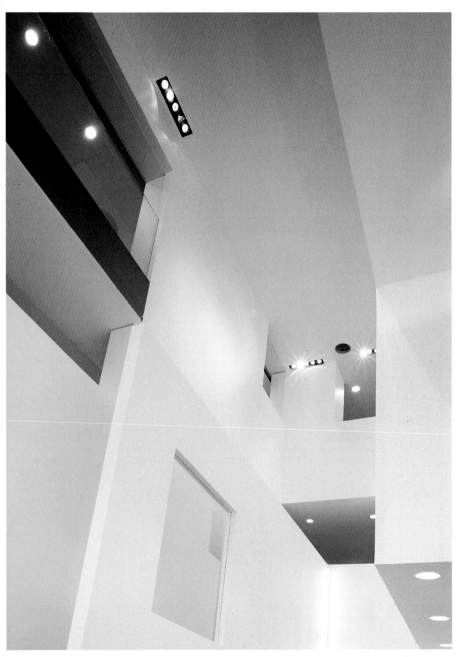

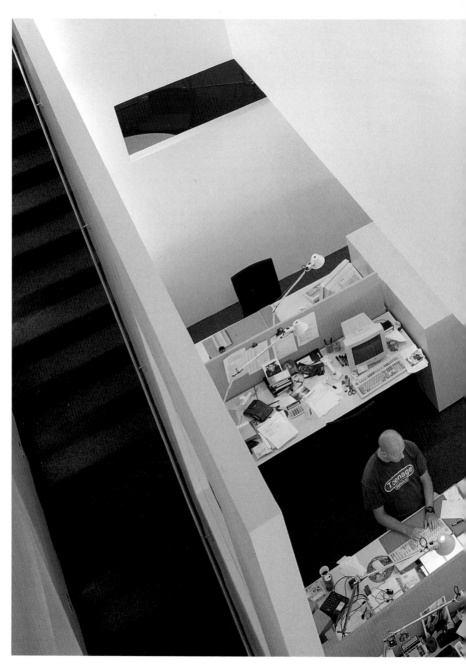

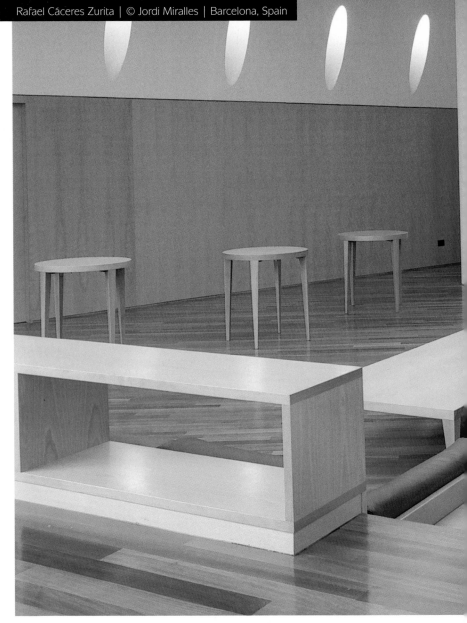

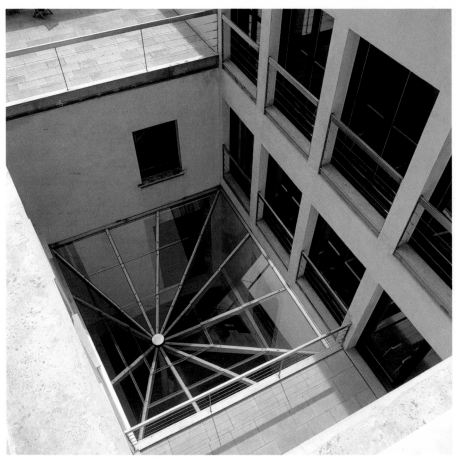

One of the goals of this project was the unification
of the building's architectural language. An attempt
was made to integrate the building's past heritage
and conserve the original structure while making
use of modern construction solutions.

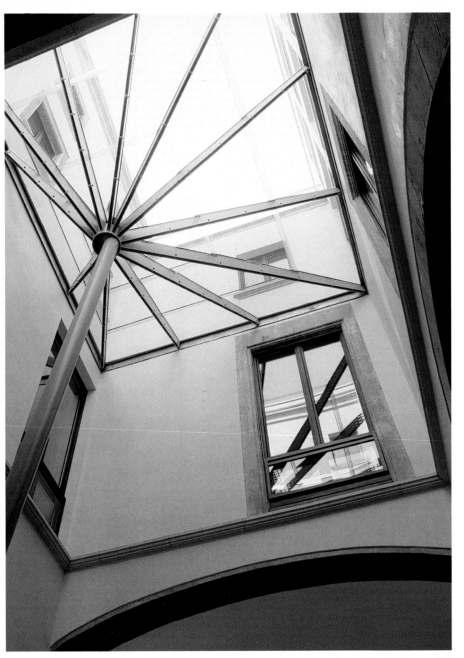

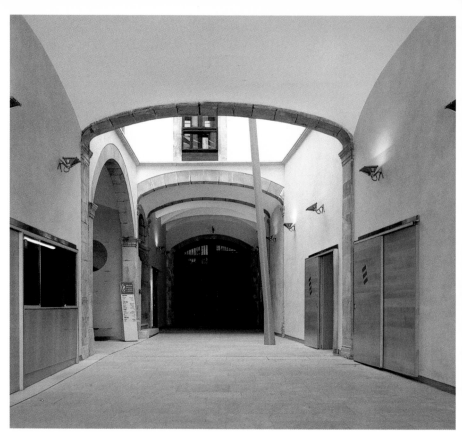

The first floor, which is organized around a central patio and the staircase, is designed as a public and cultural space, and houses the conference and recording room, the exhibition hall, a conference room and the meeting room for club members.

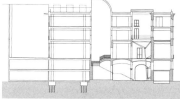

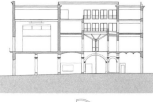

Sections

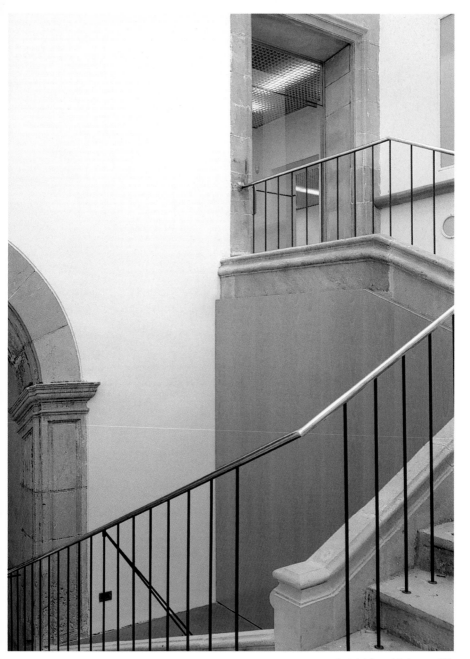

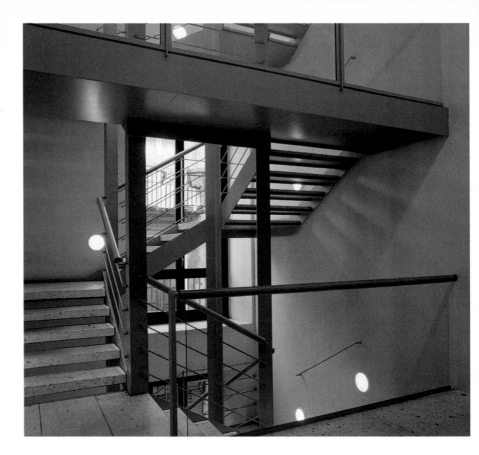

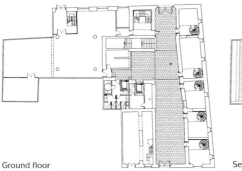

Ground floor

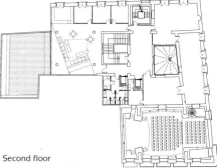

Second floor

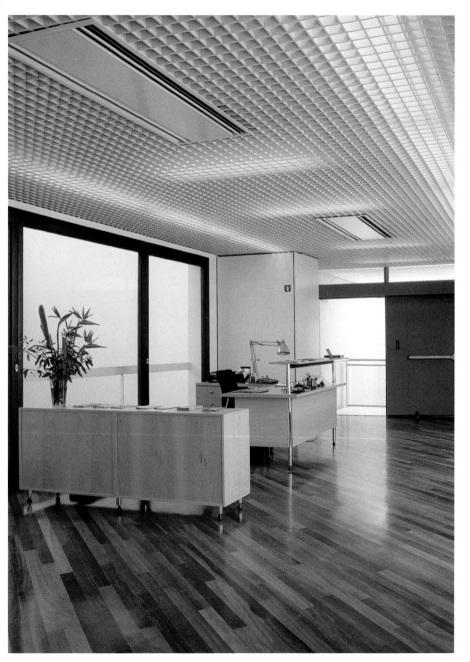

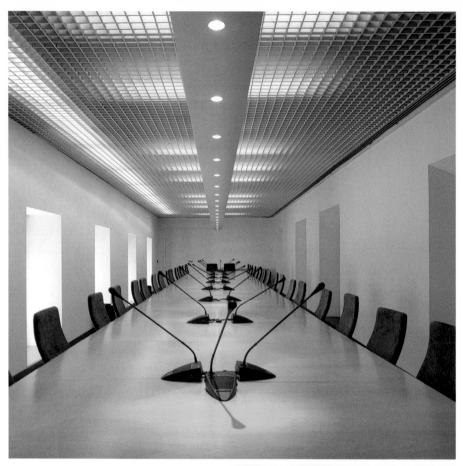

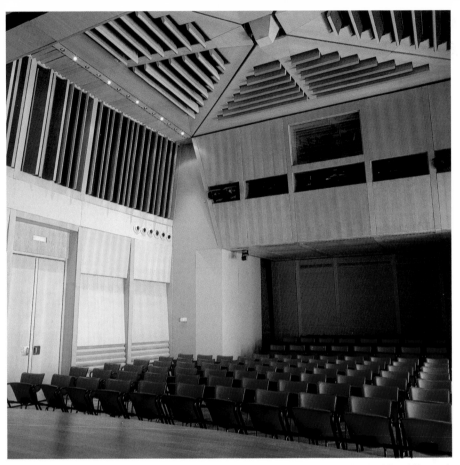

The rooms for cultural and public activities, such as the conference room, the club room, or the meeting room, are housed on the first floor in order to facilitate accessibility.

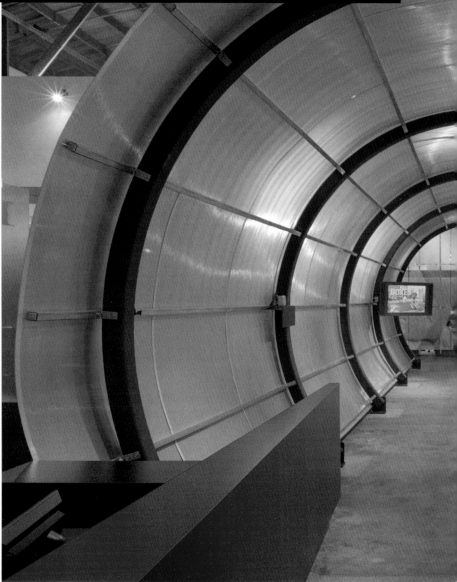

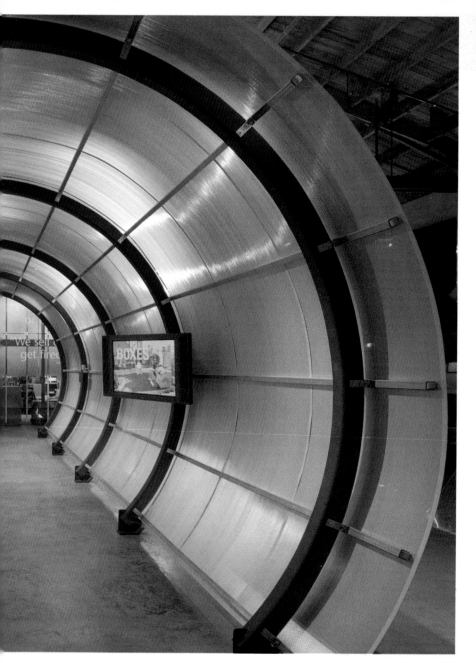

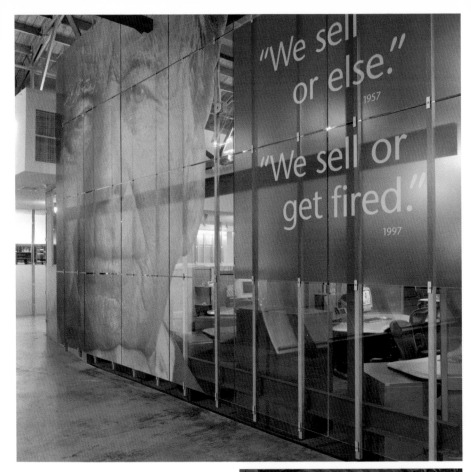

"We sell
or else." 1957

"We sell or
get fired." 1997

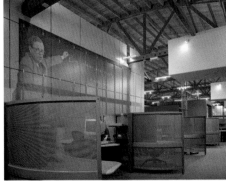

Floor plan

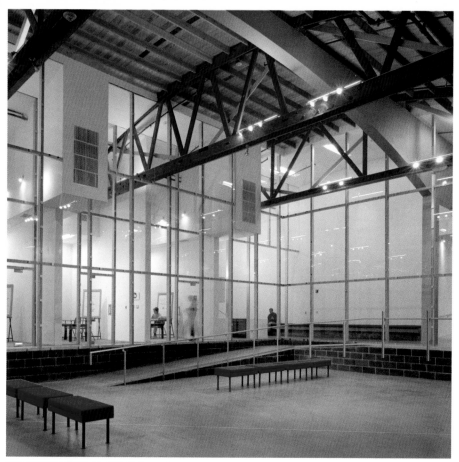

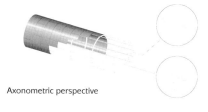

Axonometric perspective

Elevation

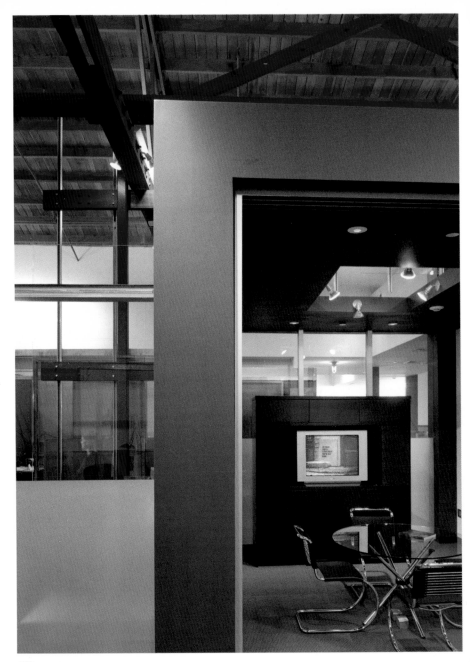

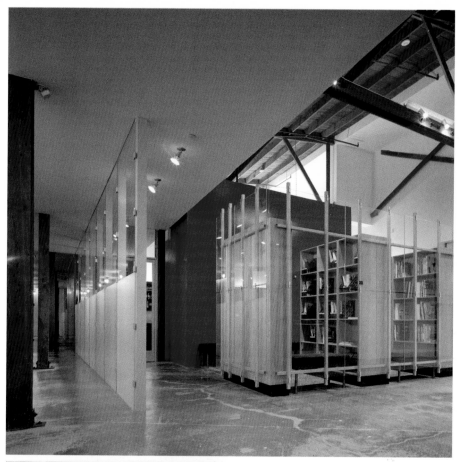

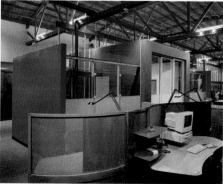

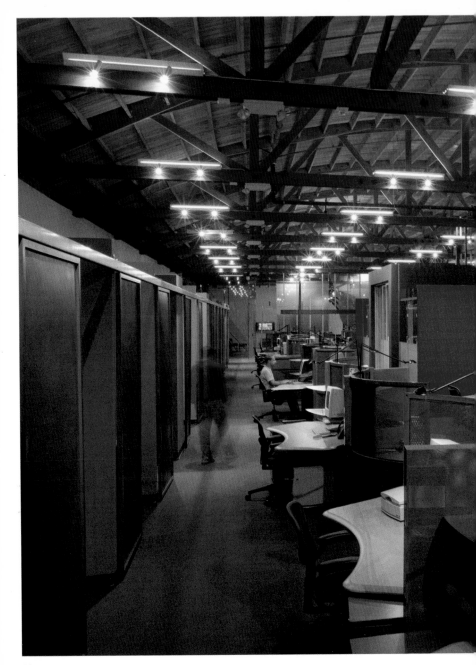

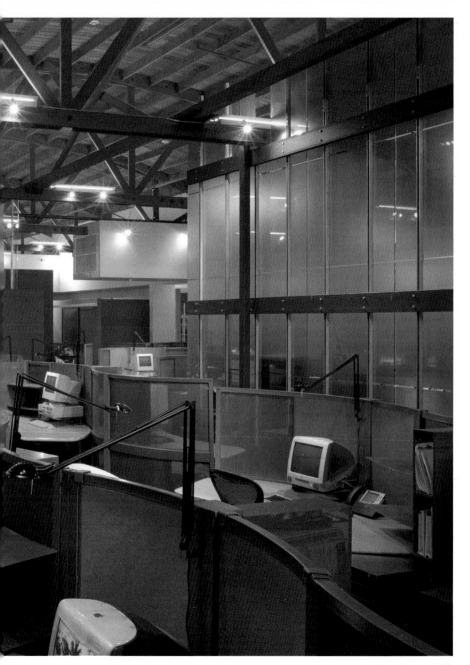

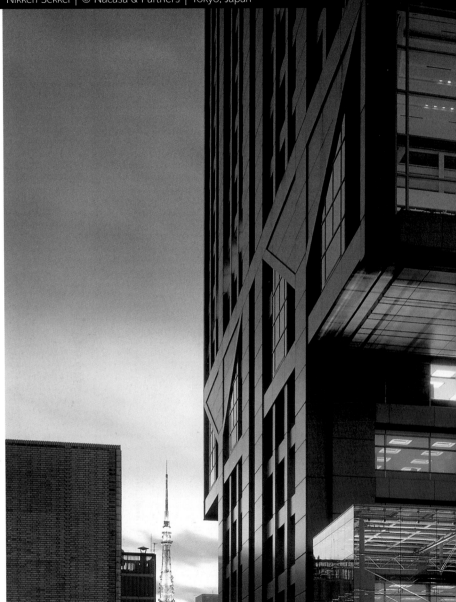

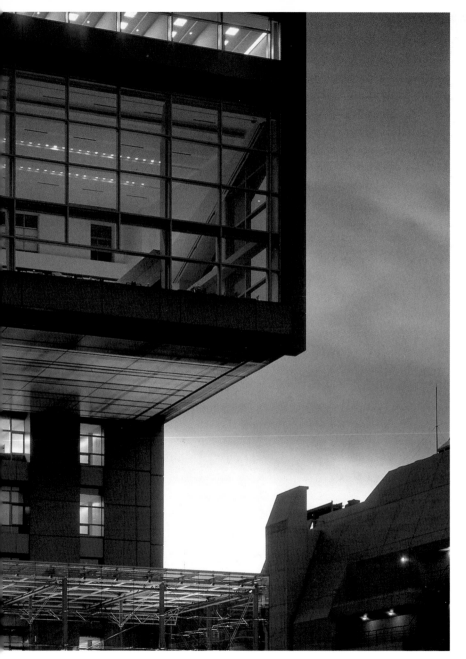

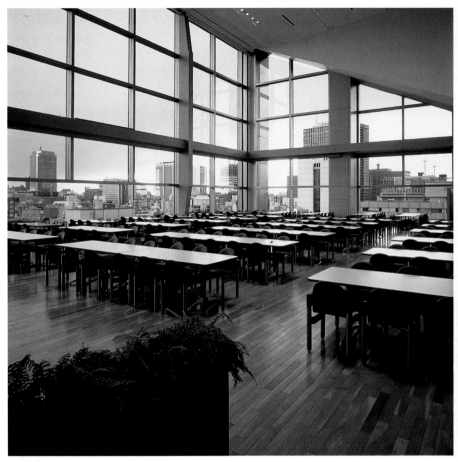

Enclosing the entire building with glass provides abundant natural light. Polished materials and smooth surfaces, such as the stone on the floor and the anodized aluminum of the interior partitions in the reception area, were used to maximize the effect of reflecting and enhancing the light.

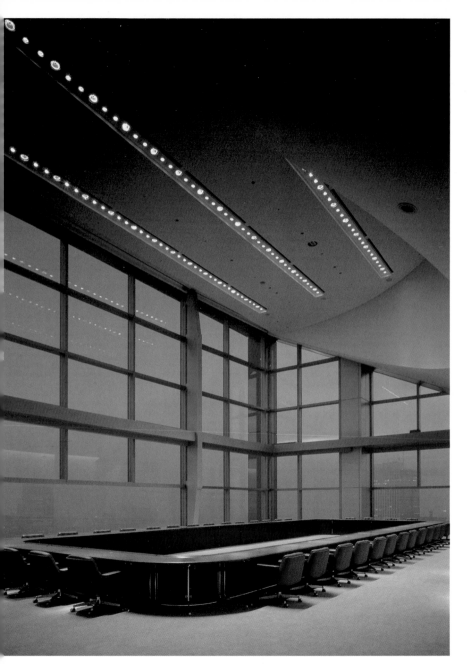

Floor plan: lower floors

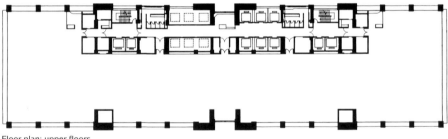

Floor plan: upper floors

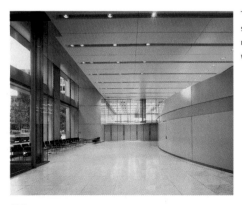

The two ends of the building, which enjoy spectacular panoramic views, house a large room for meetings and a 39-foot-tall room for welcoming visitors.

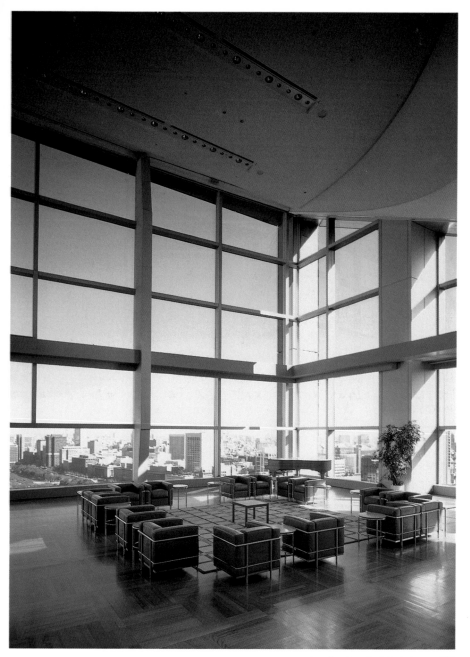

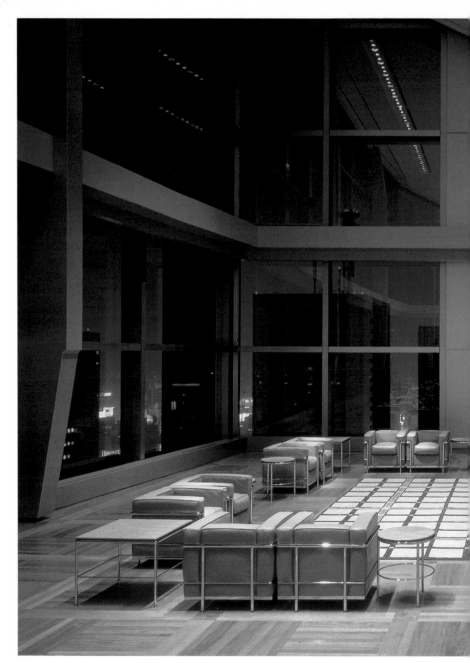

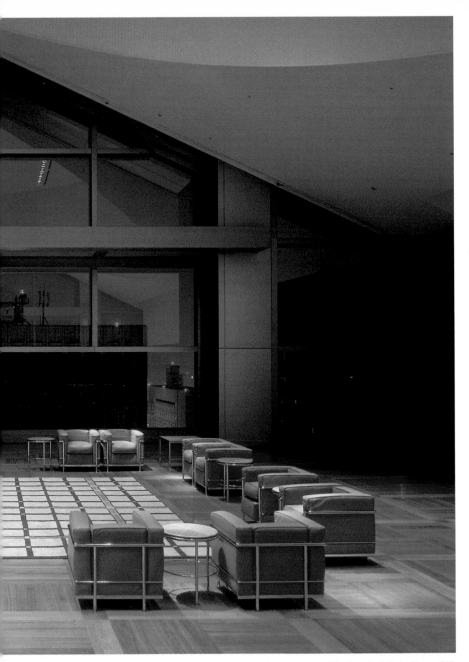

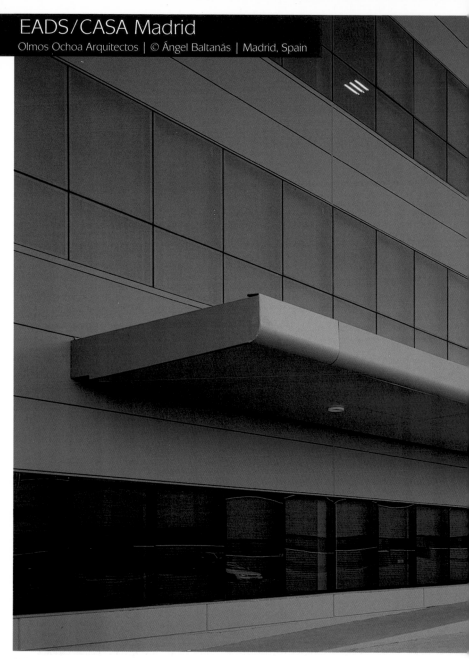

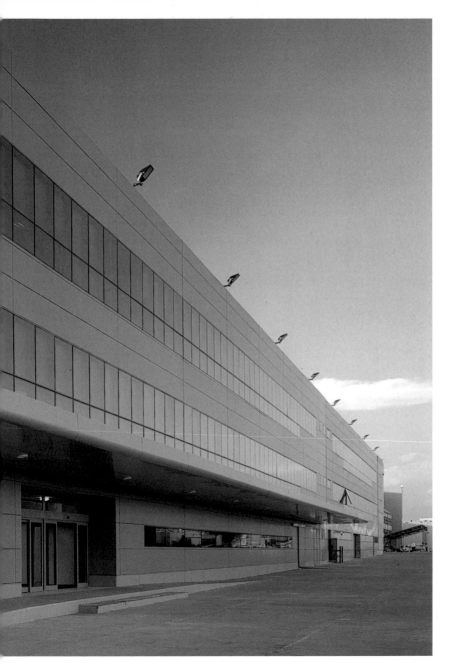

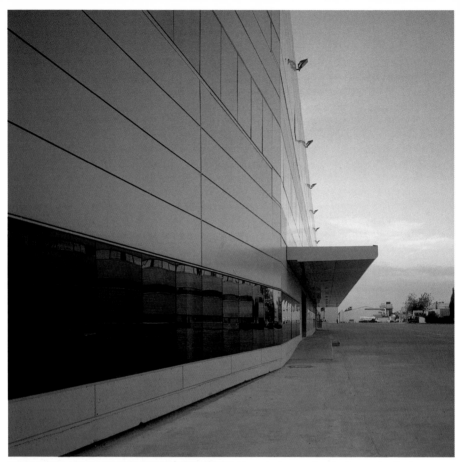

The main elements that give form to the client's particular guidelines are an imposing canopy, indicating the entrance to the building and protecting it from sun and rain; a visually powerful main staircase; and a subtle and angular enclosure on the south side—a solution that stylizes the lines of the space.

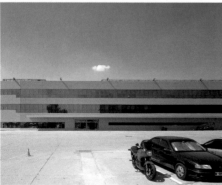

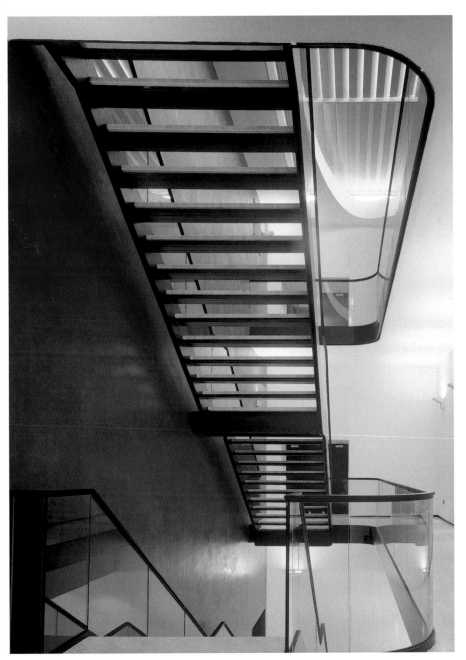

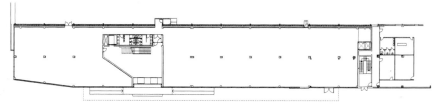

First floor

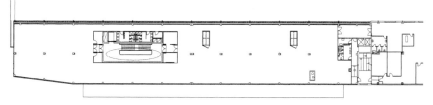

Second floor

Third floor

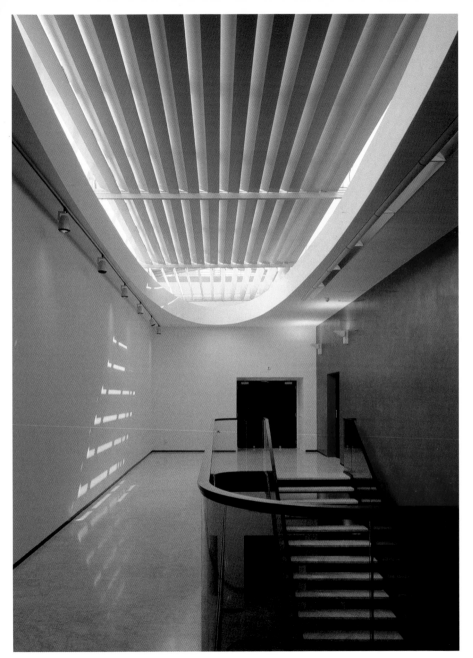

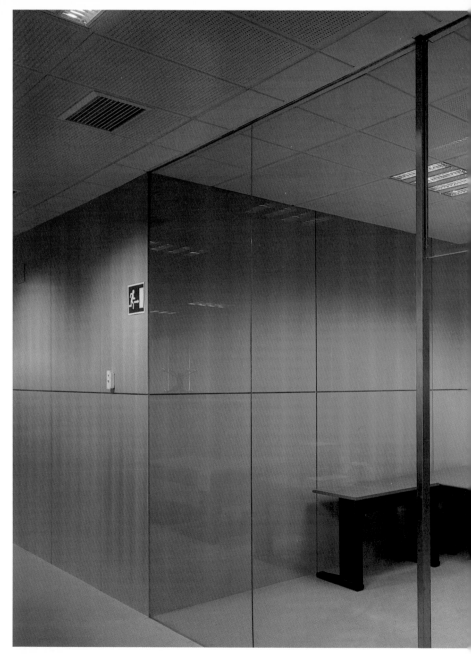

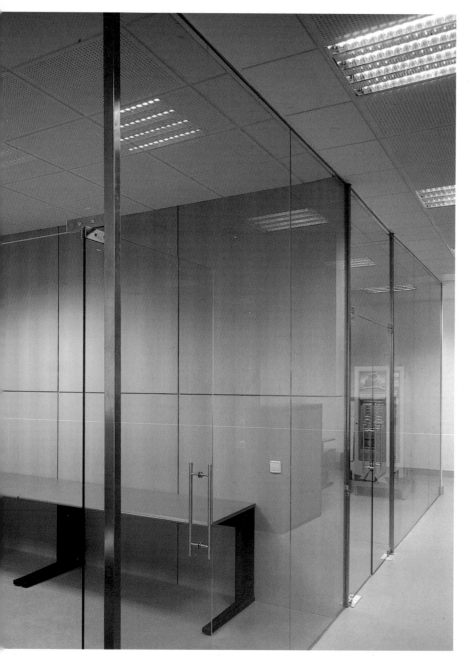

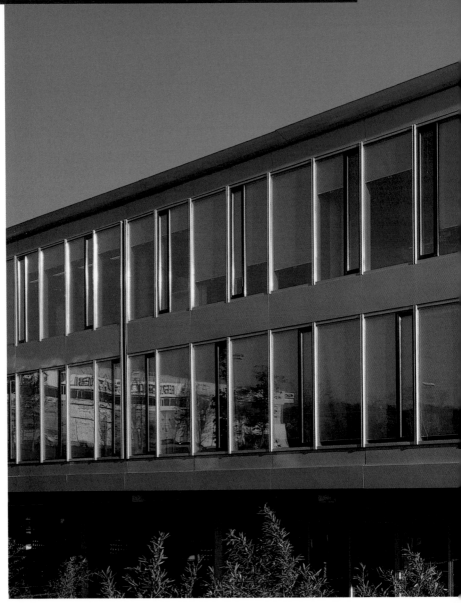

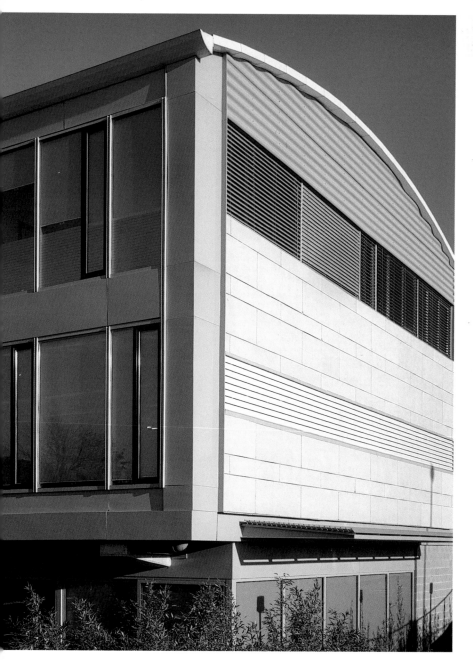

The administrative functions of this company take place on the top floors. The production areas are located on the lower level, the same level as the factory, and communicate with the factory through fire wall passages.

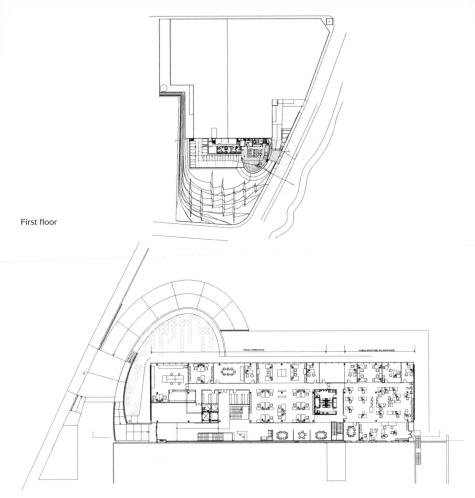

First floor

Second floor

Section

The solid industrial image projected by the entire space, which is a reflection of the activities going on inside, is achieved through the use of unfinished concrete, steel beams, and fiber-reinforced cement panels (asbestos-free) joined edge to edge. The surface coverings—which are incorporated into an environment whose vocabulary is that of production factories—include corrugated sheet metal and gypsum board.

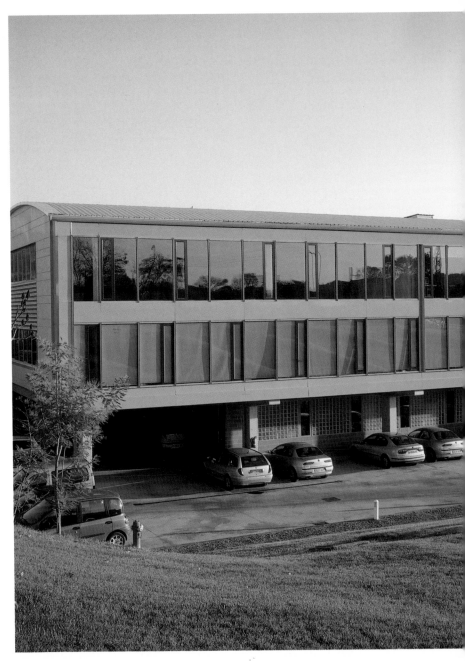

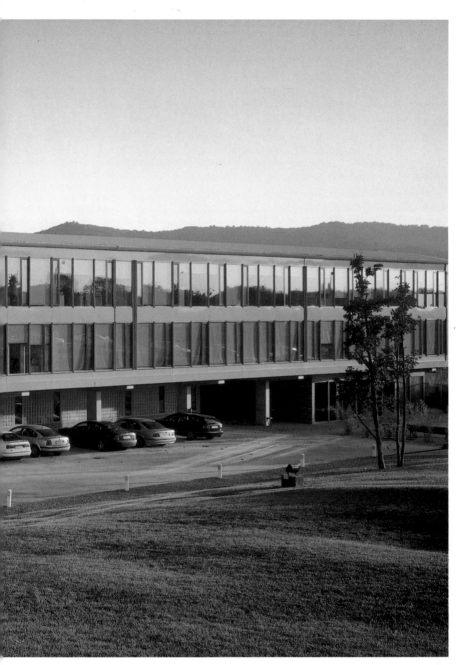

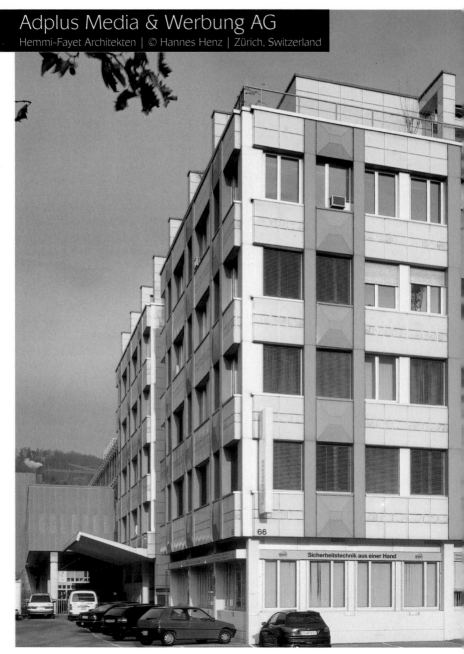

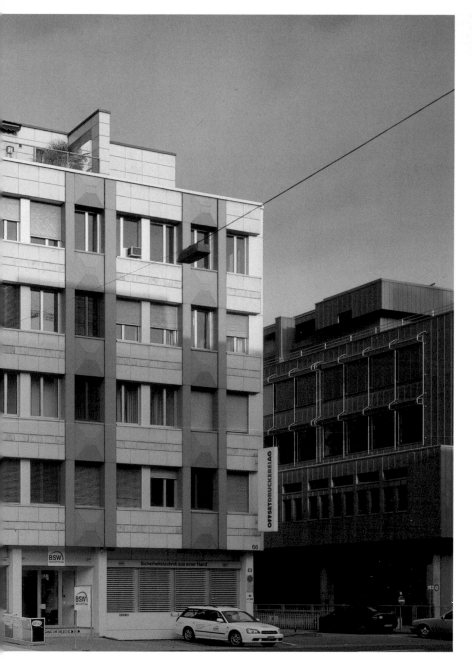

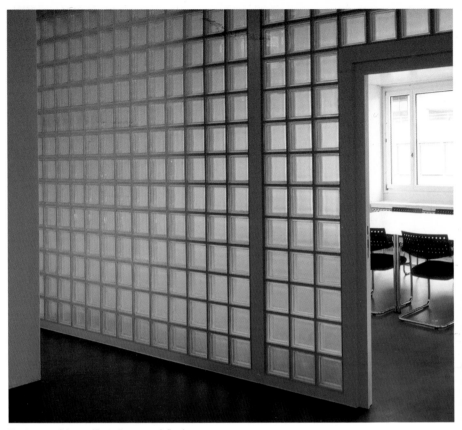

The layouts of these offices allow natural, flowing
transitions between spaces while defining their
different functions.

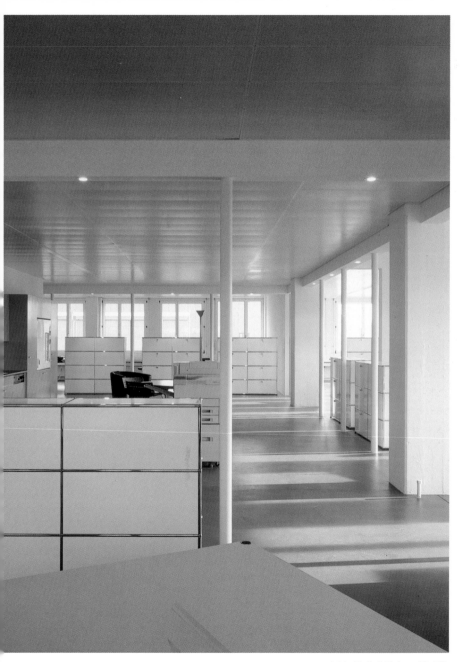

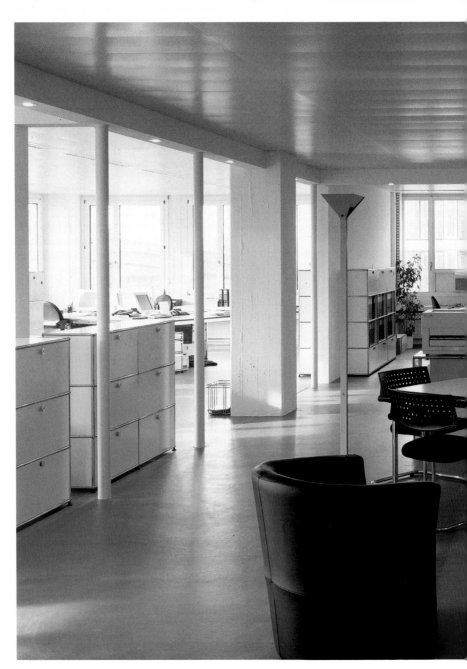

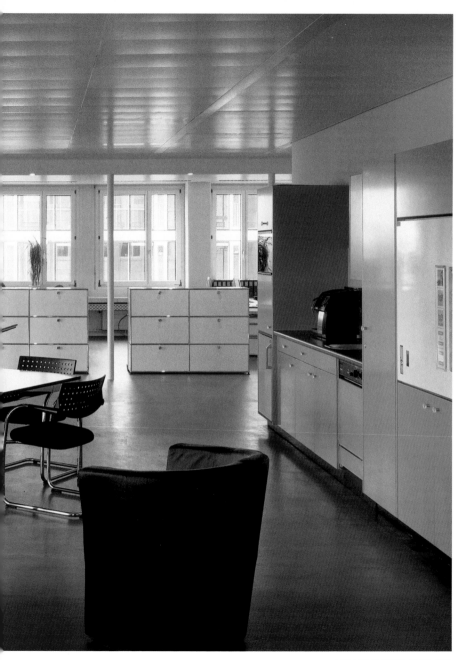

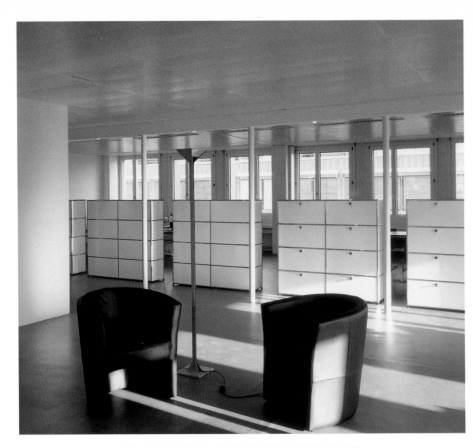

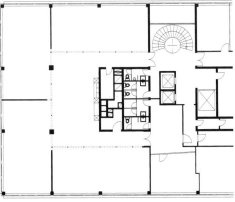

Floor plan

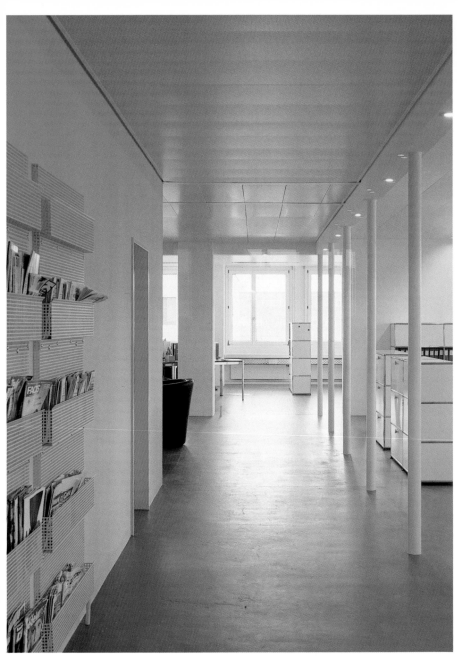

Headquarters of Bertelsmann in Barcelona

Tekno-Bau (Lluís Arcusa and Miquel Jordà) and Martín Weischer (Technical Department of Bertelsmann) | © Jordi Miralles | Barcelona, Spain

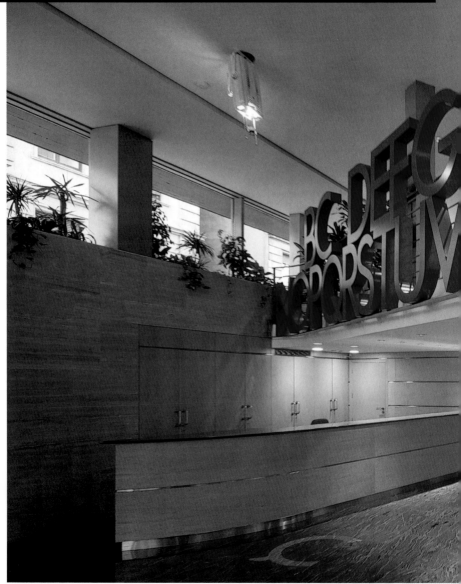

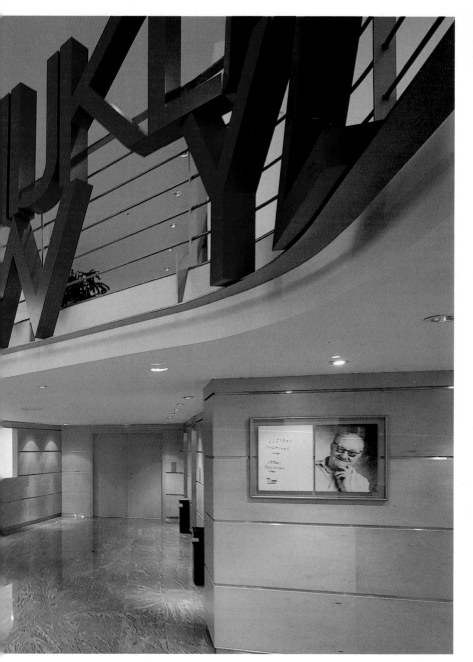

A small area for receiving visitors was created at one end of the lobby in a contained and sober style, which is repeated throughout the building's other spaces.

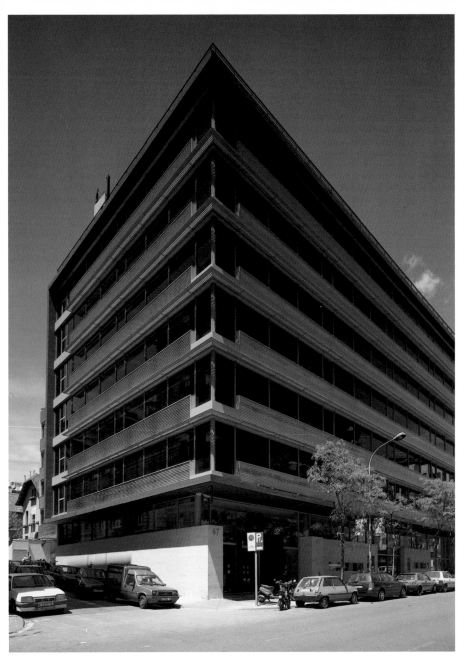

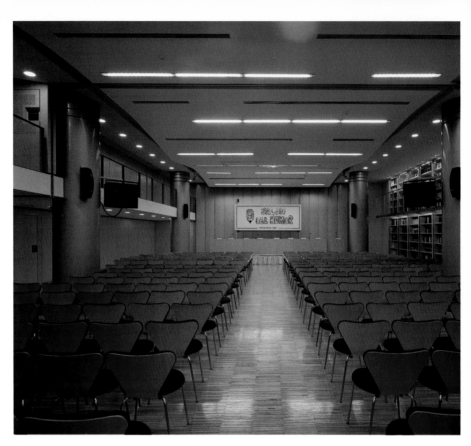

First floor

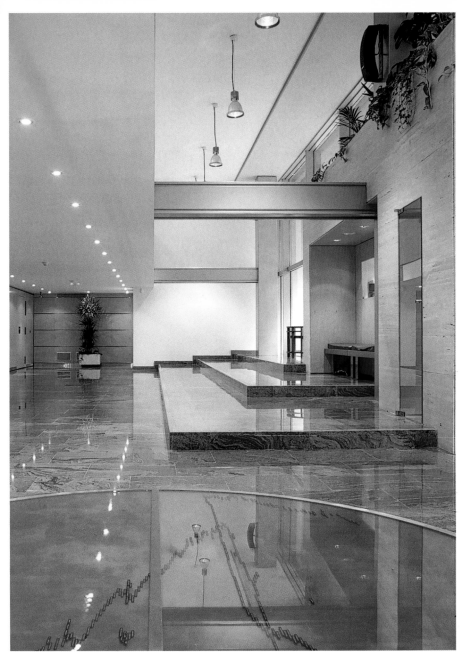

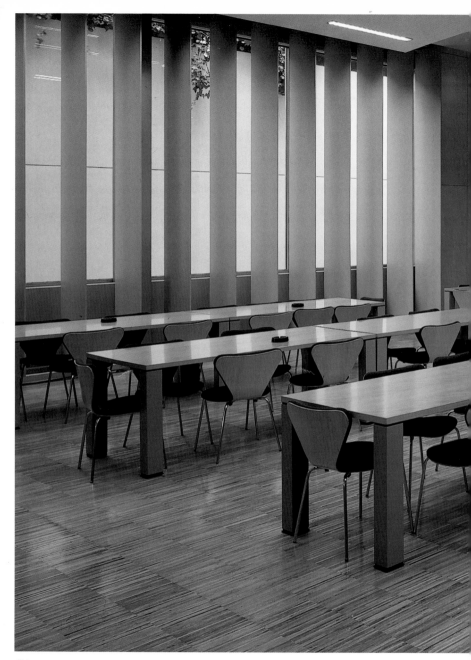

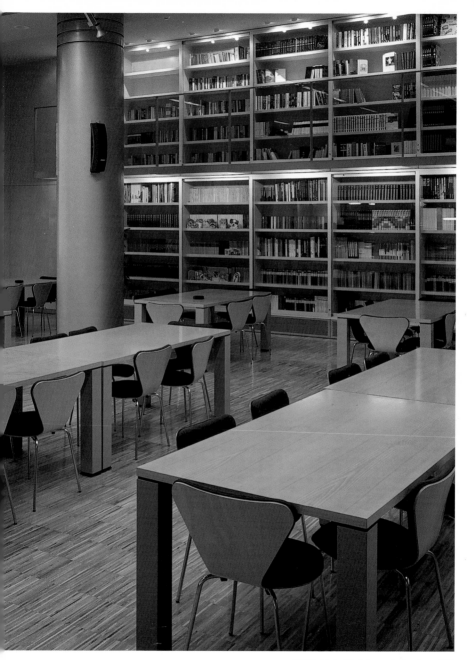

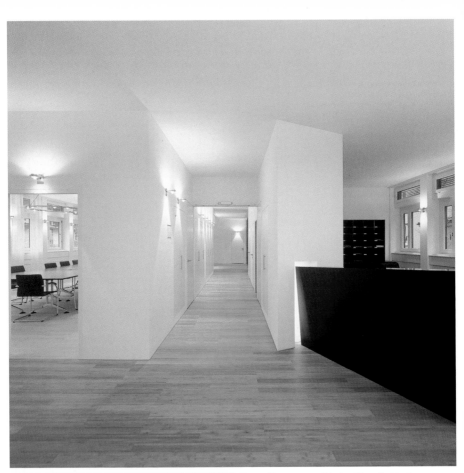

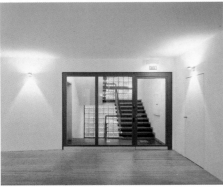

The architects responsible for this project took their inspiration from rationalism, geometry, and minimalism, balancing sobriety and avant-garde aesthetics. Their successful composition visually motivates and shapes interiors that are fresh, functional, and efficient.

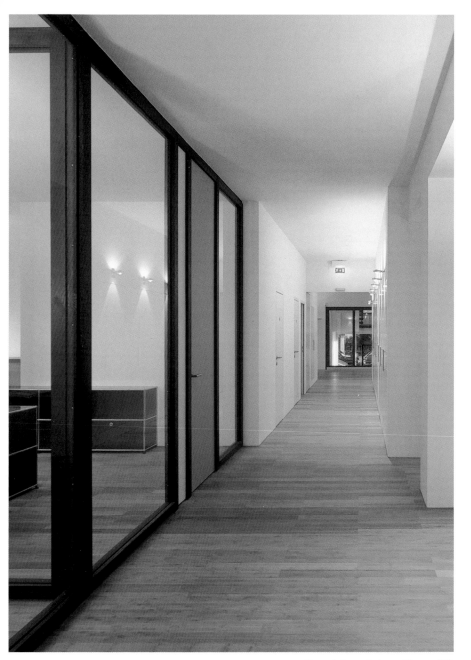

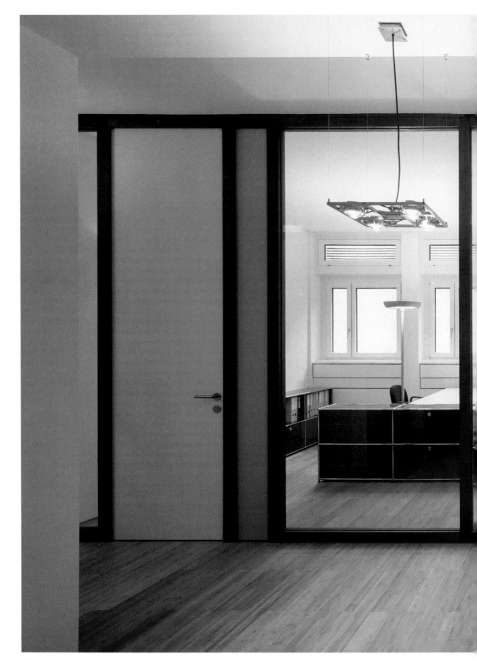

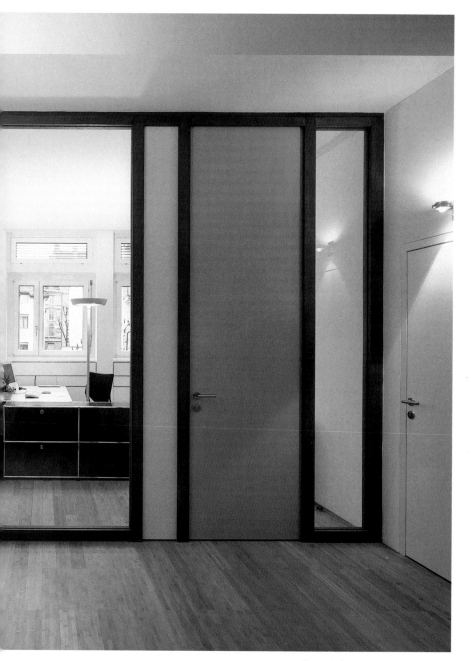

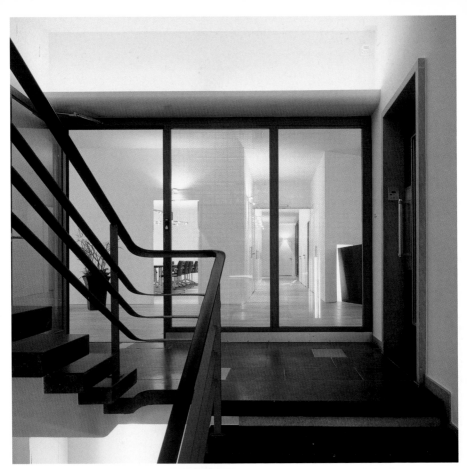

The austerity and order present in the décor are also maintained within the common areas, including the restrooms and the kitchen/dining room. In these areas, strokes of color break the purity of the white and create spaces that are both aesthetic and functional.

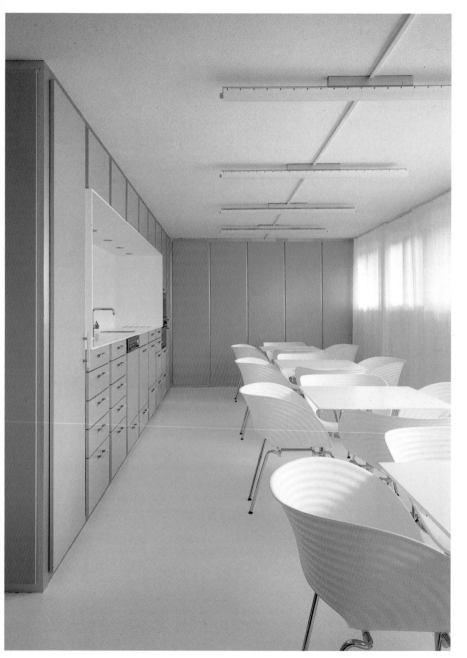

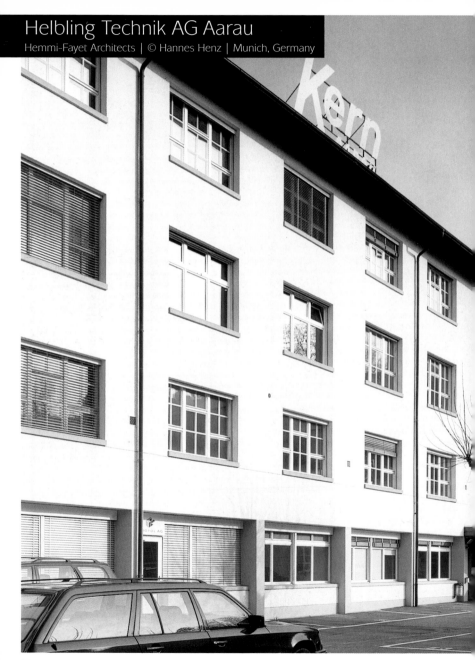

Helbling Technik AG Aarau

Hemmi-Fayet Architects | © Hannes Henz | Munich, Germany

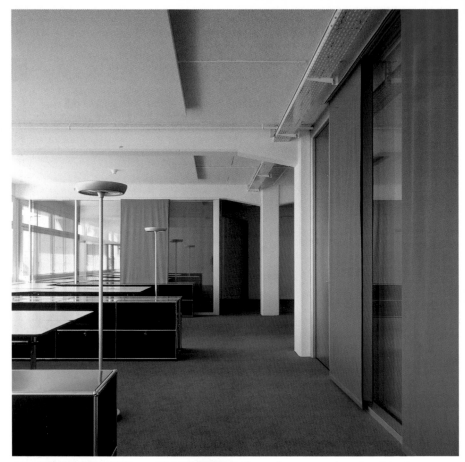

The meeting rooms are situated parallel to the work areas, separated by a row of columns that cross the space horizontally. Both areas are visually connected by glass structures encased in metal frames, which function as walls.

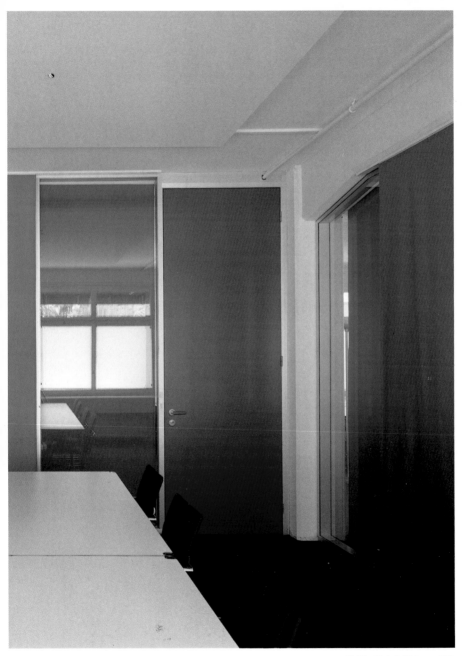

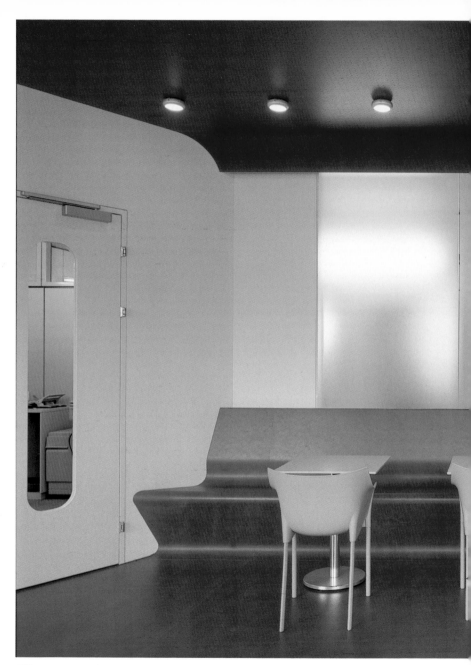

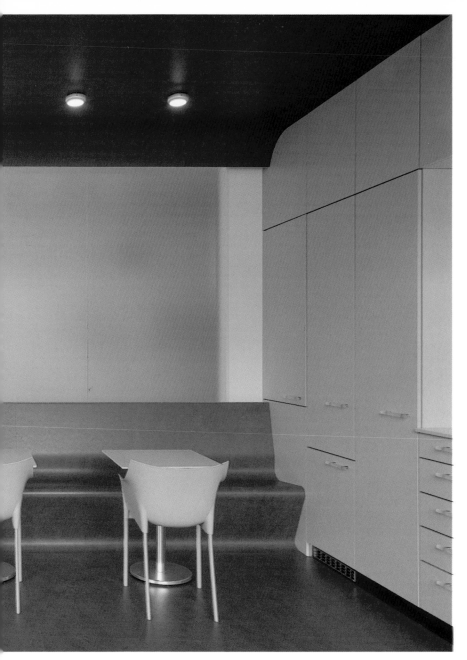

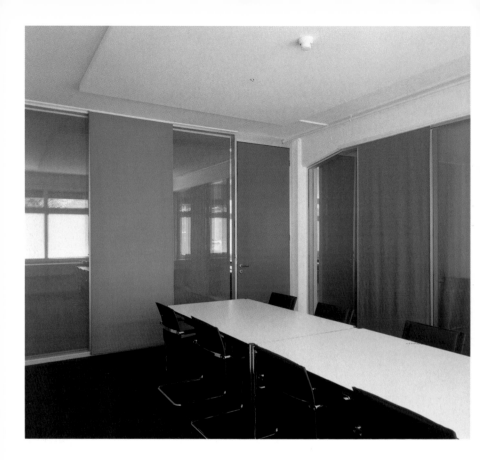

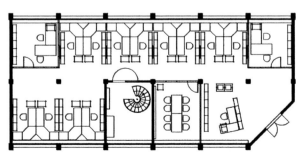

First floor

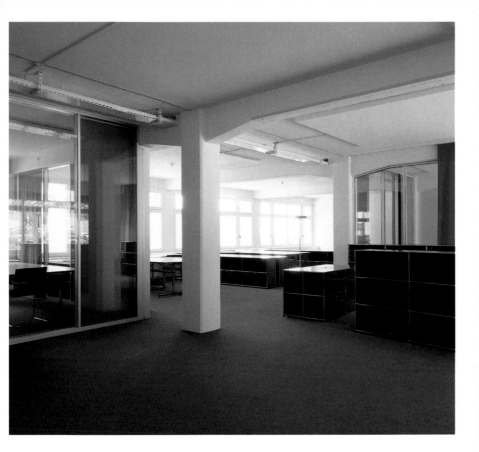

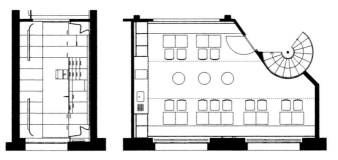

Cafeteria plan

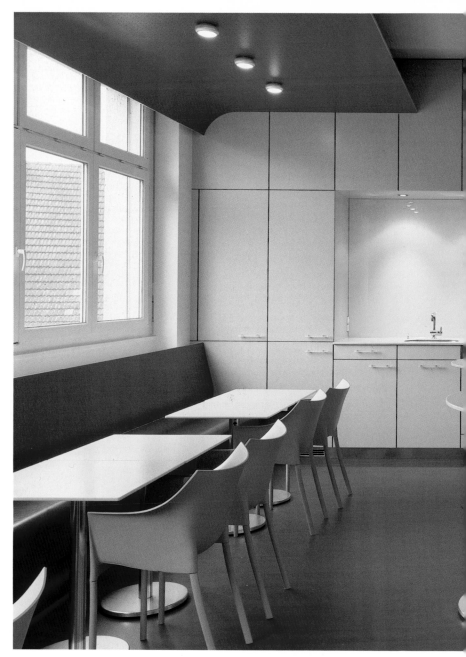

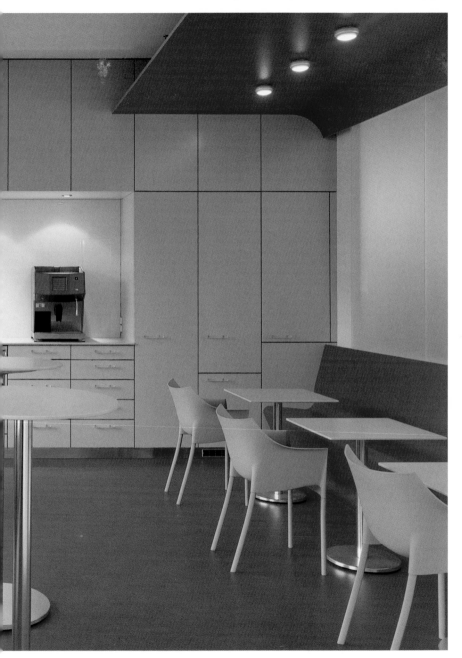

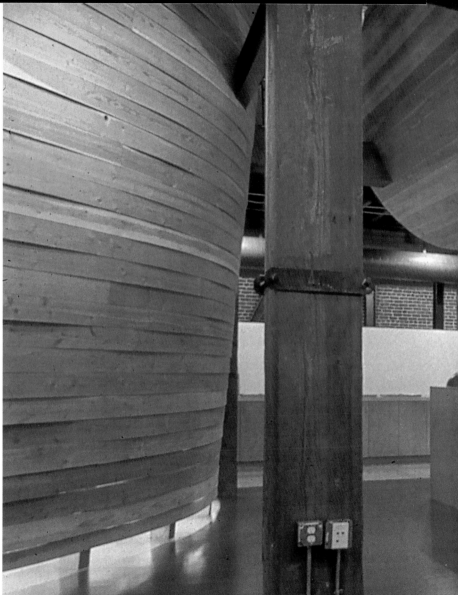

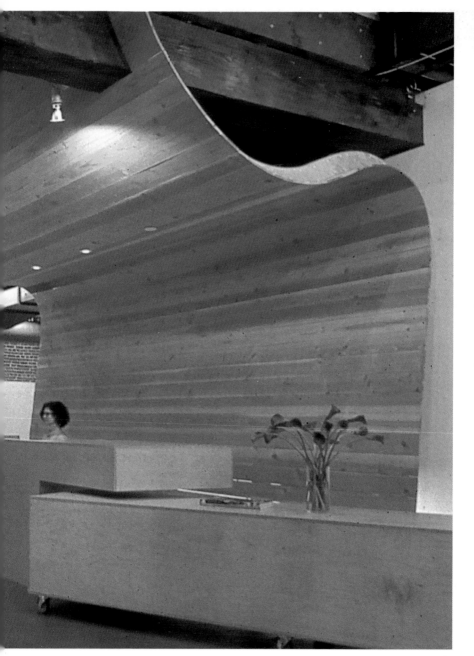

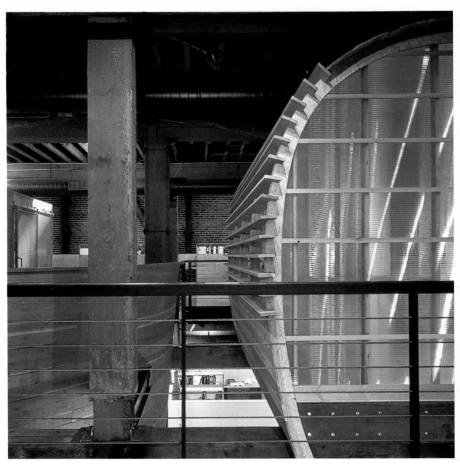

A striking curvilinear volume of unquestionable
visual power defines and connects the first level,
where the reception area is located, and the
second level.

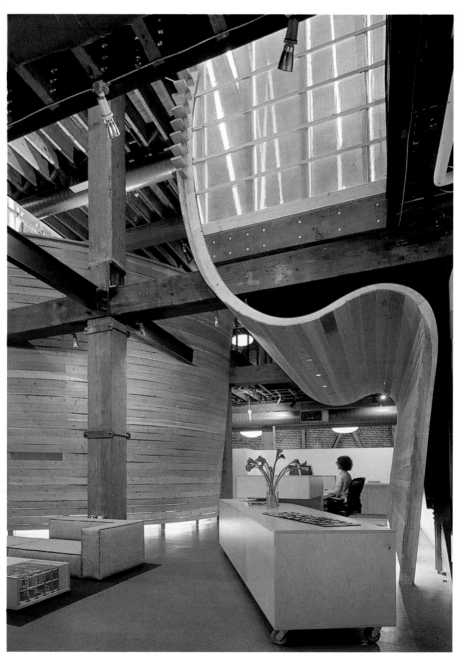

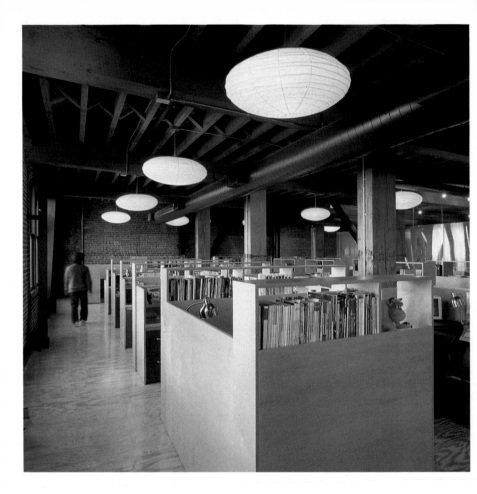

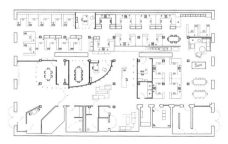

Ground floor

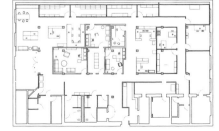

First floor

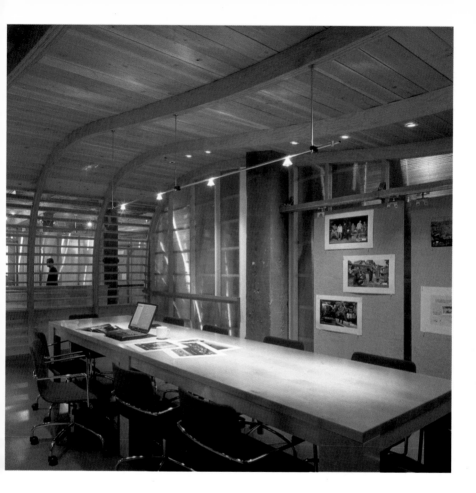

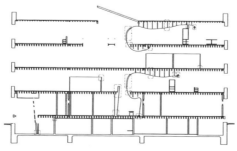

Section

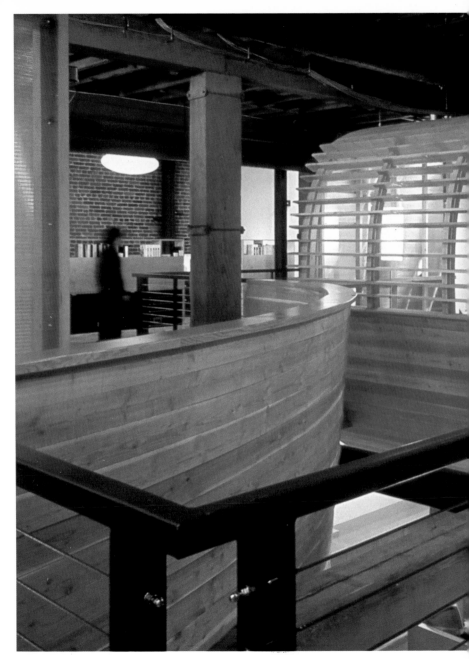

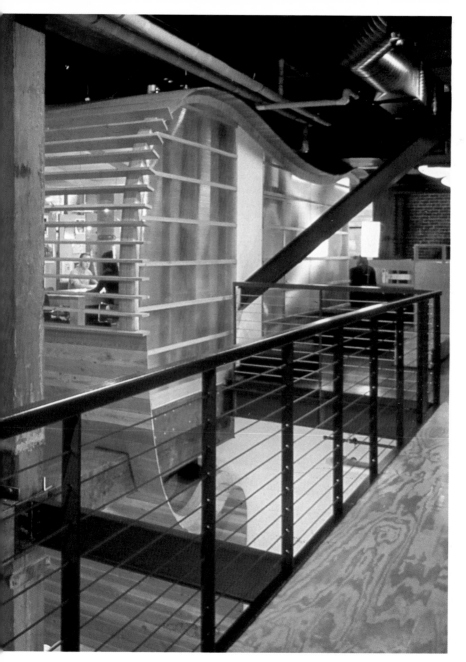

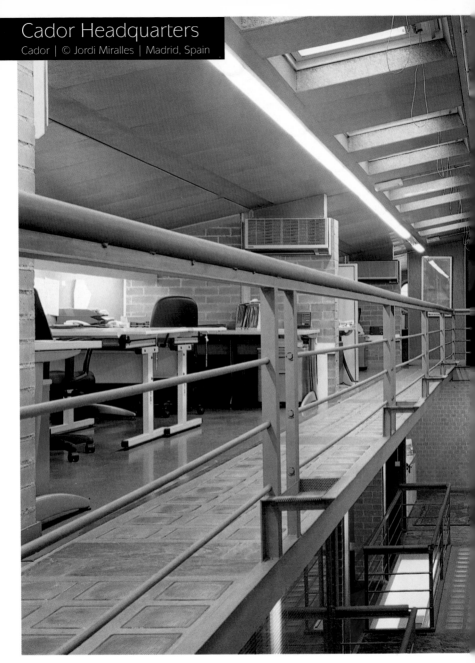

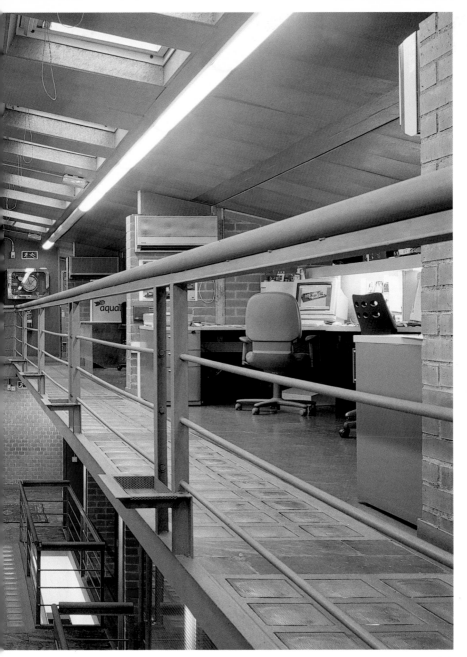

Cador Headquarters **273**

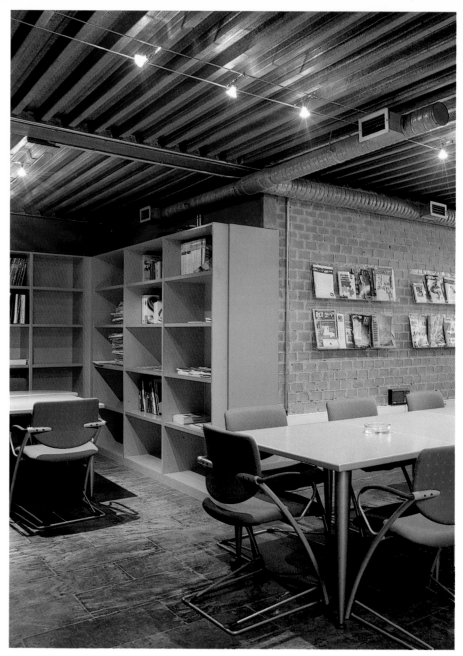

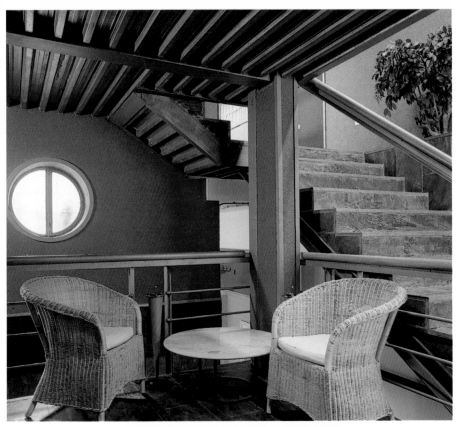

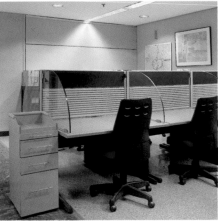

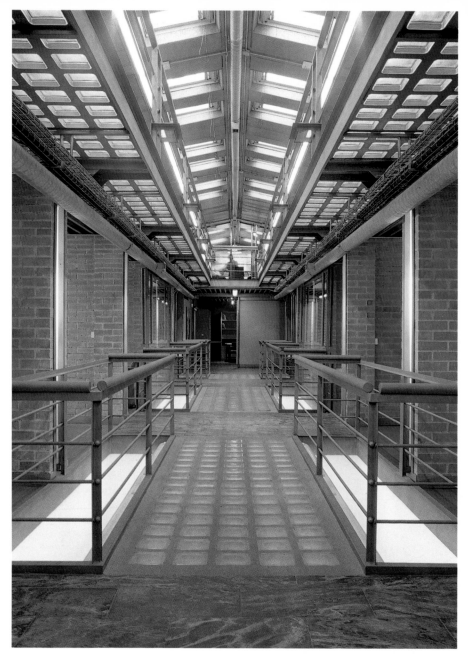

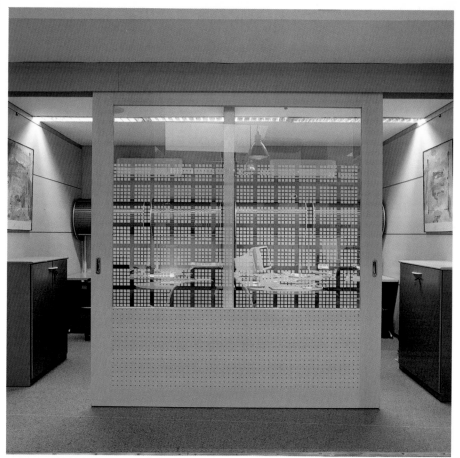

The goal of this project was to create open spaces where all of the offices would be the same size, regardless of hierarchy, and where every two offices would be connected by a sliding door. There are areas for informal meetings, nondesignated spaces for commercial and technical personnel, and facilities for breaks and sports.

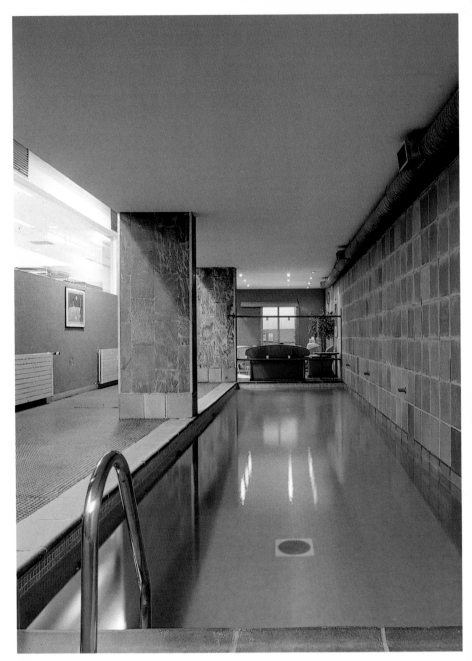

The structure of the first floor is supported by pillars of reinforced concrete and steel beams, and the subfloor is made of prefabricated hollow blocks of concrete. The second floor is supported by bearing walls, with a base of exposed brick footings and a subfloor of parallel sheets of corrugated steel.

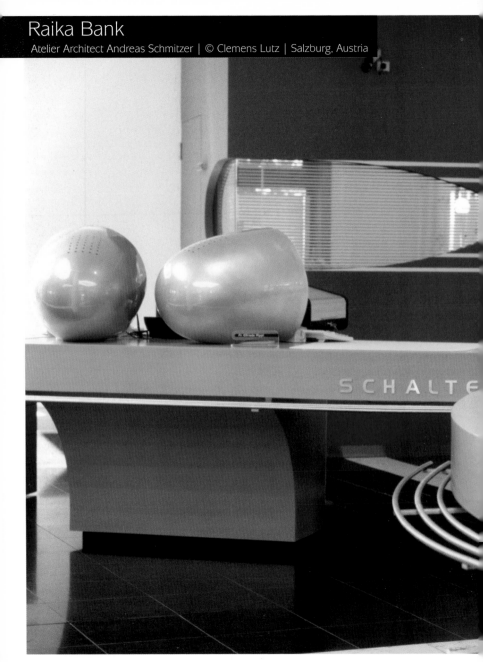

SCHALTE

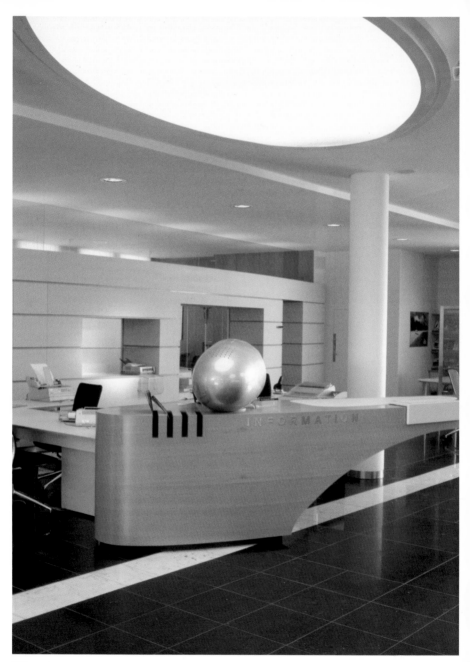

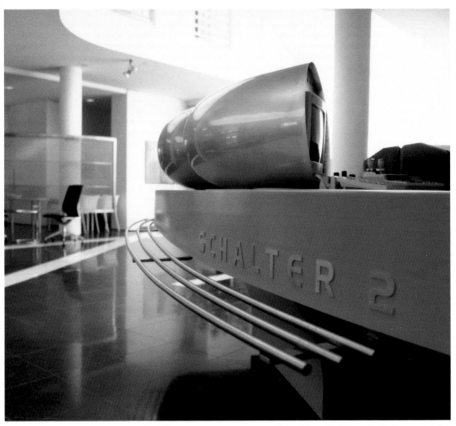

Three false ceilings hang in the foyer, providing warm, ambient lighting in orange tones.

Floor plan

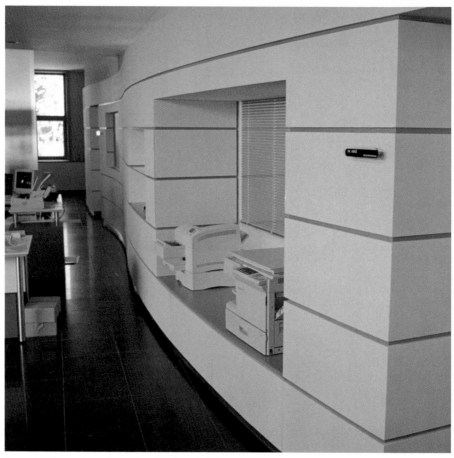

A curved wall integrates and separates all of the technical
equipment, providing storage space for the employees.

Some of the more private work spaces, such as the conference rooms, are separated from the principal area by translucent floating panels.

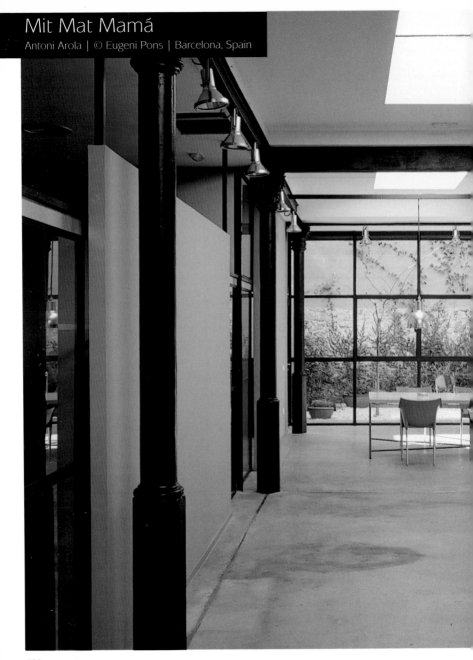

Mit Mat Mamá

Antoni Arola | © Eugeni Pons | Barcelona, Spain

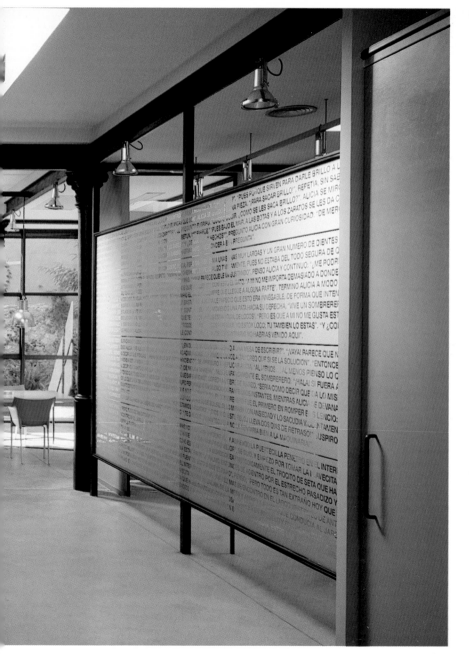

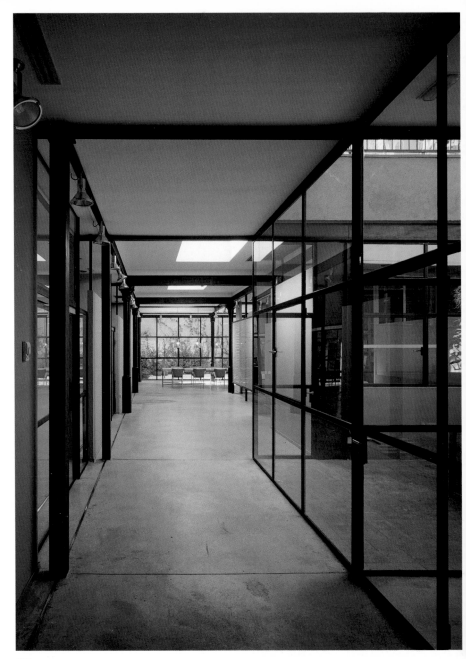

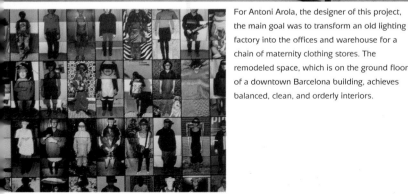

"Y DEBIJAN TODA CLASE DE COSAS..., TODO LO QUE EMPIEZA CON LA LETRA M...
¿CON LA LETRA M?" PREGUNTO ALICIA INTRIGADA. "¿Y POR QUE NO?" REPUSO LA
LIEBRE DE MARZO. ALICIA GUARDO SILENCIO. PARA ENTONCES EL LIRON YA HABIA
CERRADO LOS OJOS Y COMENZABA A CABECEAR; PERO CON LOS PELLIZCOS QUE
INMEDIATAMENTE EMPEZO A DARLE EL SOMBRERERO SE DESPERTO OTRA VEZ, CON
UN CORTO CHILLIDO, Y CONTINUO: "SI, TODO LO QUE EMPIEZA CON LA LETRA M, COMO
MARIPOSA, EL MUNDO, LA MEMORIA Y LO MUCHO..., YA SABEIS", AÑADIO REFIRIENDOSE
A ESTO ULTIMO, "COMO CUANDO SE DICE UN MUCHO MAS QUE MENOS". ¿HABEIS
VISTO ACASO ALGO TAN IMPRESIONANTE COMO UN MUCHO BIEN DIBUJADO?".

"PUES VERA USTED, SEÑOR..., YO..., YO NO ESTOY MUY SEGURA DE QUIEN SOY,
AHORA, EN ESTE MOMENTO; PERO AL MENOS SI SE QUIEN ERA CUANDO ME LEVANTE
ESTA MAÑANA; LO QUE ME PASA ES QUE ME PARECE QUE HE SUFRIDO VARIOS CAMBIOS
DESDE ENTONCES". "¿QUE ES LO QUE QUIERES DECIR?" DIJO LA ORUGA CON
SEVERIDAD, "¡EXPLICATE!". "MUCHO ME TEMO, SEÑOR, QUE NO SEPA EXPLICARME
A MI MISMA", RESPONDIO ALICIA, "PUES NO SOY LA QUE ERA, ¿VE, USTED?". "¡NO
VEO NADA!", DIJO LA ORUGA. "TEMO NO PODER DECIRSELO CON MAYOR CLARIDAD",
INSISTIO ALICIA MUY CORTESMENTE, "PUES PARA EMPEZAR, NI YO MISMA LO
COMPRENDO; Y ADEMAS, CAMBIAR TANTAS VECES DE TAMAÑO EN UN SOLO DIA ME
RESULTA MUY DESCONCERTANTE". "NO LO ES", REPLICO LA ORUGA. "BUENO QUIZA
A USTED NO SE LO PAREZCA", DIJO ALICIA, "PERO CUANDO SE HAYA TRANSFORMADO
EN UNA CRISALIDA -Y ESO HA DE PASARLE ALGUN DIA, ¿SABE?-, Y DESPUES, CUANDO
SE CONVIERTA EN UNA MARIPOSA, ¿NO CREE USTED QUE LE PARECERA TODO ESO
UN POCO EXTRAÑO?", "¡EN ABSOLUTO!", DECLARO LA ORUGA. "BUENO, QUIZAS TENGA
USTED SENTIMIENTOS DISTINTOS A LOS MIOS", DIJO ALICIA; "PERO LO QUE SI SE
ES QUE YO, EN SU LUGAR, ¡ME SENTIRIA CIERTAMENTE MUY RARA!"

"ASI QUE TU CREES HABER CAMBIADO, ¿EH?". "ME TEMO QUE SI, SEÑOR", DIJO ALICIA;
"NO ME ACUERDO DE LAS COSAS DE LA MISMA MANERA QUE ANTES..., ¡Y NO PASAN
NI DIEZ MINUTOS SIN QUE CAMBIE DE TAMAÑO!". "¿Y QUE TAMAÑO QUERRIAS TENER?",
PREGUNTO. "NO SOY NADA PARTICULAR EN CUANTO A TAMAÑOS", SE APRESURO A
REPLICAR ALICIA: "ES SOLO QUE A UNA NO LE GUSTA ESTAR CAMBIANDO DE TAMAÑOS
CON TANTA FRECUENCIA, ¿NO CREE?". "NO CREO NADA", REPUSO LA ORUGA.

"¡A VER SI NO NOS APRETAMOS TANTO!", LE DIJO A ALICIA EL LIRON, QUE ESTABA
SENTADO A SU LADO. "¡APENAS SI PUEDO RESPIRAR!". "¡NO PUEDO REMEDIARLO"
CONTESTO ALICIA CON MUCHA MODESTIA; "ES QUE ESTOY CRECIENDO". "¡NO TIENES
DERECHO A CRECER AQUI!", REPLICO EL LIRON. "¡NO DIGA TONTERIAS!", RESPONDIO
ALICIA, YA CON MAS VALOR, "¡SABE MUY BIEN QUE USTED TAMBIEN ESTA CRECIENDO!"
"¡SI, ¡PERO YO ESTOY CRECIENDO A UN RITMO RAZONABLE Y NO DE ESA MANERA
TAN DESCARADA!".

For Antoni Arola, the designer of this project, the main goal was to transform an old lighting factory into the offices and warehouse for a chain of maternity clothing stores. The remodeled space, which is on the ground floor of a downtown Barcelona building, achieves balanced, clean, and orderly interiors.

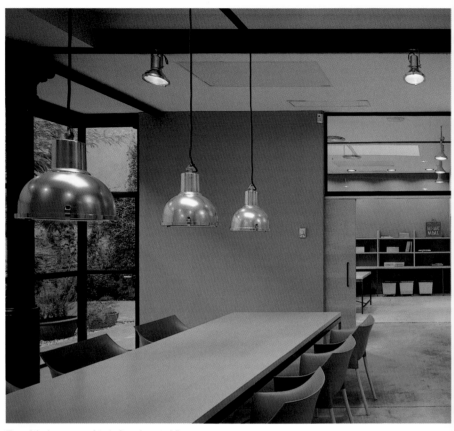

The original space consisted of an elongated floor plan that was transformed into an interior corridor, connecting the street with an indoor patio that has been decorated with a Mediterranean air. This central passageway gives access to all of the rooms on the floor: reception, offices, restrooms, design studio, and management.

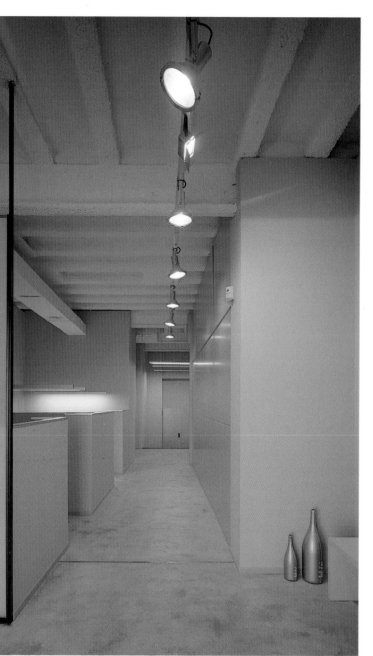

EZA CON LA LETRA M...
R QUE NO?" REPUSO LA
CES EL LIRON YA HABIA
N LOS PELLIZCOS QUE
SPERTO OTRA VEZ, CON
CON LA LETRA M, COMO
', AÑADIO REFIRIENDOSE
QUE MENOS". ¿HABEIS
BIEN DIBUJADO?".

EGURA DE QUIEN SOY,
A CUANDO ME LEVANTE
FRIDO VARIOS CAMBIOS
' DIJO LA ORUGA CON
E NO SEPA EXPLICARME
RA, ¿VE, USTED?". "¡NO
CON MAYOR CLARIDAD",
ZAR, NI YO MISMA LO
ÑO EN UN SOLO DIA ME
ORUGA. "BUENO QUIZA
E HAYA TRANSFORMADO
?-, Y DESPUES, CUANDO
E PARECERA TODO ESO
"BUENO, QUIZAS TENGA
A; "PERO LO QUE SI SE
RARA!"

SI, SEÑOR", DIJO ALICIA;
E ANTES..., ¡Y NO PASAN
ÑO QUERRIAS TENER?",
ÑOS", SE APRESURO A
AMBIANDO DE TAMAÑOS
PUSO LA ORUGA.

EL LIRON, QUE ESTABA
PUEDO REMEDIARLO",
RECIENDO". "¡NO TIENES
ONTERIAS!", RESPONDIO
BIEN ESTA CRECIENDO!".
Y NO DE ESA MANERA

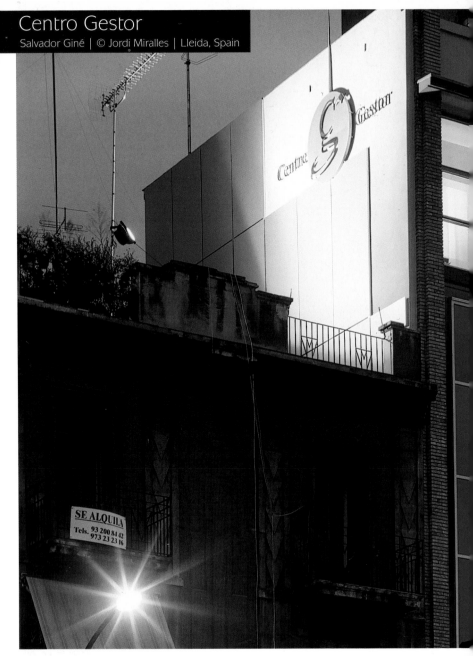

SE ALQUILA
Tels. 93 200 84 42
973 23 23 16

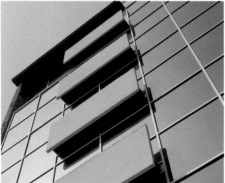

The remodeling and expansion of the preexistent building—previously the headquarters of an electric company—afforded the planning of the new offices for this firm that provides labor, financial, fiscal, legal, and management services. The architect's goal was to design a plan capable of incorporating the needs of the new company—accomodating all of its services in one building—while updating the installations.

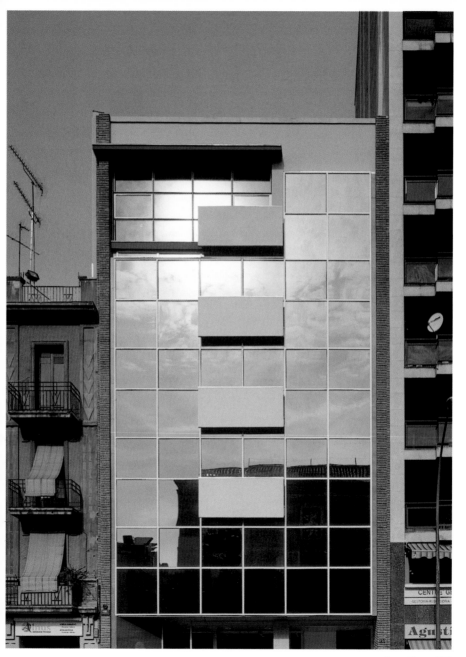

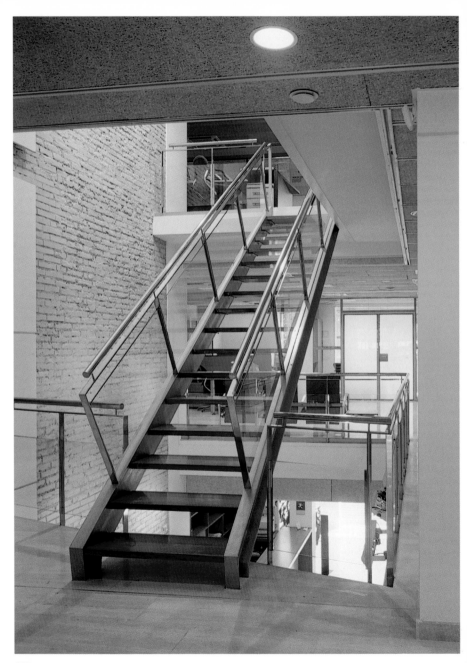

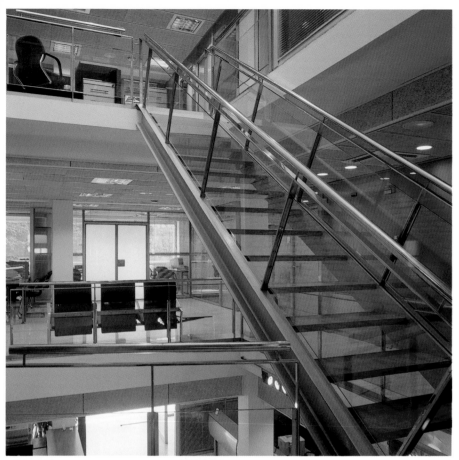

The interior of this building was emptied out by creating a large skylight through the center of the first, second, and mezzanine floors. This feature allows, on the one hand, visual communication between the levels and, on the other, articulation of the areas and the traffic around them.

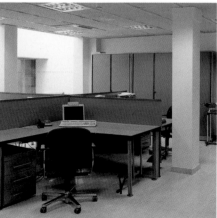

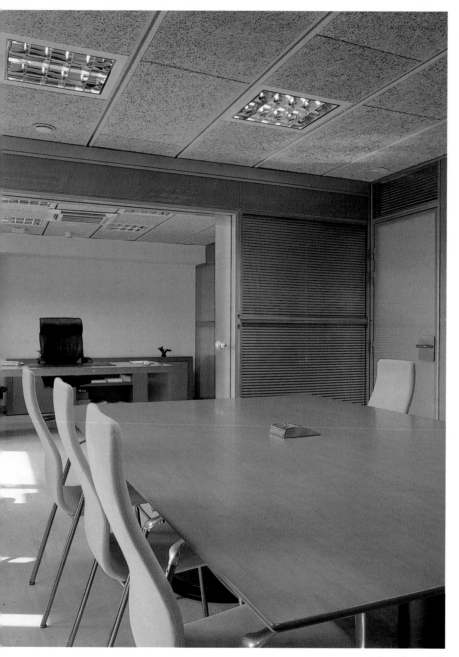

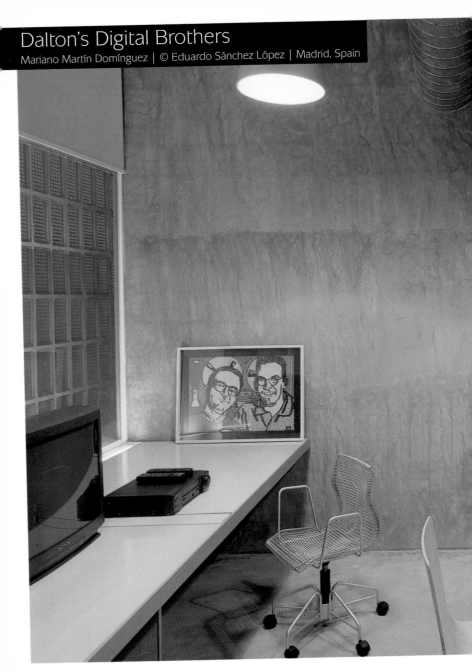

Dalton's Digital Brothers

Mariano Martín Domínguez | © Eduardo Sánchez López | Madrid, Spain

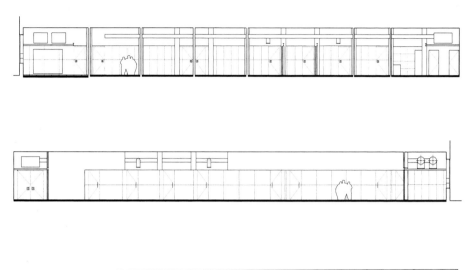

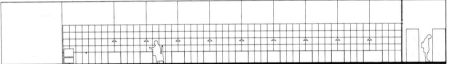

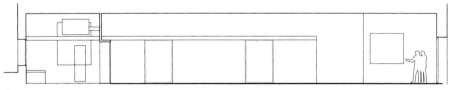

Sections

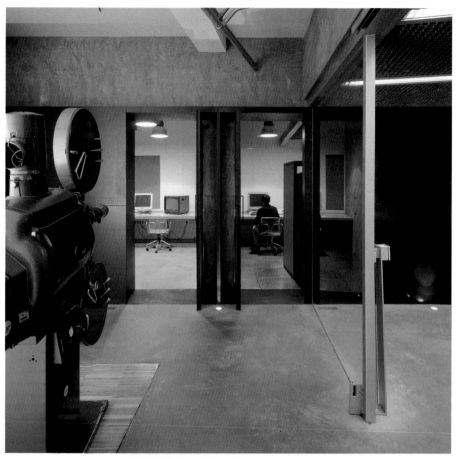

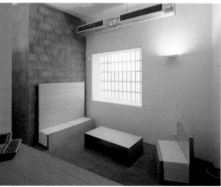

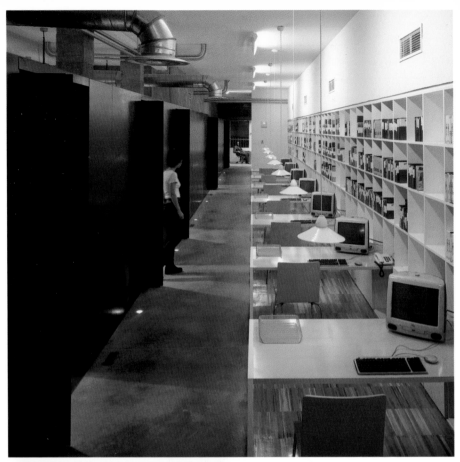

This renovation was dictated from the outset by the need to provide different rooms for different phases of making and editing videos, with each room having its own acoustics, temperature control, and light (both natural and artificial) requirements.

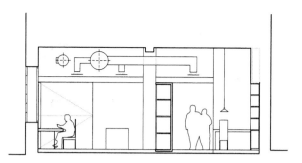

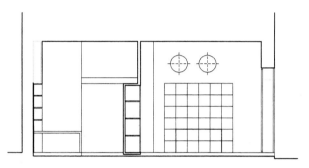

Sections

Floor plan

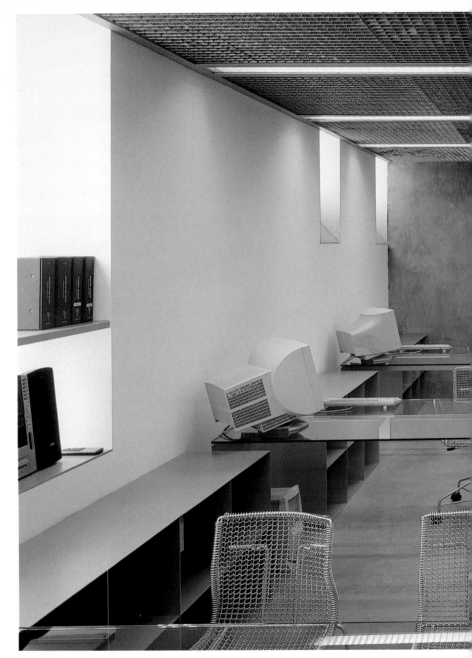

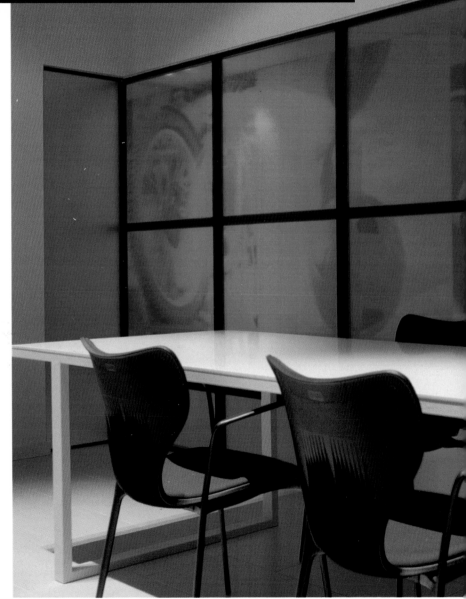

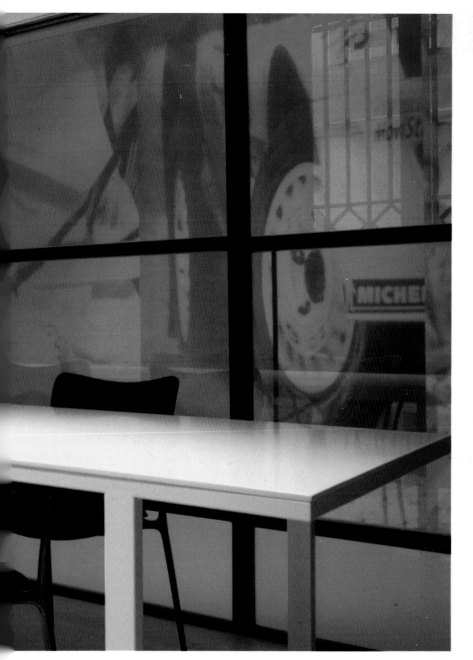

Francesc Rifé accomplished the transformation
of this 19th-century building into an avant-
garde and modern space by preserving its
architectural essence while renovating the
interiors in order to adapt them to the needs of
the client's business activities.

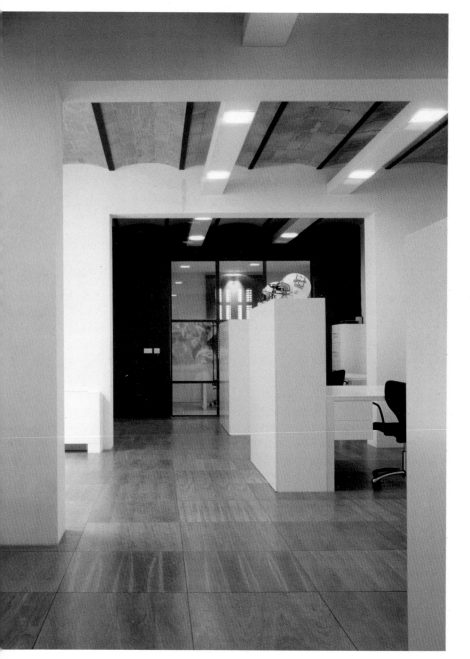

Second floor

First floor

Ground floor

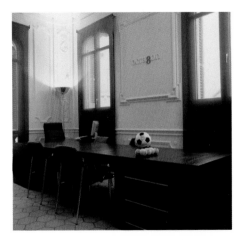

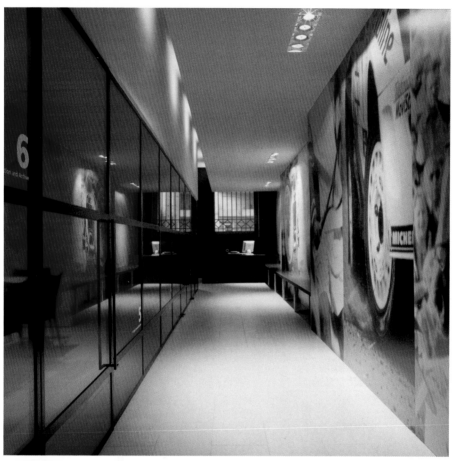

The chromatic strength of the color red, used on some of the walls, ceilings, and separation panels, contrasts with the purity and coldness of the metal structures, the parquet floors, and the simplicity of the furniture.

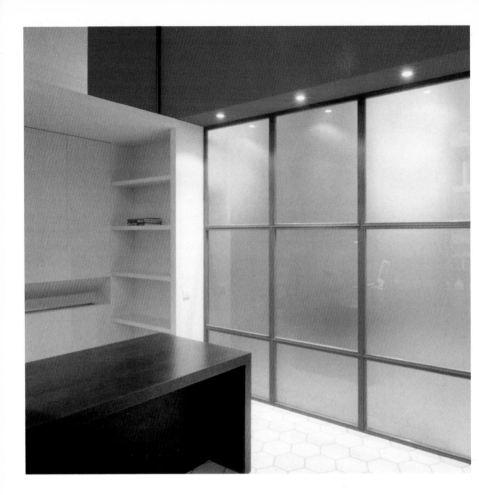

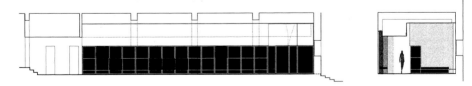

Section

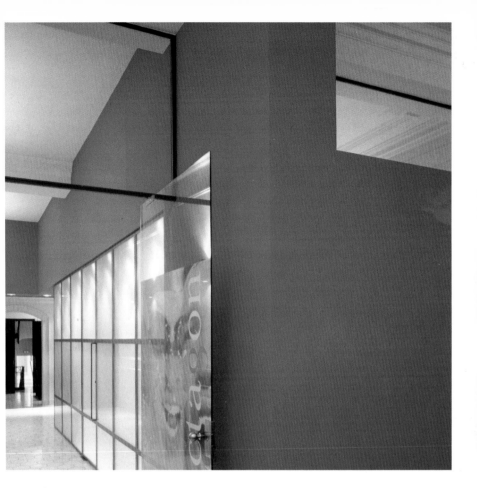

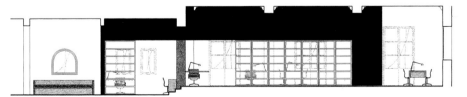

Section

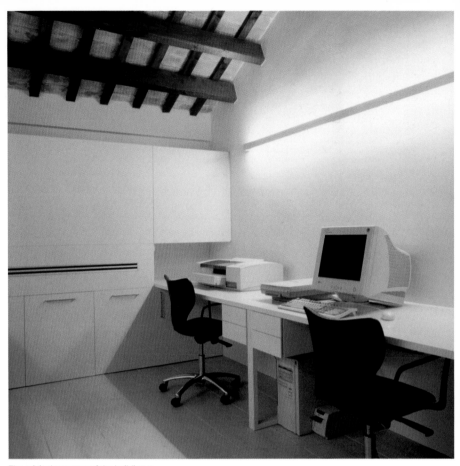

The original structure of the building, a
construction from the 19th century, was the
basis for the distribution of the newly
designed areas. The evocative architectural
lines, which truly take prominence in the
space, contrast dramatically with the discreet
and functional furniture.

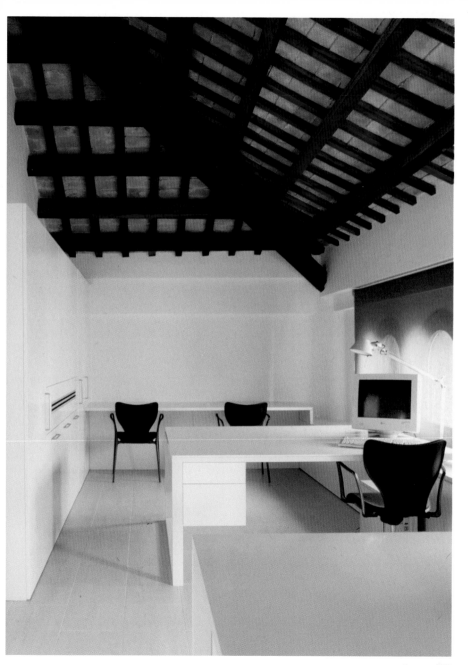

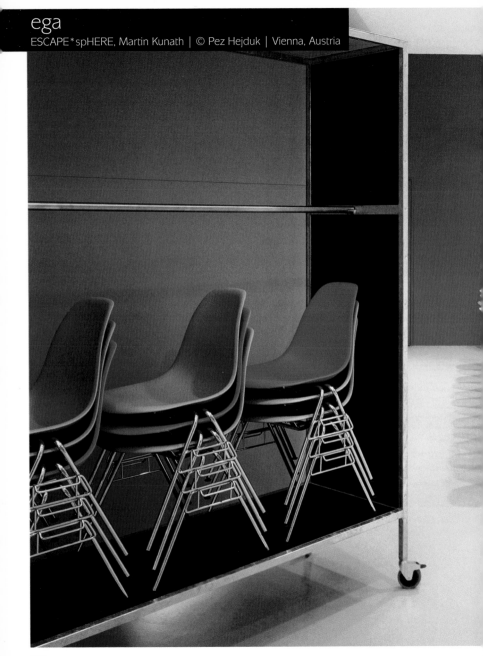

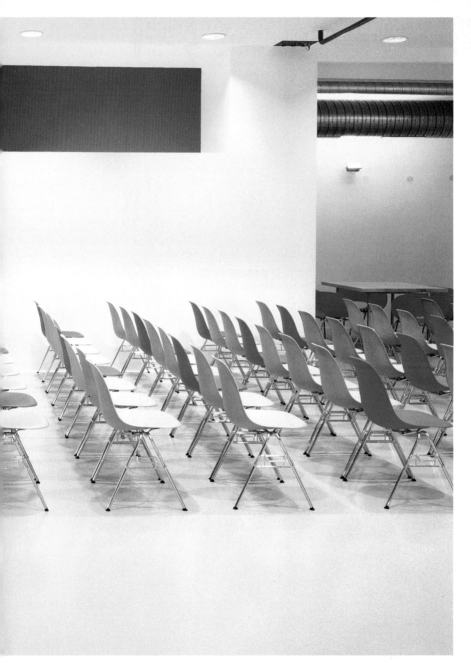

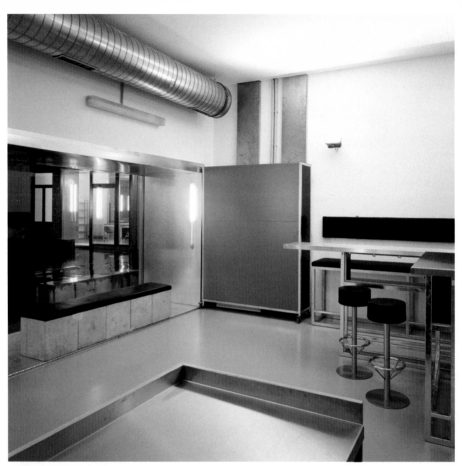

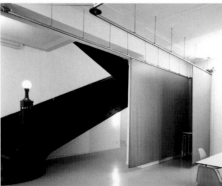

A system of flexible screens and rails anchored to the original ceiling makes it simple to rearrange the interior divisions.

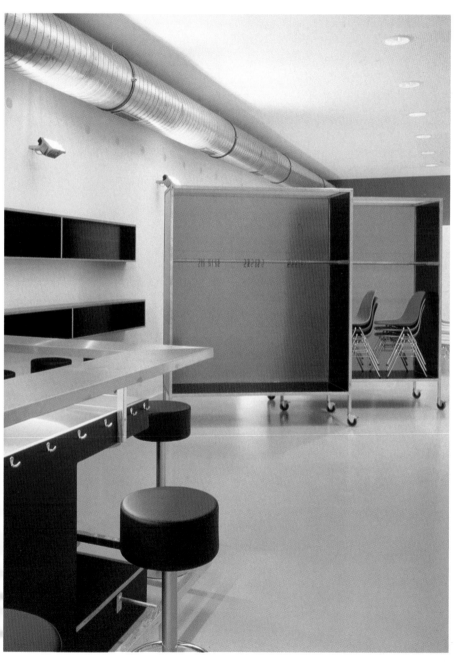

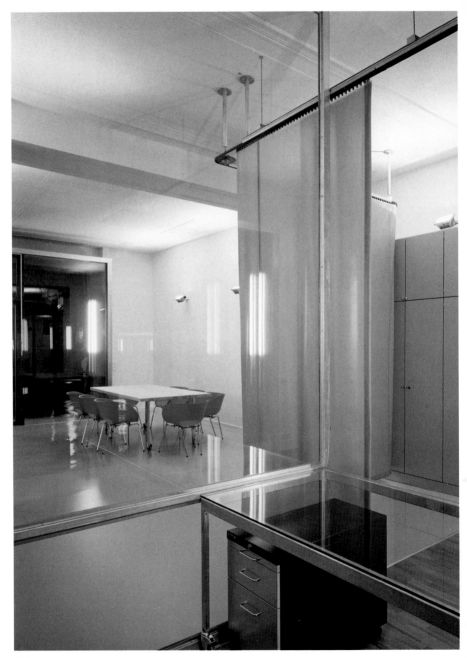

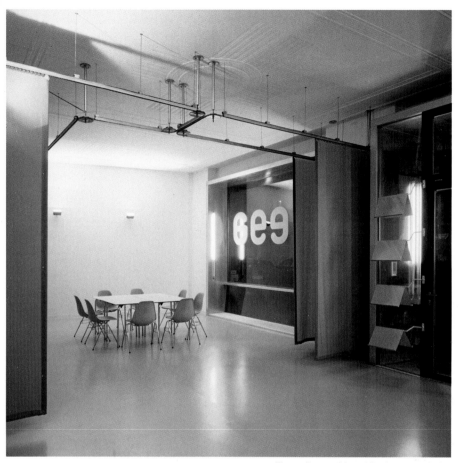

The textile material used for the screens makes both sides suitable for projecting images, as well as making it possible to use the reception area as additional classroom space.

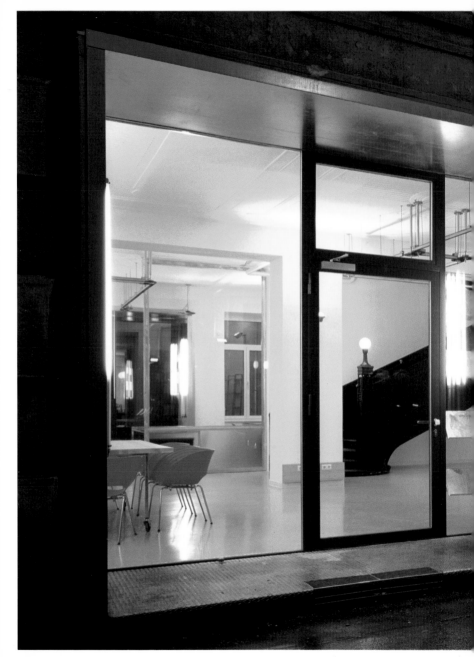

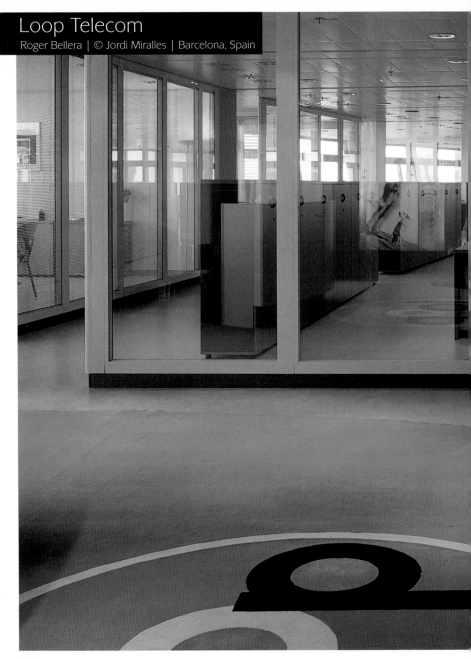

Loop Telecom

Roger Bellera | © Jordi Miralles | Barcelona, Spain

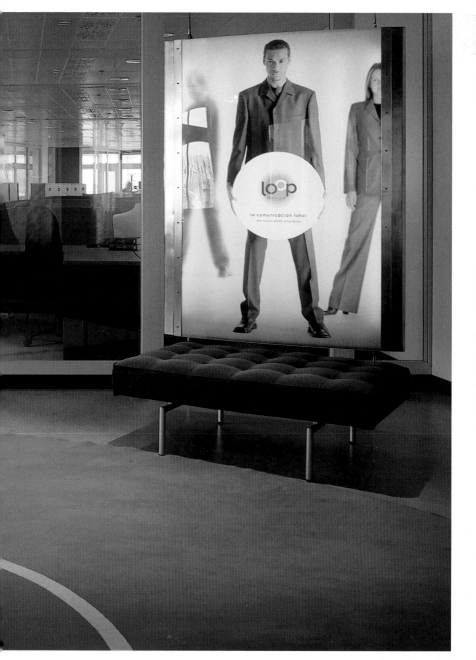

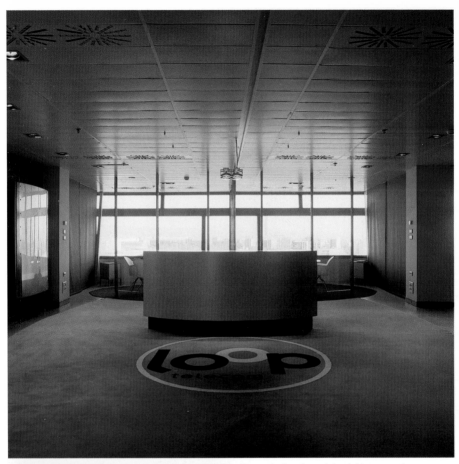

Chromatic diversity and visual richness are the main characteristics of Loop Telecom's lobby and reception areas, located in the North Building of the World Trade Center in Barcelona.

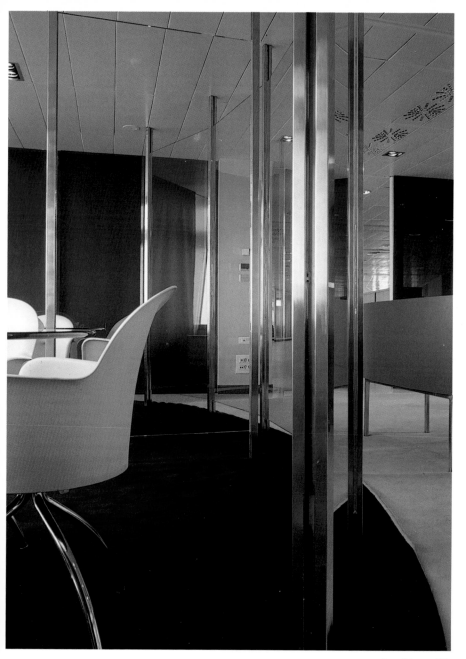

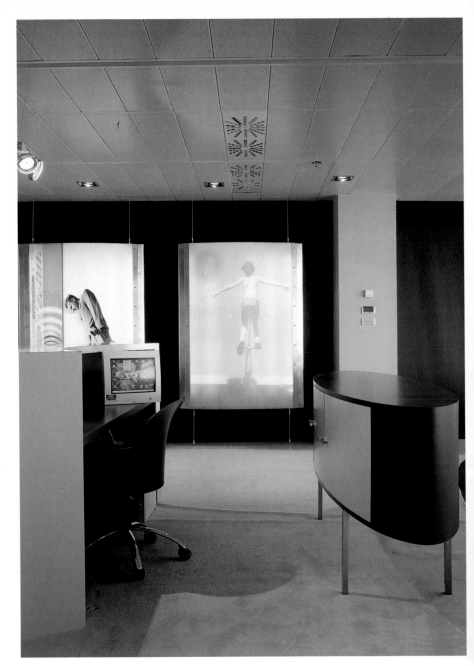

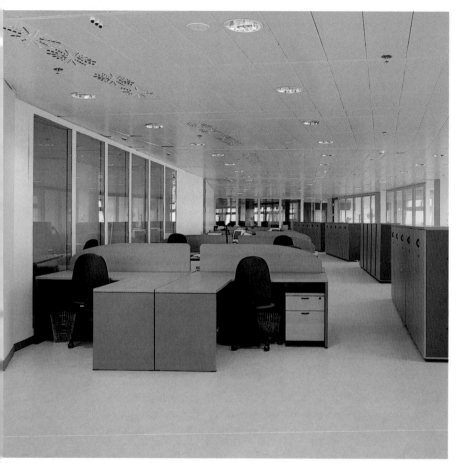

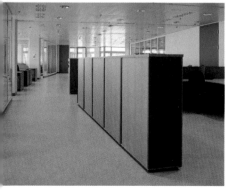

In order to emphasize the company's graphic and corporate image, the architect decided to combine materials and colors while distributing spaces into clearly distinctive areas.

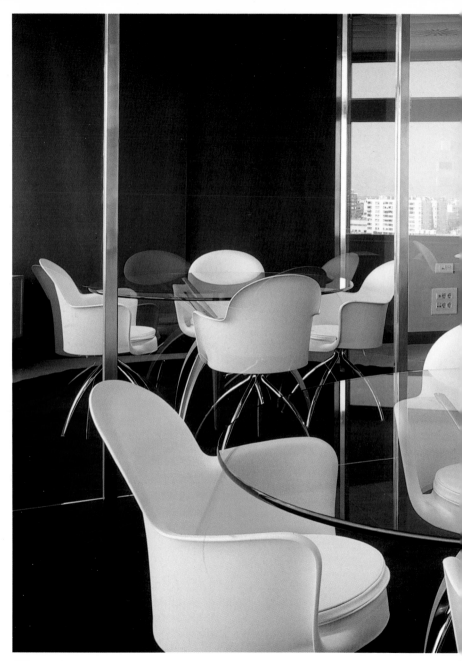

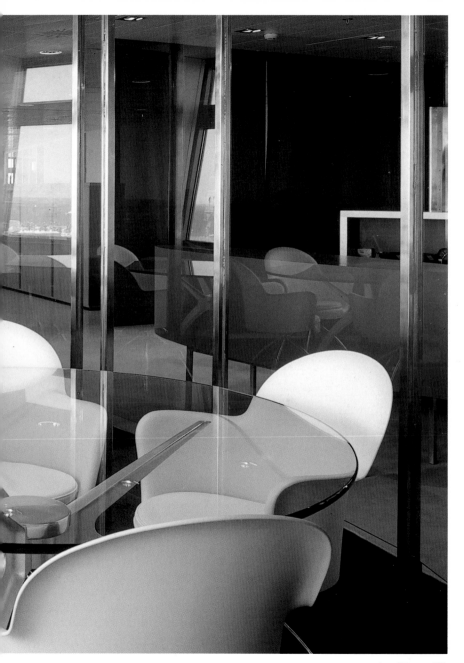

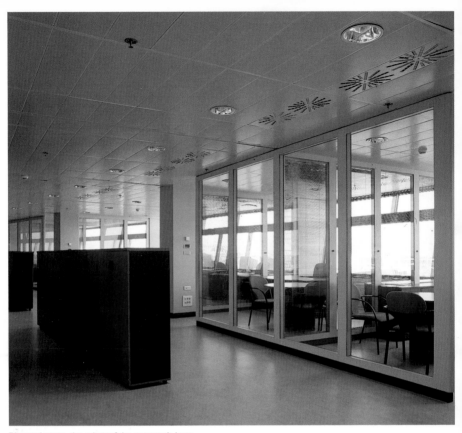

Blue and green, the colors of the company's logo, are the space's predominant tones, which bring a freshness and vitality to the carpet as well as to some of the furniture pieces and display units.

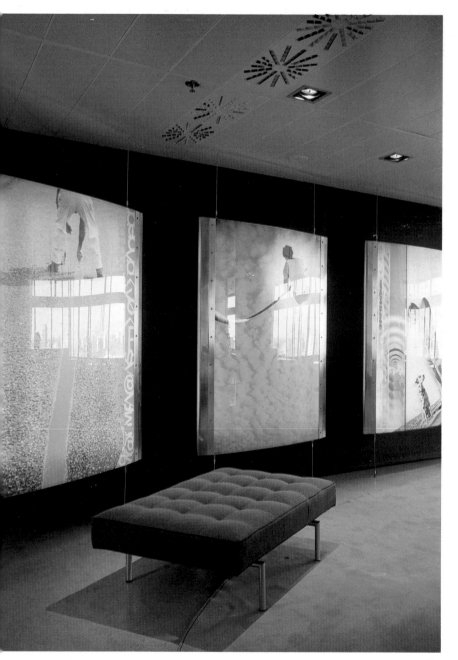

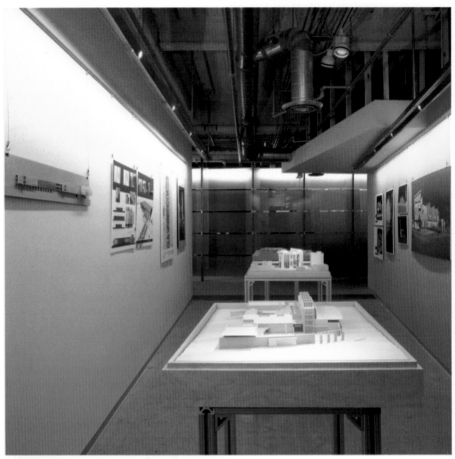

This project consisted of designing a new space capable of housing 100 employees, including architects, engineers, planning specialists, and administrative personnel. The space was finished as if it were a loft, a concept that is highlighted by the use of concrete, wood, and glass.

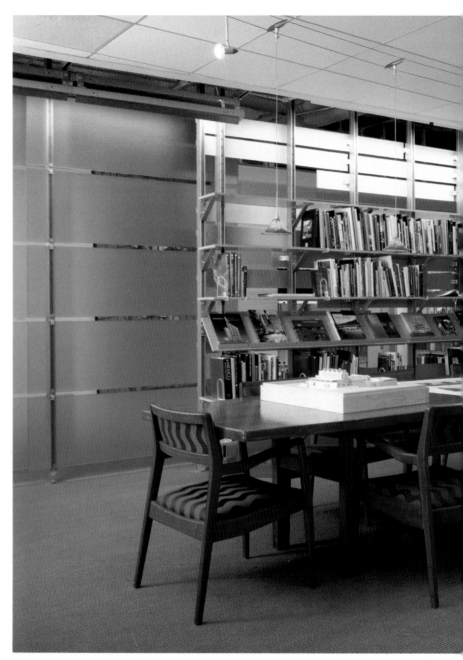

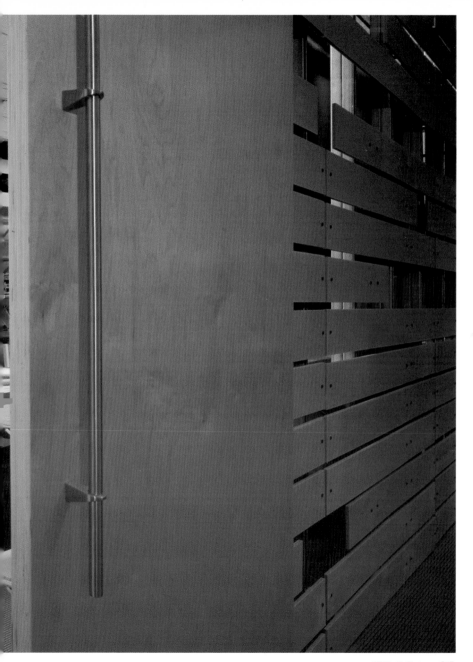

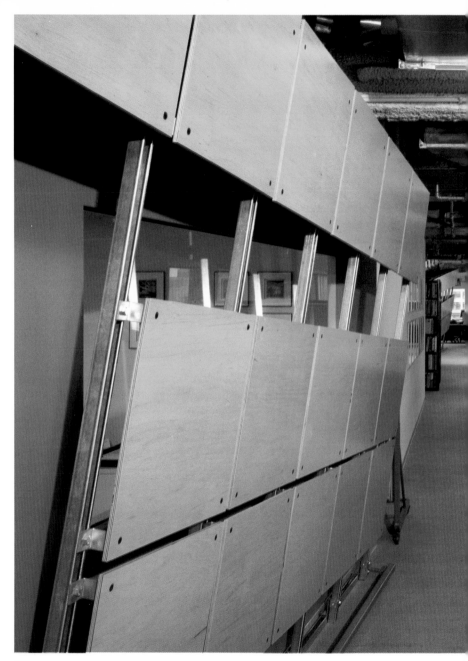

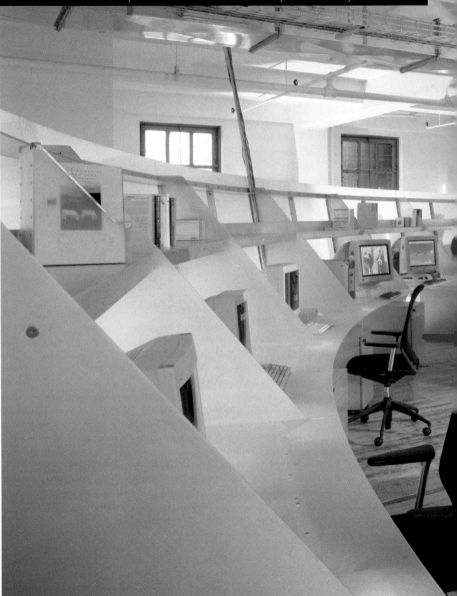

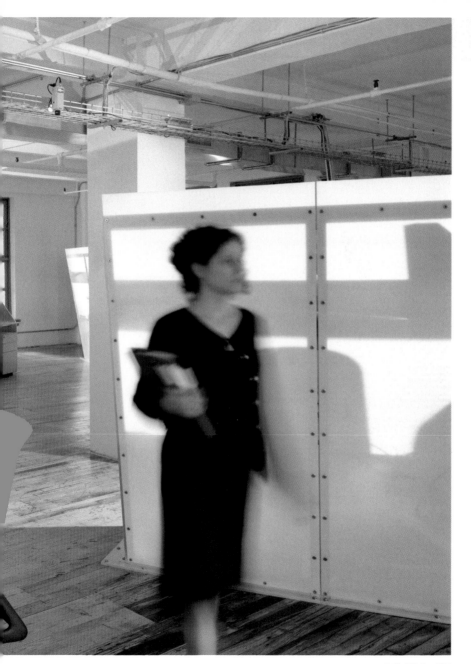

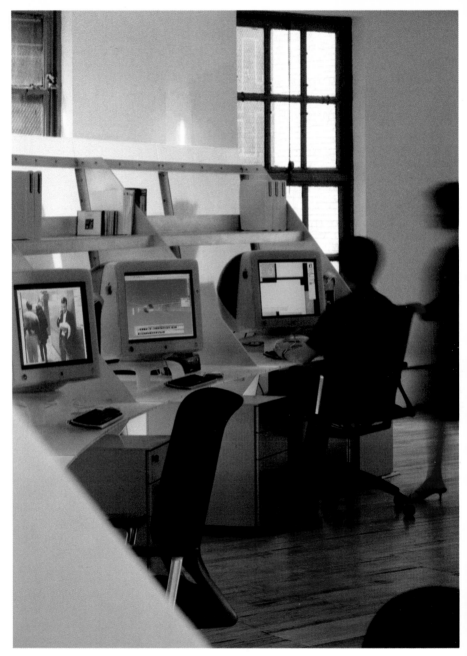

In the design of this space, the goal was to create flexible, dynamic, practical, and functional areas where work could be carried out as comfortably as possible. To achieve this, the appropriate resources and materials were used, such as the movable panels; wood, aluminum, and Plexiglas; and the carefully planned spatial organization.

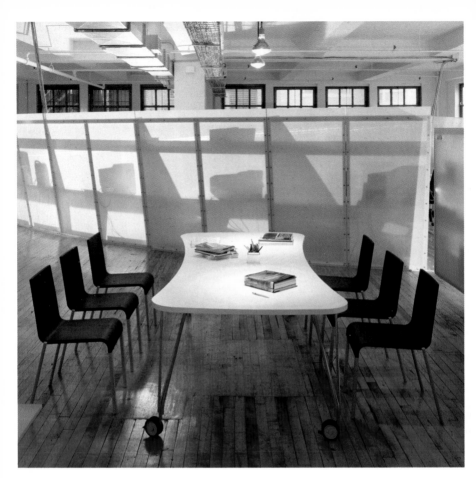

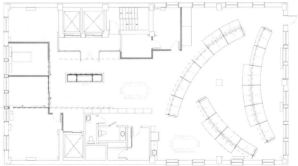

Floor plan

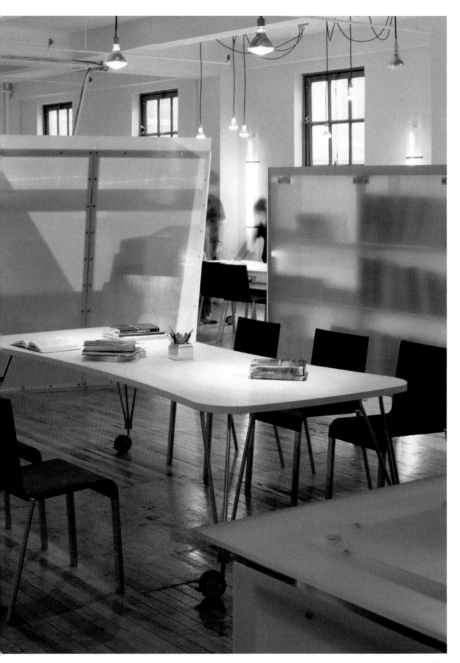

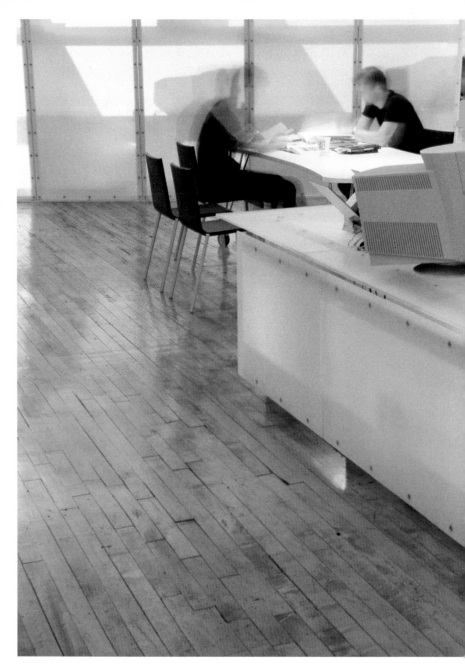

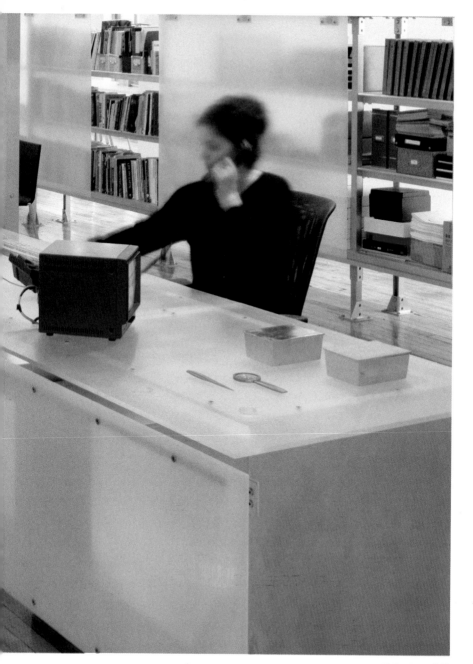

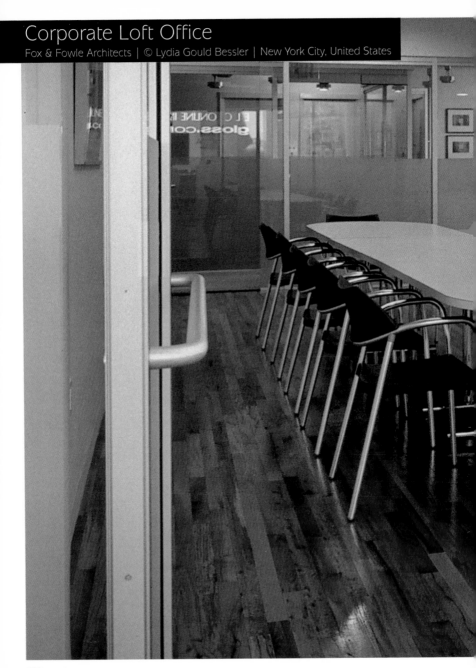

Corporate Loft Office

Fox & Fowle Architects | © Lydia Gould Bessler | New York City, United States

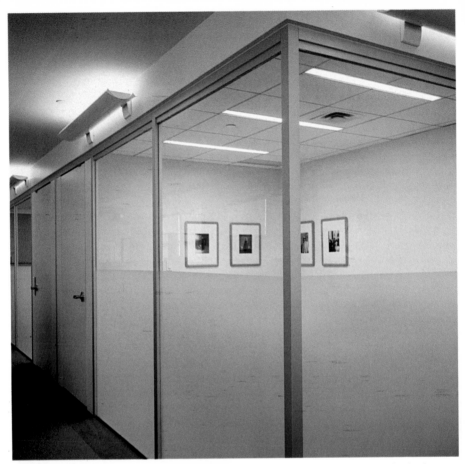

The architects decided to create welcoming interiors and environments that resemble domestic spaces more than work areas. Color is used very playfully, blatantly, and expressively in some areas, and warm textures and materials are used together with comfortable and functional furnishings.

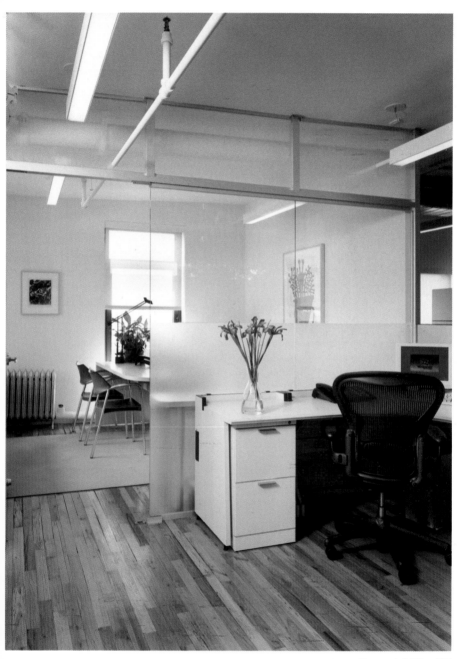

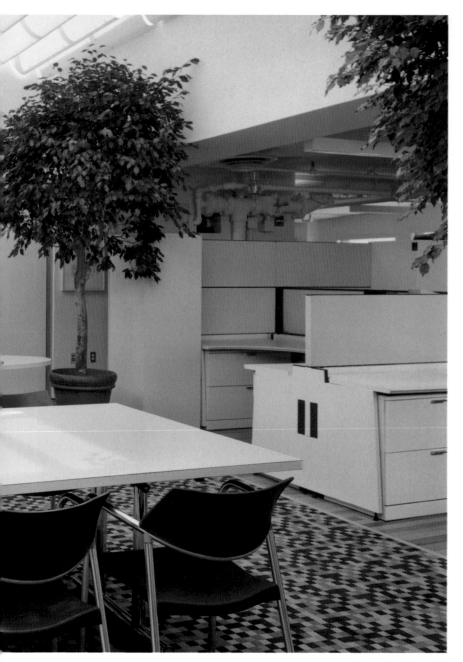

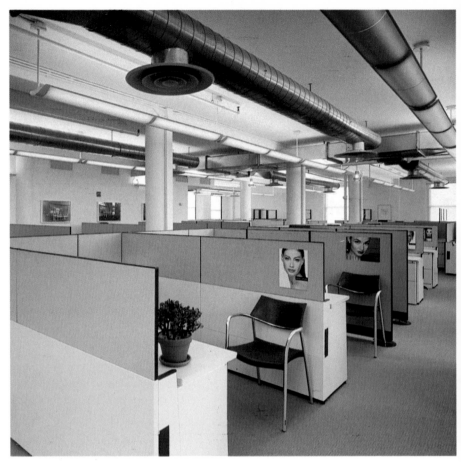

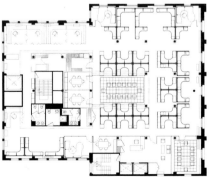

Floor plan

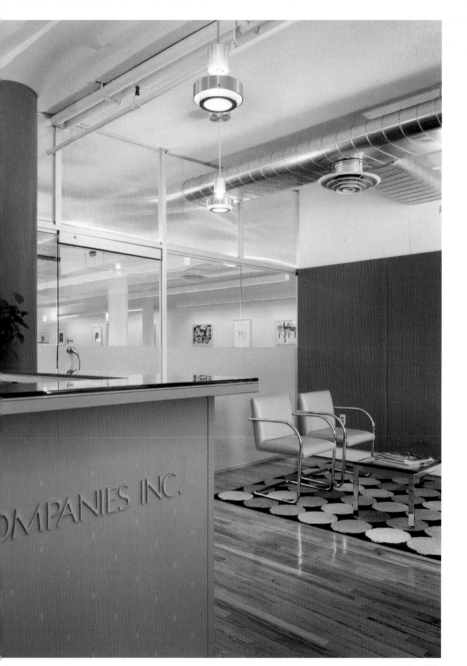

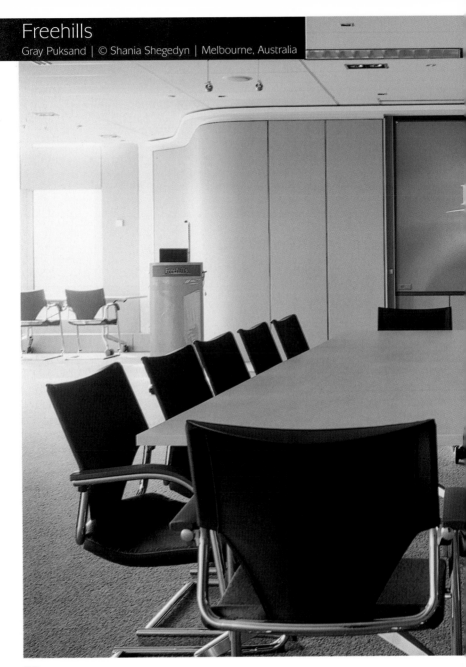

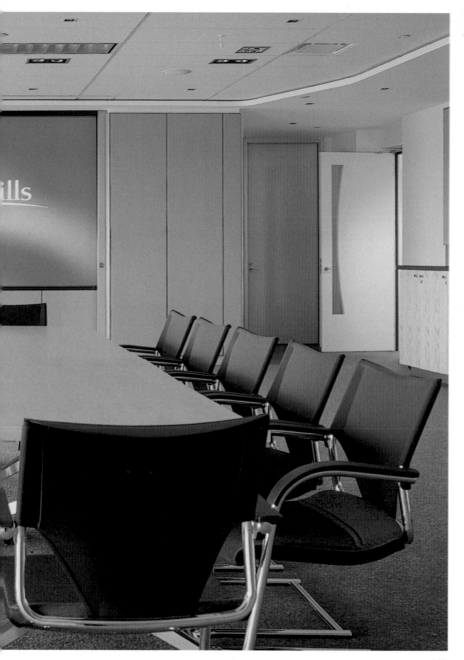

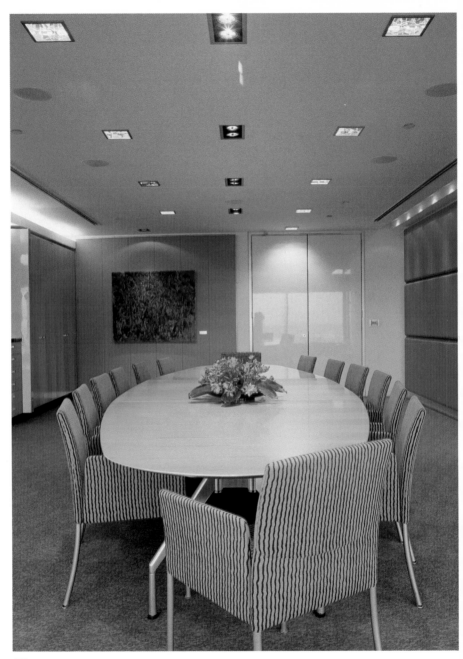

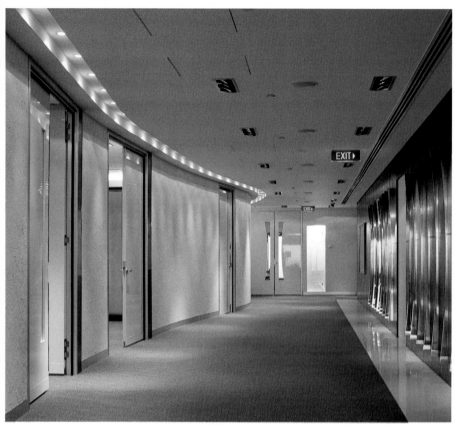

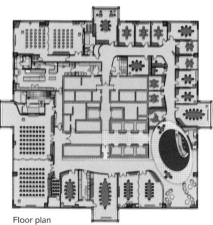

Floor plan

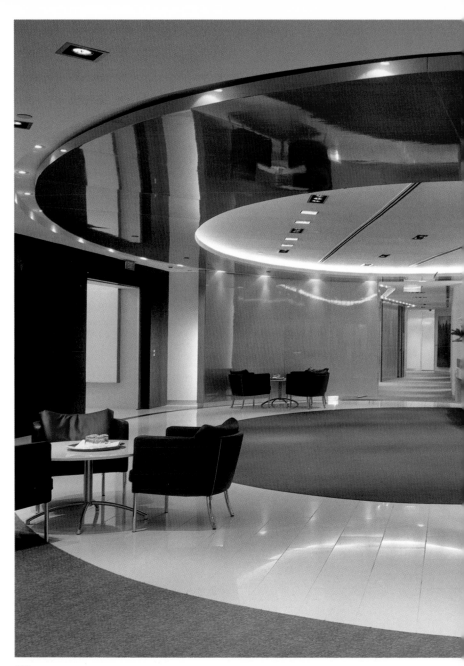

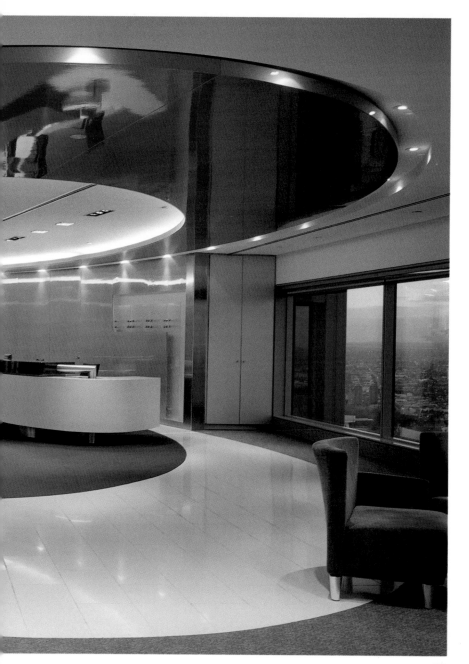

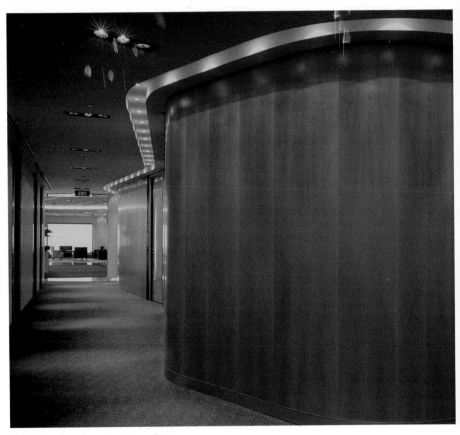

The functional requirements of these offices
dictated the design of a free-flowing and flexible
space where the different work areas—meeting
rooms, offices, common areas, dining room,
teleconferencing rooms, and reading rooms—are
connected in a natural and organized manner,
allowing the functions for which they were
intended to take place with maximum comfort.

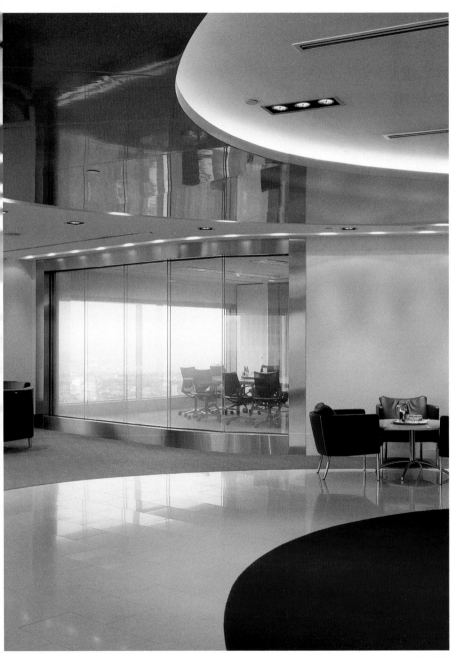

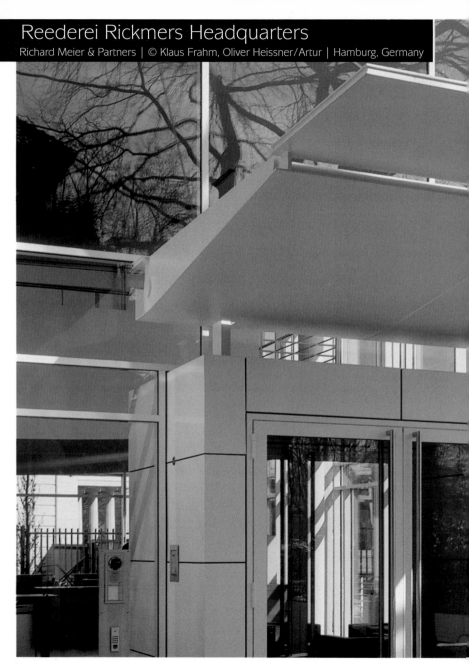

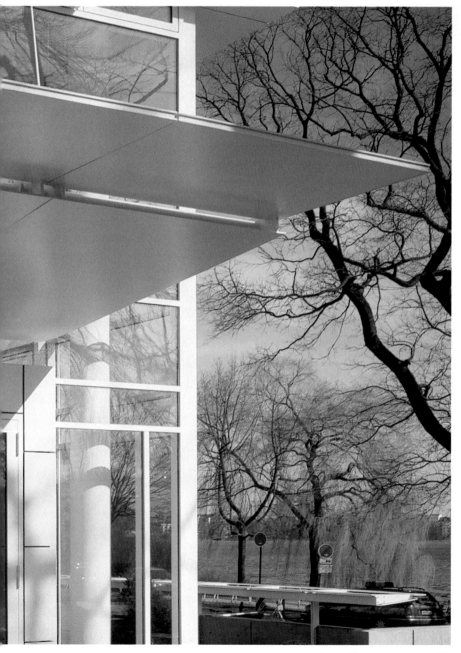

This project consists of a sober and rational space that pairs the most absolute modernism with the elegance of classicism. The main façade is made almost entirely of glass and extends above the rest of the building. The volume is slightly curved and resembles a sail propelled by the wind in the middle of the ocean.

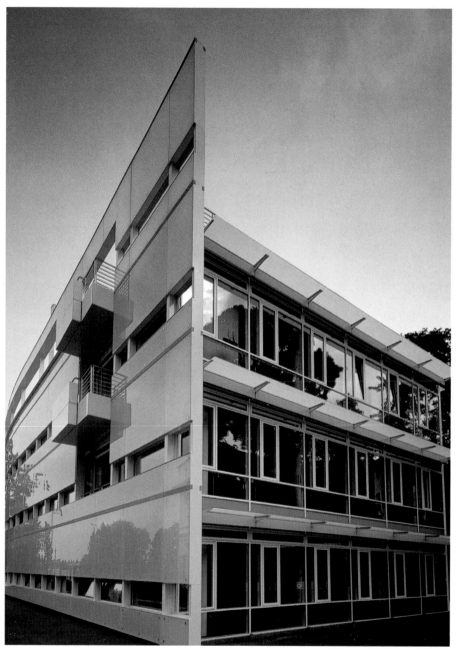

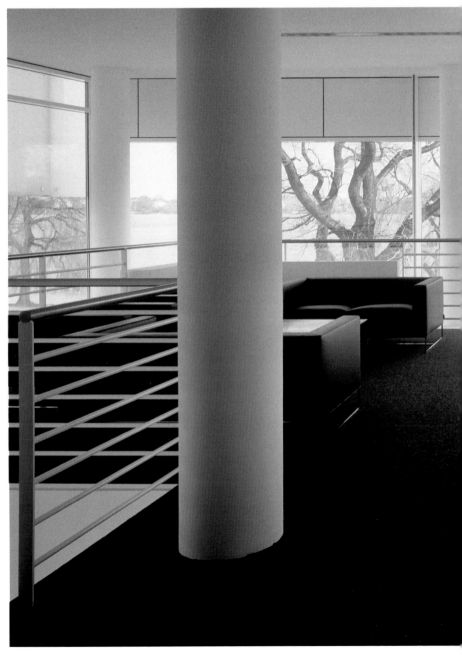

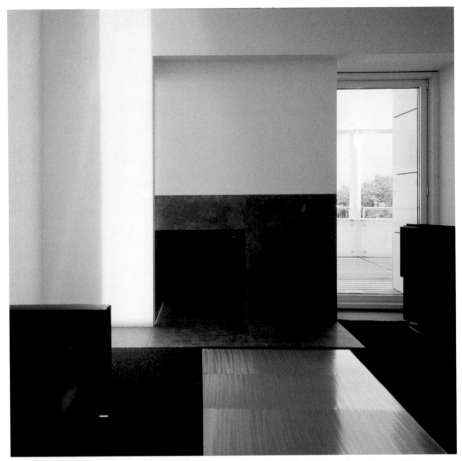

Everything in the interior of the building reflects austere spaces that were conceived as reminders of the firm's maritime activities.

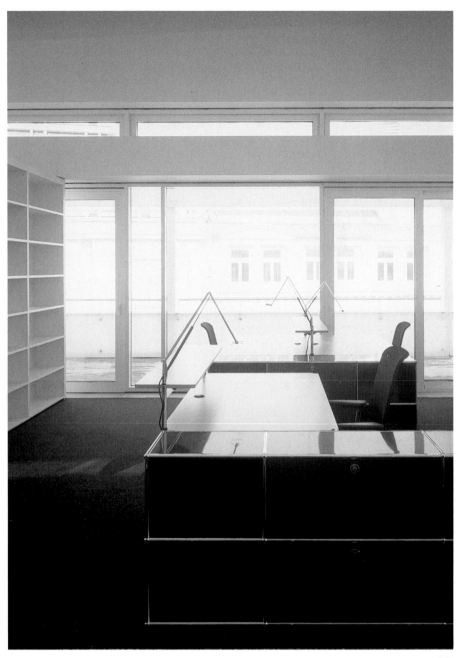

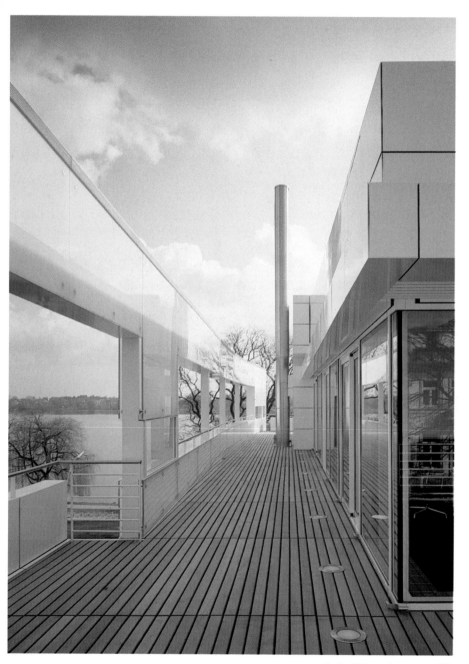

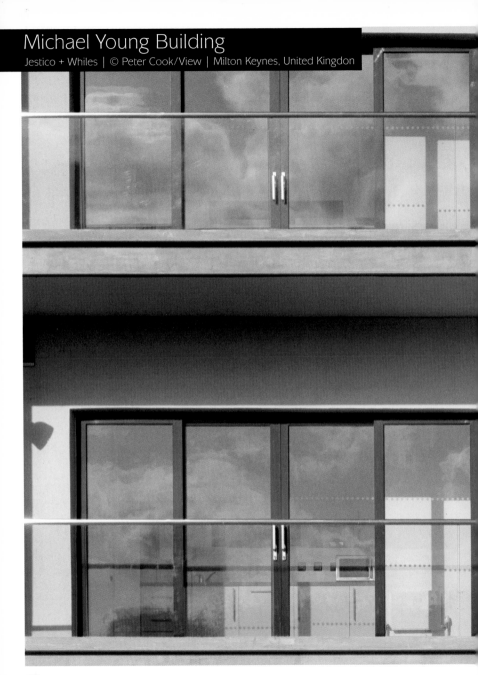

Michael Young Building

Jestico + Whiles | © Peter Cook/View | Milton Keynes, United Kingdon

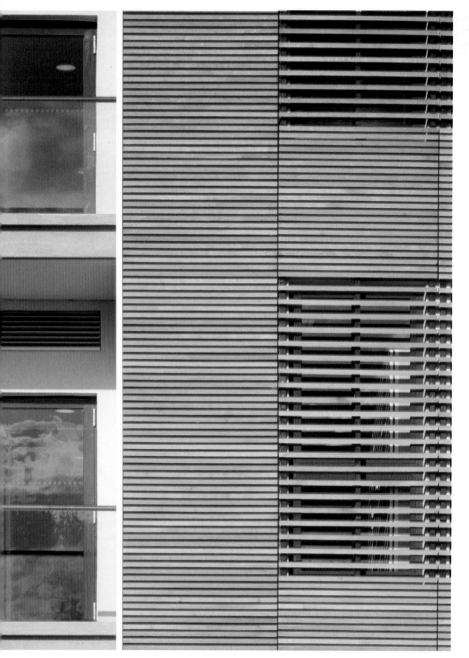

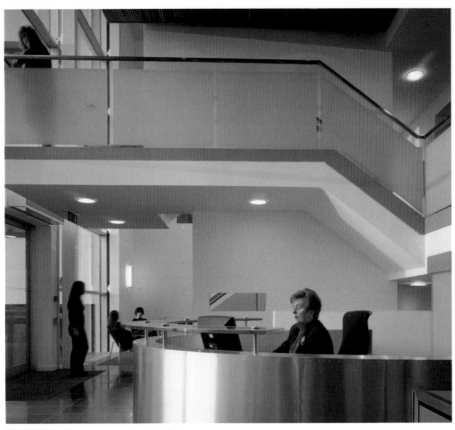

The selection of materials for both the exterior
and the interior was based on the pursuit of
clarity and transparency. This is why glass and
polished surfaces that reflect light and color
abound. Aluminum, concrete, and steel are the
structural elements that make up the restrained
palette of materials, colors, and textures that
dominate the project.

Site plan

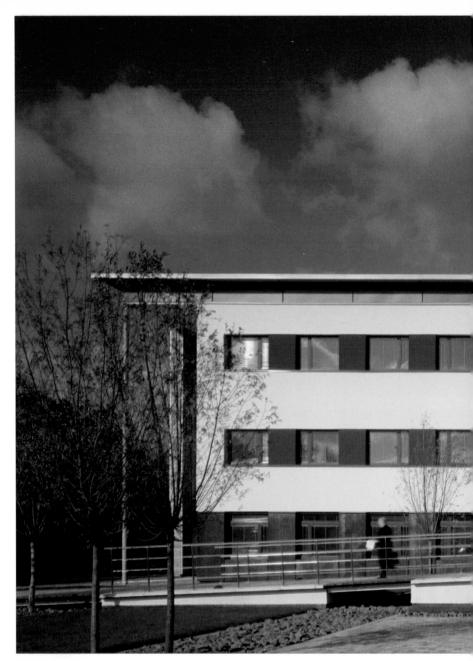

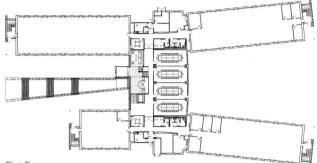

First floor

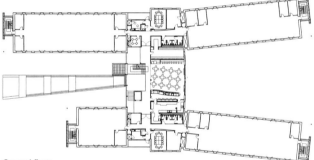

Second floor

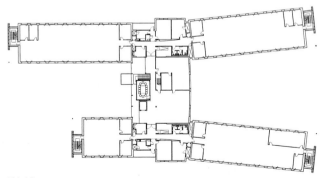

Third floor

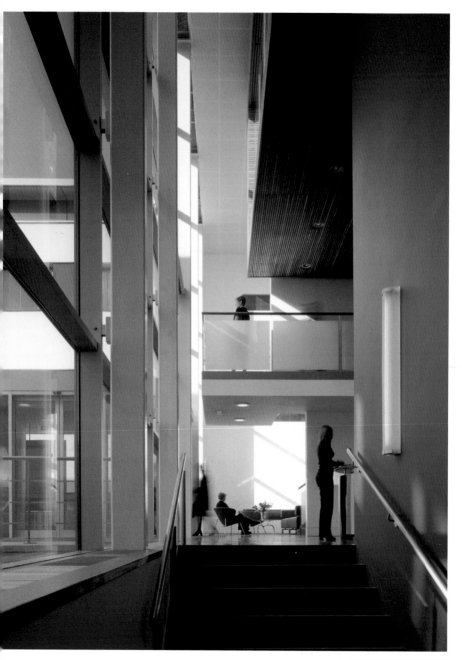

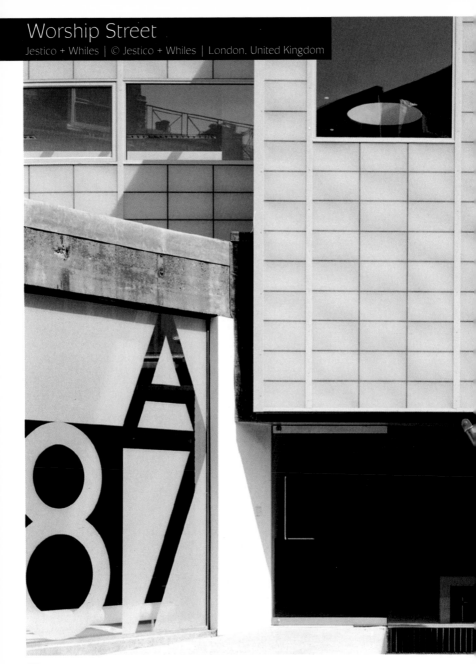

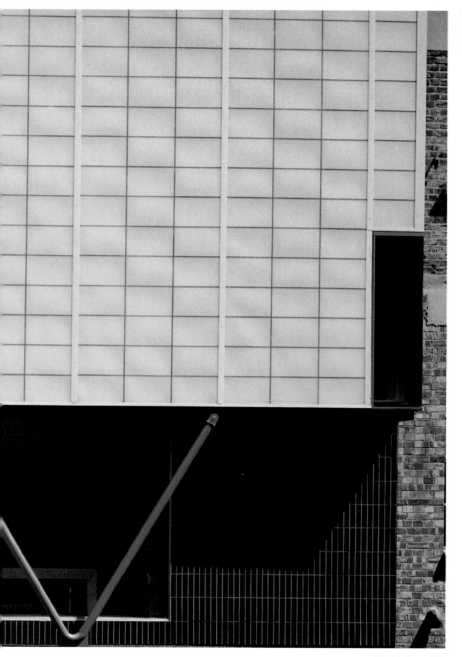

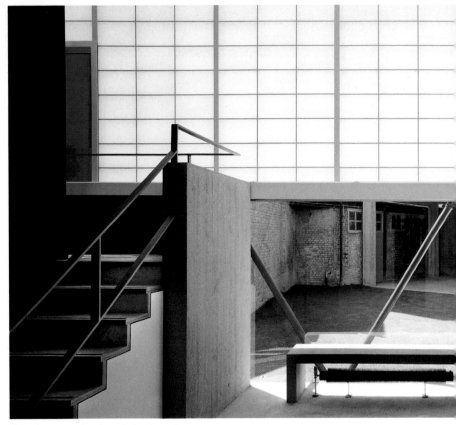

The treatment used on the main façade can be seen
clearly from the inside. The metal-outlined glass
panels replace traditional heavy walls, establishing
the transition between outdoors and indoors.

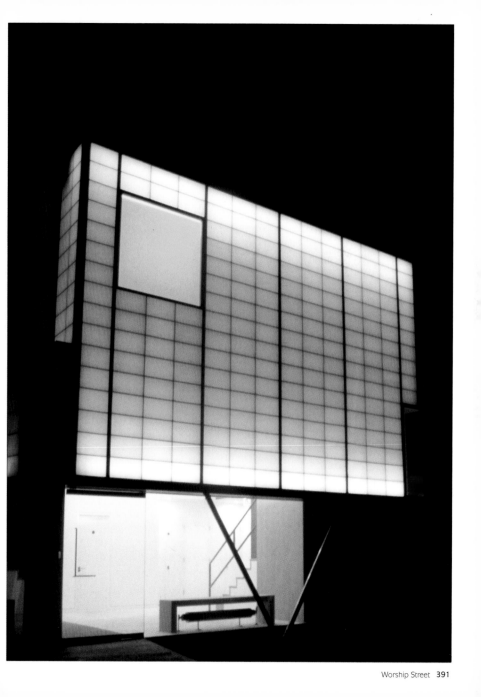

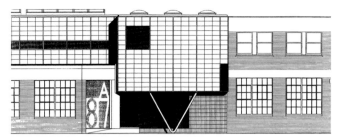

Courtyard elevation

Sections

Ground floor

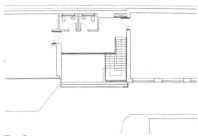

First floor

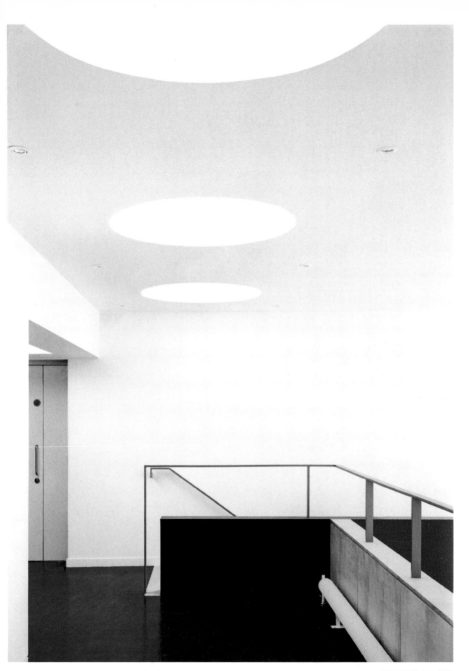

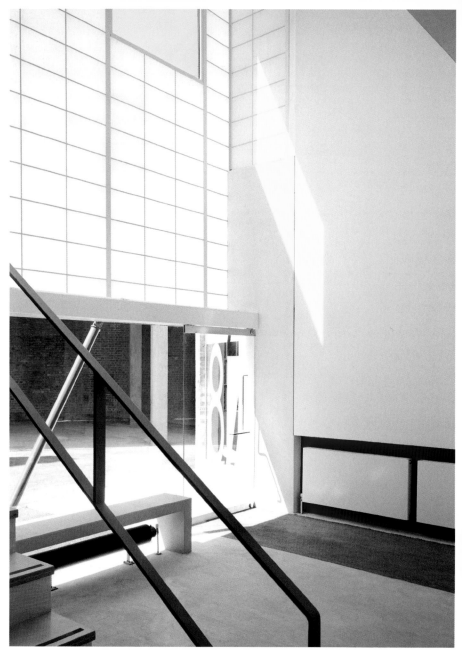

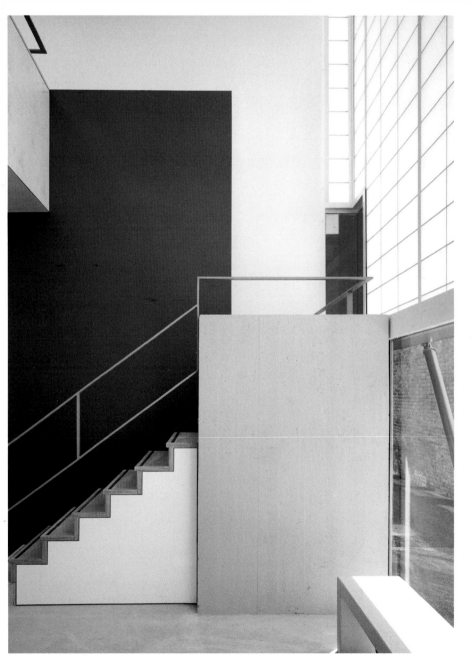

396

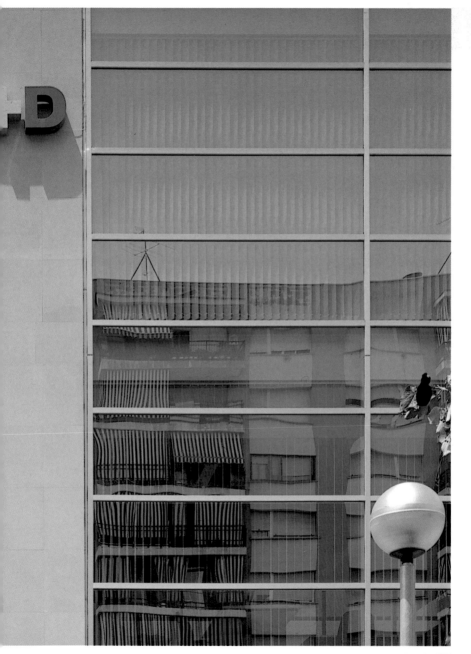

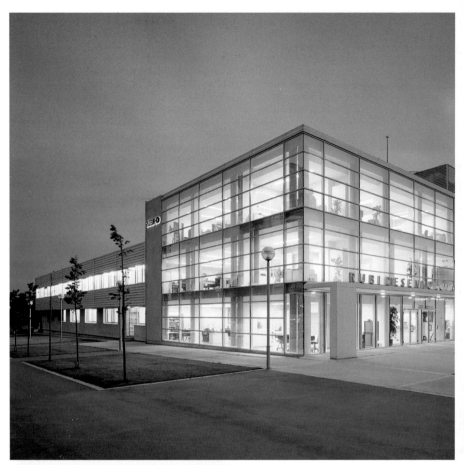

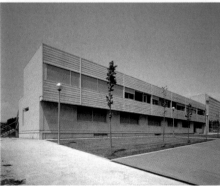

This building is located on a triangular lot with a gentle slope, aspects that were kept in mind during the design process. The central volume was designed in the shape of a cube and is divided into various levels for different functions.

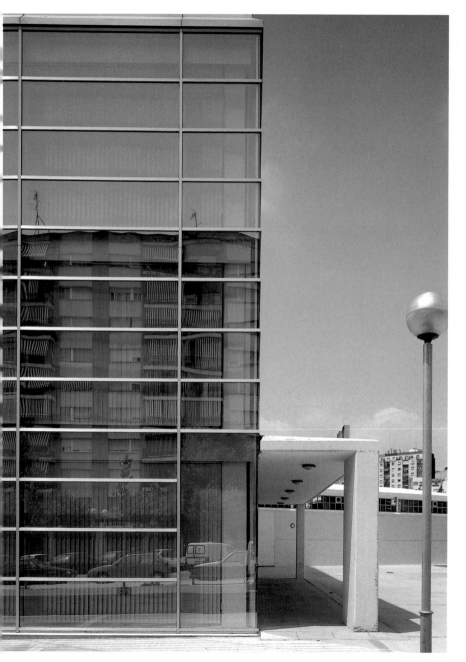

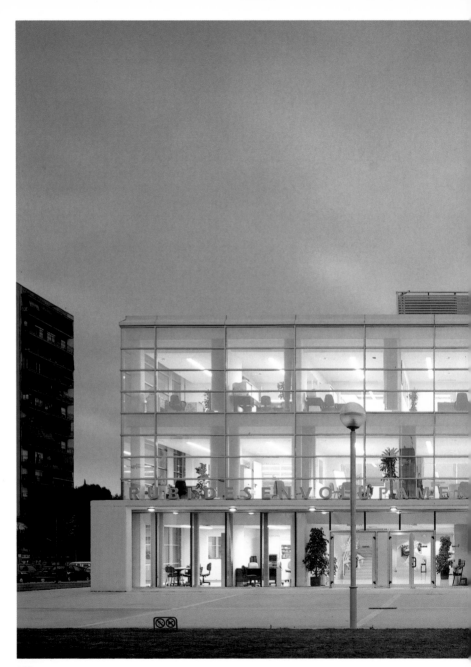

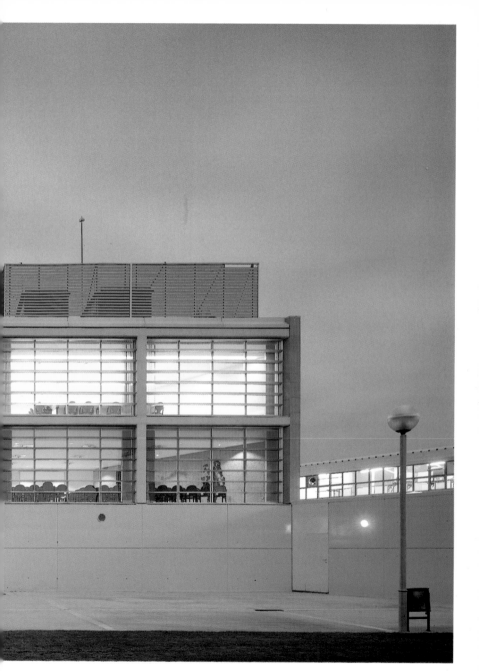

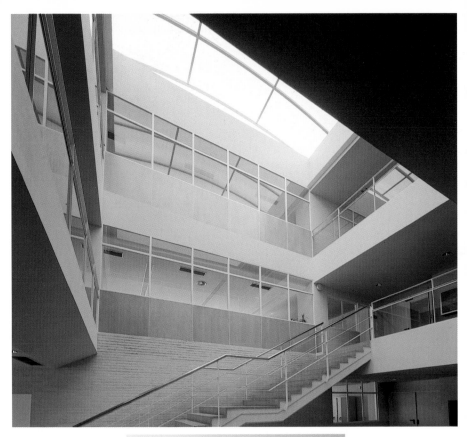

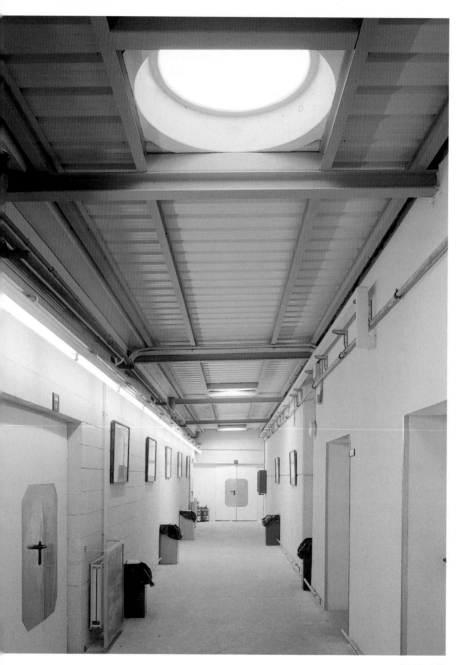

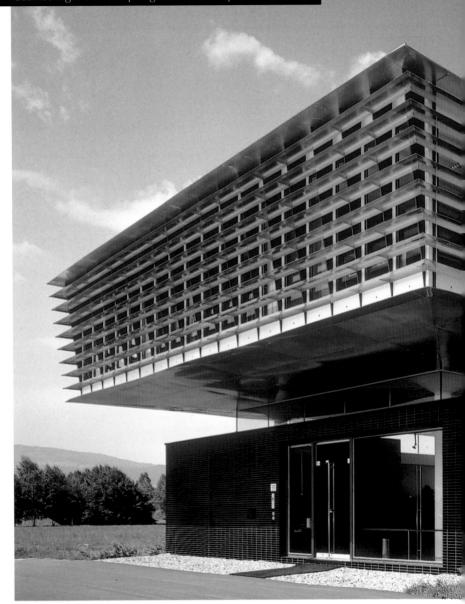

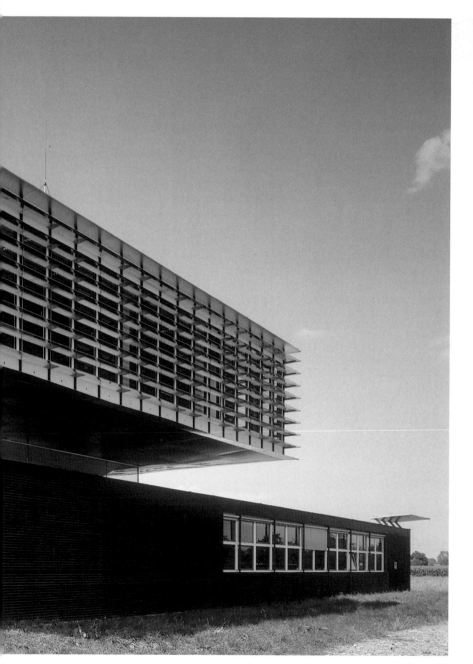

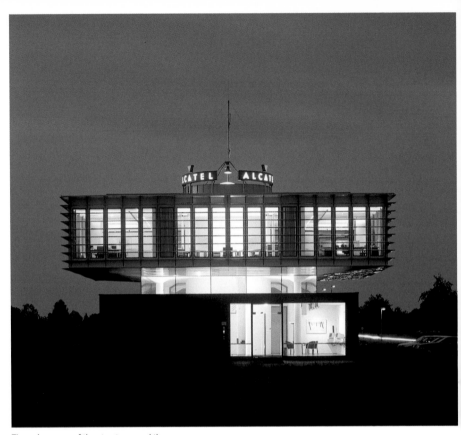

The uniqueness of the structures and the contrast of the materials create an unusual but attractive building that is contemporary in design and has little relation to the factories of the past.

Site plan

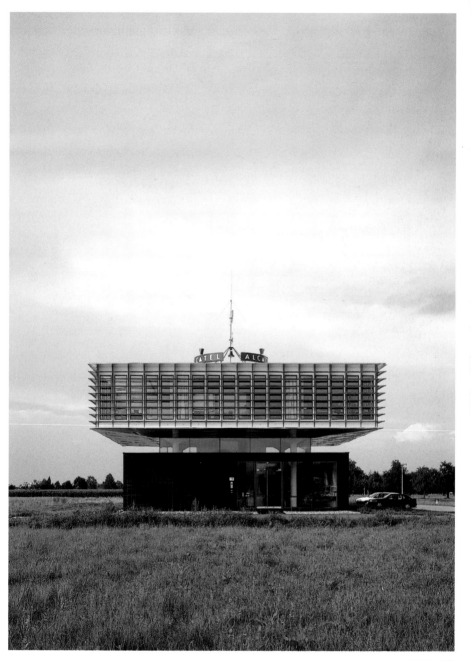

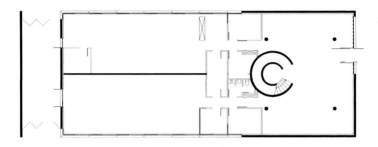

First floor

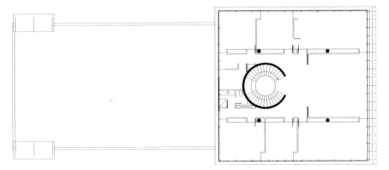

Second floor

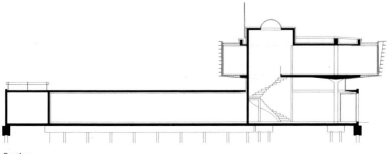

Section

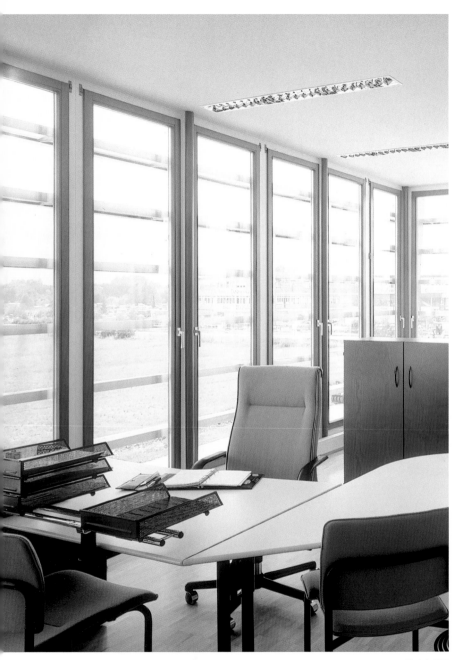

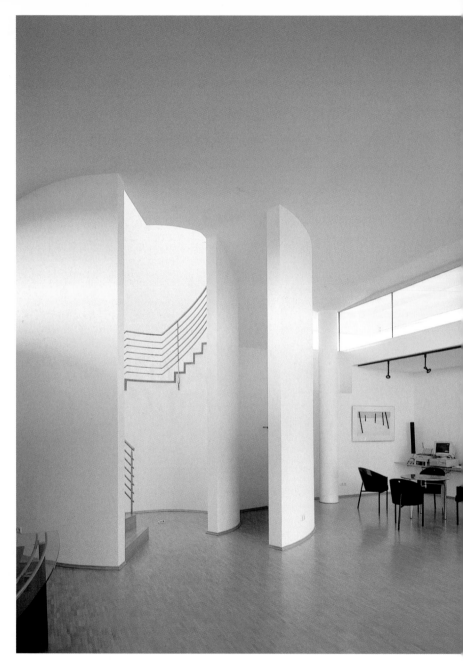

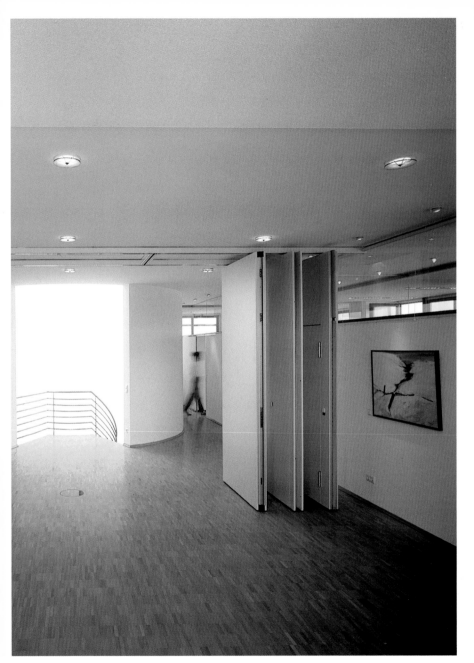

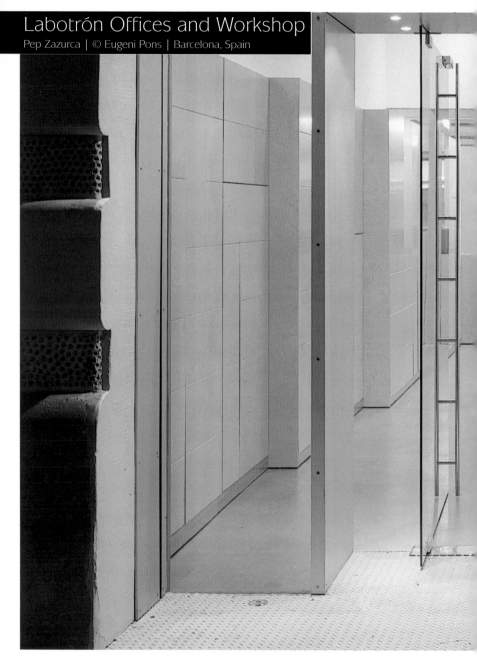

Labotrón Offices and Workshop

Pep Zazurca | © Eugeni Pons | Barcelona, Spain

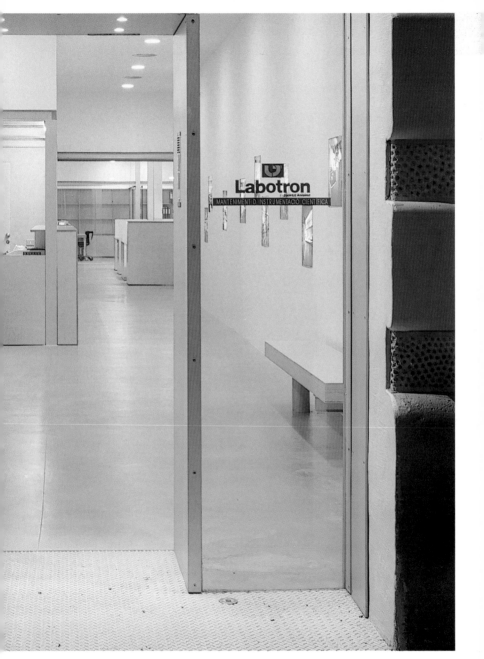

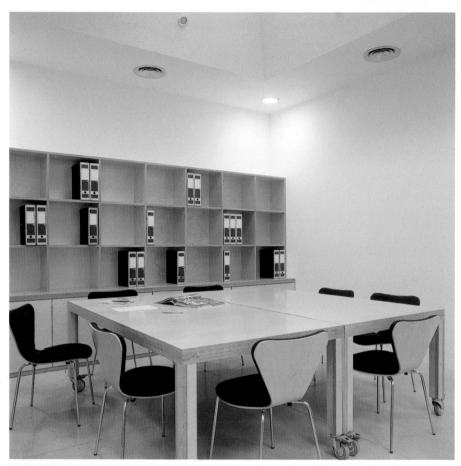

Poured concrete was the treatment chosen for
the floors, while glass doors and screens made
of light-colored laminated wood were selected
to prevent visual distractions and the loss of
natural light.

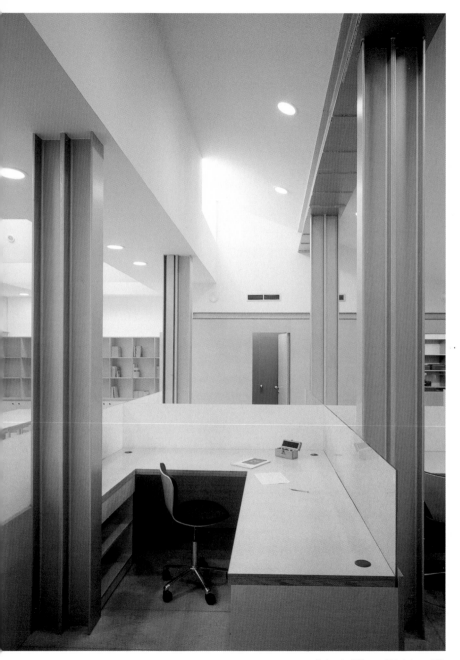

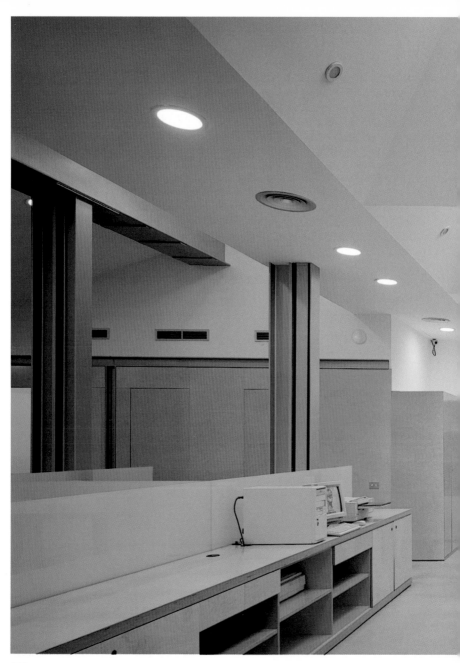

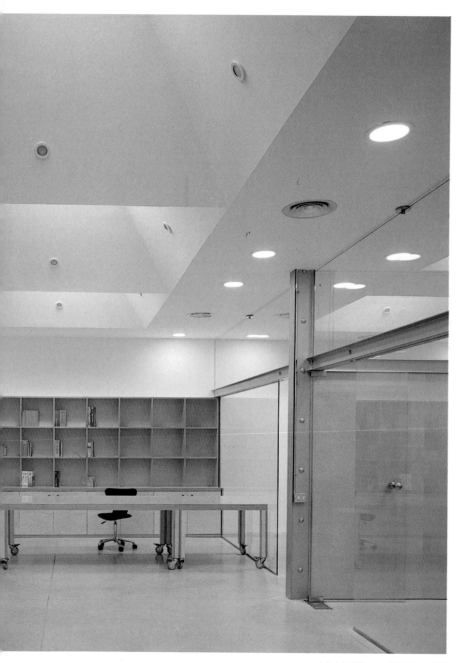

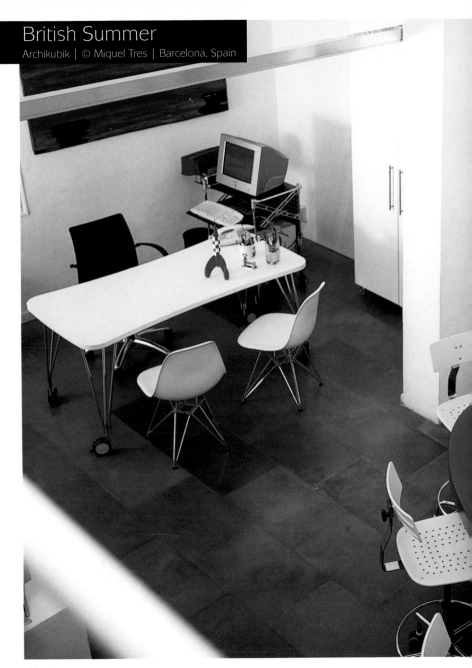

British Summer

Archikubik | © Miquel Tres | Barcelona, Spain

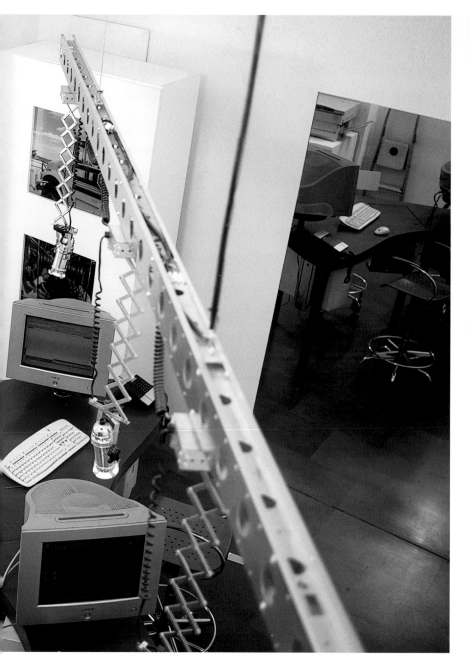

The play of colors changes with the time of day
and the season of the year: yellow for day, blue
for night, red for summer, and purple for winter.

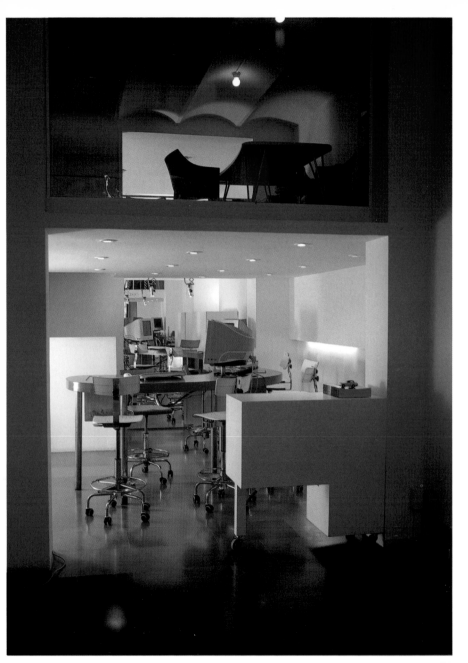

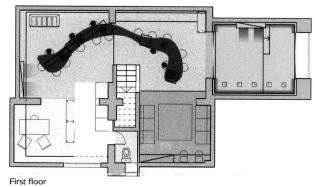

First floor

Second floor

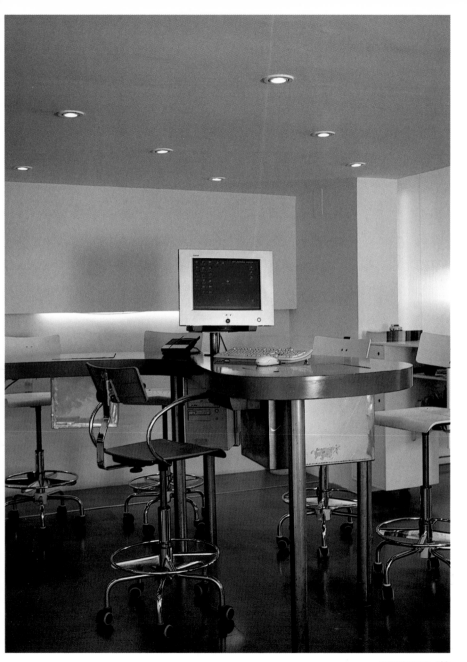

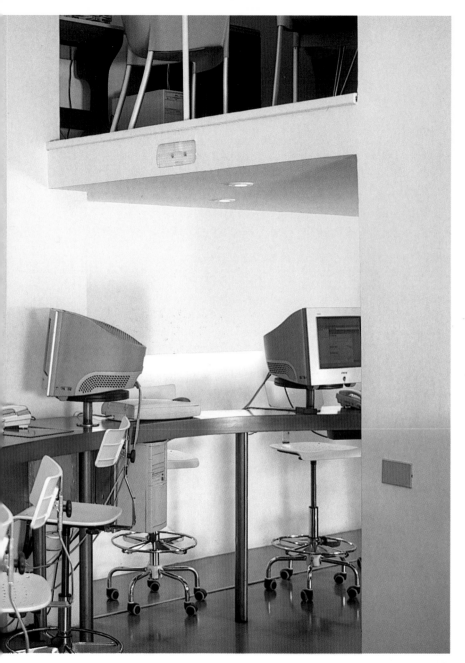

The polycarbonate lighting employed in the
entrance area creates a unique interaction
between the inside and the urban environment
outside. Different atmospheres are created by
changing the colors of the fluorescent lights.

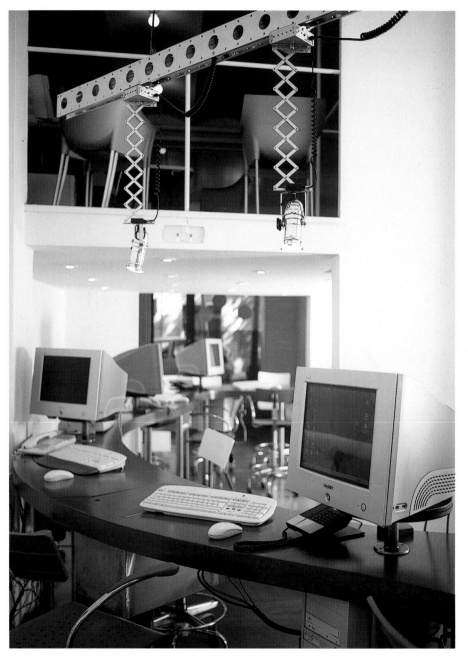

Pawson Office

John Pawson Architects | © Richard Glover, Dennis Gilbert/View | London, United Kingdom

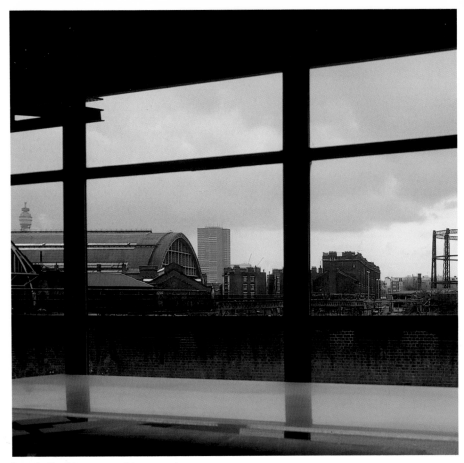

From the first floor entrance, visitors can enjoy a
panoramic view of the industrial area right behind
St. Pancras Station.

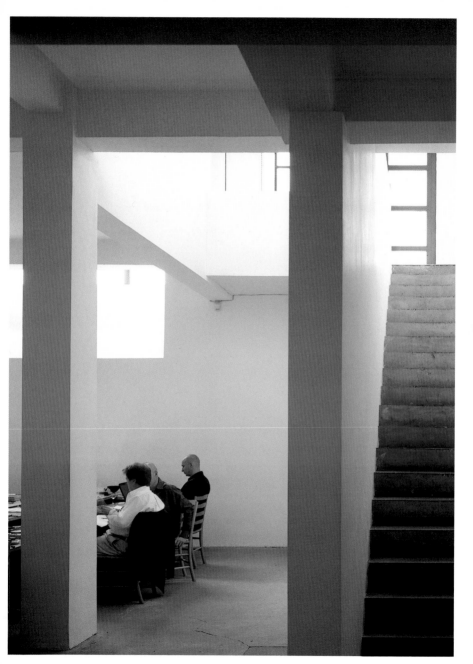

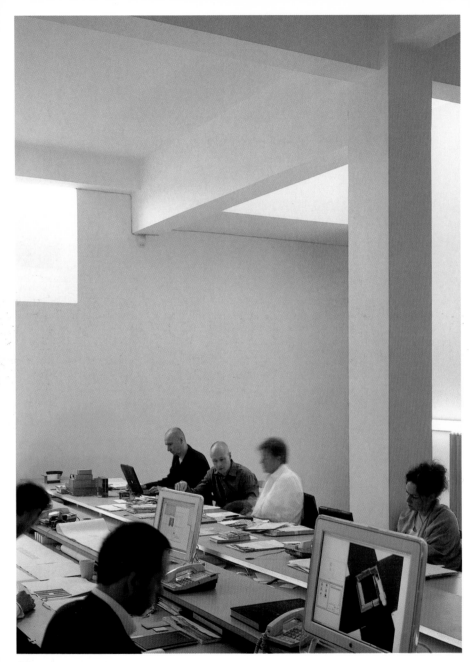

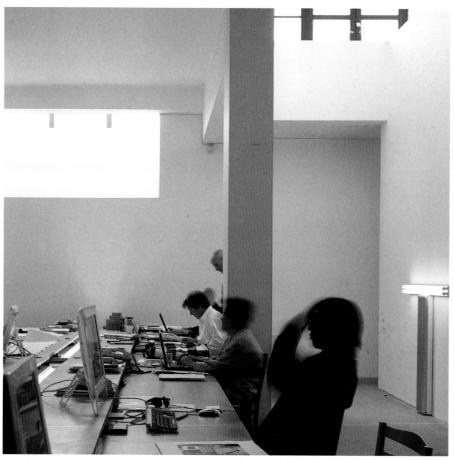

A large opening at the first floor level allows natural light to flood the office space. The large central desk has different levels to provide well-defined areas for work, equipment, and electrical fixtures.

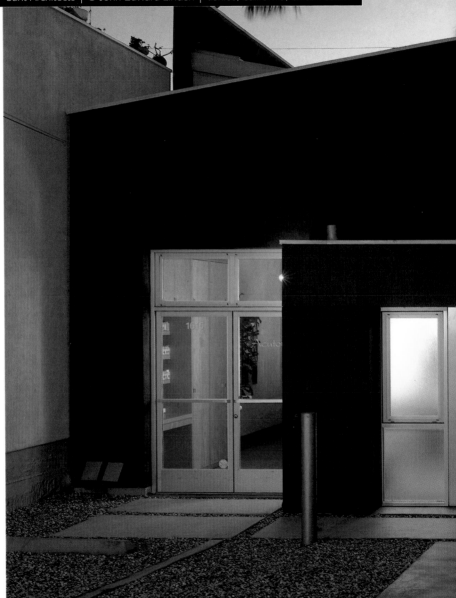

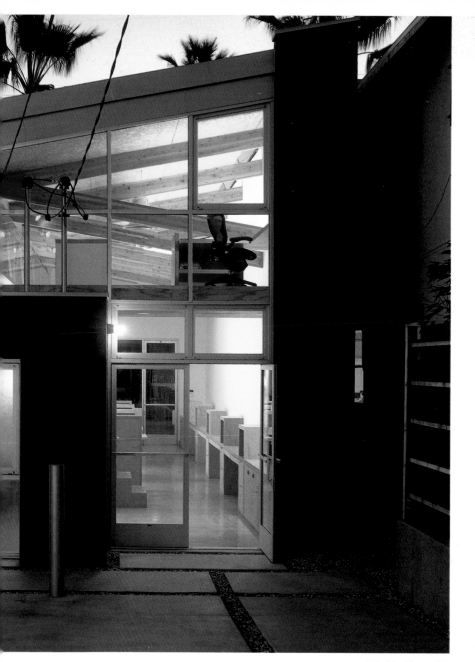

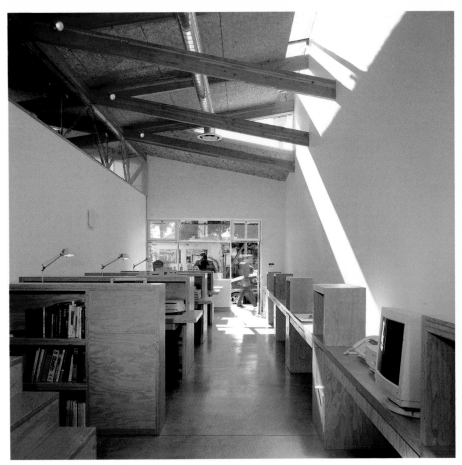

The two sections of the butterfly roof meet at a large central truss that runs the length of the building and divides its two spaces. This truss accommodates the partition—a double panel of glass that lets light in while maintaining sound insulation—as well as making its removal possible.

Section

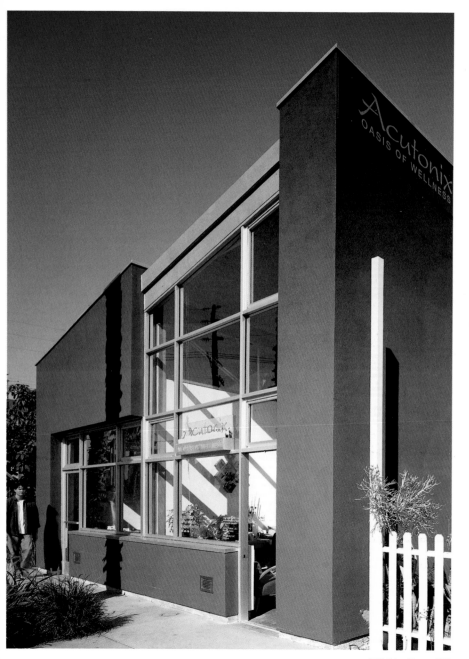

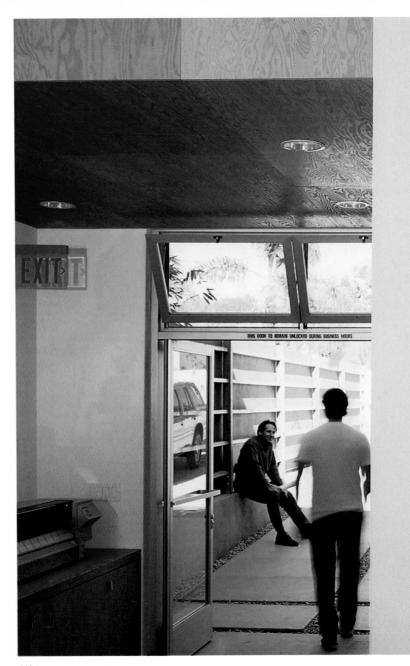

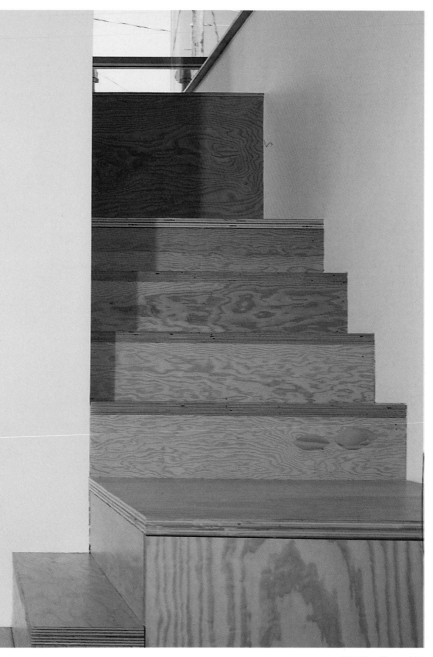

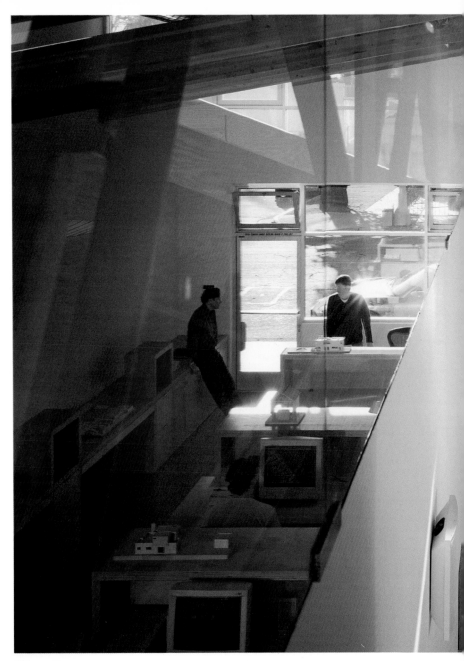

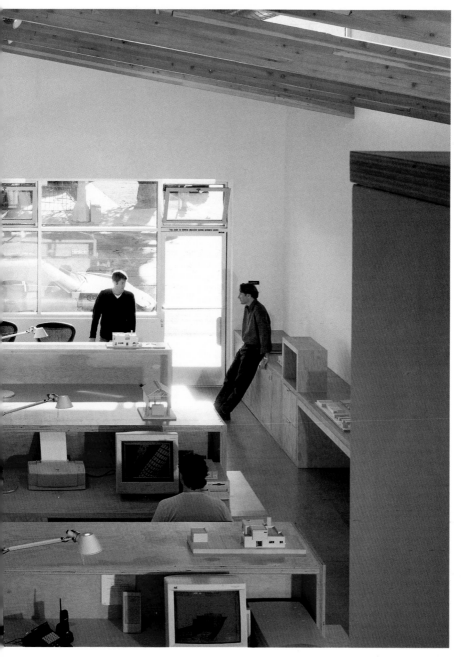

Cahoots

Tom Faulders/Beige Design Kallan Nishimoto, Yoram Wolberger | © Beige Design, César Rubio | Brisbane, California, United States

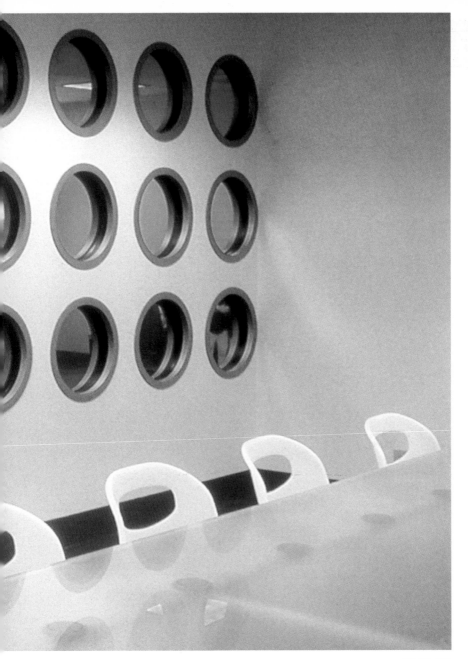

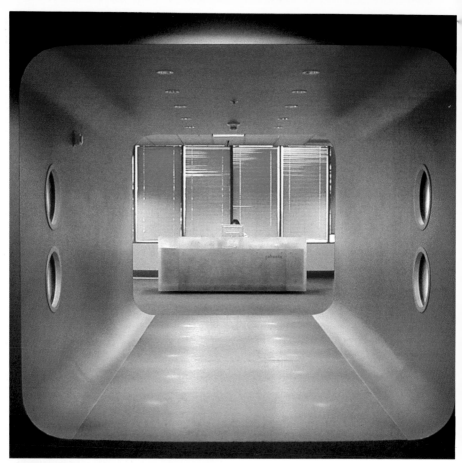

The architectural strategy of this design was based on establishing a work environment that combines the notions of space and image with the phenomena that go along with them, such as light transmission, pixelization, and acoustic vibration.

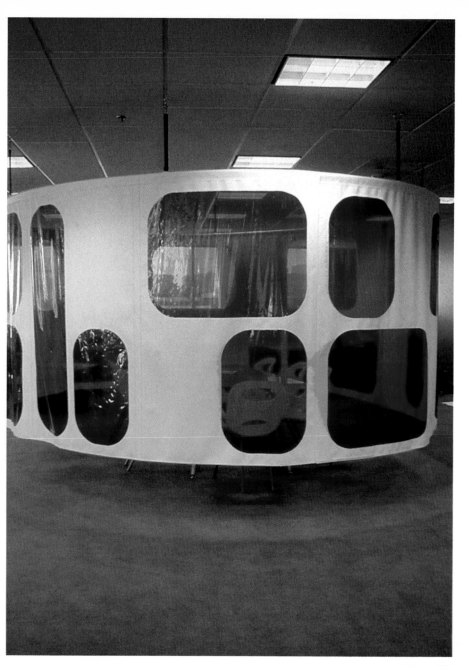

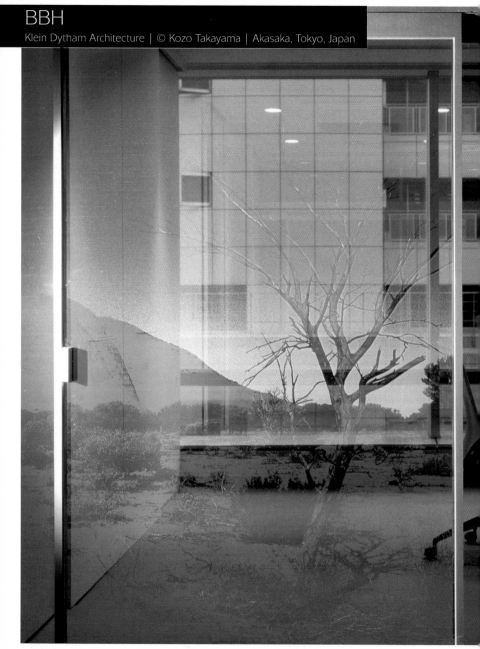

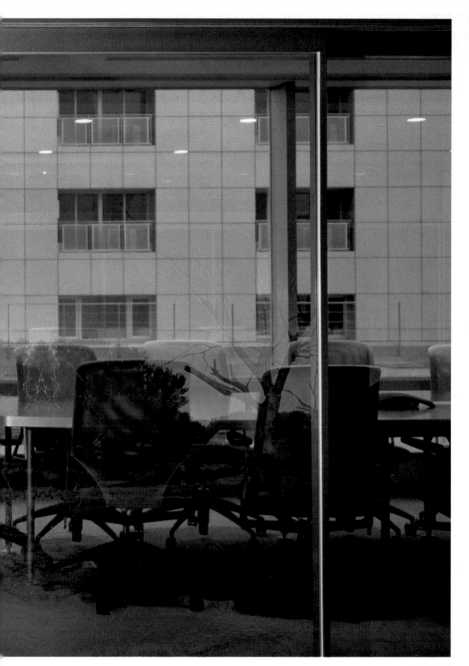

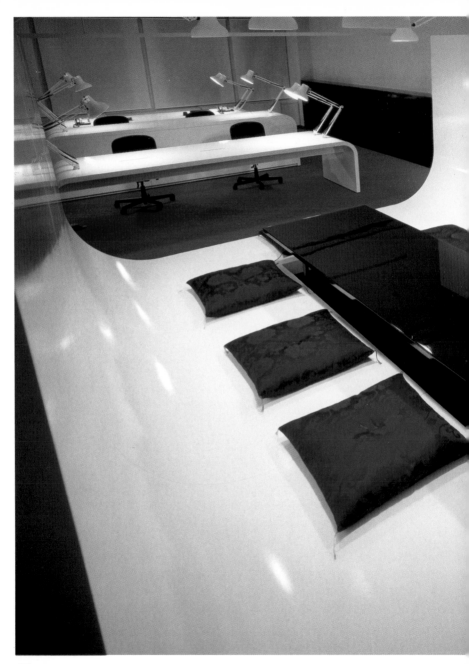

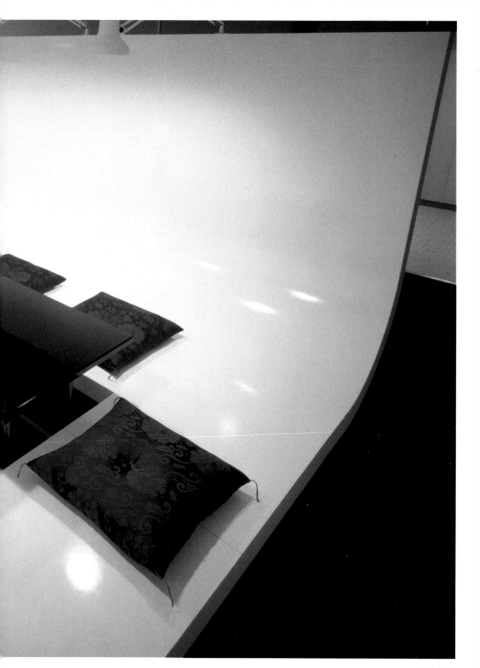

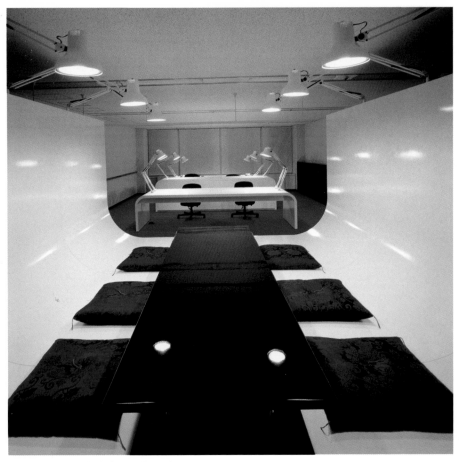

The meeting room, with its floor and curved
walls forming a U shape, reflects concepts
from traditional Japanese culture and seems to
float above the bright red floor. Silver curtains
afford both privacy and darkness for viewing
tapes or slides.

Floor plan

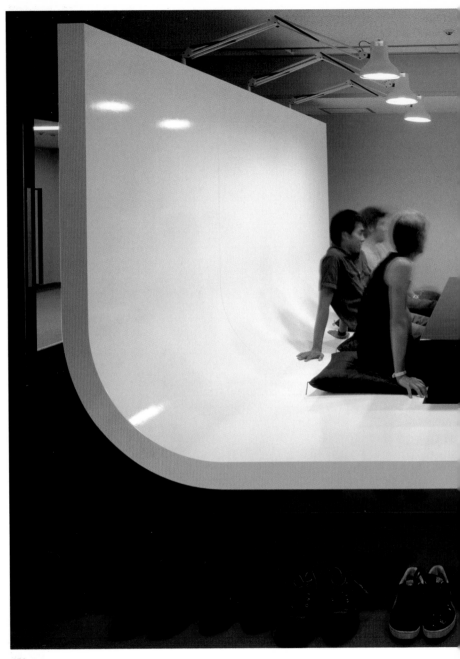

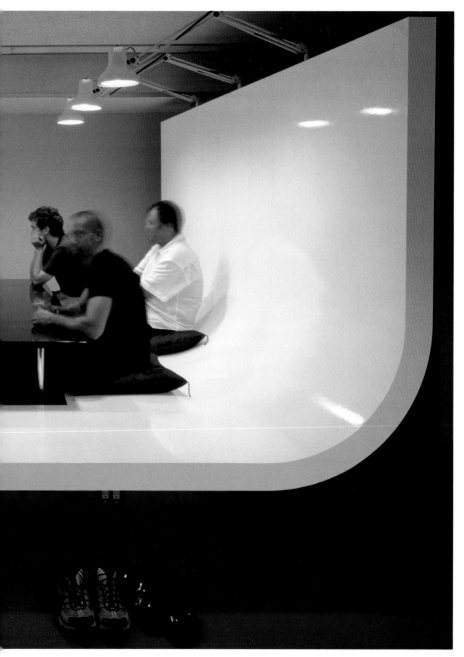

Sports Agency

Aurora Cuito + Alejandro Bahamón | © Alejandro Bahamón | Barcelona, Spain

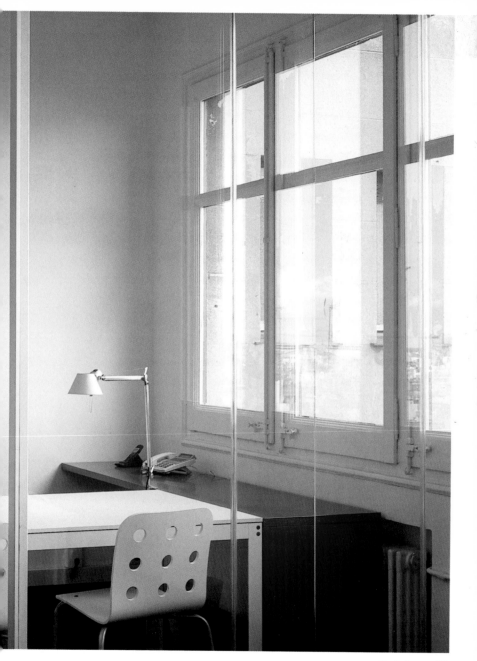

The space was divided in a direction that is
perpendicular to the office's only windows, taking
the best advantage of the available natural light.

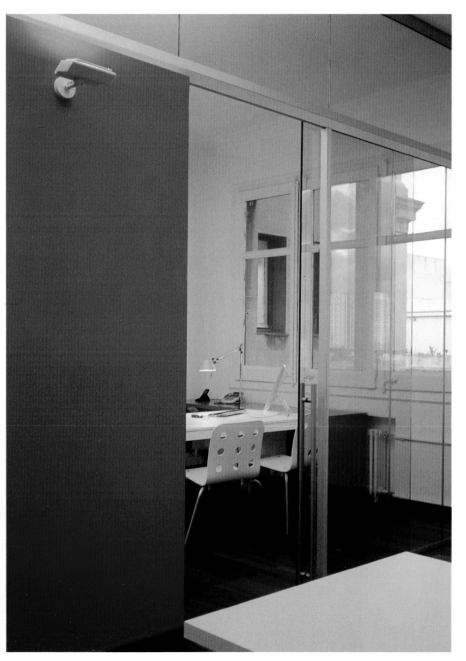

Floor plan

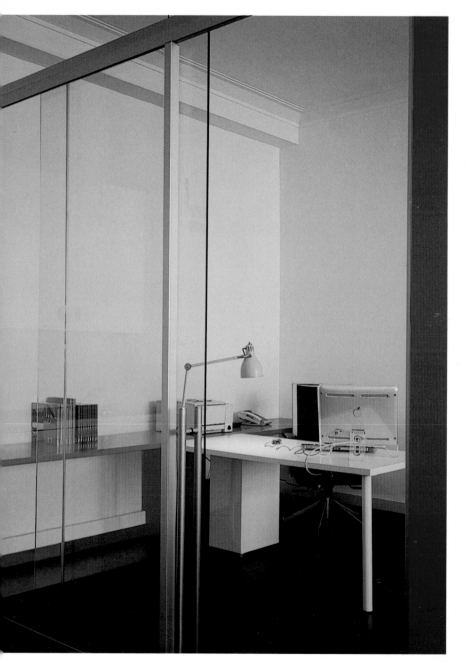

Artist, designer, and architect Pablo Chiaporri
created his own working studio, located just
above his restaurant and bar, La Corte Decó, in
the Palermo Viejo district of Buenos Aires. The
646-square-foot studio is characterized by its
abundant natural light and its use of the color
orange to accent the neutral white surfaces.

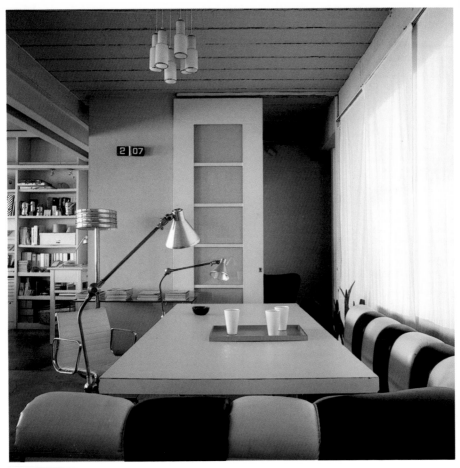

A mixture of objects—old and new—along with
artistic tools, books, magazines, and materials,
creates a balanced, heterogeneous space that is
neither excessive nor minimal.

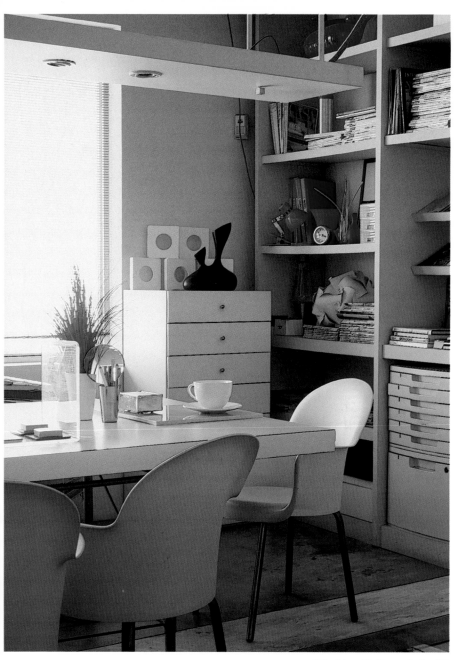

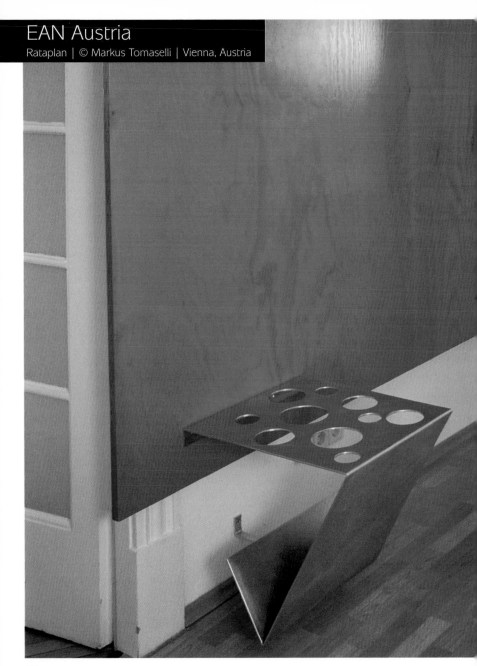

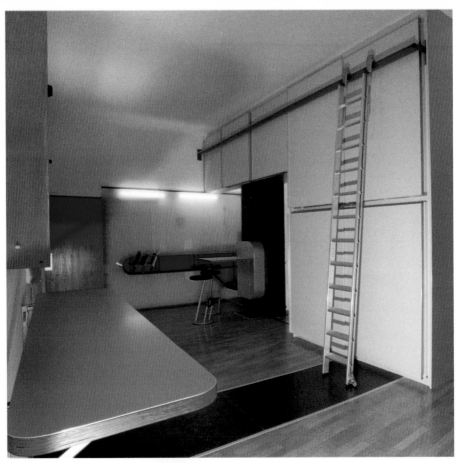

The carefully selected lighting for the areas, their successful combination of materials, and their suggestive color palette create a mixture of tendencies and styles that is current, comfortable, and functional.

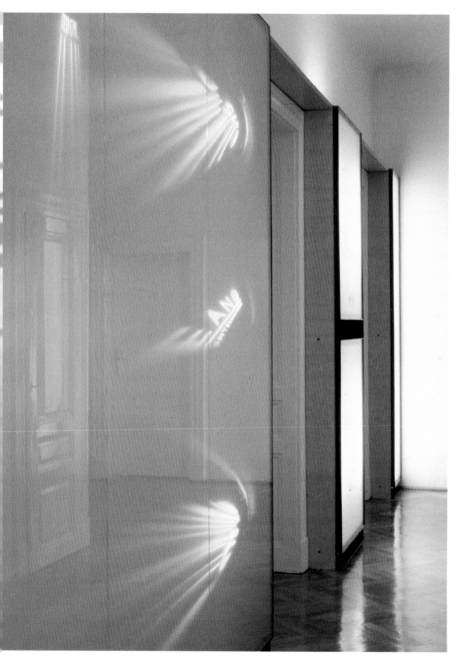

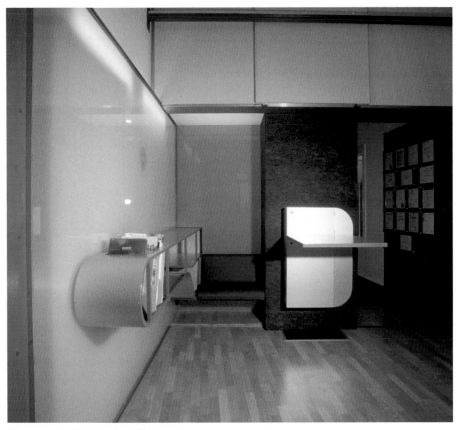

This space is captivating because of its
decorative content, where personal minimalism
mixes with elegant classicism. The new areas
have been treated with brighter colors, glass, and
metal. Movable panels and sliding doors have
been used here, allowing more freedom of
movement between the different spaces, while
also keeping costs down.

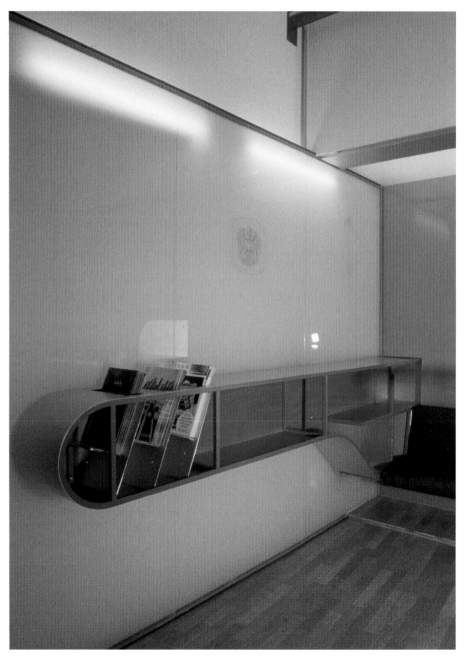

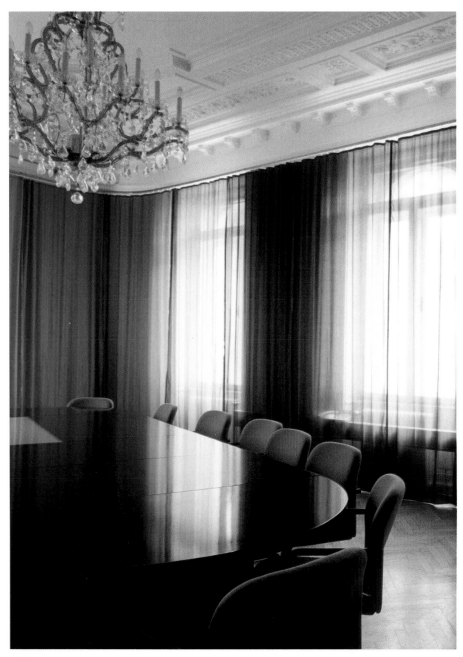

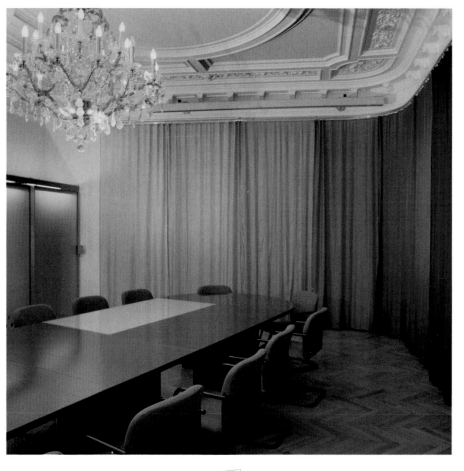

Floor plan

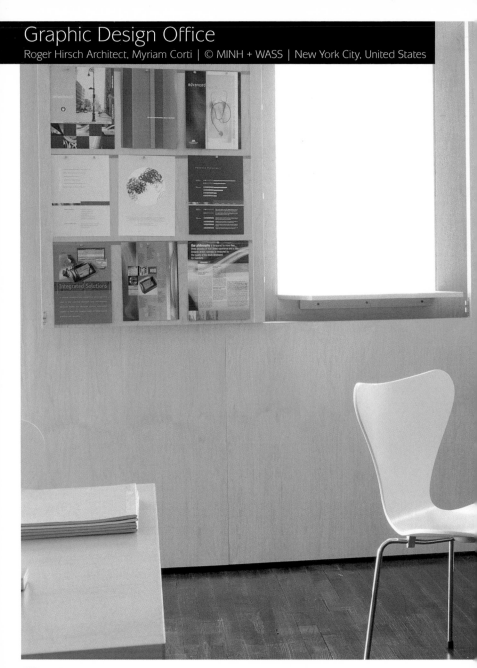

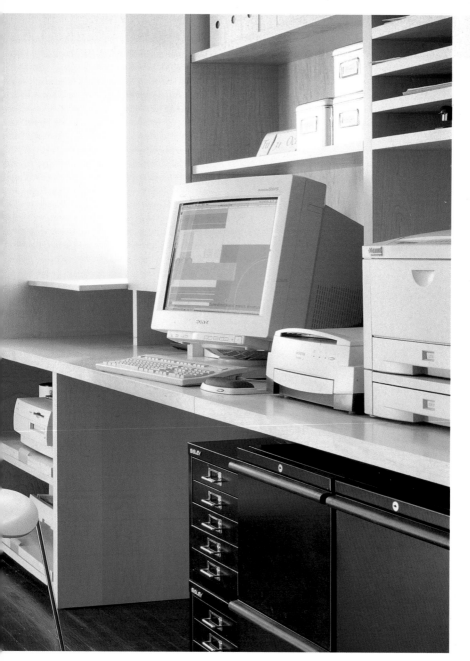

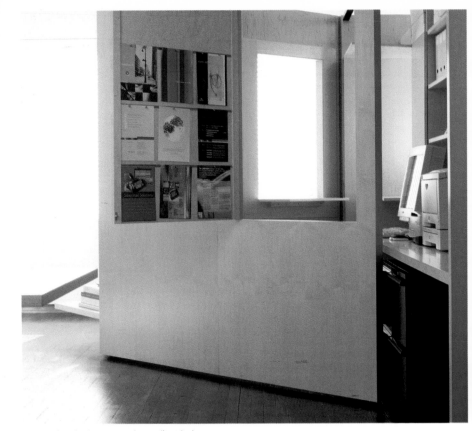

The openings in the two panels are aligned when
the panels are folded to create an interior window
that provides light for the work area.

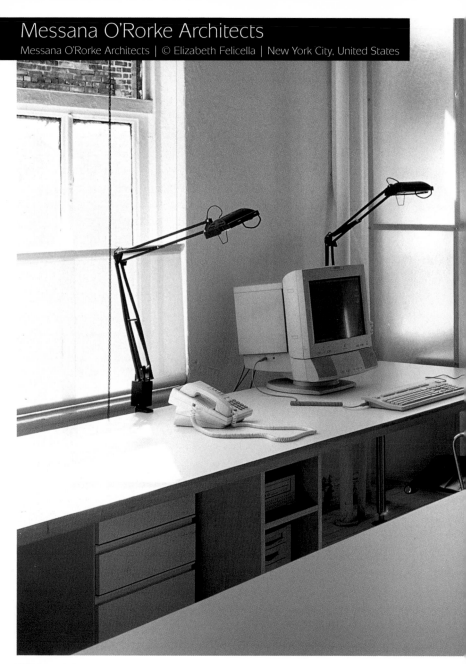

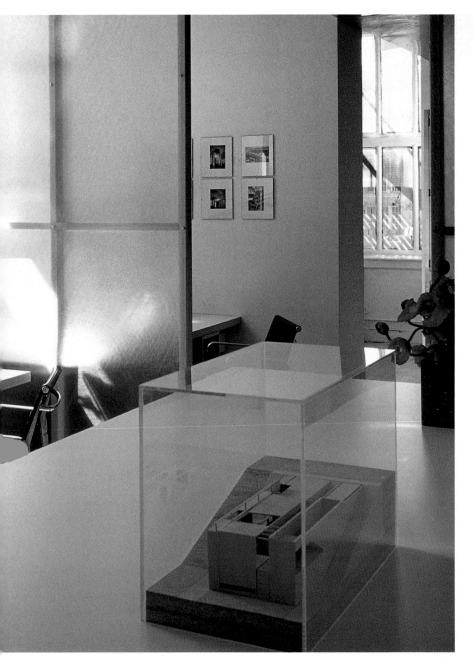

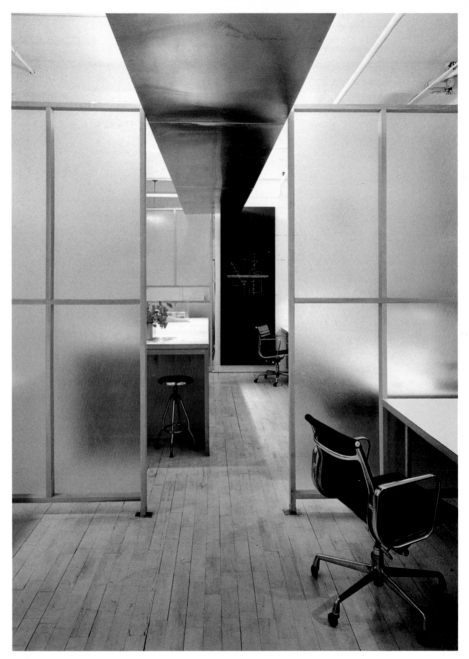

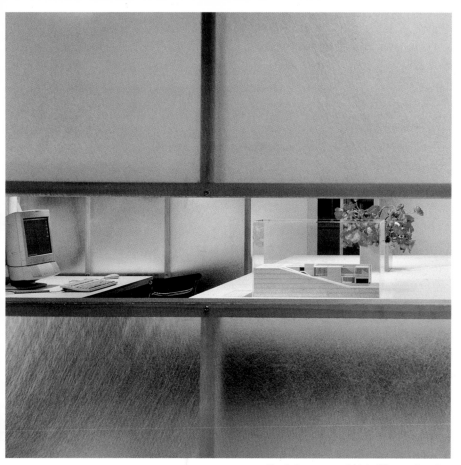

The design concept of this building was based on maximizing the sensation of spaciousness and natural lighting while creating a setting in which the space reveals itself gradually. The partitions, made of wooden frames and Plexiglas panels, brighten the rooms and make it possible to see what's going on in other parts of the office.

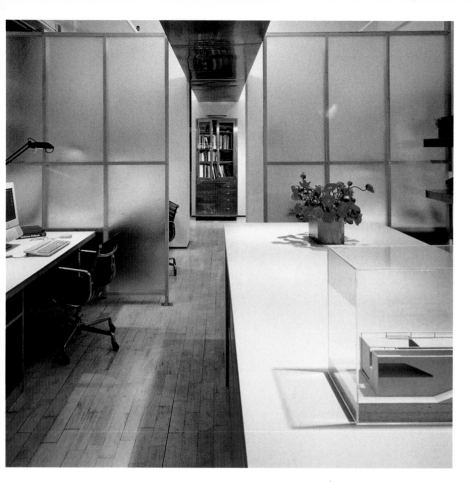

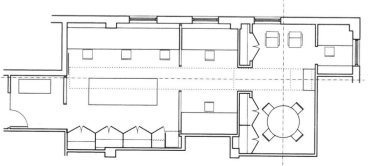

Floor plan

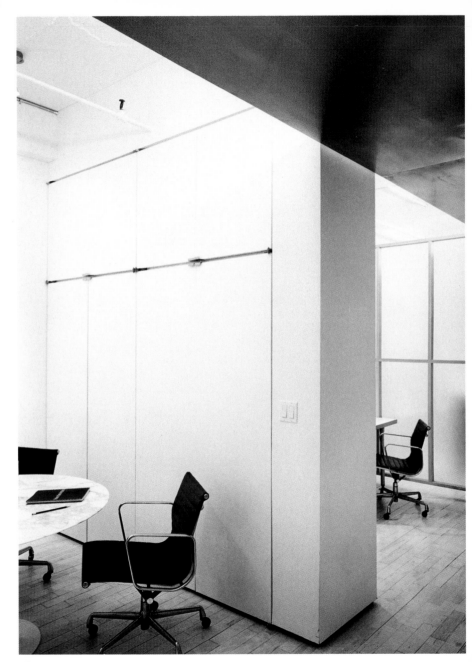

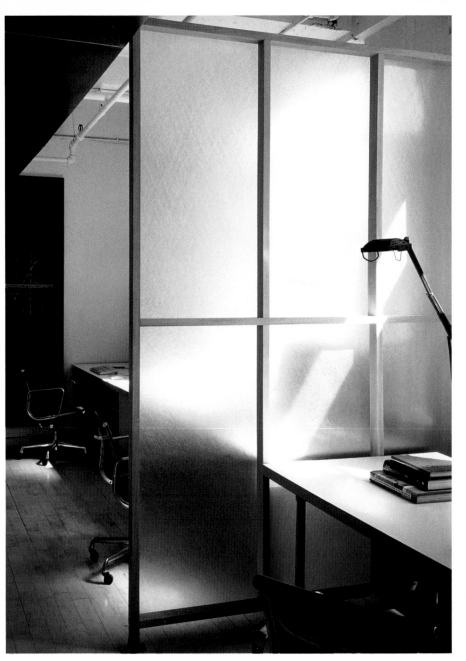

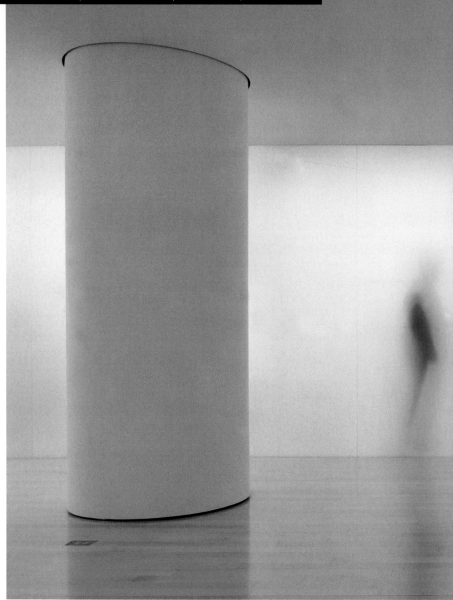

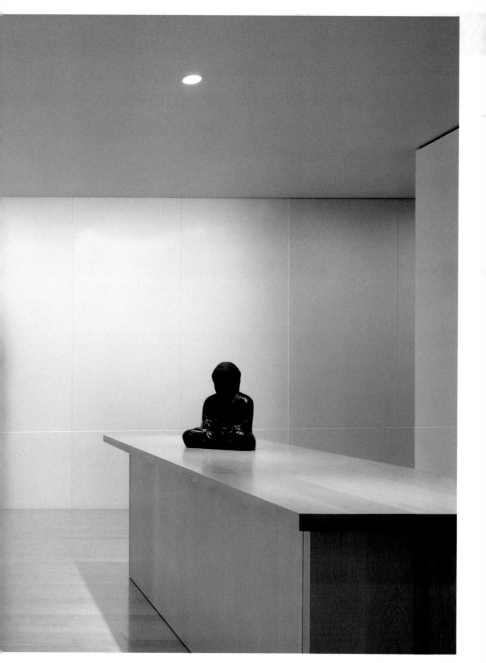

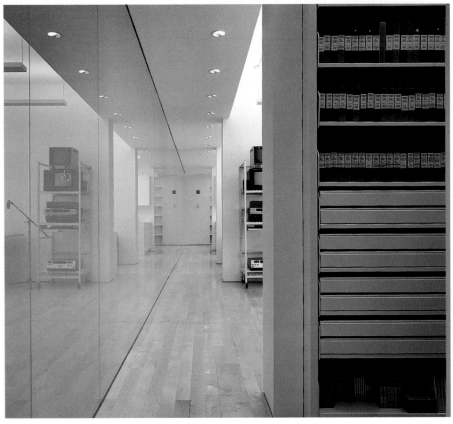

Site plan

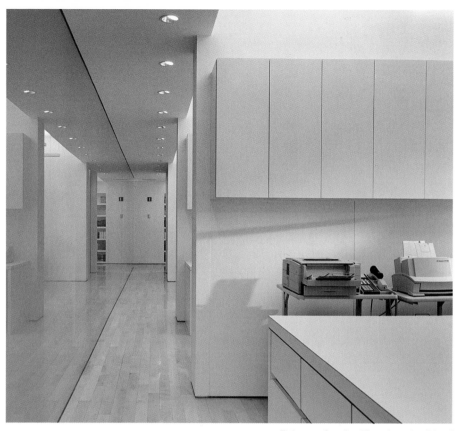

To better reflect the philosophy and activity of the company, the decision was made to use a neutral color palette with carefully selected materials and finishes to create a sense of austerity and spatial fluidity. The resulting quiet, balanced surroundings promote a harmonious working environment.

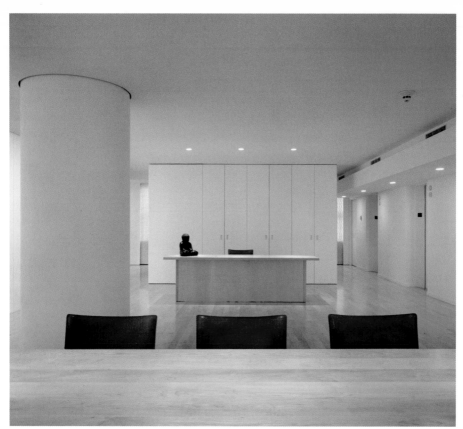

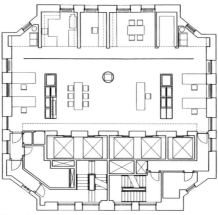

Floor plan

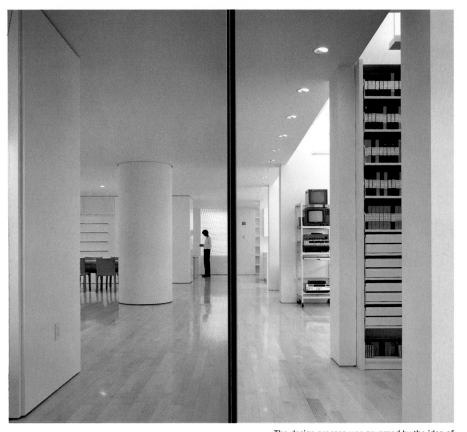

The design process was governed by the idea of unifying the entrance, reception area, and conference room into a single space. This common central space is defined by floor-to-ceiling storage modules on two of its sides.

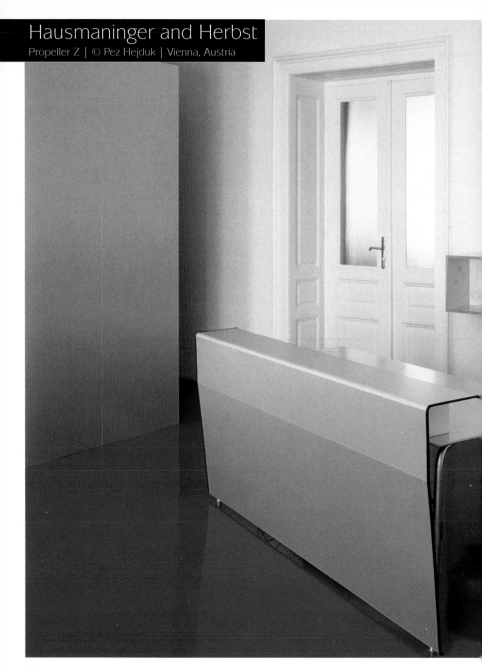

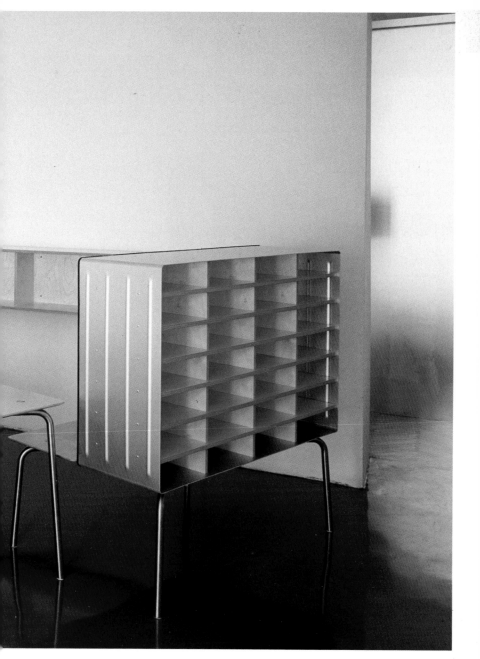

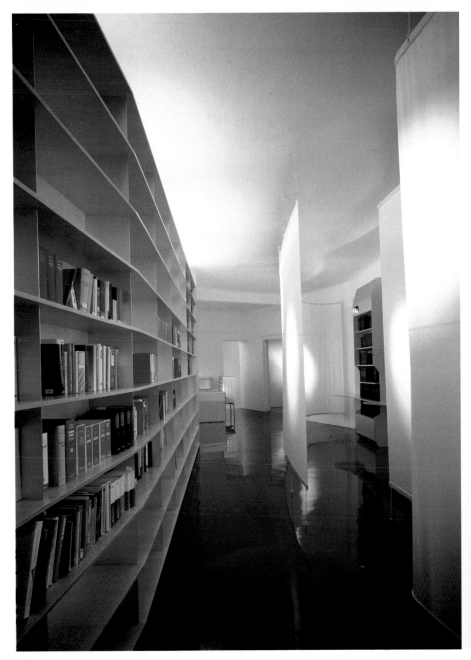

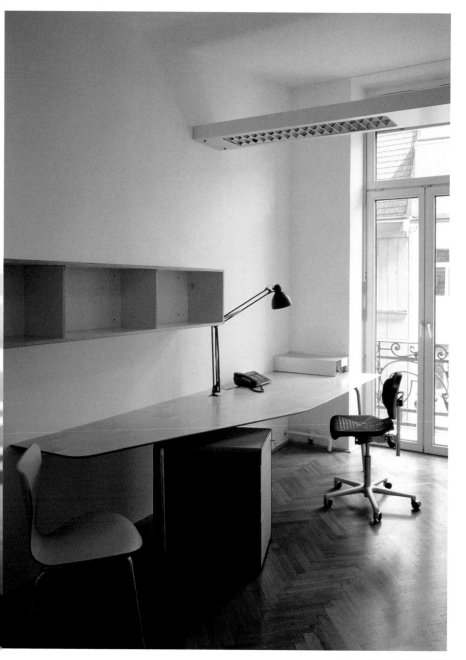

The different areas of the space are separated by
a single component that has great visual strength,
but is light and translucent—a sail-like piece of
fabric, touching neither the floor nor the ceiling,
but suspended between them by metal
turnbuckles. Made from the same fabric that is
used for sails in the bows of sailboats, the divider
is ideal for indoor use, since it transmits and
diffuses light.

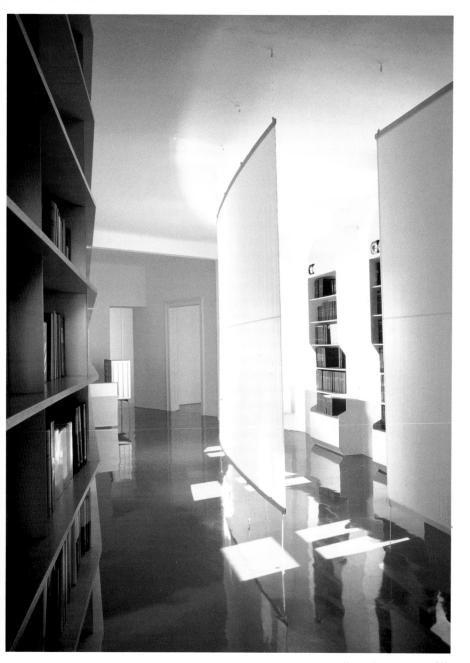

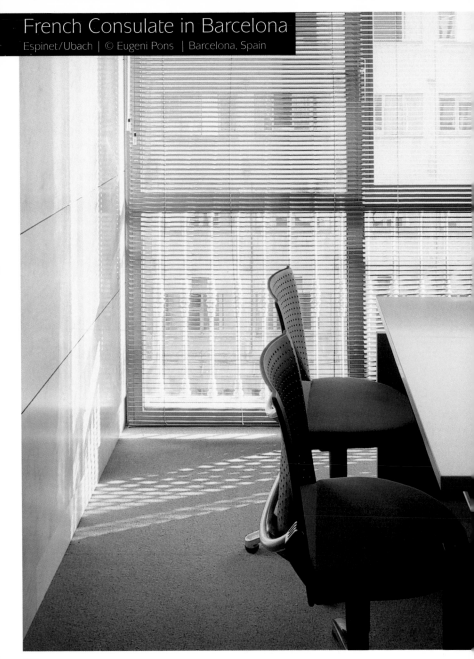

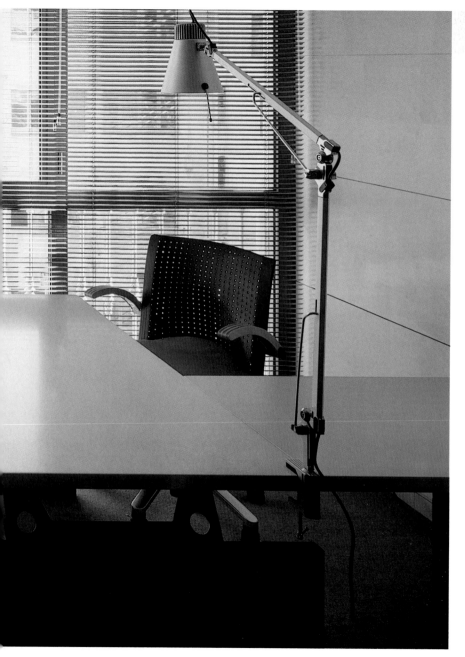

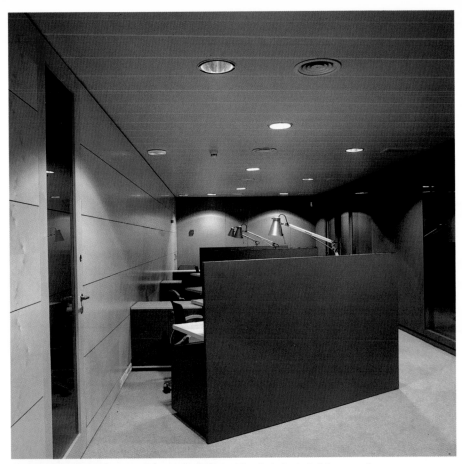

The criteria for the building renovations were security, functional traffic patterns, flexibility in the distribution of the interiors, and controlled acoustics.

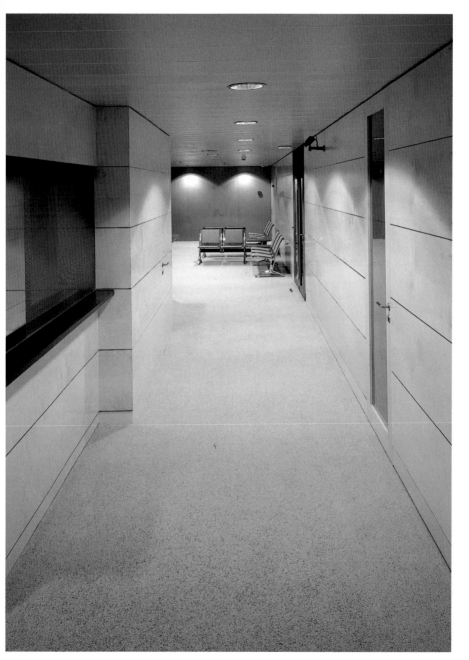

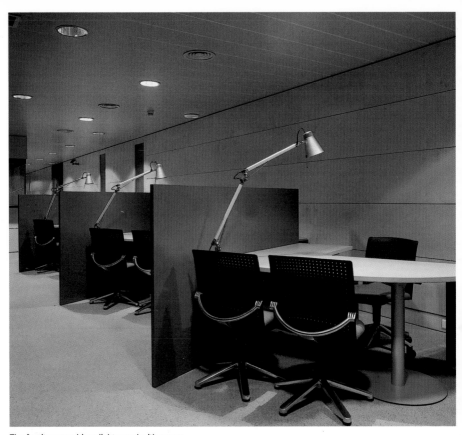

The furniture combines light wood with a gray
green color, which is also repeated in the
upholstery. In the main offices, colors get darker:
the wood acquires a leather-like tone, blue is
substituted for the green of the furnishings and
upholstery of the other areas, and merbau wood
is used for the floor.

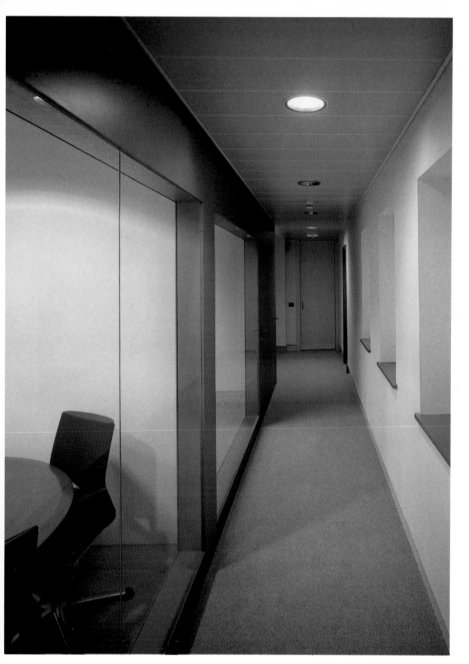

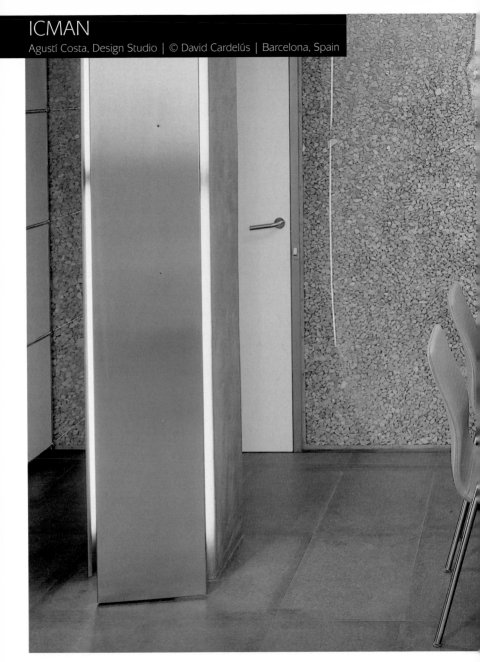

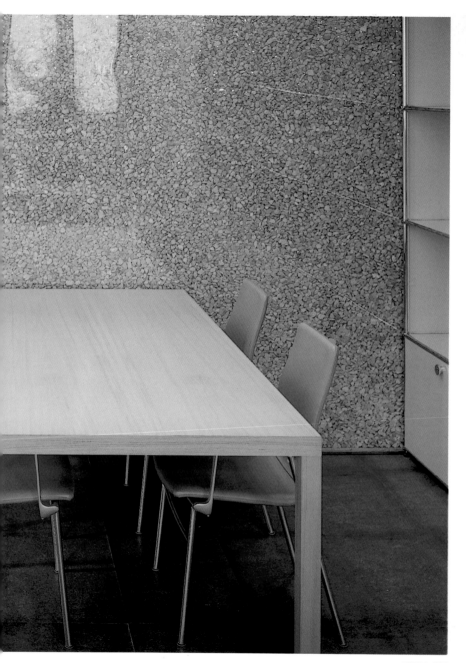

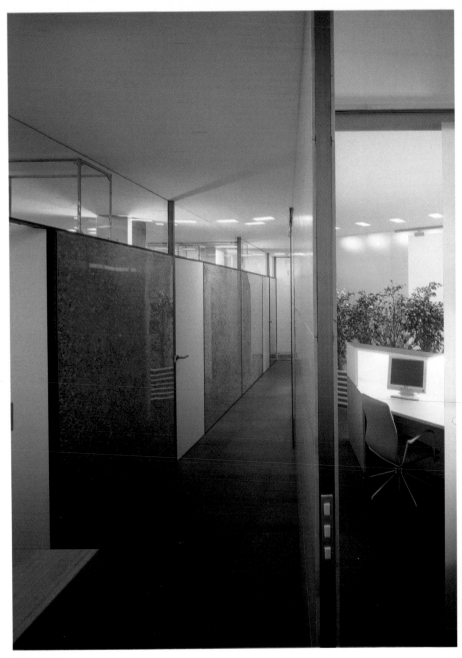

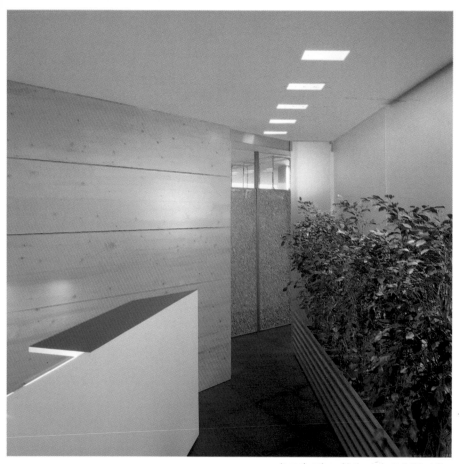

In conjunction with the desire to lightly define zones for different uses and to encourage interaction, the building was designed with an unassuming and transparent presence. This goal was achieved by using degrees of translucency, reflection, and opacity that transform with the passing of time and are subject to the variations of color brought on by the direction and intensity of the light on the surfaces.

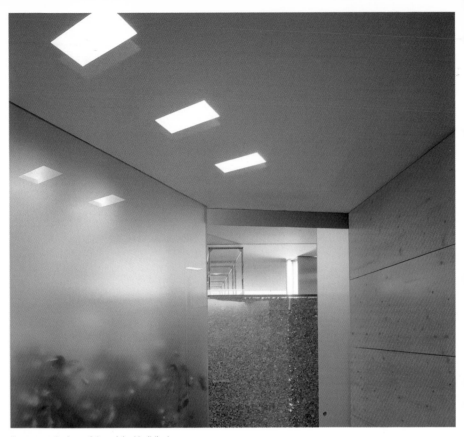

To prevent the loss of the original building's formal characteristics, the windows and the paneled wood entrance door were retained. The original floor plan was faithfully replicated to avoid altering the overall composition of the building.

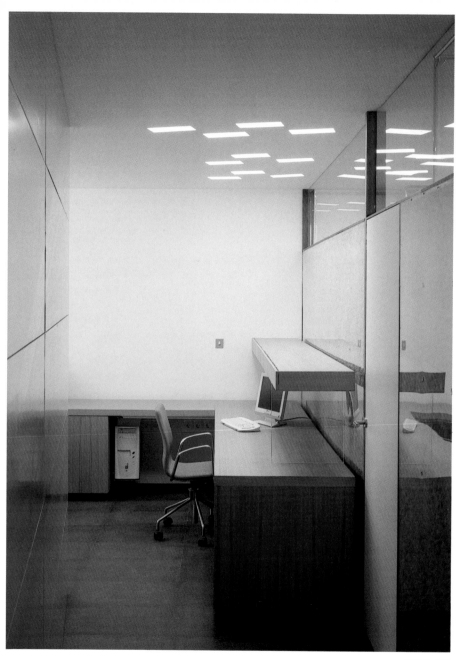

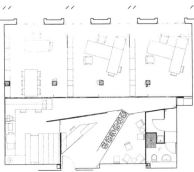

Floor plan

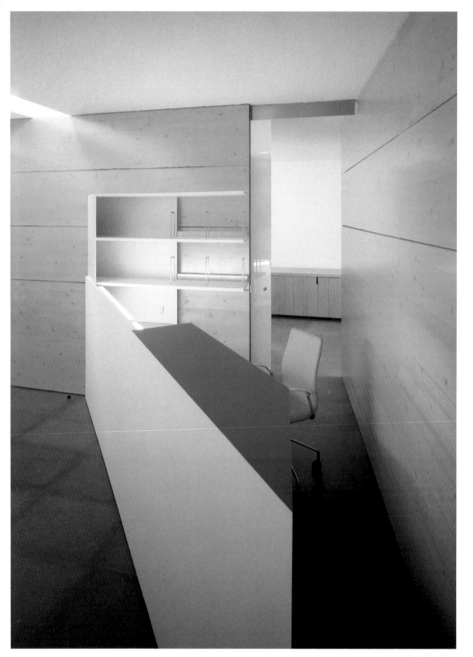

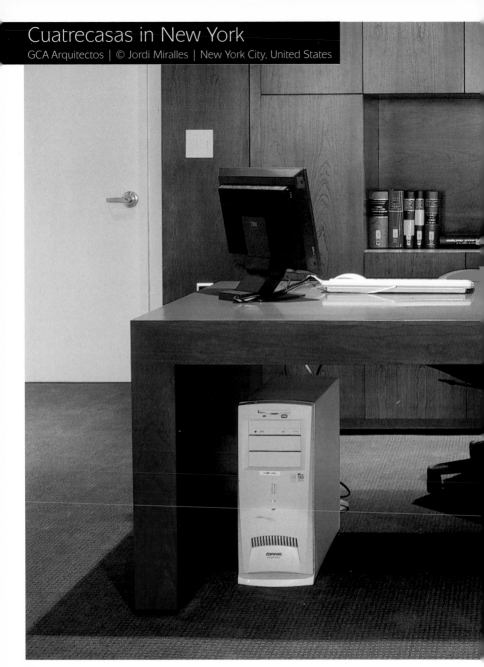

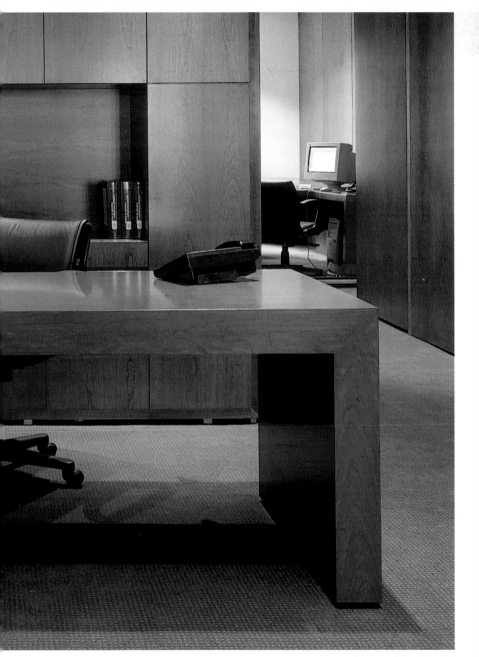

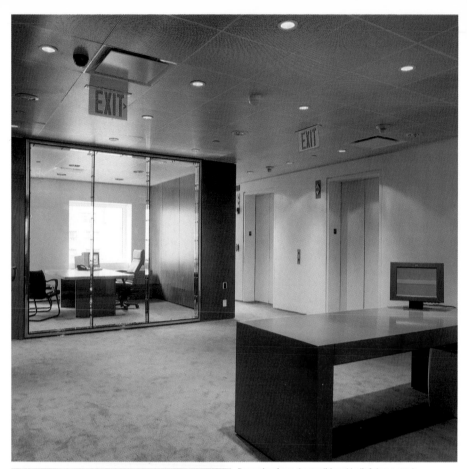

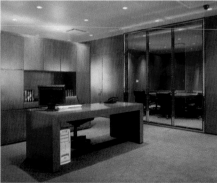

Departing from the traditional belief that a work environment has to be neutral, balanced, and serene, an effective program was conceived in which different work areas are unified. One of the elements that created this effect was the replacement of several doors and walls with glass counterparts, creating the illusion of a larger space, while at the same time connecting areas devoted to different functions, such as the meeting room and the reception area.

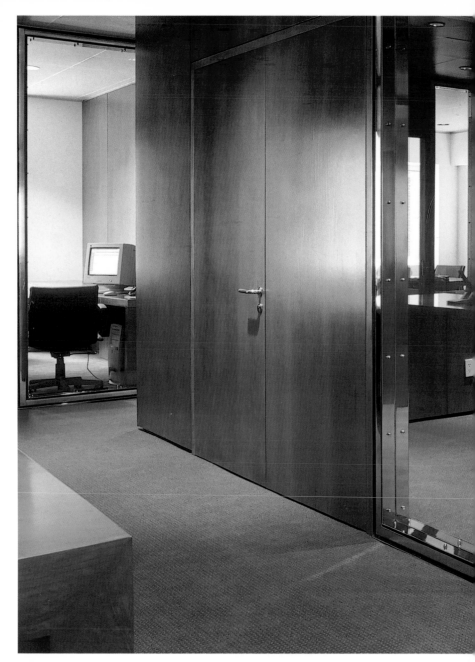

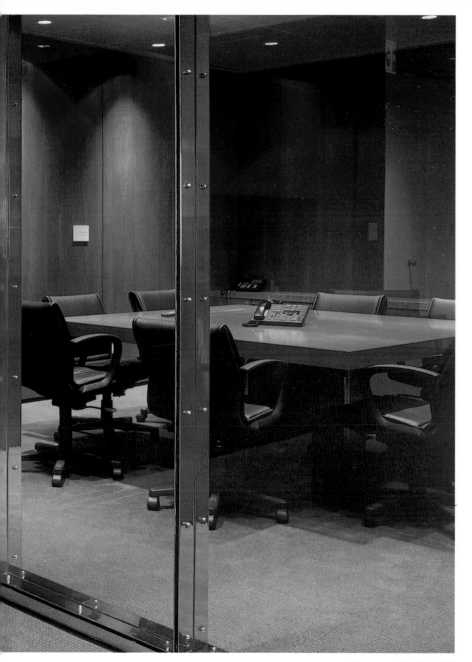

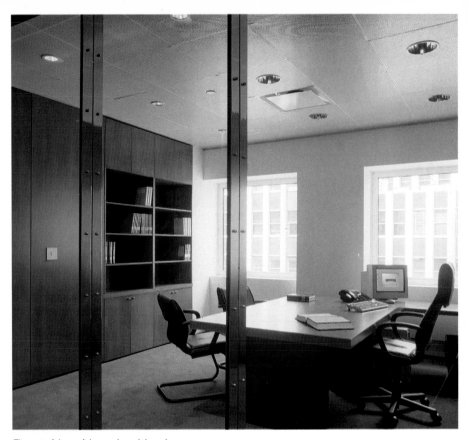

The materials—mainly wood—and the color
palette chosen were limited to a few elements.
The furnishings used in the decoration consist of
discreet and elegant lines, reinforcing the ideas
of balance, practicality, and elegance already
outlined by the architectural features.

Cuatrecasas in New York 529

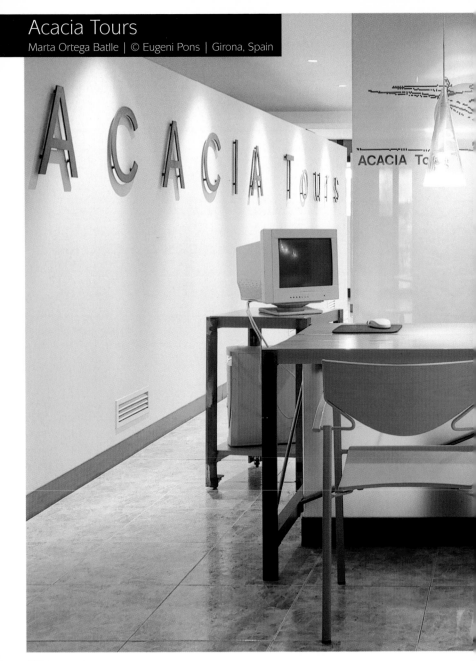

Acacia Tours
Marta Ortega Batlle | © Eugeni Pons | Girona, Spain

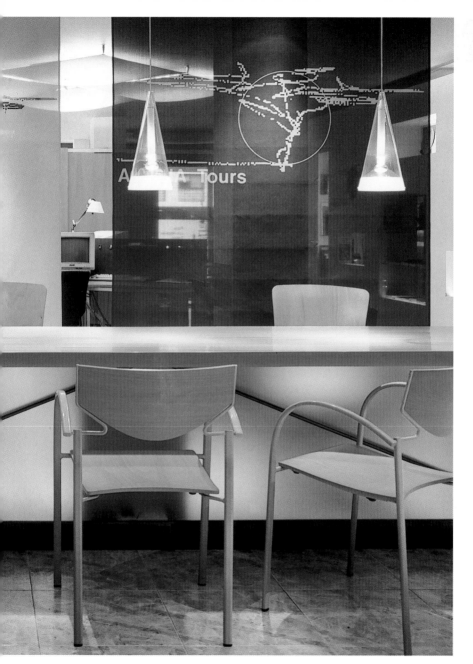

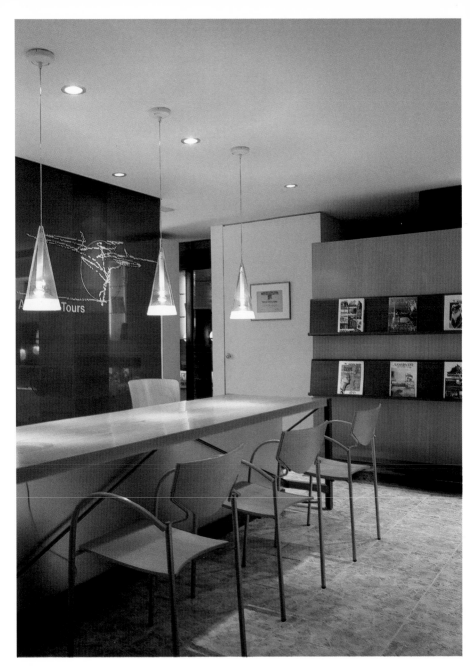

Interior designer Marta Ortega Batlle planned this neutral and perfectly organized space, where the independent vertical planes—made of wood, plasterboard, and screen—define the different functions of the agency, such as the administrative, customer service, storage, and offices areas.

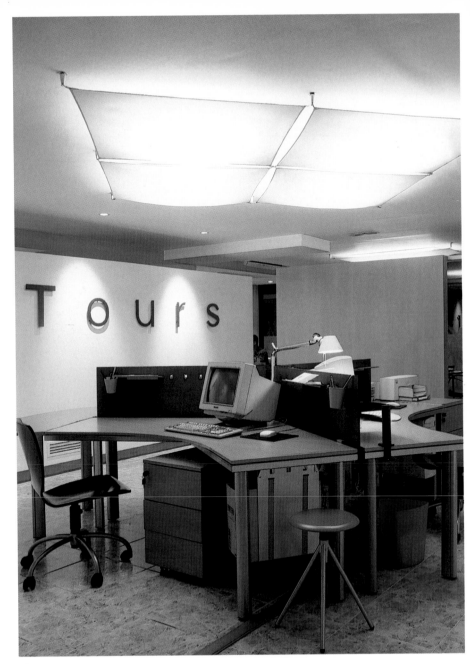

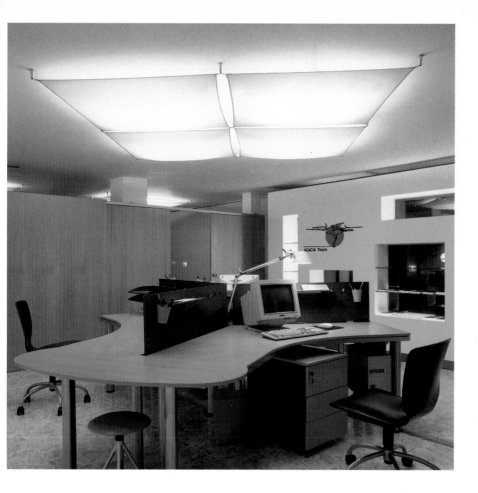

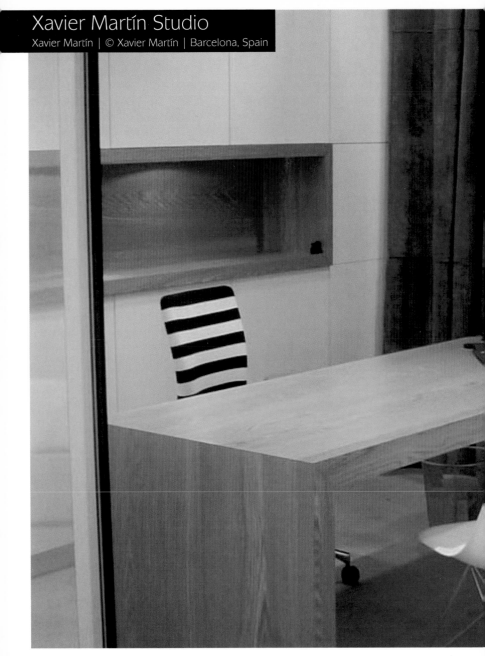

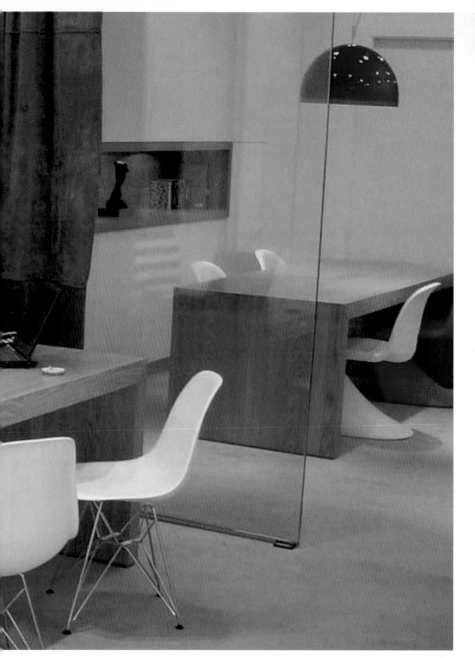

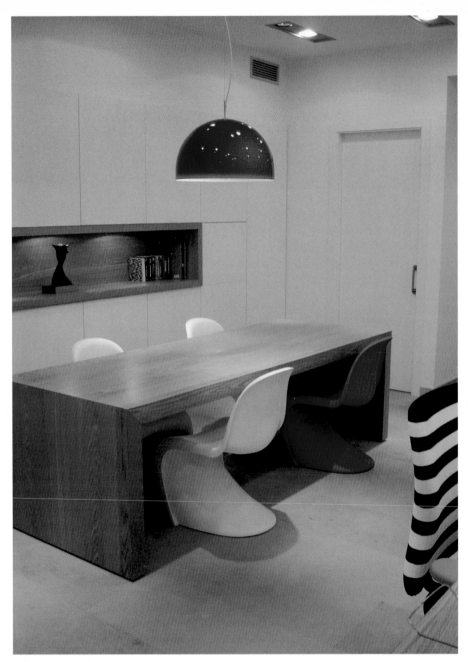

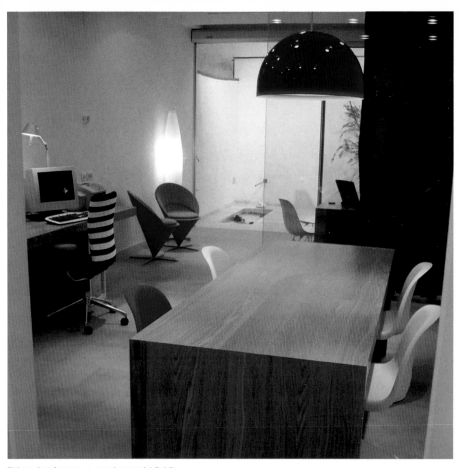

This project focuses on creating spatial fluidity and order. Following the guidelines used for traditional lofts, a single space was created where the different areas are defined by the distribution of furnishings.

Floor plan

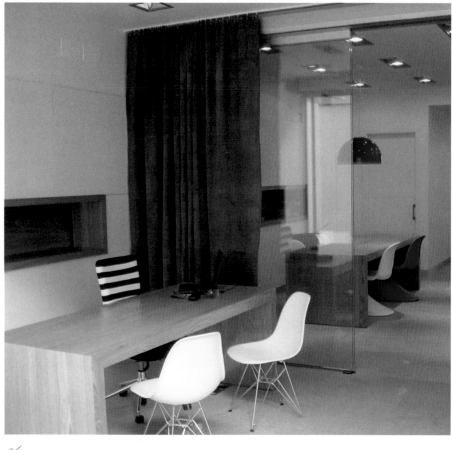

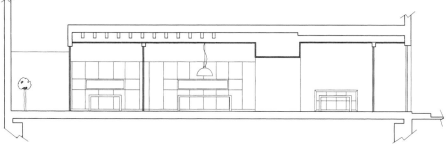

Section

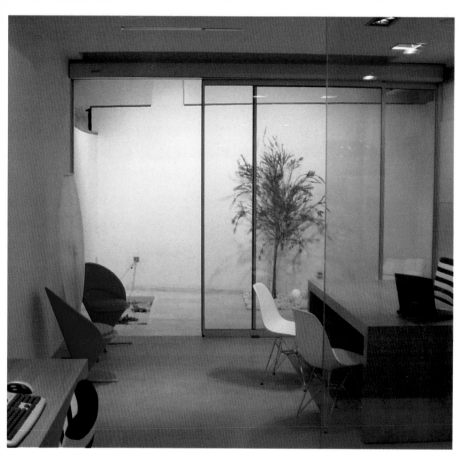

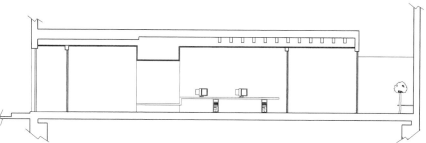

Section

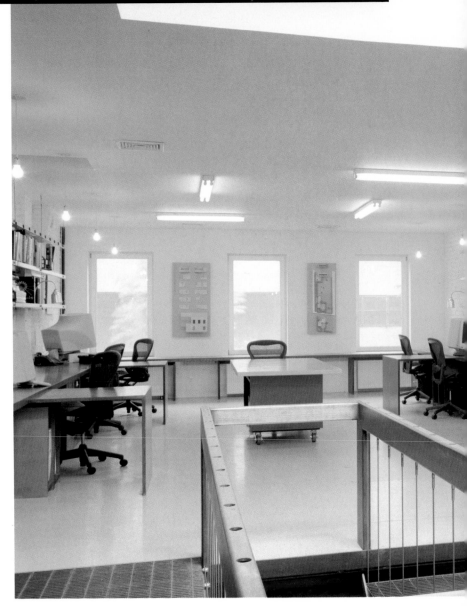

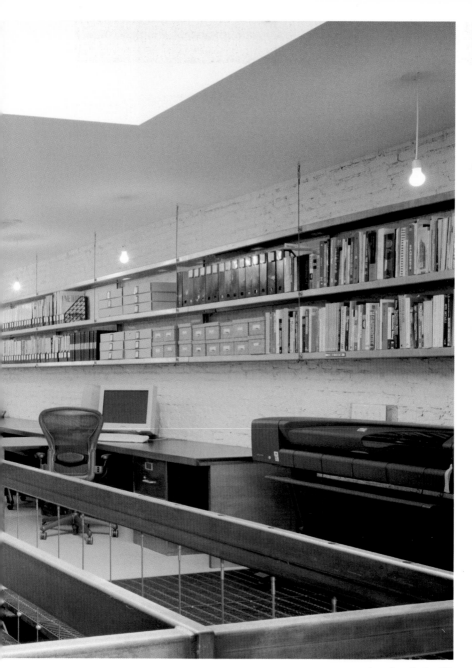

Two young architects, colleagues since their days
at Yale University, decided to restore a small,
rundown store/warehouse in Manhattan's West
Village and fit it out as their own architecture
studio. To make the two-story unit feel more like
a single space, a very light metal staircase was
installed, permitting visual contact between the
two levels.

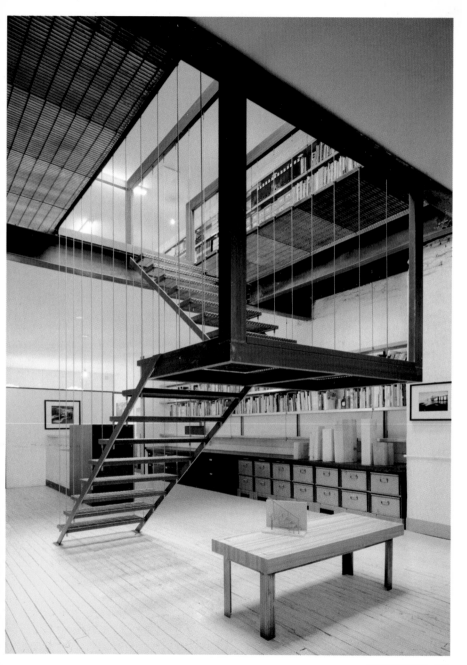

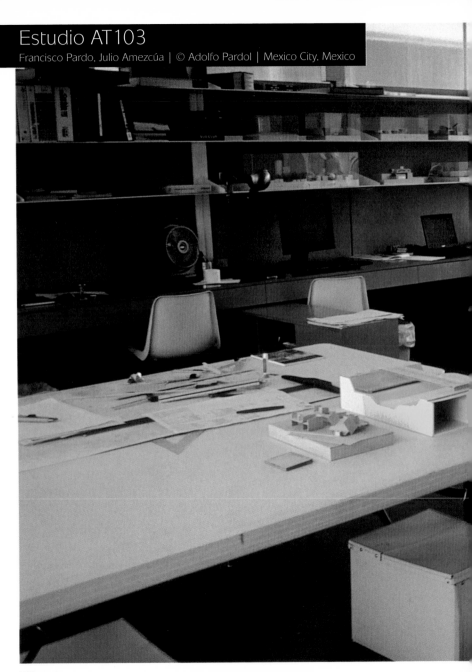

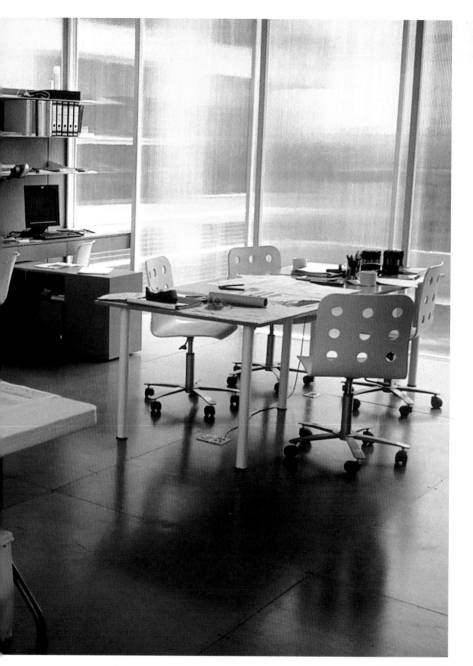

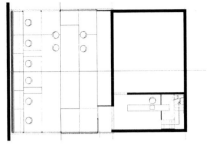

Floor plan

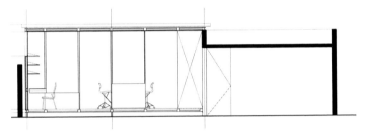

Section

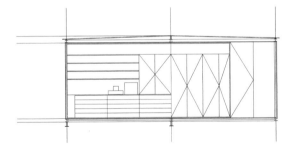

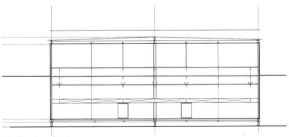

Interior elevations

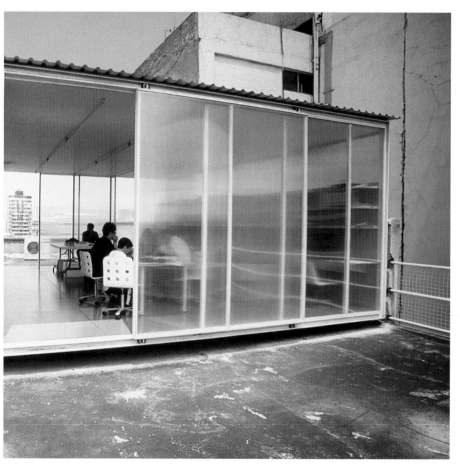

This temporary structure is part of the urban landscape of modern Mexico City. Small units such as this are erected on the roofs of buildings as a partial solution to the space limitations of this city of 25 million inhabitants. The interior of the office is free of dividers, and the façades that are not adjacent to other structures are composed of translucent polycarbonate panels.

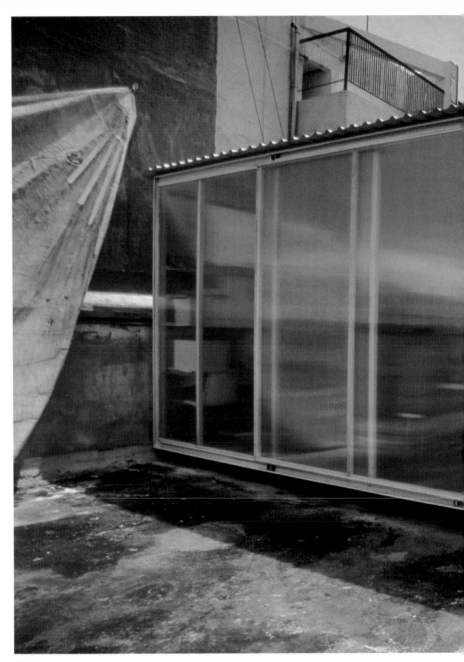

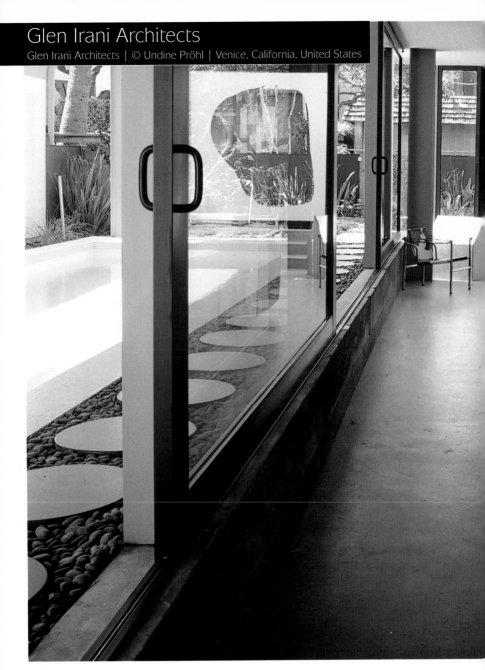

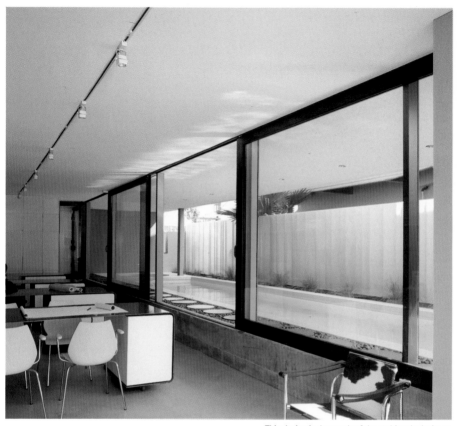

This design is the result of the architect's desire to combine his family home with his workplace. Since he spends most of his time in the office, he chose an exceptional location: the 775-square-foot office occupies the entire lower floor, is right next to the garden, and has direct access to the outdoor pool.

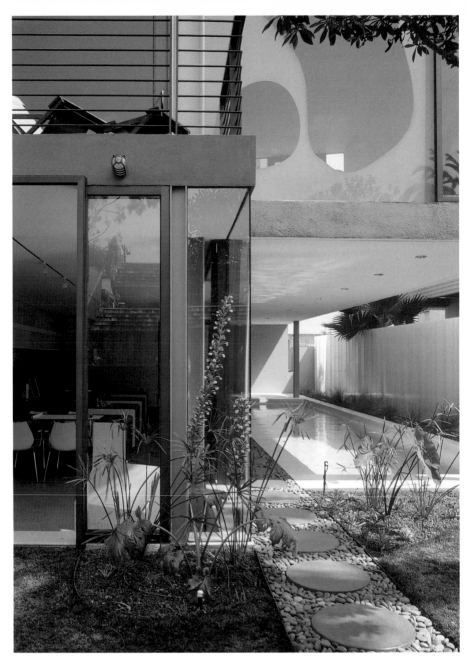

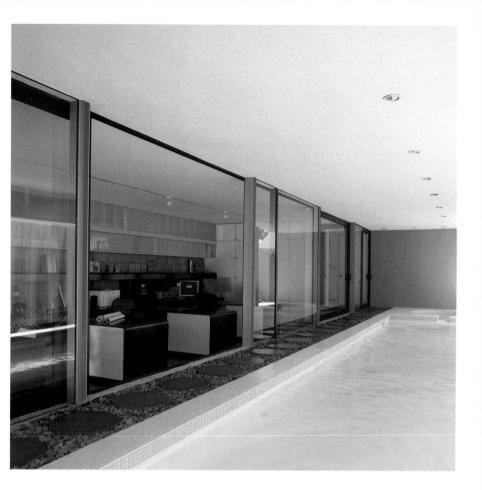

Floor plan

The interior was carefully designed to
accommodate a number of activities: recreational
use of the garden, small social or professional
receptions, after-hours reading, and weekend
leisure activities.

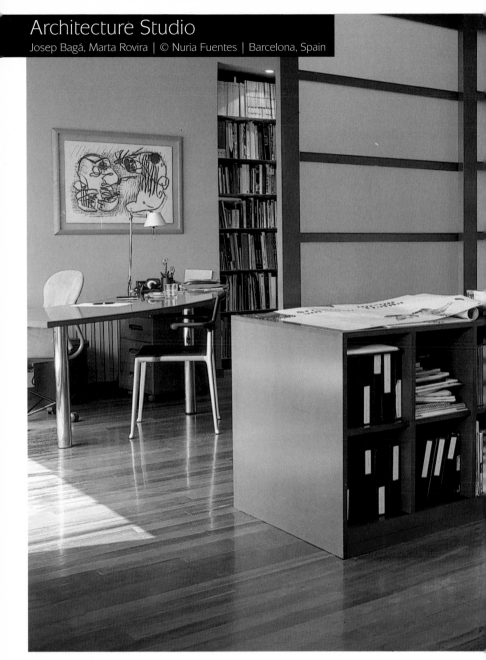

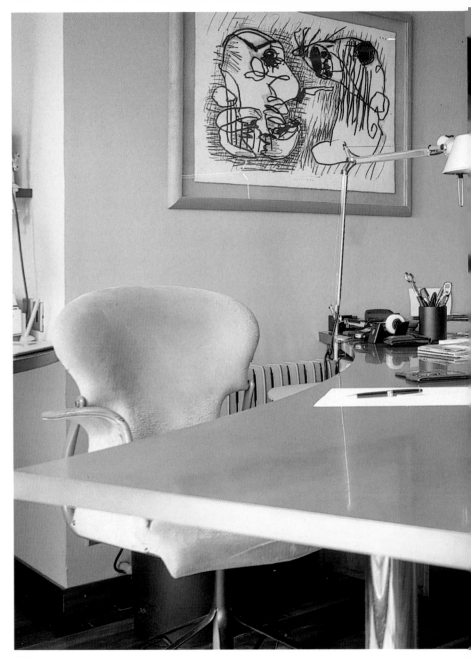

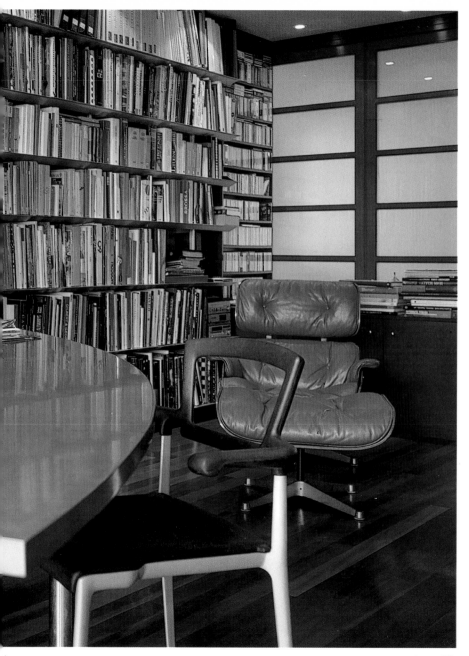

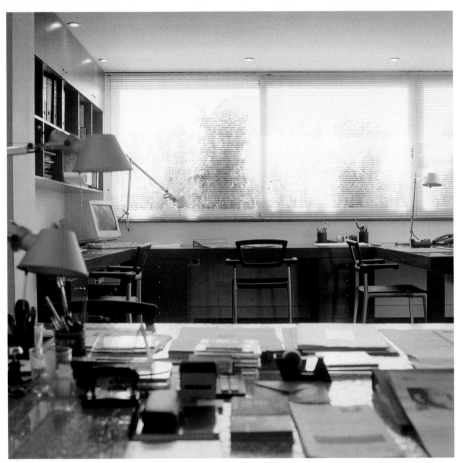

This project transforms part of a typical Barcelona apartment into an architecture studio for two partners. The existing partitions in this apartment were eliminated to create a loft-like space in which two open areas are connected by large sliding doors. This creates better use of the space and improves the natural lighting and ventilation.

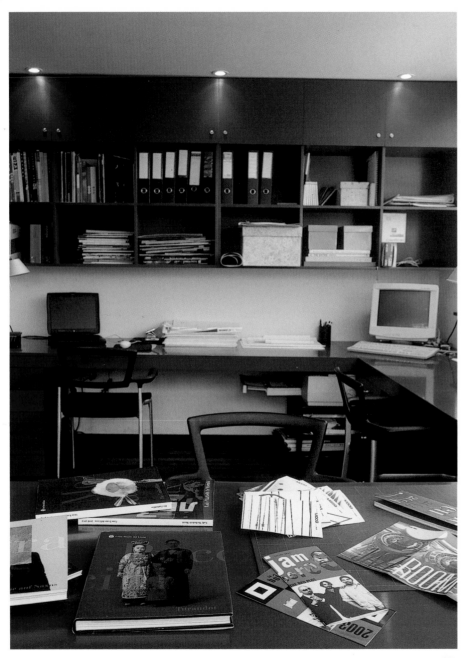

Xavier Gomà Studio

Xavier Gomà | © Nuria Fuentes | Barcelona, Spain

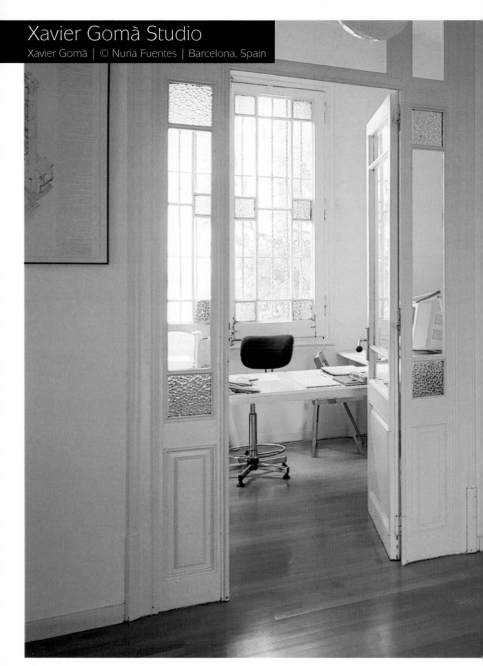

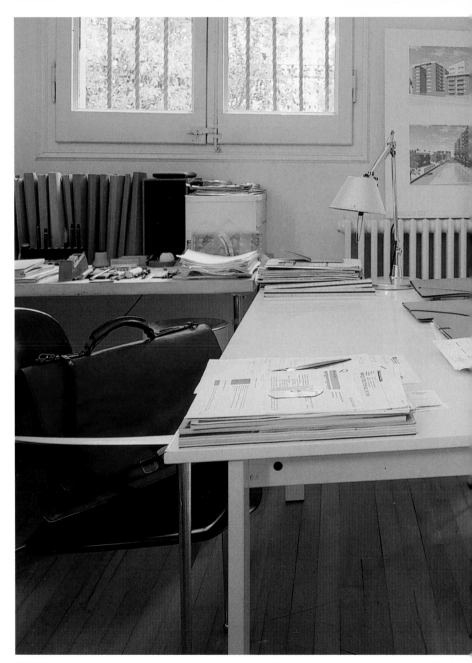

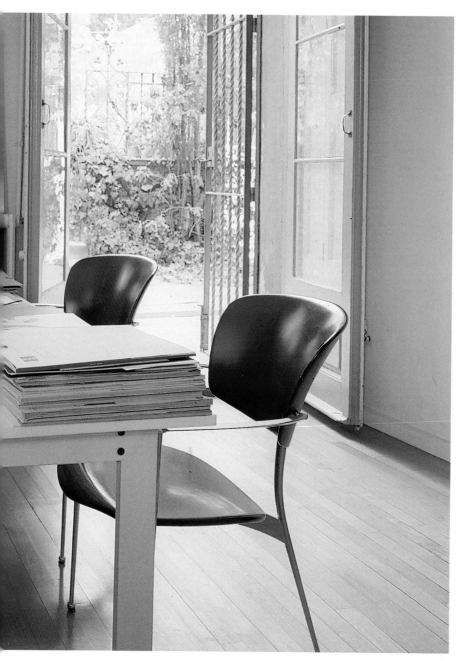

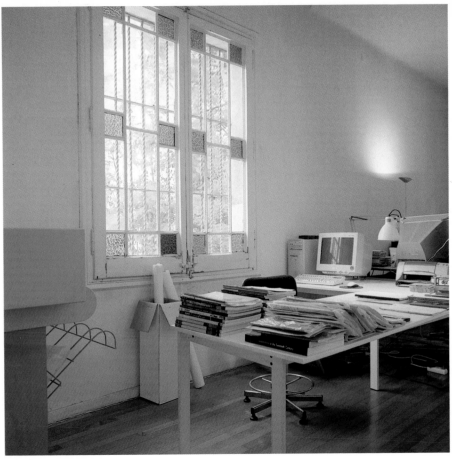

This office occupies the lower floor of a typical
Barcelona villa, an old home surrounded by a
garden.

Certain elements—such as the original stained glass
windows, which overlook the rear garden, and the
molding—retain the original character of the villa.

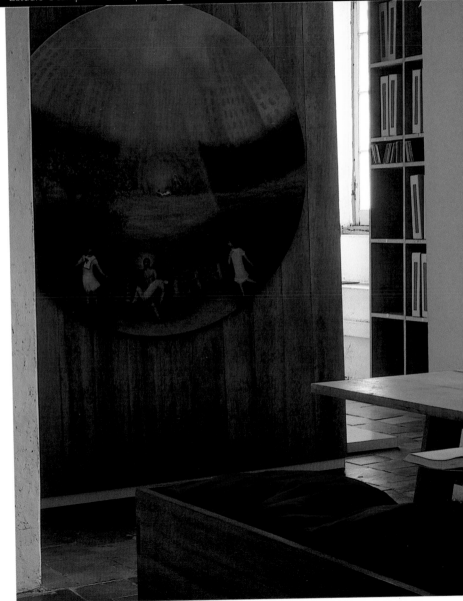

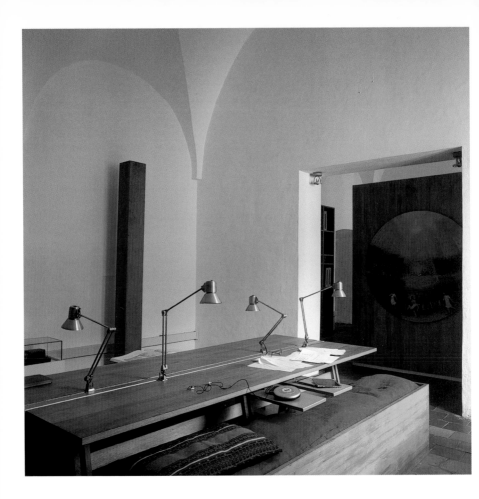

Thirty years after this 300-year-old monastery was abandoned, part of the building was converted into a private media center for consulting books, magazines, records, videos, and DVDs. Its classically sober construction was preserved and dotted with an austere, contemporary selection of custom-made furnishings and decorations that incorporate noble materials and pure forms.

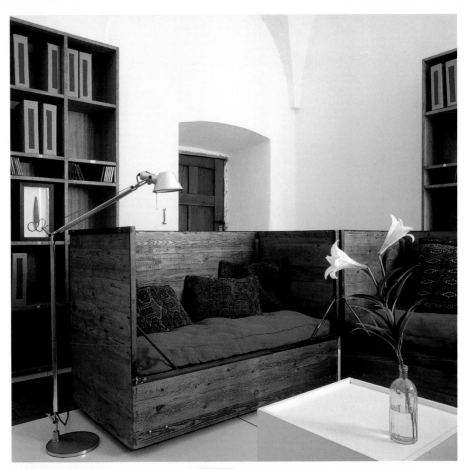

Three box-like benches—constructed from old wood and iron and made comfortable by simple cushions—provide a reading area and meditative space in which to absorb information and enjoy the peaceful and mysterious atmosphere of the building.

Designer's Office

Patrizia Sbalchiero | © Andrea Martiradonna | Milan, Italy

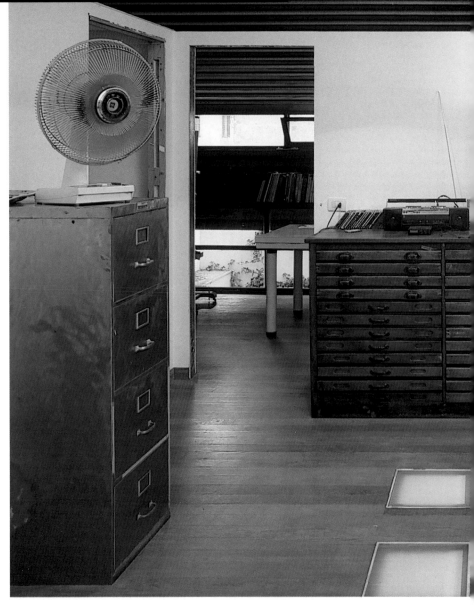

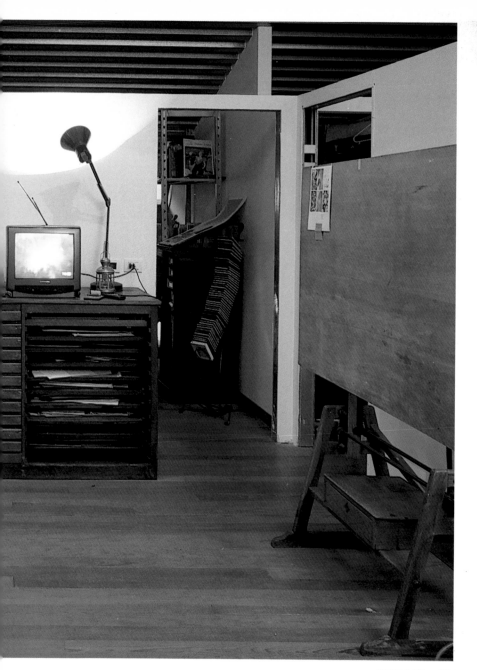

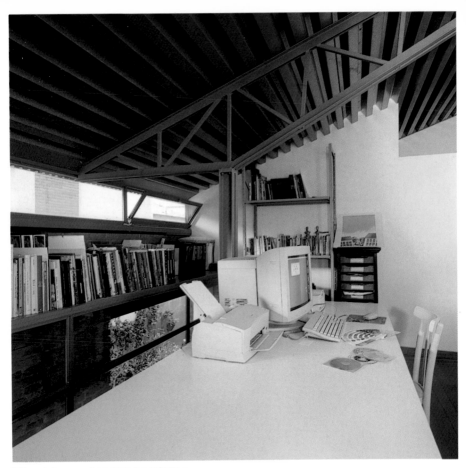

This workshop was divided into two units by a slender, airy, metal mezzanine that is situated in the rear and accommodates the office suite.

Floor plan

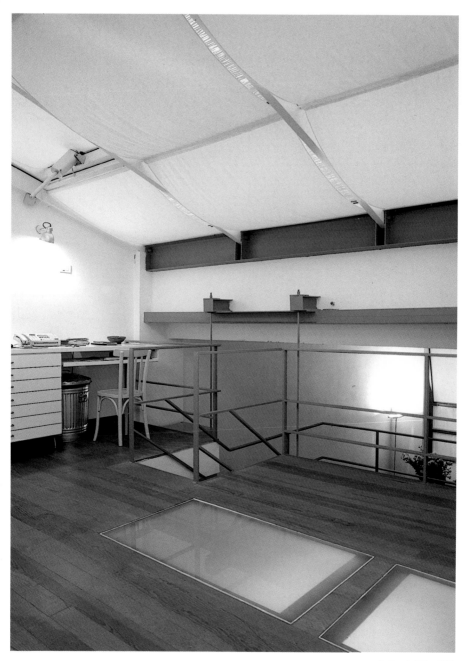

Printmakers Live Work Space

Kennedy & Violich Architecture | © Bruce T. Martin, Kennedy Violich Architecture | Boston, Massachusetts, United States

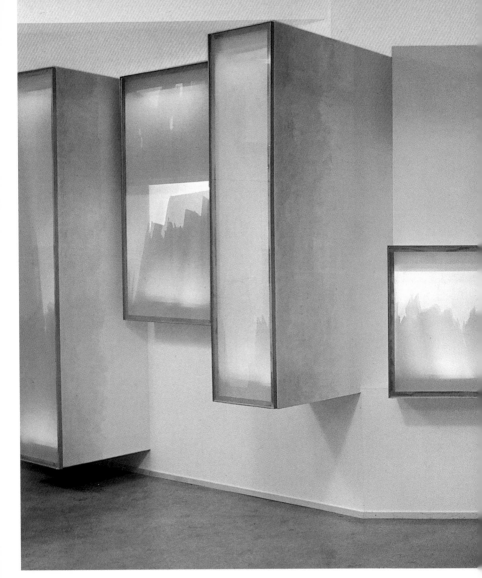

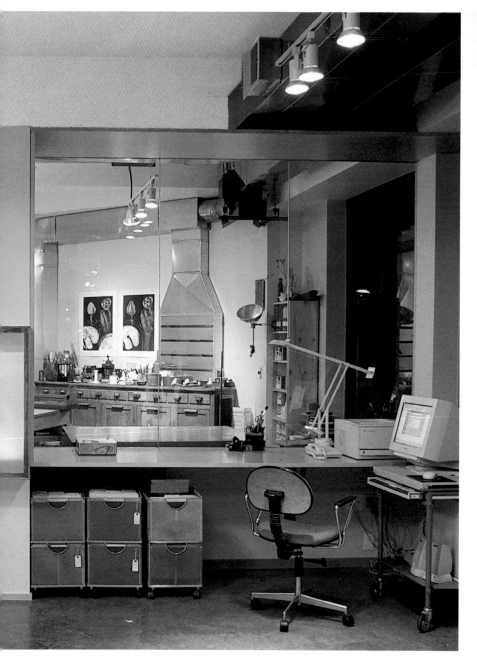

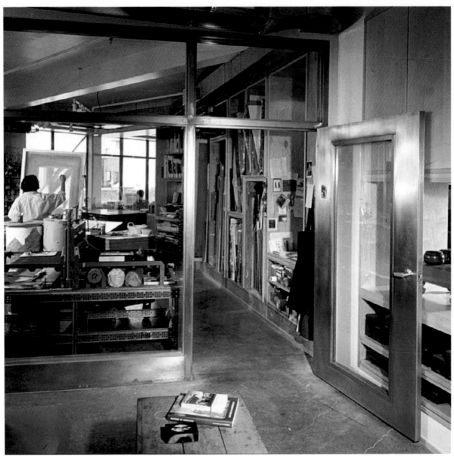

Dividing glass panels separate some of the areas.
They serve as reflecting screens at night, and
during the day they allow natural light to flood the
different areas.

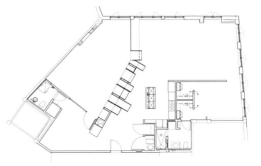

Floor plan

The storage space was custom designed to accommodate work tools, canvases, and finished works.

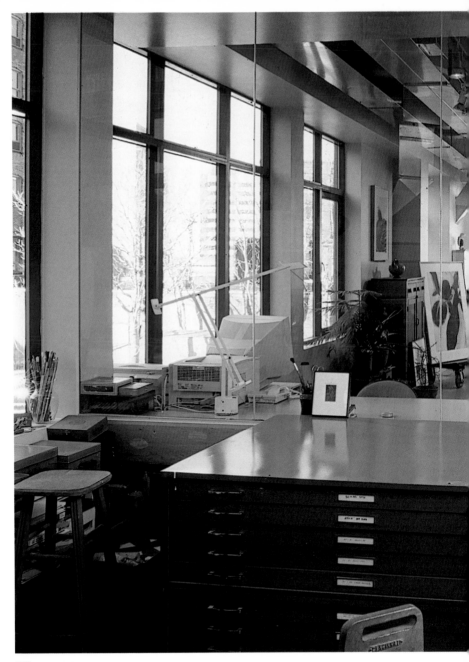

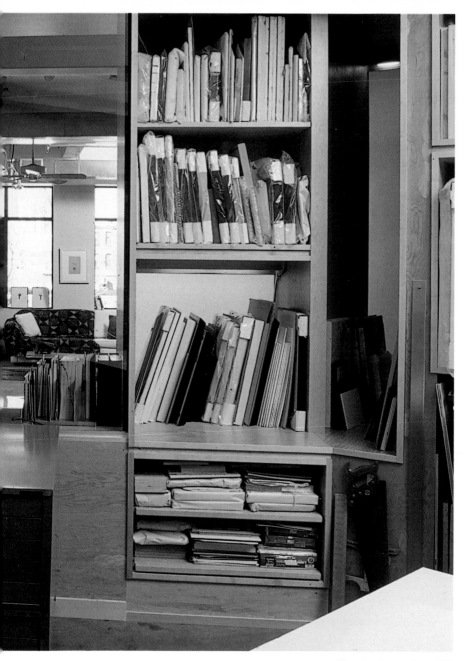

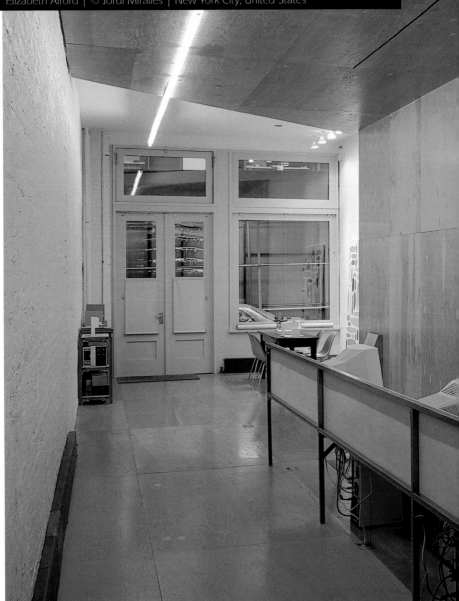

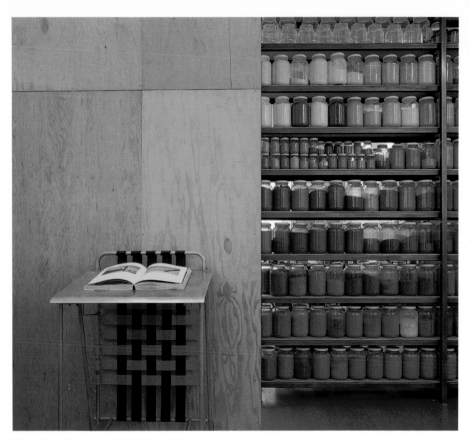

This project relies on functional design, straight lines softened by touches of color distributed throughout the space, and a close relationship between its materials.

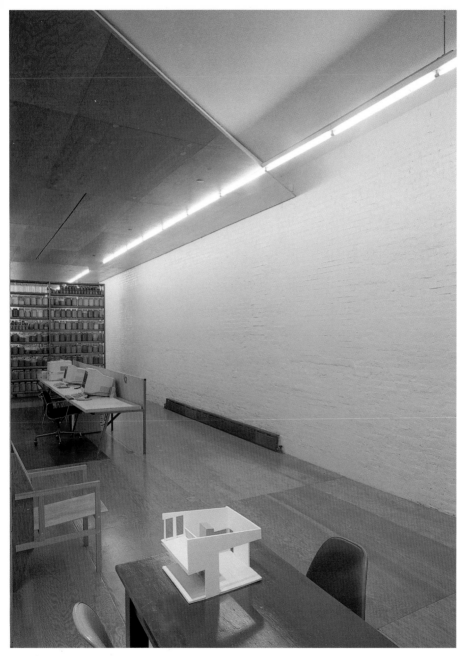

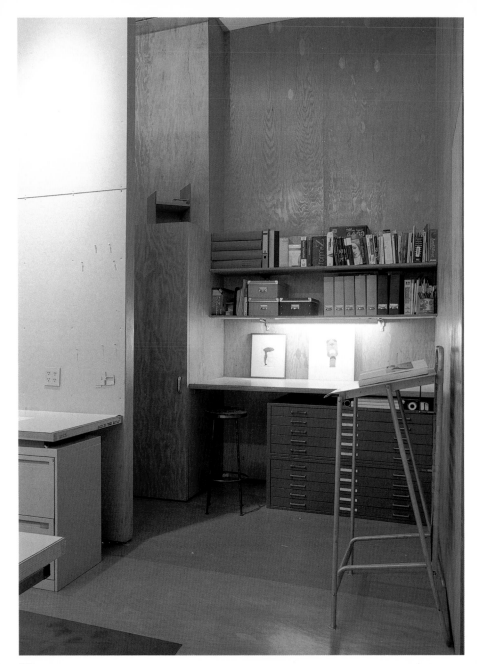

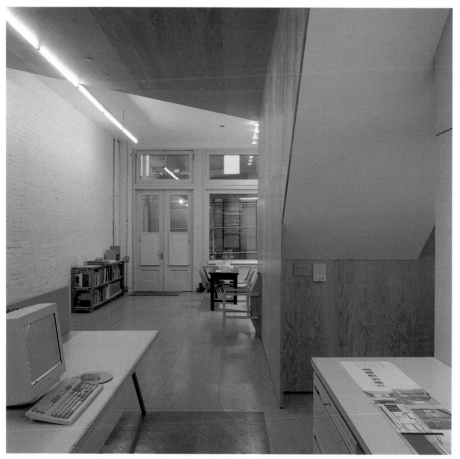

In the office area, austerity is the main feature. Sober and functional furnishings, bare walls, and the predominance of wood reinforce the idea of discretion and restraint.

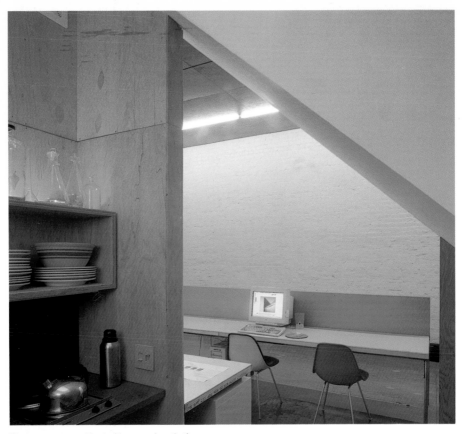

These textures, combined with a sound aesthetic sense, create a pleasant and contemporary space where work can be carried out freely and in harmony.

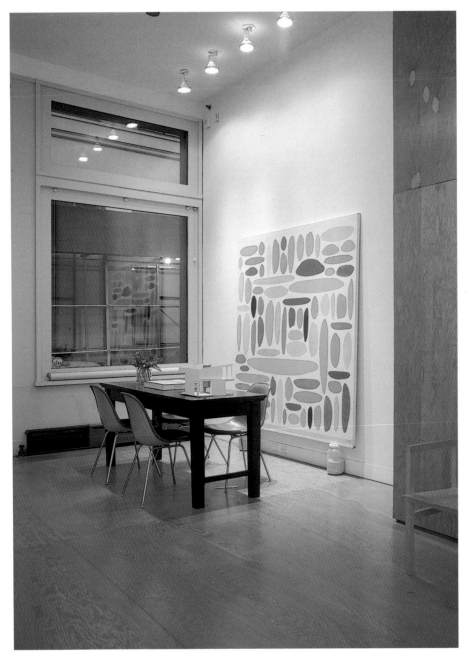

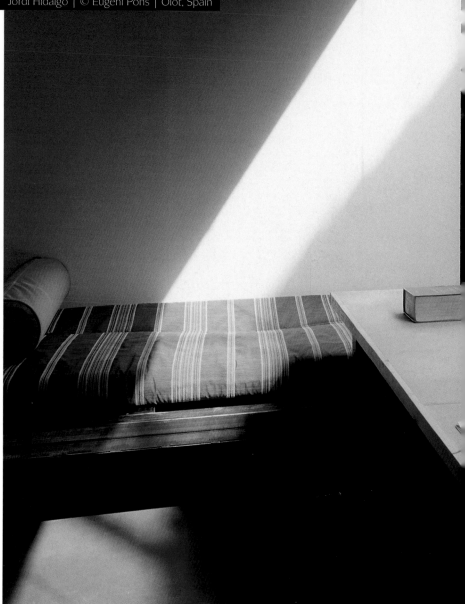

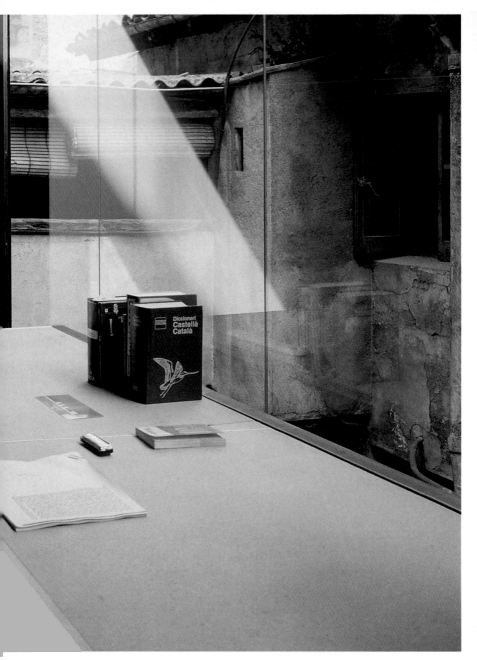

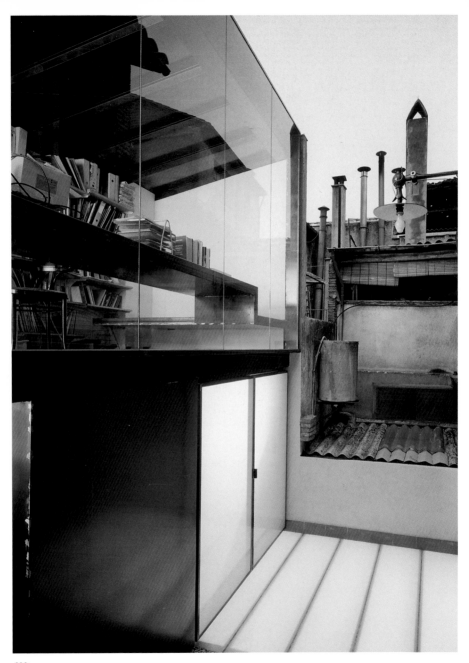

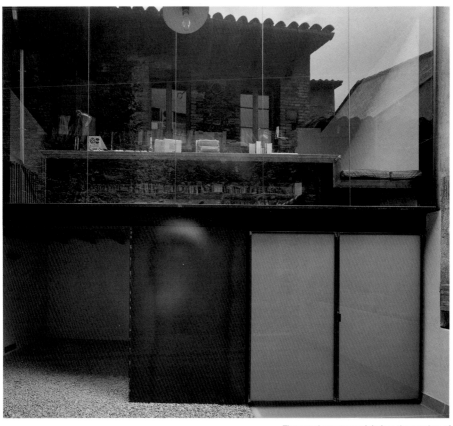

The metal structure minimizes the number of construction elements, resulting in a very light unit that communicates with the exterior.

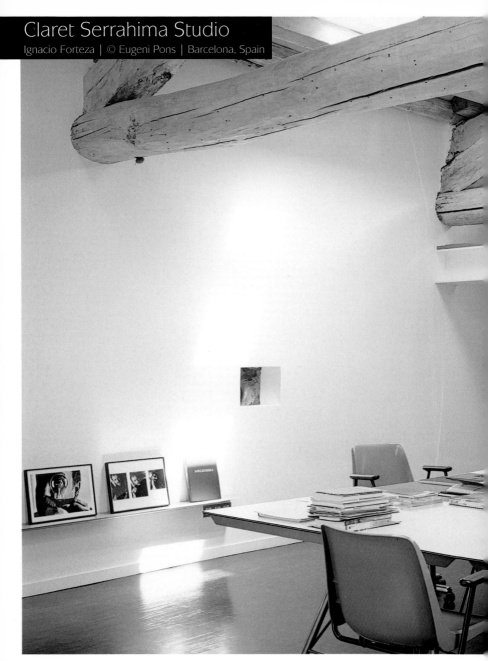

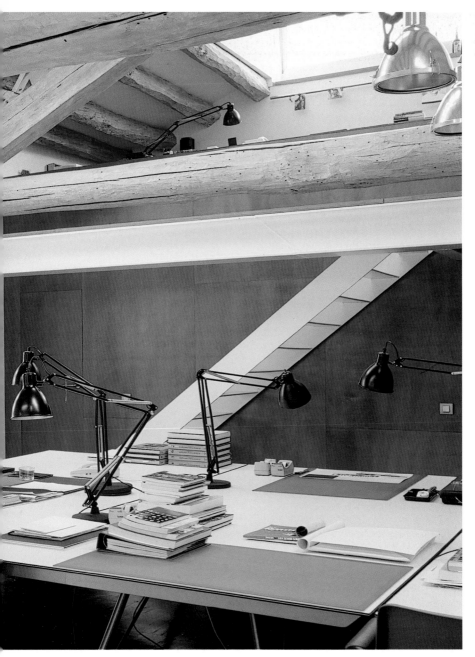

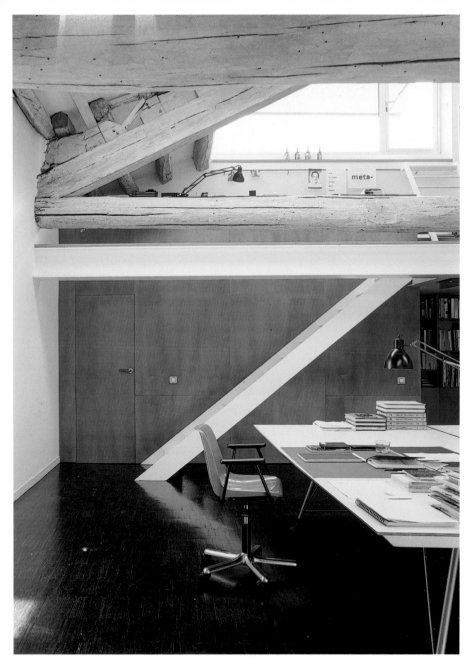

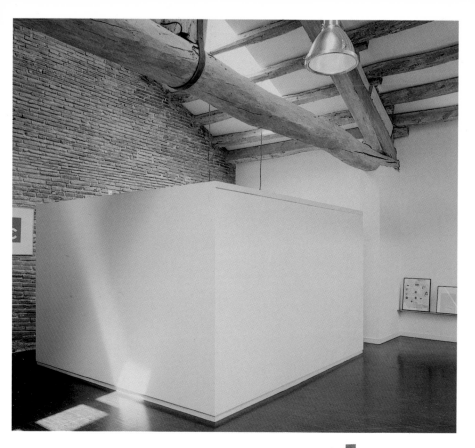

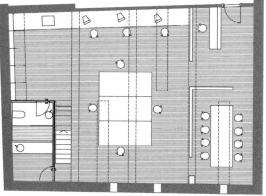

First floor

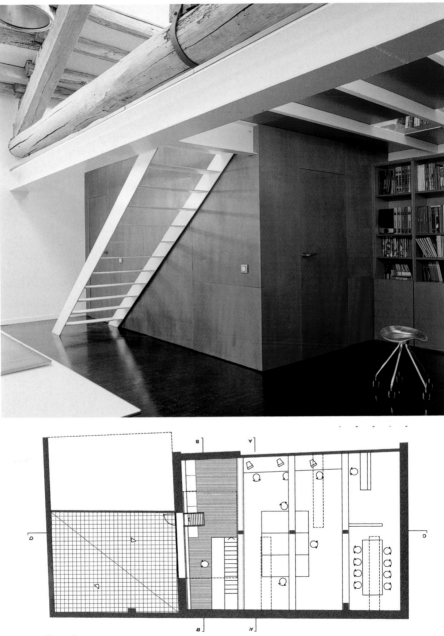

Mezzanine

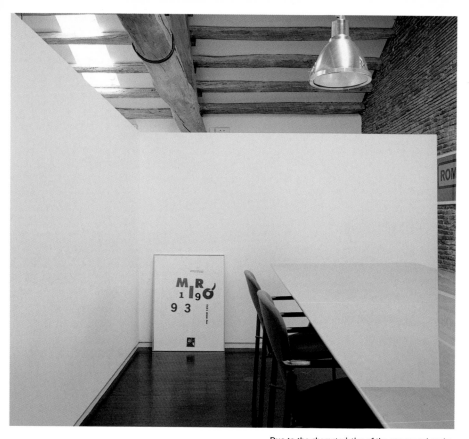

Due to the characteristics of the space and to the activity for which it was intended (graphic design), separate workrooms were not needed. The architects decided to create zones without visually breaking up the space. This allows the rest of the area to be seen from the reception zone and the meeting room. A mezzanine was created to access the terrace.

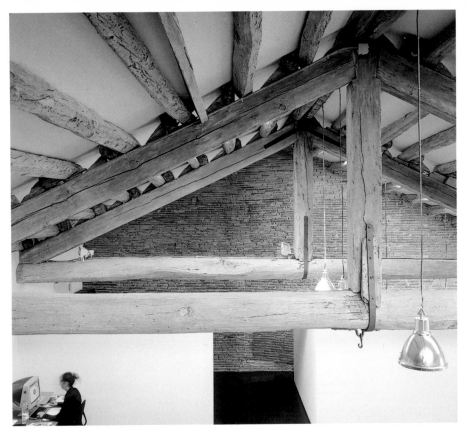

Sections

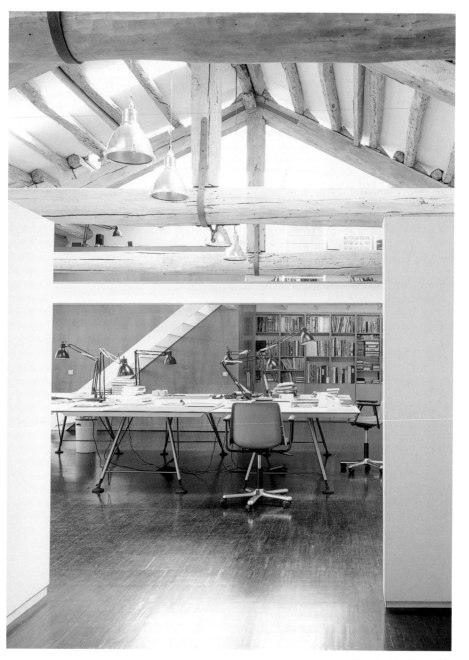

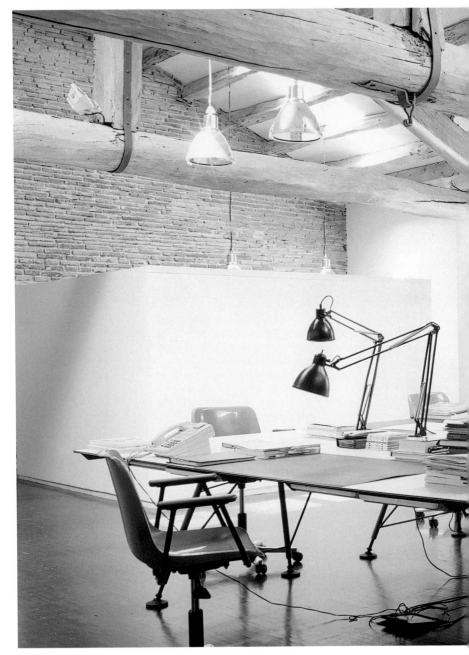

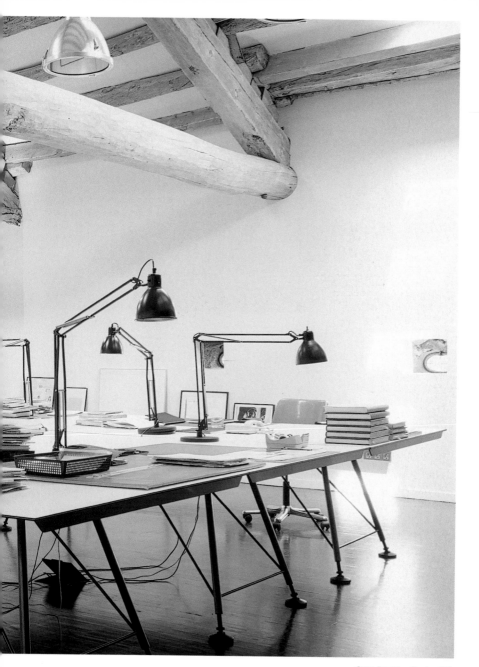

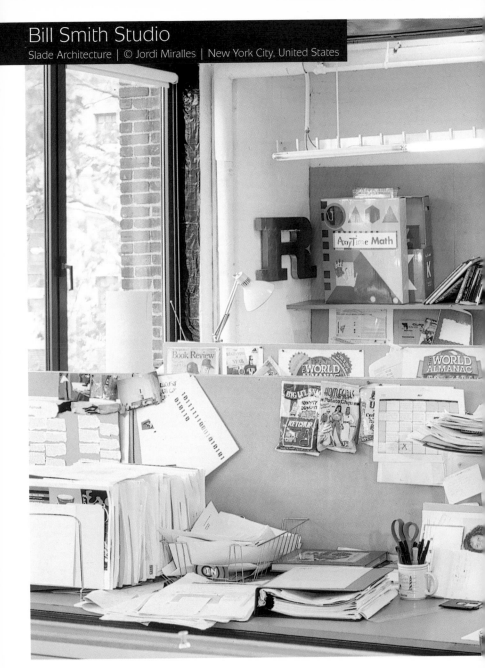

The furnishings, custom designed for this project, are
a constant reminder that children are the company's
customers. The furnishings were also made to be
easily moved within the space as needed.

Fiberglass panels make slim dividers that diffuse the natural light. The panels are anchored to the same types of structures as those used for the shelving.

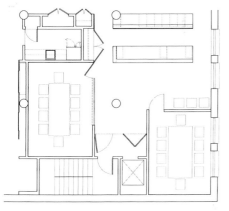

Floor plan

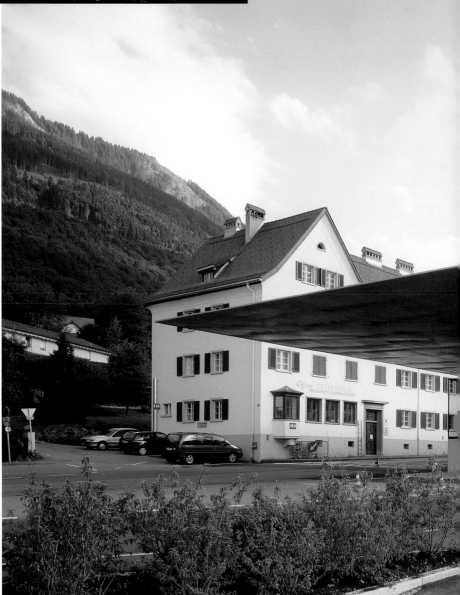

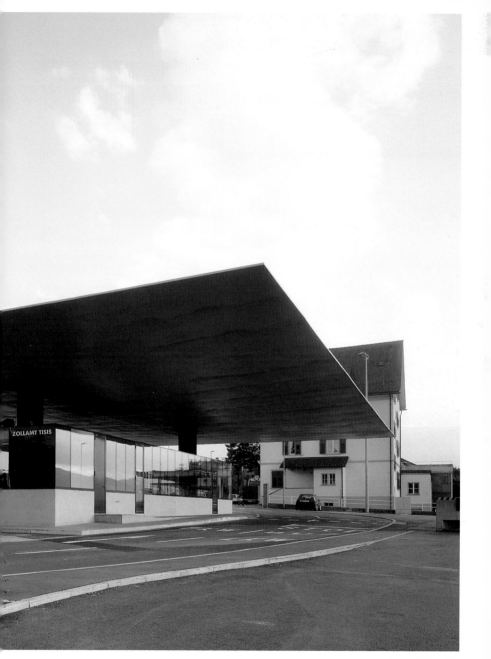

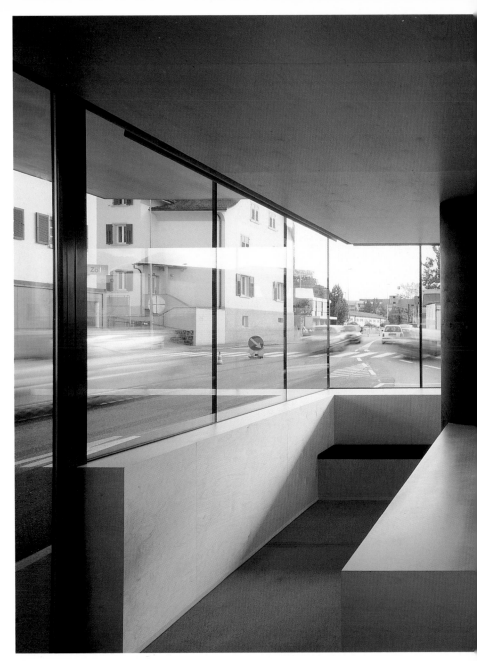

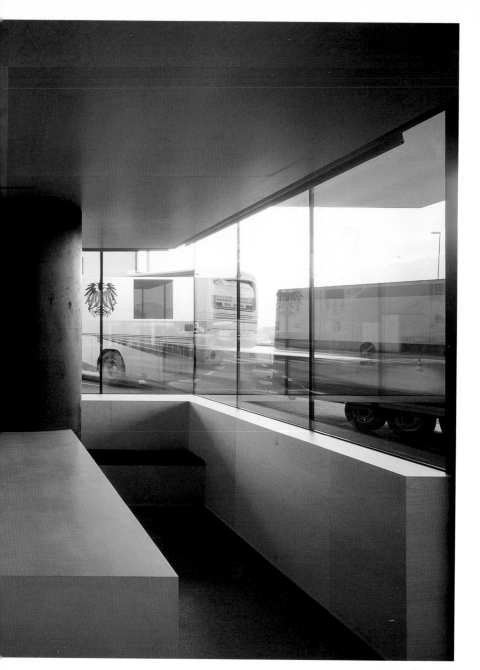

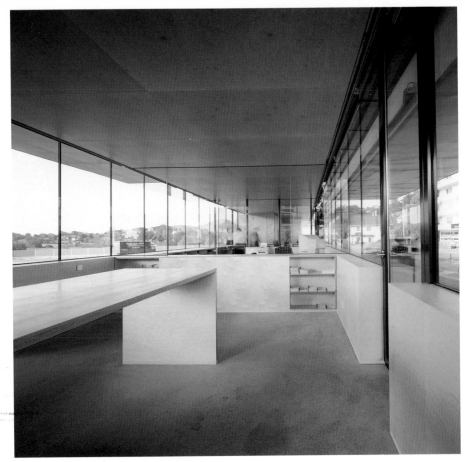

This office is divided into three parts that afford different levels of privacy. The first area is where the public is served, another is a work space, and the most private space houses the restrooms.

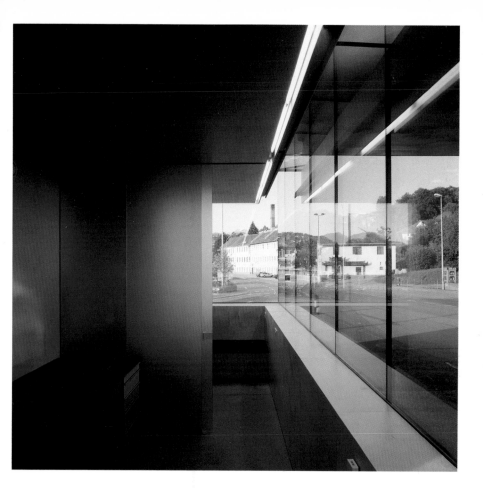

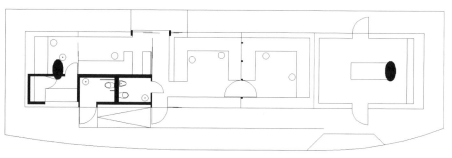

Floor plan

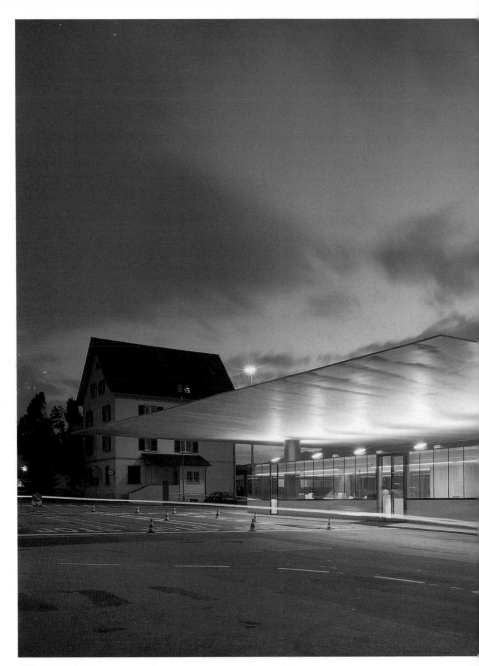

Rohner Office

Bernd Spiegel | © Ignacio Martínez | Wolfurt, Austria

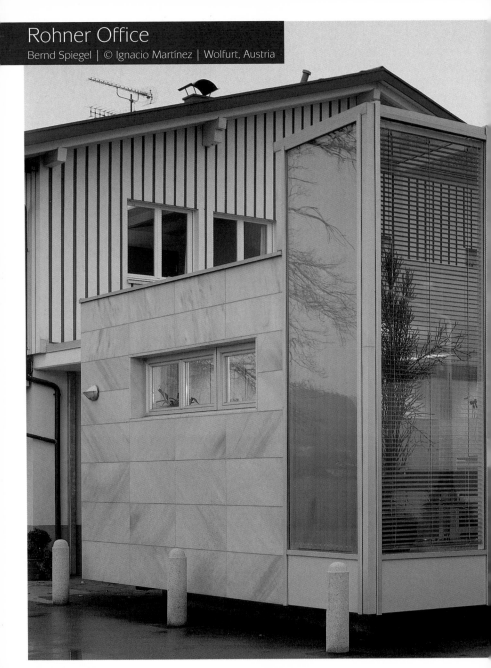

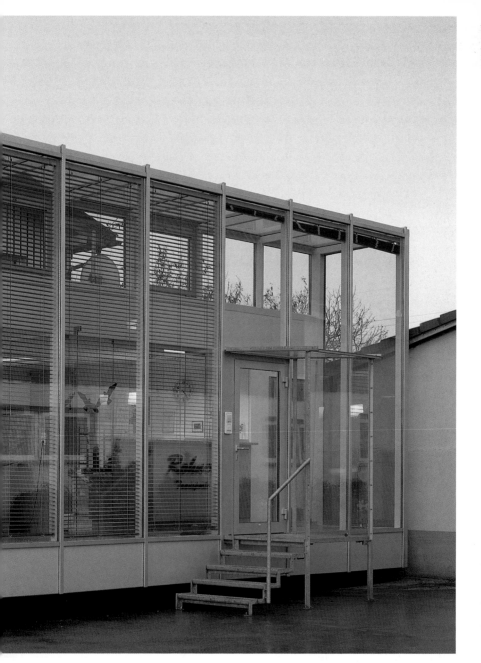

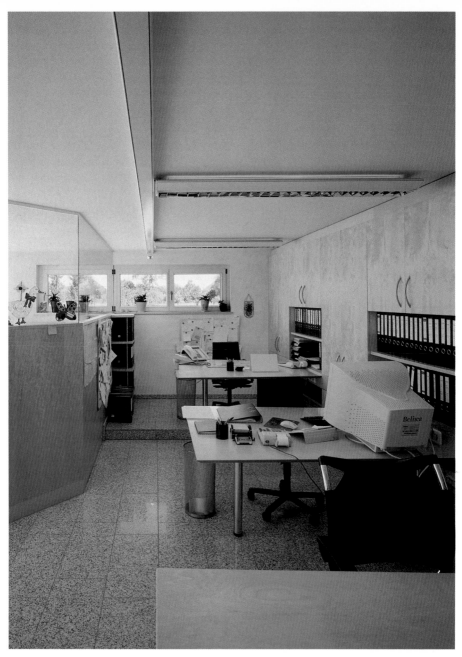

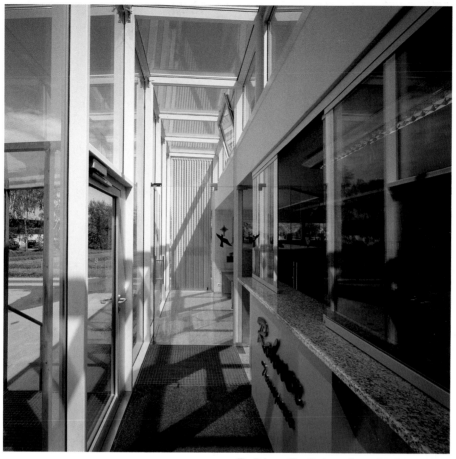

The Rohner office, the base of operations for a company
that provides transportation and moving services,
occupies a tiny plot next to the owners' home. The
requirements for this unit included a corporate
appearance, accommodations for several workstations, a
conference room, and a public service area.

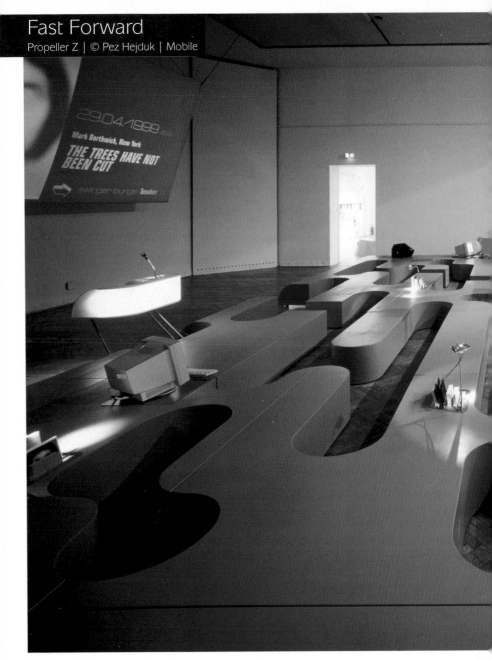

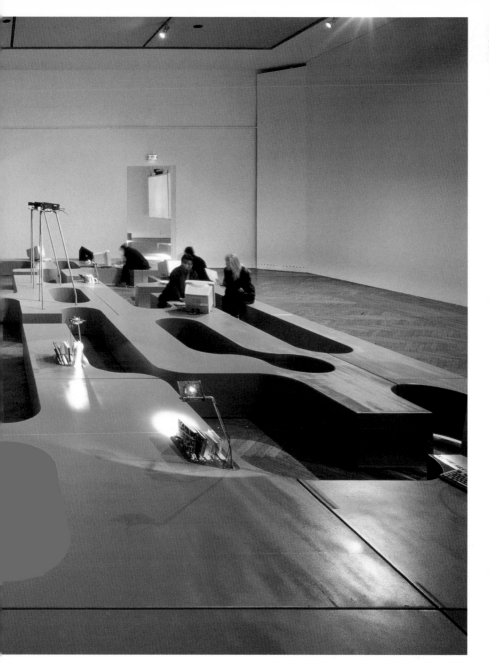

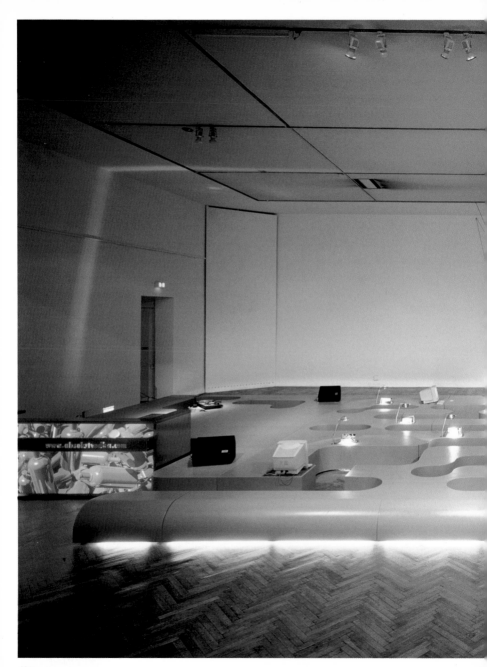

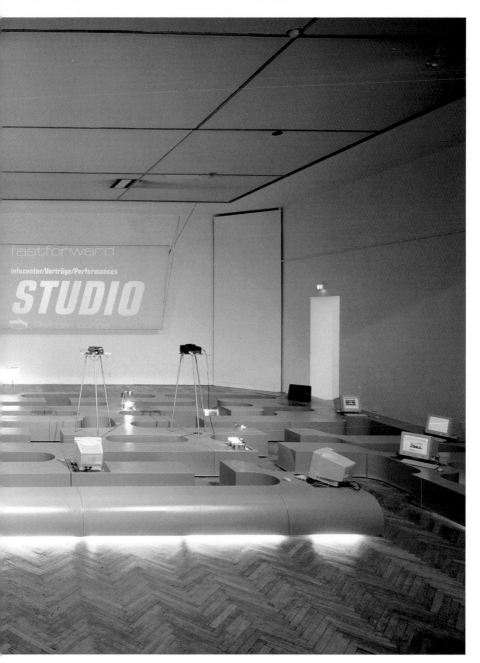

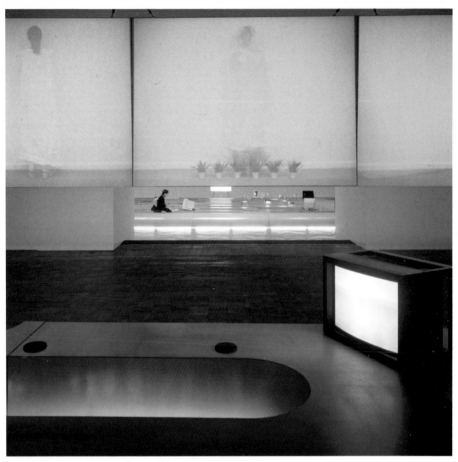

An office that contains a work of art could be the defining concept behind this hybrid system, which offers the opportunity to sit down, recline, work at a computer, or store or display information. A horizontal platform from which parts are removed, the system forms a sinuous labyrinth that can accommodate each artist's needs.

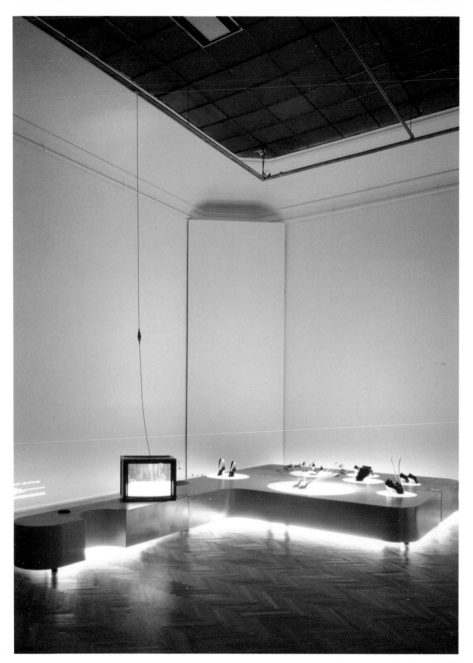

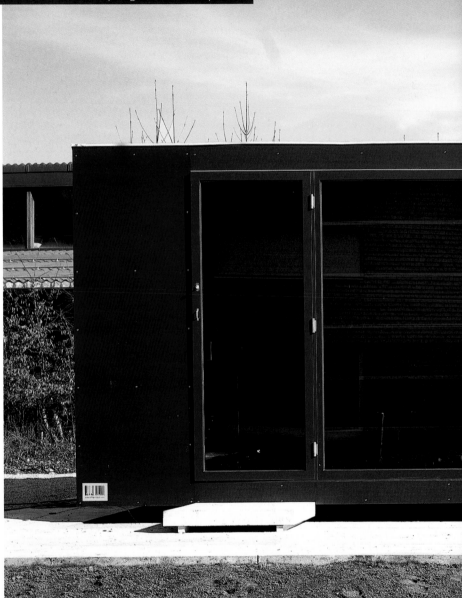

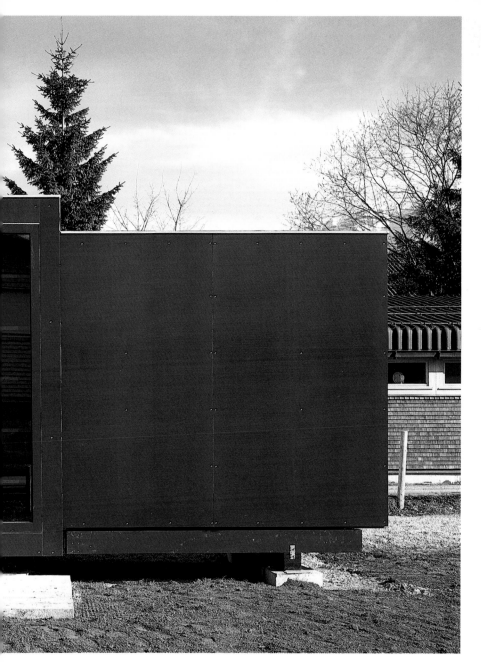

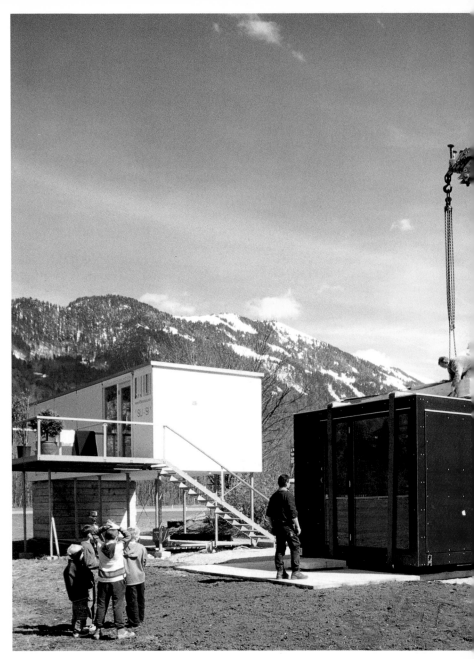

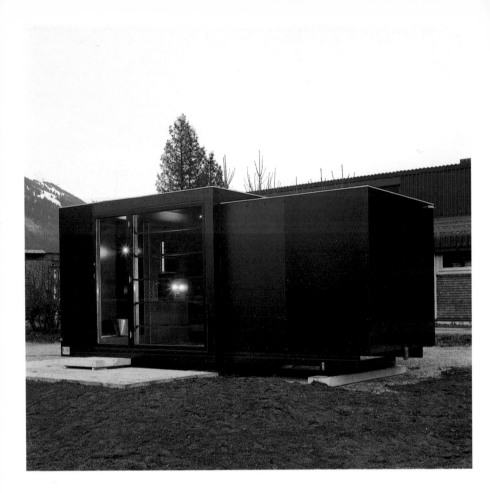

Floor plan

Extended floor plan

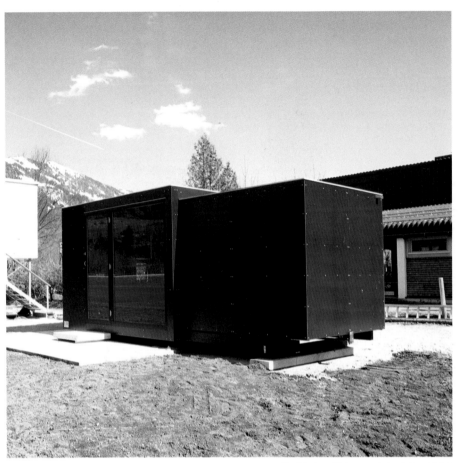

The interior of this expanded unit is used as a work space with a restroom and a kitchenette. An inner box slides out over two rails on the bottom of the unit, doubling the amount of interior space.

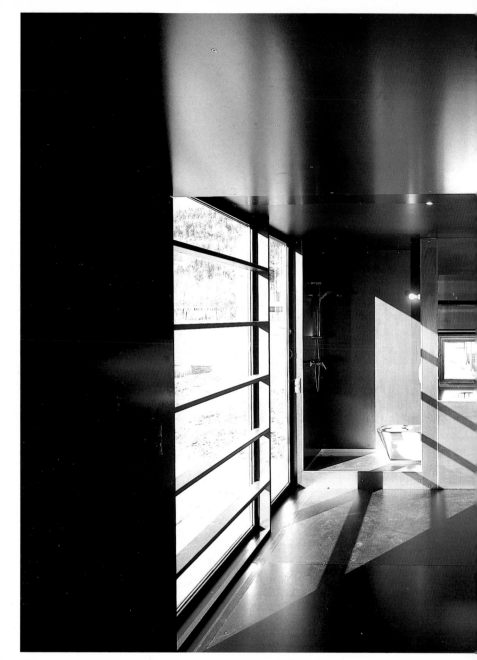

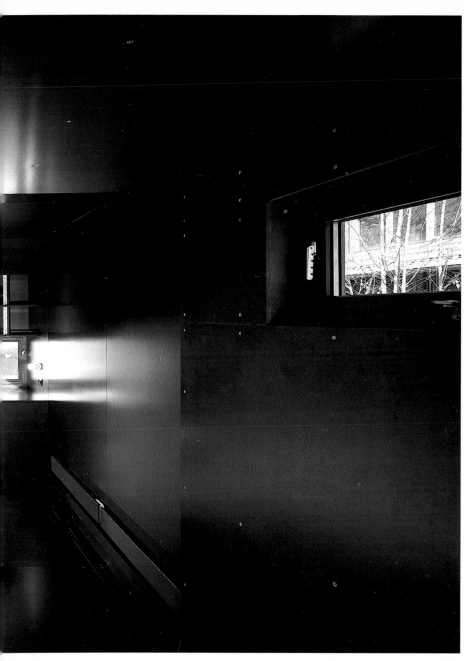